Cultural Encounters

D0420637

Cultural Encounters examines how 'otherness' has been constituted, communicated and transformed in cultural representation. Covering a diverse range of media including film, television, advertisements, video, photographs, painting, novels, poetry, newspapers and material objects, contributors explore the cultural politics of Europe's encounters with Islam, Brazil, India, Israel, Australia and Africa, examining the ways in which visual and textual forms operate in their treatment of cultural difference.

The opening section considers how certain narrative forms support notions of cultural and historical unity and difference, focusing on the European representation of 'otherness'. The ways in which such images are contested and subverted in art, cinema and the visual media are then explored in different social contexts. The second section turns to processes of cultural representation in museums and wider social and political arenas. Contributors examine how museum collections have operated as markers of 'otherness', organising and privileging certain forms of knowledge, and consider recent challenges to traditional museum practices.

Elizabeth Hallam is Director of Cultural History at the University of Aberdeen. **Brian V. Street** is Professor in the School of Education at King's College, London.

SOAS

18 0472743 X

Sussex Studies in Culture and Communication
Series Editors: Roger Silverstone, London School of Economics, Craig Clunas, University of Sussex and Jane Cowan, University of Sussex

Books in this series express Sussex's unique commitment to interdisciplinary work at the cutting edge of cultural and communication studies. Transcending the interface between the social and the human sciences, the series explores some of the key themes that define the particular character of life, and the representation of life, at the end of one millennium and the beginning of the next.

Our relationships to each other, to our bodies and to our technologies are changing. New concepts are required, new evidence is needed, to advance our understanding of these changes. The boundaries between disciplines need to be challenged. Through monographs and edited collections the series will explore new ways of thinking about communication, performance, identities, and the continual refashioning of meanings, messages, and images in space in time.

Virtual Geographies
Bodies, Space and Relations
Edited by Mike Crang, Phil Crang and Jon May
The House of Difference
Cultural Politics and National Identity in Canada
Eva Mackey
Visual Digital Culture
Andrew Darley

Forthcoming:
A National Joke
Andy Medhurst

829589

Cultural Encounters

Representing 'otherness'

Edited by Elizabeth Hallam and
Brian V. Street

London and New York

First published 2000
by Routledge
11 New Fetter Lane, London EC4P 4EE

Simultaneously published in the USA and Canada
by Routledge
29 West 35th Street, New York, NY 10001

Routledge is an imprint of the Taylor & Francis Group

© 2000 Elizabeth Hallam and Brian V. Street for selection and editorial
matter; individual chapters to their contributors

Typeset in Galliard by RefineCatch Limited, Bungay, Suffolk
Printed and bound in Great Britain by
Biddles Ltd, Guildford and King's Lynn

All rights reserved. No part of this book may be reprinted or
reproduced or utilised in any form or by any electronic,
mechanical, or other means, now known or hereafter
invented, including photocopying and recording, or in any
information storage or retrieval system, without permission in
writing from the publishers.

British Library Cataloguing in Publication Data
A catalogue record for this book is available from the British Library

Library of Congress Cataloging in Publication Data
Cultural encounters : representing 'otherness' / edited by Elizabeth
Hallam and Brian V. Street.
 p. cm.
 Includes bibliographical references and index.
 1. Ethnicity. 2. Ethnicity in art. 3. Mass media and culture.
4. Mass media and ethnic relations. 5. Museum exhibits.
6. Ethnocentrism – Europe. 7. Europe – Relations – Foreign
countries. 8. Europe – Ethnic relations. 9. Europe – Civilization –
Foreign influences. I. Hallam, Elizabeth, 1967– . II. Street, Brian V.
GN495.6.C83 2000
305.8'0094 – dc21 99–057236

ISBN 0–415–20279–5 (hbk)
ISBN 0–415–20280–9 (pbk)

SOAS LIBRARY

Contents

PART II
Displaying cultures 149

Illustrations

Notes on contributors

Talal Asad is Distinguished Professor of Anthropology in the Graduate School at the City University of New York and was formerly Professor of Anthropology at Johns Hopkins and at the New School for Social Research in New York. He has held visiting professorships at a number of universities in the USA and also internationally, including the Sudan and Cairo. He has been active in Middle East studies for over twenty years and published a number of leading books and articles in this area, including *The Kababish Arabs* (Hurst & Co, 1970) and *The Sociology of Developing Societies: The Middle East* (Macmillan, 1983). He was co-founder of the *Review of Middle East Studies*. He is well known for seminal work in the field of representation of colonial discourse, notably with *Anthropology and the Colonial Encounter* (Ithaca Press, 1973) and *Genealogies of Religion* (Johns Hopkins University Press, 1993). In addition to four books he has written over forty scholarly articles. He is currently preparing a book on colonialism, the state and category of secularism in Egypt.

Rangan Chakravarty teaches at the University of Sussex and is researching for a doctoral thesis on the politics of popular music in Calcutta in the 1990s. He worked as a creative director in corporate and brand advertising in India, as well as in Nepal and Bangladesh. During his fifteen years in advertising, he continuously volunteered to produce a number of video documentaries, print campaigns as well as conduct theatre and communications workshops for development organisations. He also produced radio serials based on primary health programmes and wrote storybooks for children in rural schools. In 1993, he returned to academia via an MA in Media Studies at the New School for Social Research, New York.

Nandini Gooptu is a University Lecturer in South Asian Studies at Oxford, and a Fellow of St Antony's College. She has completed a monograph on the politics of the urban poor in north India in the late-colonial period. Her research interests include the history of caste, communal and nationalist politics in twentieth-century India.

Elizabeth Hallam is Director of Cultural History at the University of Aberdeen. She has taught cultural anthropology at the Universities of Kent and Sussex.

Her research and publications focus on historical anthropology, gender and cultural representations in Britain and Europe. She is co-author of *Beyond the Body. Death and Social Identity* (Routledge, 1999). She is currently working on *Death, Memory and Material Culture,* a co-authored book, for Berg Publications and is completing further work on gender, ritual and the body in historical and contemporary England.

Ludmilla Jordanova is Professor of Visual Arts and teaches cultural history at the University of East Anglia. Her training was in the natural sciences, history and philosophy of science and art history. Her research interests include the visual culture of the long eighteenth century, the history of women, gender and the family, and the history of medicine. *Nature Displayed: Gender, Science and Medicine 1760–1820* was published by Longman in 1999. She is author of *History in Practice* (Edward Arnold, 2000).

Ivan Karp is National Endowment for the Humanities Professor in the Graduate Institute of Liberal Arts at Emory University. He is the author of *Fields of Change, Among the Iteso of Kenya* (1978) and the author of articles on social organisation, African systems of thought, social theory and the ethnography of museums.

Corinne A. Kratz is Assistant Professor of Anthropology and African Studies at Emory University. She has written on culture, communication and performance in ceremonies, exhibitions, and other cultural displays. She is the author of *Affecting Performance: Meaning, Movement, and Experience in Okiek Women's Initiation* (1994).

Yosefa Loshitzky is Senior Lecturer in the Department of Communication and Journalism at the Hebrew University, Jerusalem. She is the author of *The Radical Faces of Godard and Bertolucci*, and the editor of *Spielberg's Holocaust: Critical Perspectives on Schindler's List*. She is currently completing a book on Israeli identity. She has also written extensively on film, media and culture for a variety of journals.

Julie Marcus holds the Chair of Social Anthropology at Charles Sturt University, Bathurst, Australia and is a member of the Centre for Cultural Risk Research. She has research interests in cultural differences, gender, race and sexuality and has carried out fieldwork in Turkey and central Australia. She has a special interest in museums and exhibitions and is writing a biography of Olive Muriel Pink, a remarkable anthropologist and human rights activist who worked in central Australia during the 1930s, and is preparing a study of the interactions of policy, anthropology and racism in central Australia that focuses on Arrernte resistance to the flooding of their sacred sites. Her other research projects include a study of secrecy and freedom of speech and the compilation of a National Dictionary of Australian Lesbian Biography.

Partha Mitter is Reader in History in the School of English and American Studies at Sussex University. He was a Fellow of Clare Hall, Cambridge University

and Visiting Fellow at the Institute for Advanced Studies at Princeton University. He is best known for *Much Maligned Monsters: a History of European Reactions to Indian Art* (University of Chicago Press, 1977) which has just been reprinted and he has just completed a book on art and nationalism in colonial India

Ana Reynaud did her BA in Art Education at the Pontificia Universidade Católica do Rio de Janeiro. She did an MPhil in Literature at the Universidade do Estado do Rio de Janeiro. She has recently finished her PhD thesis, 'Brazilian video works: diversity and cultural identity in a global context', a critical account of the work of four Brazilian video makers, at the University of Sussex, where she has been teaching visual media analysis: film, video and television for the past three years. She published a book of short stories last year, called *A Cidade em Fuga* (*The Fleeing City*).

Emma Sandon teaches film and television studies at Bournemouth University and Birkbeck College. She is currently writing a DPhil based on an oral history of the BBC Television Service at Alexandra Palace between 1936 and 1952. She has published articles on women's film-making for several magazines, including *Everywoman* and *Vertigo*. She has also worked as a camerawoman since 1990 and is involved in the running of a small independent production company which produces educational films and documentaries.

Anthony Alan Shelton has held curatorial posts at the British Museum and the Royal Pavilion, Art Gallery and Museum, Brighton, where he established the Green Centre for Non-Western Art and Culture. He is currently Head of Collections, Research and Development at the Horniman Museum, London. He has conducted fieldwork in Mexico and Guatemala and has published extensively on the anthropology of art, museums and on issues in Mexican ethnography.

Brian V. Street is Professor of Language Education in the School of Education at King's College, London and Visiting Professor of Education in the Graduate School of Education, University of Pennsylvania He undertook anthropological fieldwork in Iran during the 1970s, taught cultural anthropology for twenty years at the University of Sussex and has worked in the fields of language, literacy and education in the USA, Britain, and South Africa. He has had a long-standing interest in 'representations' and his book *The Savage in Literature* (RKP, 1975) was one of the early examples of research on colonial discourse. He has also written and lectured extensively on literacy practices from both a theoretical and an applied perspective. He is best known for *Literacy in Theory and Practice* (Cambridge University Press, 1985), has edited *Cross-Cultural Approaches to Literacy* (Cambridge University Press, 1993) and a collection of his own articles, *Social Literacies* (Longman, 1995). In addition to six books, he has written over sixty scholarly articles.

Preface and acknowledgements

This book arises out of a series of interdisciplinary lectures and seminars, film and video screenings, exhibitions and musical events organised by the editors and based in the Graduate Research Centre for Culture and Communication (Cul-Com) at the University of Sussex, 1995–96. The central issues discussed during the 'theme year' focused upon Cultural Encounters, a theme around which the following chapters cohere. This theme provided a focus for a range of research activities and provided a special opportunity for faculty and graduate students at Sussex as well as international scholars to explore, in particular, the cultural politics of representation and reception. Participation by researchers in the fields of anthropology, art history, media and film studies, literary and cultural studies led to a stimulating range of debates. In order to facilitate discussion of a variety of cultural representations the lectures were accompanied by a film and a music strand. The theme year was characterised by the critical and constructive examination of various media employed to represent cultures by academic and museum institutions. Similarly, the discourses surrounding cross-cultural contacts, which integrate complex textual, visual, material and aural elements, were examined. Practitioners in museum curatorship and film-making also provided important insights from perspectives beyond the university.

The theme year was very much a collaborative effort and we would like to thank all of those who helped to make it so productive and enjoyable. Our programme of lectures included Talal Asad, Homi Bhabha, Shirley Brice-Heath, Michael Finnessy, Stuart Hall, Gavin Jantjes, Ludmilla Jordanova, Ivan Karp, Yosefa Loshitzky, Julie Marcus, Donald Mitchell and Susan Stewart as visiting speakers. Staff at Sussex who gave key lectures and chaired discussions included Stephen Barber, Eddie Chambers (Curator in residence), James Donald, Catherine Lupton, and Partha Mitter. The film screenings and related discussions were coordinated by graduate students in CulCom and we very much appreciated the efforts of Rangan Chakravarty, Steffi Donald, Ana Reynaud and Emma Sandon. Avril Johnson from Black Audio Film provided valuable contributions as a film-maker.

The two associated exhibitions were the result of work undertaken by university and museum staff. 'Communicating Otherness: Cultural Encounters', which opened at Brighton Museum and Art Gallery in February 1996, was

curated by Elizabeth Hallam and Nicki Levell with invaluable help from Louise Tythacott and Anthony Alan Shelton. Staff from CulCom who kindly provided their research materials for the display included Christina Brink, Brian Short and Sue Wright. Craig Clunas also supplied materials from the Barlow Gallery. Gareth Reast, together with students from Brighton University, was responsible for the innovative exhibition design. Erica Smith designed the exhibition catalogue and posters. The second exhibition in the theme year was curated by Craig Clunas and involved the redisplay of the Barlow Gallery at Sussex University. This was undertaken with the help of undergraduate art history students.

Many of the staff at Sussex University provided creative input and support. We would particularly like to thank Margot Latcher and Roger Silverstone who provided continual enthusiasm and inspiration. At Aberdeen University, Paul Coates read and commented on an earlier version of the Introduction; Fidelma Farley was always helpful in our discussions about film and colonialism and Jill Davey provided valuable secretarial support in the preparation of the manuscript.

Elizabeth Hallam, University of Aberdeen
Brian V. Street, King's College, London

Introduction

Cultural encounters – representing 'otherness'

Elizabeth Hallam and Brian V. Street

Overview

This book explores and analyses cultural encounters to expose the diversity of ways in which 'otherness' has been constituted, communicated and transformed in contemporary and historical contexts. The complex processes of othering, crucial in the formation of identities in Europe and beyond, are investigated here through the analysis of cultural representation understood as both an epistemological and a political issue. The theoretical concerns and themes addressed throughout the book contribute to debates about representation and encounter, engaging with the work of Bhabha, Clifford, Fabian, Hall, Said and other analysts of cultural and gender politics. As such, the book attempts to 're-present 'otherness' by extending and re-evaluating current work on the politics of representation in the fields of anthropology, cultural history, film and media studies. In pursuance of this aim, the authors in this book bring interdisciplinary perspectives to bear upon the cross-cultural dynamics of cultural representation, especially in relation to the production, appropriation, collection and display of written texts, visual images and material objects. Examining the social, cultural and political institutions and processes through which 'otherness' has been constructed in terms of race and gender, the book also provides critical reflection upon academic discourse which exaggerates or essentialises the 'other'. The authors, then, explore issues around cultural encounters that move beyond traditional conceptions of the 'West and the rest' towards genuinely dialogic, multidirectional and polyphonic perspectives.

Cultural representation: epistemological issues

Debates about cultural difference and 'otherness' provoke fundamental questions with regard to the nature of social knowledge, an issue of particular concern to contemporary anthropologists whose debates on these issues contribute centrally to the themes of this book. In reflecting upon these issues, Fabian observes that 'Awkward and faddish as it may sound, othering expresses the insight that the Other is never simply given, never just found or encountered, but made. For me, investigations into "othering" are investigations into the production of

anthropology's object' (Fabian 1991: 208). Anthropologists have become particularly sensitised to the ways in which their discipline has traditionally constructed its objects of analysis, reflecting upon their methods, theoretical concerns, and writing practices to bring anthropological discourse itself within the frame of analysis (Clifford and Marcus 1986). Central to this reflexive turn is the recognition that anthropologists are always implicated in the social and cultural processes that they describe and analyse. Clear distinctions between 'indigenous' cultures and anthropologists' accounts become problematic in the light of recent critiques which expose anthropological representations as negotiated, constructed and partial (Street 1996).

This marked shift in anthropologists' relationships with their objects of study is particularly apparent in the work of Clifford: 'The other for Clifford is the anthropological representation of the other.' (Rabinow 1986: 242). This gives rise to a meta-anthropology which analyses the textual conventions and modes of authority at work in anthropological writing. Rejecting 'transparency of representation and immediacy of experience' in anthropological writing and practice, Clifford asserts that culture is 'composed of seriously contested codes of meaning and representation' (Clifford 1988: 2). Here direct attention is paid to the means of communication employed within ethnographic writing. Constituted within relations of power, and institutional constraints together with the use of particular conventions, ethnographic writings convey 'partial truths' which are always mediated in historical context (Clifford 1988: 6–7).

Such recognition of the partiality of cultural and historical truths necessarily raises questions about the cultural effects of any given representation: how does it operate to exclude, silence, translate or exaggerate others? Here there is a critical acknowledgement of the politics of anthropological poetics such that written texts are recognised as instruments of power with their own culturally specific modes of authority. But while Clifford recognises ethnographic techniques of persuasion which 'enact power relations' he also stresses that the function of anthropological representations is 'complex, often ambivalent, potentially counter-hegemonic' (Clifford 1988: 9). This complex formulation of the ways in which representations work both to maintain and to undermine dominant ideas arises out of a critique of Western discourses in their claims to represent the other. The problematising of cross-cultural representation is reinforced through critical cultural histories of colonialism and is related to decolonisation, which means that 'the West can no longer present itself as the unique purveyor of anthropological knowledge about others' (Clifford 1988: 22).

Alongside the analysis of early twentieth-century ethnographic representations there has been an examination of particular notions about the other as devices embedded in longer term historical processes. Interrogating the intellectual history of anthropology, Fabian discusses conceptions of the 'other' which have been elaborated within anthropological discourse since the eighteenth century in Europe. Anthropology, as a 'science of disappearance', has tended to construe the 'other' as negative: the 'savage', without history, writing, religion and morals, was seen as part of a vanishing world which consequently required documentation.

Fabian refers to the conceptual structure of anthropology which emerged in the context of colonisation and the extension of empire. While there was a connection between knowledge of the 'other' and domination, industrialisation, the rise of bureaucracy and notions of progress further reinforced oppositions between civilised and savage/primitive, subject and object, present and past. These oppositions formed relations of difference and, crucially, of distance. It is this spatio-temporal remoteness which was a necessary 'conceptual category in the constitution of the other' (Fabian 1991: 193–7). As Street (1975, 1996) demonstrated in an early rendition of such reflexivity, popular fiction in nineteenth-century Britain drew upon and in turn reinforced anthropological writing rooted in conceptions of 'Progress', 'Primitivism' and the contradictory tropes of noble and ignoble 'savage'. Similarly, Mitter (1977) has shown how European conceptions of art influenced both the interpretation of Indian representations of deities as 'monstrous' and the development of Indian art forms themselves. At the same time, as with literary representations, there was ambivalence and contradiction in such accounts, primitivism vying with progress as the 'essential' frame. Mackenzie (1995) later added to these literary and artistic sources of representation the detailed materials of the Imperial era, from pamphlets to iconography, equally understood in terms of conflicting scholarly interpretations.

The development of feminist theory has also provided the analyses of the 'other', coded as female and constructed in the context of hierarchical relations of power. Mascia-Lees *et al.* outline the feminist concerns and political motivations which have driven the theorising of woman as 'other' from the work of de Beauvoir to current writing in experimental feminist anthropology (1989). Here they identify a commitment to politicised interpretations of woman as other which expose the ways in which 'men in Western culture have constituted themselves as subjects' (1989: 11). From the 1970s, building on the theoretical developments which interpreted women's experiences within patriarchal structures, feminist theory was concerned with the limitations of supposedly gender neutral academic discourse. The feminist work addressed 'women's experience of "otherness"' and 'the inscription of women as "other" in language and discourse' (Mascia-Lees 1989: 12).

This early focus on women's 'otherness', associated with their position of subordination in relation to men, has given way to the analysis of difference among women. Moore, for example argues that 'All the major axes of difference, race, class, ethnicity, sexuality and religion, intersect with gender in ways which proffer a multiplicity of subject positions within any discourse'. Therefore it is difficult to conceive of forms of difference in isolation, especially in contexts where they refer to, invoke and reinforce one another: there is a 'mutual determination of discourses on gender and race' which requires investigation in historical perspective (1994: 61). Approaches to gender in terms of binary oppositions, and assumptions about the universal othering of women, have been revised in line with attempts to theorise the processes through which complex engendered subjects are constructed. Moore suggests, that with respect to these processes, analysis should seek to examine 'how the social representations of gender affect

subjective constructions, and how the subjective representation or self-representation of gender affects its social construction' (1994: 53). Emphasis has shifted from a concern with representation as an objectifying process which subordinates the 'other', towards an investigation of the significance of representation in the formation of multiple, negotiated subjectivities and social identities.

Cohen argues for a similar shift in anthropological writing which has, he argues, tended to 'deny to cultural "others" a self consciousness which we so value in ourselves'. This is largely a consequence of an assumption of difference between the anthropological self and the anthropologised other. A 'neglect of others' selves' is an ethical issue which leads to misrepresentation and should be addressed if the relationships between individuals and society are to be more adequately theorised (Cohen 1994: 5–6).

Attention to this dimension of anthropological representations is evident in recent works which highlight the range of meanings of representation as 'interpretation, communication, visualisation, translation and advocacy' (James *et al.* 1997: 2), all of which might come into play within cross-cultural analysis. Such work emphasises the complexity of cultural processes involved in the understanding and invention of 'otherness'. Responses to the problematising of 'otherness' and its position within academic discourse are diverse. Rabinow has called for a closer analysis of academic practice and institutions following Bourdieu, together with an examination of Western world views: 'We need to anthropologise the West: show how exotic its constitution of reality has been; emphasise those domains most taken for granted as universal (this includes epistemology and economics); make them seem as historically peculiar as possible; show how their claims to truth are linked to social practices and have hence become effective forces in the social world' (Rabinow 1986: 241). Fardon's edited volume on ethnographic writing (1990) represents a complex attempt to meet this demand: a number of the leading anthropologists in Britain here apply their knowledge and experience of specific regions to both the ethnographic data derived from classic 'fieldwork' and to the regional studies themselves as they emerged in contested intellectual traditions. Here attempts were made to combine the tools of the reflexive turn, notably linguistic and discursive analytic approaches that deconstruct the written texts of anthropologists themselves, with the tools of the ethnographic tradition, notably participant observation, fieldwork and oral linguistic knowledge as applied to people in specific regions. This othering of their own work was conducted within a framework that still insisted on the validity and value of the ethnographic project, a debate that is central to the present volume in its broader, interdisciplinary concern with the themes of representation and 'otherness'.

Cultural representation: texts, images, objects

While debates about the construction of 'otherness' within anthropological and feminist discourses continue, there are further cultural processes which require analysis. Understanding cross-cultural representation entails not only a

self-reflexive and historical awareness of academic modes of production, but also an analysis of the ways in which 'others' have themselves translated and subverted 'Western' discourses. Without denying inequalities of power or the homogenising tendencies of global processes, attention needs to be paid to the ways in which dominant representations are incorporated, resisted and reinvented. The present volume draws together a range of contributions which examine the diversity of local as well as metropolitan representations implicated in the formation and contestation of 'otherness'. The authors attend to the production, dissemination and appropriation of such cultural forms as films, television, advertisements, video, photographs, paintings and printed images, novels, newspapers, and material objects.

Exploring the ways in which these representations intersect or diverge in their treatment of cultural difference, the authors provide analysis of these forms paying particular attention to the local, national or international relations and tensions which impinge on the emergence and transformation of cultural forms over time. Representations are examined, throughout this volume, with an emphasis on the contexts in which cultural meanings are constituted and negotiated. Probing the content and context of representations, and the ways in which these are disrupted and reconstituted, the authors trace the cultural politics of Europe's encounters with Islam, Brazil, India, Israel, Australia, and Africa. Here the analysis of representation as content and representation in context, necessitates a close examination of cultural codes, conventions and practices as well as the social and political relations which sustain or marginalise them. However, the notions of content and context become increasingly problematic with the recognition that geographical, social and conceptual spaces are becoming increasingly hybrid. As Bhabha notes, such hybridity, both as social fact and a countervailing concept, becomes itself a focus for the re-presentation of dominant discourses of 'otherness':

> Hybridity is the sign of the productivity of colonial power, its shifting forces and fixities: it is the name for the strategic reversal of the process of domination through disavowal (that is, the production of discriminatory identities that secure the 'pure' and original identity of authority). Hybridity is the revaluation of the assumption of colonial identity through the repetition of discriminatory identity effects.
>
> (Bhabha 1985)

Conceptualising hybridity itself challenges the 'discriminatory identity effects' of the reification of 'otherness' endemic to dominant colonial and neocolonial discourse. There are historical complexities here that cannot be reduced to simple dichotomies of European self and 'exotic other': ' "Cultural" difference is no longer a stable, exotic 'otherness'; self-other relations are matters of power and rhetoric rather than of essence' (Clifford 1988: 14). Self and other are not stable unitary categories but shifting and sometimes contradictory constructs which the authors examine throughout this book, identifying more complex formulations of 'otherness' in visual images, institutional sites and discourses. This leads to some

cogent criticism of tendencies towards essentialism where contributors recognise, instead, the nuanced and varied ways in which representation works. Underlying the approaches taken by the authors in this volume is the assertion that representing 'otherness' is about the complex processes and channels through which representations flow in different directions: the representation of 'other' is integrally related to the representation of 'self'.

That 'self' and 'other' are mutually constituting categories is advanced by Crick, when he considers their interdependent meanings:

> A change in the value of the 'self' invariably alters the image of the 'other', and vice versa; and either change alters the nature of the difference which they constitute, and by which they are constituted. Different cultures characterise the diversities and the unifying features differently, and over time the images of what is universal and what separates one culture from another change. (. . .) so there can be no final definition of the relation between 'ourselves' and 'others'. The real meaning of the relation is thus all its versions.
>
> (Crick 1976: 165)

Furthermore, the conception of cultural difference in terms of distinct cultural domains is increasingly questioned: 'With expanded communication and intercultural influence, people interpret others and themselves in a bewildering diversity of idioms – a global condition of what Mikhail Bakhtin (1953) called "heteroglossia". This ambiguous multivocal world makes it increasingly hard to conceive of human diversity as inscribed in bounded, independent cultures. Difference is an effect of inventive syncretism' (Clifford 1988: 22–3). Whilst examining the construction of cultural boundaries and spaces, this collection explores cultural dynamics which work through representations in the form of written texts, visual images and material objects situated within social practices.

Cultural representation: relations of power

The contributors to this volume draw attention to the underlying ideological preconceptions of 'self' and 'other' on which so much of contemporary representation is founded. The evident recognition of the problems of colonial political relations with the 'other' is complemented here by a subtler level of analysis regarding the naturalisation of ideology and the role of representations in the persistence of dominant conceptions of race and gender. Whilst linking cultural representations to broader colonial relations, industrialisation, scientific and academic discourses, the authors highlight the uncertainty and vacillation between the foreign and the familiar that makes these accounts subtler keys to understanding the construction of 'otherness' than if they were taken as mere, reductionist images of colonial exploitation and European domination. The ideological work of representation is often to translate social and cultural heterogeneity into homogenous unity and to emphasise boundaries which map zones of inclusion

and exclusion. Thus, certain conceptions, values and visions are prioritised in the cultural processes of representation, reproducing patterns of inequality and power.

Representations are, however, rarely monolithic, with no space for alternative visions, and the processes involved in the reception and consumption of representations are complex. A major contribution of the present volume is to both argue this case theoretically and to demonstrate it through detailed case studies. Authors attend to the multivocality of representations and the possibilities of different readings and interpretative strategies. There is recognition of the hierarchical ordering of representations which privileges some and marginalises or discredits others. But while the contributors examine the relations of dominance extended through certain processes of representation, they also explore their contestation and transformation.

Cultural encounters: representing 'otherness'

The present volume, then, offers contributions to work in the field of cultural representation, developing distinctive approaches to the cross-cultural dynamics which shape concepts of 'otherness'. The authors explore a wide range of cultural representations, highlighting similarities and differences in their modes of production and reception. They analyse the social, institutional and political relations which inform and constrain the meanings of cultural representations, tracing historical continuities and transformations. In doing so, they describe a diversity of cultural processes and encounters, highlighting the complex and polymorphous character of representations and cross-representations over time and space. They attend to the politics and poetics of representation, gender and racial representation in film and Western media, visual cultures in cultural and institutional context, and questions of 'otherness' in history. Collectively the papers contribute to a re-conceptualisation and a re-presentation of 'otherness' that challenges dominant images of the cultural encounters that have characterised the post-Enlightenment world. This volume addresses these issues by attending to key areas of debate in anthropology, cultural history, film and media studies. Beginning with a chapter by Asad, the book is then divided into two parts, 'Visualising 'otherness''; and 'Displaying cultures'. Each part is preceded by a short introduction which summarises the contributions of the various authors. In the final section of this Introduction, we place these sections in the context of current theoretical concerns regarding the poetics, politics and transformation of cultural representations.

Talal Asad's opening chapter examines the forms and politics of textual representation, especially historical narrative, in the construction of identity and difference. It offers critical perspectives on the ways in which certain narrative forms work to reproduce notions of cultural and historical unity and operate as a cultural politics of exclusion and silencing: the heterogeneity of embodied social practices is often translated or abstracted to reinforce a unitary, for example national, identity. Representations of violence and civilisation, in particular,

have figured strongly in European discourses implicated in the construction of 'otherness'. Such cultural representations do, however, have complex historical trajectories and this chapter advances the analysis of these, questioning how and in what ways such representations serve to exclude 'others'.

Thus Asad explores the representation of Islam in Europe through an analysis of historical narratives which have sought to convey a sense of homogenous space and linear time. Within this narrative, which symbolically constitutes Europe's borders, 'Islam' formed a category against which Christian, European identity has been fashioned. Asad proposes a cultural politics that derives from a complex analysis of the nature of cultural encounters and their representation in recent Western history. This chapter sets up the provisionalising and reflexive discourse that the rest of the volume draws upon, introducing some of the key concepts that other authors employ: whilst they may not all subscribe, for instance, to the particular political response evident in Asad's piece, they all engage with similarly complex reanalysis of boundaries, identities and rights in the making of representation and recognise this not simply as an abstract problem but as a political project. For Asad, texts are enmeshed in their historical and ideological contexts as sites in which categories of European knowledge can be interrogated and dominant discourses questioned. These are themes that are variously addressed in subsequent chapters, whether in relation to the visual images analysed in Part I or the conventions of institutional display considered in Part II.

Part I: visualising 'otherness'

The first Part, 'Visualising "otherness"', considers the representation of 'otherness' in visual media, notably art and cinema, in both historical and cross-cultural perspectives. As indicated here, representation has been explored via a number of modes of communication and recent academic attention to writing culture might itself be seen as simply reinforcement of a Western hegemonic concern for the written channel. Indeed, the linguists Kress and van Leeuwen (1996) have argued that this tradition is coming to an end and that visual 'codes' are beginning to predominate in many sectors of late modernity. How to interpret such codes becomes a major concern for those analysing how relations of power are constructed and reproduced: according to Kress and van Leeuwen, the more evident a channel of communication, the more subject it becomes to the policing and control of its minutiae, as is evidenced by the almost hysterical concern with spelling, pronunciation and 'proper' English of recent British governments (Street 1999). If visual codes take on the social role previously allotted to written codes, they too, it is predicted, will be subject to such inspection and correction. These debates are of particular relevance to the interests of the present volume, for those wishing to understand the power of representation and othering across the communicative repertoire. The authors in this volume bring to bear a range of approaches for interpreting such visual representation, from historical accounts of artistic form to cross-cultural accounts of film, video and still imagery.

The chapters range from Mitter's account of the Hottentot Venus and

the origins of its depiction in European Classical conceptions of beauty, to Loshitzky's analysis of how both Arabs and Palestinians have been depicted in postcolonial film and literature, with further cross-cultural accounts of cinema and video images by Sandon, Reynaud, Chakravarty and Gooptu. In all of these cases the notion that representation as culturally constructed is central and each author teases out the meanings or historical and cultural associations of specific images with respect to the often implicit assumptions underlying them. By making these assumptions explicit and by tracing their routes in specific intellectual and social traditions, the authors provide layered accounts of 'otherness', moving beyond the simplistic political and moral slogans that have accompanied the exposure of racism in the colonial heritage. Providing a critique of the reductionist dichotomy of 'self' and 'other' the authors foreground the complexity of cross-representations, the contestations within dominant canons and the subtler naturalisations of ideology. 'Otherness' both within and between social groups is constructed through subtle manipulations of signs and images and case studies of how this happens in different times and places can help us recognise and interpret the unmarked cases through which racism and stereotyping of difference operate in contemporary society.

Part II: displaying cultures

Part II, 'Displaying cultures', is concerned with processes of cultural representation located in museums and in wider institutional, social and political arenas. The authors analyse a range of museums and less clearly demarcated social spaces in order to explore the ways in which the politics and aesthetics of display construct 'otherness'. Here displays, which provide particular views of social, cultural and historical difference, are examined with reference to the politics of cultural representation and reception. The chapter by Shelton provides a detailed historical investigation of the ways in which museum collections have operated as markers of 'otherness' informed by complex social and ideological factors. Karp and Kratz analyse ethnographic displays in museum and related non-museum settings, focusing upon the ways in which certain forms of knowledge are organised and privileged. They discuss display as a means by which museum authority is reproduced and this theme is also taken up in Marcus' chapter which addresses the interplay between erotics, power and knowledge in museums. The limits of critical display strategies are exposed in this chapter where Marcus identifies the continued marginalisation of Aboriginal perspectives within Sydney Museum's post-modern exhibits. Jordanova's chapter discusses the various forms of 'otherness' which are associated with the past. She examines the display of history in museums and in everyday spaces and practices, arguing that the abstract, intellectual work of historians is difficult to represent in visual terms. Hallam's chapter explores and contrasts aspects of the textual and visual representation of otherness in two institutional sites: the university and the museum. The chapters in Part II, then, share a concern with historical processes and the politics which inform the representation of cross-cultural interactions over time.

References

Bhabha, H. (1985) 'Signs taken for wonders' in H. L. Gates Jr. (ed.) *'Race' Writing and Difference*, Chicago: University of Chicago Press.

Clifford, J. and Marcus, G. E. (eds) (1986) *Writing Culture. The Poetics and Politics of Ethnography*, Berkeley: University of California Press.

Clifford, J. (1988) *The Predicament of Culture. Twentieth-Century Ethnography, Literature and Art*, Cambridge, MA: Harvard University Press.

Cohen, A. (1994) *Self Consciousness. An Alternative Anthropology of Identity*, London: Routledge.

Crick, M. (1976) *Explorations in Language and Meaning. Towards a Semantic Anthropology*, London: Malaby Press.

Fabian, J. (1991) *Time and the Work of Anthropology. Critical Essays 1971–1991*, Chur, Switzerland: Harwood Academic Publishers.

Fardon, R. (ed.) (1990) *Localising Strategies: Regional Traditions of Ethnographic Writing*, Scottish Academic Press/Smithsonian Institution Press: Edinburgh/Washington.

James, A., Hockey, J. and Dawson, A. (eds) (1997) *After Writing Culture. Epistemology and Praxis in Contemporary Anthropology*, London: Routledge.

Kabbani, R. (1986) *Europe's Myths of Orient*, Bloomington: Indiana University Press.

Kaplan, E. Ann (1997) *Looking for the Other. Feminism, Film and the Imperial Gaze*, London: Routledge.

Kress, G. and van Leeuwen, T. (1996) *Reading Images: The Grammar of Visual Design*, London: Routledge

Mackenzie, J. (1984) *Propaganda and Empire*, Manchester: Manchester University Press.

Mackenzie, J. (1995) *Orientalism: History, Theory and the Arts*, Manchester: Manchester University Press.

Mascia-Lees, F. E. *et al.* (1989) 'The postmodernist turn in anthropology: cautions from a feminist perspective', *Signs*, 15 (1): 7–33.

Mitter, P. (1977) *Much-Maligned Monsters: A History of European Reactions to Indian Art*, Chicago: University of Chicago Press.

Moore, H. (1994) *A Passion For Difference*, Cambridge: Polity Press.

Rabinow, P. (1986) 'Representations are social facts: modernity and post-modernity in anthropology', in J. Clifford and G. E. Marcus (eds) *Writing Culture. The Poetics and Politics of Ethnography*, Berkeley: University of California Press.

Street, B. (1975) *The Savage in Literature*, London: Routledge.

Street, B. (1996) 'Culture is a verb' in D. Graddol (ed.), *Language and Culture, Multilingual Matters*/BAAL, 23–43.

Street, B. (1999) 'New literacies in theory and practice: what are the implications for Language in Education?', *Linguistics in Education*, 10 (1): 1–24.

1 Muslims and European identity

Can Europe represent Islam?

Talal Asad

no citizen of Europe could be altogether an exile in any part of it.
(Edmund Burke, *Letters on the Regicide Peace*, 1794)

Simultaneously, and despite the parochialism of the governments at home, a sort of international solidarity was slowly evolving in the colonies. . . . Out of interest if not out of good will, an embryonic European understanding had at last been found in Africa. We could hate one another in Europe, but we felt that, between two neighboring colonies, the interest in common was as great as between two white men meeting in the desert.
(Count Carlo Sforza, *Europe and Europeans*, 1936)

Today, as many of the old political barriers between Western and Eastern Europe are collapsing, and as increased economic and political union within the European community becomes a fact of life, the question of what 'Europe' means – and could come to mean – to its diverse peoples takes on even greater significance. The events of the 1990s would seem to have the potential for radically reshaping people's identities. But will they?
(Sharon Macdonald, *Inside European Identities*, 1993)

Muslims and the idea of Europe

Muslims are present in Europe and yet absent from it. The problem of understanding Islam in Europe is primarily, so I claim, a matter of understanding how 'Europe' is conceptualised by Europeans. Europe (and the nation states of which it is constituted) is ideologically constructed in such a way that Muslim immigrants cannot be satisfactorily represented in it. I argue that they are included within and excluded from Europe at one and the same time.

I take it for granted that in Europe today Muslims are often misrepresented in the media and discriminated against by non-Muslims.[1] More interesting for my present argument is the anxiety expressed by the majority of West Europeans about the presence of Muslim communities and Islamic traditions within the borders of Europe. (In France, for example, a 1992 poll showed that two-thirds of the population feared the presence of Islam in that country.[2]) It is not merely that the full incorporation of Muslims into European society is thought to be especially hard for people who have been brought up in an alien culture. It is their

attachment to Islam that many believe commits Muslims to values that are an affront to the modern Western form of life.

Admittedly there is no shortage of voices that respond to such anxieties with characteristic liberal optimism.[3] They speak of the diverse linguistic and ethnic origins of Muslim immigrants, and of the considerable variation in individual attachments to old traditions. There is little to fear from most immigrants – liberals say – and much more from the consequences of the higher unemployment and greater prejudice to which they are subjected. Muslims in Europe can be assimilated into Western society. Liberals maintain that it is only the extreme right for whom the presence of Muslims and Islam in Europe represents a potential cultural disaster, and that its xenophobia is rooted in the romantic nativism it espouses, and consequently in its rejection of the West's universalist principles. In this as in other matters liberals stand for tolerance and an open society.

All these claims may be true, but the liberal position is more layered than one might suppose. To begin with the Islamic disregard of 'the principle of secular republicanism' (as symbolised by the *affaire du foulard*), and the Islamic attack against 'the principle of freedom of speech' (as exemplified in the Rushdie affair) have angered liberals and the left no less than the extreme right. These events within Europe have been read as all of a piece with the Islamist resort to civil violence in North Africa and West Asia, and they have led even liberals to ask with growing scepticism whether the Islamic tradition (as distinct from its human carriers) can find a legitimate place in a modern Western society.

But I begin elsewhere. In this chapter I focus not on liberal opposition to right-wing intolerance or dismay at immigrant closed-mindedness but with a larger question. How can contemporary European practices and discourses represent a culturally diverse society of which Muslim migrants (Pakistanis in Britain, Turks in Germany, North Africans in France) are now part? To answer this question I shall first address another: how is Europe represented by those who define themselves as authentic Europeans?

Before attempting to answer this question I note that the general preoccupation in the social sciences with the idea of *identity* dates from after the Second World War, and that it marks a new sense of the word, highlighting the individual's social locations and psychological crises in an increasingly uncertain world .[4] 'This is my name,' we now declare, 'I need you to recognize me by that name.' More than ever before identity now depends on the other's *recognition* of the self. Previously the more common meaning of *identity* was 'sameness', as in the statement that all Muslims do not have identical interests, and attributively, as in 'identity card'. In Europe the newer twist in the sense of the word is almost certainly more recent than in America, and perhaps in both places the discourse of *identity* indicates not the rediscovery of ethnic loyalties so much as the undermining of old certainties. The site of that discourse is the individual's suppressed fear. The idea of European identity, I say, is not merely a matter of how a more inclusive name can be made to claim loyalties that are attached to national or local ones. It concerns *exclusions* and the desire that those excluded recognise what is included in the name. It is a symptom of anxieties.

What kind of identity, then, does Europe represent to Europeans? An empirical response would base itself on comprehensive research into literature, popular media, parliamentary debates, local interviews. My primary interest, however, is in analysing the structure of a discourse rather than with its empirical spread. So I begin with a partial answer to the question through this anecdote as reported in the 1992 *Time* magazine cover story on Turkey's attempt to become a member of the European Community:

> However it may be expressed, there is a feeling in Western Europe, rarely stated explicitly, that Muslims whose roots lie in Asia do not belong in the Western family, some of whose members spent centuries trying to drive the Turks out of a Europe they threatened to overwhelm. Turkish membership 'would dilute the E.C.'s Europeanness,' says one German diplomat.[5]

Clearly neither the genocide practised by the Nazi state nor its attempt to overwhelm Europe have led to feelings in Western Europe that would cast doubt on where Germany belongs. I do not make this statement in a polemical spirit. On the contrary, I affirm that given the idea of Europe that exists, such violence cannot dilute Germany's Europeanness. Violence is a complicated moral language. Far from being threatened by internal violence, European solidarity is strengthened by it.

Let me explain: a powerful article by Tony Judt on Europe argues that the idea of Europe stands as a convenient suppressor of collective memories of the widespread collaboration with Nazi crimes in East and West alike, as well as of mass brutalities and civil cruelties for which all states were directly or indirectly responsible.[6] His account has nothing to say, however, about violence perpetrated in this period by Europeans outside Europe – in colonial Africa, say, or in the Middle East. No mention is made even of Algeria, which was, after all, an internal department of France. I stress that my comment here is not moralistic but descriptive. It has to do with how the conceptual boundaries of moral and legal solidarity are actually traced. I do not object to Judt's leaving colonial violence out of his discussion, I merely point to what he thinks is important. I indicate that his discussion of collective culpability is limited in precisely the way that the 'myth of Europe' defines the extent of its own solidarity. 'The myth of Europe', I say, does not simply suppress the collective memories of violence within Europe; the resurrection of those memories strengthens that myth. Moral failure is regarded as particularly shameful in this case because Europeans try to cover up their past cruelties in Europe to *other Europeans* instead of confronting that fact fully. The Turkish assault against Europe has quite a different salience.

Historically, it was not Europe that the Turks threatened but Christendom, for *Europe* was not then distinct from *Christendom*. 'For diplomats and men of affairs', writes Denys Hay, 'the intrusion of the Turk was a fact which could not be ignored and the practical acceptance of a Moslem state into the field of diplomacy might well have produced an early rejection of Christendom in the field of international relations. . . .' The language of diplomacy maintained the established

terminology: 'the common enemy', 'the Christian republic', 'the Christian world', 'the provinces of Christendom' are found in the phraseology of a large number of sixteenth- and early seventeenth-century treaties. A similar attitude is to be found in the treatises of the international lawyers down to, and even beyond, Grotius. If the Turk was not different under natural law, he was certainly different under divine law: the Turk was not far short of a 'natural enemy' of Christians.'[7] In the contemporary European suspicion of Turkey it is this Christian history, enshrined in the tradition of international law, that is being reinvoked in secular language as the foundation of an ancient identity.

Consider another case: the 1995 interview with Tadeusz Mazowiecki (former UN Representative of Human Rights in the Balkans) conducted by Bernard Osser and Patrick Saint-Exupery, on the subject of Mazowiecki's principled resignation.[8] At one point the interviewers pose the following question: 'You are Polish and Christian. Is it strange to hear yourself defending Bosnians, many of whom are Muslims?' Some readers might wonder how it is that two French intellectuals, heirs to the secular Enlightenment, can formulate such a question in Europe today. But of course the aim of this leading question is to elicit the plea for tolerance which the interviewers know will be forthcoming. So I find it more significant that Mazowiecki expresses no surprise at the question itself. Instead, he responds as expected by urging tolerance. He assures his interviewers that the war in Bosnia is not a religious one, and that Bosnian Muslims are not a danger to *Europe*. 'It bodes ill for us,' he warns, 'if, at the end of the twentieth century, Europe is still incapable of coexistence with a Muslim community.'

Mazowiecki's assumption (accepted without comment by his French interlocutors) is that Bosnian Muslims may be *in* Europe but are not *of* it. Even though they may not have migrated to Europe from Asia (indeed they are not racially distinguishable from other whites in Europe), and may have adjusted to secular political institutions (in so far as this can be said of Balkan societies)[9] they cannot claim a Europeanness – as the inhabitants of Christian Europe can. It is precisely because Muslims are external to the essence of Europe that 'coexistence' can be envisaged between 'us' and 'them'.

In what follows I propose that for both liberals and the extreme right the representation of 'Europe' takes the form of a narrative, one of whose effects is to exclude Islam. I do not mean by this that both sides are equally hostile towards Muslims living in Europe.[10] Nor do I assume that Muslim immigrants are in no way responsible for their practical predicament. I mean only that for liberals no less than for the extreme right, the narrative of Europe points to something regarded as embodying its unchangeable essence.

Islam and the narrative of Europe

Europe, we often read, is not merely a continent, but a civilisation. The word 'civilisation' is no longer as fashionable in the West as it was at the turn of the nineteenth century, but it appears to be returning. Some still object that the

term 'civilisation' should not be applied to Europe, while insisting that there is something that Europeans share. Thus Michael Wintle:

> To talk in terms of a quintessential or single European culture, civilization, or identity leads quickly to unsustainable generalization, and to all manner of heady and evidently false claims for one's own continent. Nonetheless, if the triumphalism can be left to one side there is a long history of shared influences and experiences, a heritage, which has not touched all parts of Europe or all Europeans equally, and which is therefore hard and perhaps dangerous to define in single sentences or even paragraphs, but which is felt and experienced in varying ways and degrees by *those whose home is Europe*, and which is recognized – whether approvingly or disapprovingly – by many from outside.[11]

The key influences on European experience, Wintle continues, are the Roman Empire, Christianity, the Enlightenment, and industrialisation. It is because these historical moments have not influenced Muslim immigrant experience that *they are not those whose home is Europe*. These moments are precisely what others have designated 'European civilisation'. Raymond Williams notes in *Key Words* that the word 'civilisation' is used today in three senses: to mean (1) a single universal development (as in 'human civilisation'), (2) the collective character of a people or a period which is different from and incommensurable with others (as in 'the civilisation of the Renaissance in Italy'), and (3) the culture of a particular population, which is rankable as higher or lower than another, and perhaps also capable of further development. The three senses together articulate the essence of 'European civilisation': it aspires to a universal (because 'human') status, but also claims to be distinctive (it defines modernity), and is (at least in terms of quantifiable criteria) undoubtedly the most advanced. Taken together, these senses require a narrative definition of 'Europe.'

The two journalistic examples I cited above both assume a historical definition of Europe as a civilisation. But they do so in ways that are largely implicit. Hugh Trevor-Roper's *The Rise of Christian Europe*[12] is one of many academic texts that express the essence of European identity explicitly by means of a historical narrative. Trevor-Roper's book is interesting because it defines European civilisation – and therefore European identity – as a narrative, or at least as the beginning of one whose proper ending is already familiar. Like other texts with which it may be compared, its notion of *history* takes the form both of the history of 'the idea of Europe' and of 'European history' as an idea.[13] It also has an interesting historical location. It appeared in 1965, when British decolonisation was more or less complete, and when the flood of non-European immigrants from the former colonies was stemmed by new legislation brought in – amidst charges of betrayal of its principles – by the then Labour government. It was also the time when there was a vigorous public debate, involving all sections of the political spectrum, about a new role for Britain in its post-imperial phase. The option of 'joining Europe' politically was an important part of that debate.

When Trevor-Roper speaks of 'European history' he does not mean narratives about the inhabitants of the European continent, which is why there is nothing at all in his book about Byzantium and Eastern Europe, or about North-Western Europe (other than brief references to Viking destructiveness), or about Jews (other than as victims), or about Muslim Spain (other than as an intrusive presence). 'European history' is the narration of an identity many still derive from 'European (or Western) civilisation' – a narrative that seeks to represent homogeneous space and linear time.

What is the essence of that civilisational identity? Trevor-Roper reminds his readers that most of its ideas and many of its techniques entered European civilisation from outside. The things that belong to European civilisation, therefore, are those that were taken up and creatively worked on by Europe. Productive elaboration becomes an essential characteristic of Europe as a civilisation. This view makes sense, I would suggest, in the context of a particular Enlightenment theory about property first propounded by John Locke. Locke argued that a person's right to property comes from the mixing of labour with the common things of this world. 'God gave the world to men in common, but since He gave it them for their benefit and the greatest conveniencies of life they were capable to draw from it, it cannot be supposed He meant it should always remain common and uncultivated. He gave it to the use of the industrious and rational *(and labor was to be his title to it)*; not to the fancy or covetousness of the quarrelsome and contentious.'[14] Applied to whole peoples, property was 'European' to the extent that Europeans appropriated, cultivated, *and then lawfully passed it on to generations of Europeans as their own inheritance.*

'European history' thus becomes a history of continuously productive actions defining as well as defined by Law. Property is central to that story not only in the sense familiar to political economy and jurisprudence, but in the sense of the particular character, nature, or essence of a person or thing. It is a story that can be narrated in terms of improvement and accumulation, in which the industrial revolution is merely one central moment. According to this conception, 'European civilisation' is simply the sum of properties, all those material and moral acts which define European identity.

It follows from this view of Europe that real Europeans acquire their individual identity from the character of their civilisation. Without that civilisational essence individuals living within Europe are unstable and ambiguous. That is why not all inhabitants of the European continent are 'real' or 'full' Europeans. Russians are clearly marginal. Until just after the Second World War, European Jews were marginal too, but since that break the emerging discourse of a 'Judeo-Christian tradition' has signalled a new integration of their status into Europe.[15]

Completely external to 'European history' is medieval Spain. For although Spain is now defined geographically as part of Europe, Arab Spain from the seventh to the fourteenth century is seen as being outside 'Europe', in spite of the fact that there were numerous intimate connections and exchanges in the Iberian peninsula during that period between Muslims, Christians and Jews.

There is a problem for any historian constructing a categorical boundary for

'European civilisation' because the populations designated by the label 'Islam' are, in great measure, the cultural heirs of the Hellenic world – the very world in which 'Europe' also claims to have its roots. 'Islamic civilisation' must therefore be denied a vital link to the properties that define so much of what is essential to 'Europe' if a civilisational difference is to be postulated between them. There appear to be two moves by which this is done. First, by denying that it has an essence of its own, 'Islam' can be represented as a *carrier civilisation* which helped to bring important elements into Europe from outside, material and intellectual elements that were only contingently connected to Islam.[16] Then, paradoxically, to this carrier civilisation is attributed an essence: its *ingrained* hostility to all non-Muslims. That constitutes it as the primary *alter* whose antagonism to Christians was crucial to the formation of European identity. In this, as in other historical narratives of Europe, this oppositional role gives 'Islam' a quasi-civilisational identity.[17] But while one aspect of the identity of Islamic civilisation is that it represents an early attempt to destroy Europe's civilisation from outside, another is that it signifies the corrupting moral environment which Europe must continuously struggle to overcome from within.[18]

This construction of civilisational difference is not exclusive in any simple sense. *The de-essentialisation of Islam* is paradigmatic for all thinking about the assimilation of non-European peoples to European civilisation. The idea that people's historical experience is inessential to them, that it can be shed at will, makes it possible to argue more strongly for the Enlightenment's claim to universality: Muslims, as members of the abstract category 'humans', can be assimilated – or as some recent theorists have put it – 'translated' into a global ('European') civilisation once they have divested themselves of what many of them regard (mistakenly) as essential to themselves. The belief that human beings can be separated from their histories and traditions makes it possible to urge a Europeanisation of the Islamic world. And by the same logic, it underlies the belief that the *assimilation* to Europe's civilisation of Muslim immigrants who are – for good or for ill – already in European states, is both necessary and desirable.

The motive of 'European history' in this representation is the story of Europe's active power to reconstruct the world (within Europe and beyond) in its own Faustian image.[19] Europe's colonial past is not merely an epoch of overseas power that is now decisively over. It is the beginning of an irreversible global transformation which remains an intrinsic part of 'European experience', and is part of the reason that Europe has become what it is today. It is not possible for Europe to be represented without evoking this history, the way in which its active power has continually constructed its own exclusive boundary – and transgressed it.

Where are the borders of modern Europe?

It is often conceded that several peoples and cultures inhabit the European continent, but it is also believed that there is a single history that constitutes European civilisation – and therefore European identity. The official EC slogan expresses this thought as 'unity in diversity'. But determining the boundaries of

that unity continues to be an urgent problem for anyone concerned with the civilisational basis of the European Community. Perry Anderson has noted some of the difficulties about boundaries encountered in recent discourse:

> Since the late Eighties, publicists and politicians in Hungary, the Czech lands, Poland and more recently Slovenia and even Croatia have set out to persuade the world that these countries belong to a Central Europe that has a natural affinity to Western Europe, and is fundamentally distinct from Eastern Europe. The geographical stretching involved in these definitions can be extreme. Vilnius is described by Czeslaw Milosz, for example, as a Central European city. But if Poland – let alone Lithuania – is really in the center of Europe, what is the east? Logically, one would imagine, the answer must be Russia. But since many of the same writers – Milan Kundera is another example – deny that Russia has ever belonged to European civilisation at all, we are left with the conundrum of a space proclaiming itself center and border at the same time.[20]

Anderson's witty account highlights the illogicality of recent definitions of Europe. Yet it is precisely *the politics of civilisational identity* that is at work in the discourse of Europe's extent. For Poles, Czechs and Hungarians it is not only a matter of participating in the European common market, but of distancing themselves from a socialist history. Where Europe's borders are to be drawn is also a matter of representing what European civilisation is. These borders involve more than a geography. They reflect a history whose purpose is to separate Europe both from alien times ('communism', 'Islam') as well as from alien places ('Islam', 'Russia').

J. G. A. Pocock has articulated another aspect of this politics of civilisation: ' "Europe" – both with and without the North America whose addition turns it from "Europe" into "Western civilisation" – is once again an empire in the sense of a civilised and stabilised zone which must decide whether to extend or refuse its political power over violent cultures along its borders but not within its system'.[21] In separating a 'civilised culture' from 'violent cultures', we sense that Europe's borders at once protect and threaten its unity, define its authority and engage with external powers that have entered its domain. The 'inside' cannot contain the 'outside', violent cultures cannot inhabit a civil one – Europe, in brief, cannot contain non-Europe. And yet Europe must try to contain, subdue or incorporate what lies beyond it, and what consequently comes to be within it. European capitalism and European strategic interests cannot be confined to the European continent.

The representation of Europe's borders is, of course, symbolic. But the signs and symbols have a history. Like the borders of its constituent states, the European Community's boundaries are inscribed in treaties according to the conventions of international law – itself the cumulative result of earlier narratives of Europe. The status of individual borders as well as the very institution of international law that regulates today's worldwide society of nation states

have been constituted by narratives of Europe. Adam Watson summarises the story:

> The expansion of Europe was neither uniform nor systematic. It occurred over several centuries, for a number of reasons, and assumed many different forms. Chronologically we can distinguish in retrospect four main phases. First came the medieval crusades into Iberia and round the Baltic. The second phase covered three centuries of competitive maritime exploration and expansion and the parallel evolution of a European international society. Thirdly in the nineteenth century the industrial revolution enabled the European Concert to encompass the entire globe and to administer most of it. Lastly in our own century the tide of European dominion ebbed, and was replaced by a world-wide society based on the European model but in which Europeans now play only a modest role.[22]

What this story misses is that Europe did not simply expand overseas; it made itself through that expansion. And it also underestimates the role that Europeans – including especially those who inhabit the United States – still play in regulating 'worldwide society'. The borders of political Europe have varied not only over time, but also according to the European model governing global relations.

Can Muslims be represented in Europe? As members of states that form part of what Watson and others call European international society Muslims have, of course, long been represented (and regulated) in it. But representing Muslims in European liberal democracies is a different matter. It raises a question that does not apply to the international system: of how a European state can represent its 'minorities'.

How can minorities be represented in European liberal democracy?

So far I have explored the idea that Islam is excluded from representations of Europe and the narratives through which the representations are constituted. I now approach the question from another angle. What are the possibilities of representing Muslim minorities in modern European states?

I argue that the ideology of political representation in liberal democracies makes it difficult if not impossible to represent Muslims as Muslims. Why is that so? Because in theory the citizens who constitute a democratic state belong to a class that is defined only by what is common to all its members and its members only. What is common is the abstract equality of individual citizens to one another. Marie Swabey has stated the issue succinctly:

> The notion of equality central to democracy is clearly a logical and mathematical conception. . . . [O]nce equality is admitted, the notions of number, per capita enumeration, and determination by the greater number are not far to seek. . . . Citizens are to be taken as so many equivalent units and issues are to

be decided by the summation of them. . . . Once we conceive the whole (the state) as composed of parts (the citizens) which are formally distinct but without relevant qualitative differences, we are applying the notion in its essentials. Involved here is the assumption not only that the whole is authoritative over any of its parts, but that what there is *more of* has *ipso facto* greater weight than that which differs from it merely by being less. In the democratic state this idea is expressed as the postulate that the opinion of the people as a whole, or of the greater part of them, is authoritative over that of any lesser group.[23]

It follows, Swabey goes on, that the opinion of a majority 'is more likely to represent approximately the opinion of the whole body than any other part.' In this conception *representative government* is assimilated to the notion of an outcome that is *statistically representative* of 'the whole body' of citizens. The same principle applies to segments of 'the whole (the state)' according to which representatives of geographically-demarcated constituencies represent aggregates of individual voters. It is no accident that the statistical concept of representativeness emerged in close connection with the construction of the welfare state (a process that began towards the end of the nineteenth century) and the centralisation of national statistics. Several developments were jointly important both in the history of statistical thinking and in the evolution of democratic politics, especially demography, social security legislation, market research and national election polls.

In principle, therefore, nothing should distinguish Muslims from non-Muslims as citizens of a European democratic state other than the fact that they are fewer in number – that they are 'a minority'. But a minority is not a purely quantitative concept of the kind stipulated by Swabey, not an outcome of probability theory applied to determine the opinion of a corporate body – 'the people as a whole'. The concept of minority arises from a specific Christian history: from the dissolution of the bond that was formed immediately after the Reformation between the established Church and the early modern state. *This* notion of minority sits uncomfortably with the Enlightenment concept of the abstract citizen.

The post-Reformation doctrine that it was the state's business to secure religious uniformity within the polity – or at least to exclude Dissenters from important rights – was crucial to the formation of the early modern state. By contrast, the secular Enlightenment theory that the political community consists of an abstract collection of equal citizens was propounded as a criticism of the religious inequality characterising the absolutist state. The most famous document embodying that theory was the 'Declaration of the Rights of Man and the Citizen'. The theory was criticised almost from the moment it was first stated – notably by Burke for the licence it gave to destructive passions, and by Marx for disguising bourgeois self-interest. However, the decisive movements that helped to break the alliance of Church and State seem to have been religious rather than secular – Tractarianism in England, and Ultramontanism in France and Europe

generally. The arguments they deployed most effectively were strictly theological, and were aimed at securing the freedom of Christ's Church from the constraints of an earthly power.[24] An important consequence of abandoning the total union of Church and state was the eventual emergence of 'minority rights' as a central theme of national politics. Members of minorities became at once equal to all other citizens, members of the body politic ('the people as a whole') and unequal to the majority in requiring special protection.

The political inclusion of minorities has meant the acceptance of groups formed by specific (often conflicting) historical narratives, and the embodied memories, feelings, desires that the narratives have helped to shape. The rights that minorities claim include the right to maintain and perpetuate themselves as groups. 'Minority rights' are not derivable from general theories of citizenship – that is to say, minority status is connected to membership in a specific *historical* group not in the abstract class of citizens. In that sense minorities are no different from majorities, who are also a historically constituted group. The fact that they are usually smaller in number is an accidental feature. Minorities may actually be numerically much larger than the body of equal citizens from whom they are excluded, as in the British empire where vast numbers of colonial subjects were ruled by a democratic state of citizens far smaller in number through a variety of constitutional devices.[25] Minorities are defined *as minorities* by structures of ruling power.

Take the case of France. Religious Muslims who reside in France are similar to the Christian (and post-Christian) inhabitants of that country in this regard: each group has constituted itself *as a group* through its own narratives. These narratives, and the practices they authorise, help to define what is essential to each group. To insist in this context that Muslim groups must not be essentialised is in effect to demand that they can and should shed the narratives and practices they take to be necessary to their lives as Muslims. The crucial difference between the 'majority' and the 'minorities' is, of course, that the majority effectively claims the French state as *essentially its national state*. In other words, to the extent that 'France' embodies the Jacobin narrative, it essentially represents the Christian and post-Christian citizens who are constituted by it.

Thus Le Pen's insistence in the early 1980s on the right of the majority ('the French in France') to protect its distinctive character against the influence of minority difference is not only an extension of the left slogan 'the right to difference'. It is a claim that the *majority's* right to be French 'in their own country' precludes the right of minorities to equal treatment in this regard. 'We not only have the right but the duty to defend our national personality,' Le Pen declares, 'and we too have our right to be different.'[26] Given the existence of a French national personality of which the Jacobin republic is claimed to be the embodiment, and given also that the majority is its representative, Le Pen can argue that only those immigrants able and willing to join them (thereby ceasing to belong to a minority) have the right to remain in France as French citizens. It follows that the 'inassimilable' ones (North African Muslims) should be encouraged to leave when their labour is no longer required by France. This may be an intolerant

position but it is not illogical.[27] To be a French citizen is to reflect, as an individual, the collective personality that was founded in the French Revolution and embodied in the laws and conventional practices of the French Republic, and that is recounted in its national story. Although that personality may not be regarded as eternal and unchangeable, it represents a precondition of French citizenship. As even liberals concede, the individual citizen cannot make just any contract with the state he or she chooses independently of that personality. In brief, the narratives that define 'being French', and the practices they authorise, cannot be regarded as inessential. *French citizens cannot be de-essentialised.* This view, shared by Left, Centre and Right, rejects the notion that the citizen is identical only with himself or herself, that he or she therefore essentially represents an abstract quantity which can be separated from his or her social identity, added up and then divided into groups that have only numerical value. It should not be surprising that Le Pen has been able to push the greater part of the majority towards endorsing reforms of the Nationality Code in the direction demanded by the extreme right.[28] The very existence of the French Jacobin narrative permits the extreme right to occupy the ideological centre in contemporary French immigration politics.

Liberals are often dismayed by the resurgence of the right, but the notion of primordial intolerance will not explain it. Many critics have observed that part of the problem resides in the identification of national boundaries with those of the state. Some of them have sought a solution in the radical claim that all boundaries are indeterminate and ambiguous. William Connolly has recently theorised the matter more perceptively. He asks, pointedly, 'whether it is possible to prize the indispensability of boundaries to social life while resisting overdetermined drives to *overcode* a particular set', and goes on to question the assumption that 'the boundaries of a state must correspond to those of a nation, both of these to a final site of citizen political allegiance, and all three of those to the parameters of a democratic ethos.'[29]

The problem of representing Islam in European liberal democracies cannot be addressed adequately unless such questioning is taken seriously. With America especially in mind, Connolly urges a shift in the prevalent idea of pluralism 'from a majority nation presiding over numerous minorities in a democratic state to a democratic state of multiple minorities contending and collaborating with a general ethos of forbearance and critical responsiveness.'[30] The decentred pluralism he advocates in place of liberal doctrines of multiculturalism requires a continuous readiness to deconstruct historical narratives constituting identities and their boundaries (which, he argues, have a tendency to become sacralised and fundamentalised) in order to 'open up space through which *care* is cultivated for the abundance of life'.[31]

To what extent and how often historical narratives that constitute identities can be deconstructed remains a difficult question. Thus I have been arguing on the one hand that Europe's historical narrative of itself needs to be questioned, and on the other that the historical narratives produced by so-called 'minorities' need to be respected. This apparent inconsistency is dictated partly by the concern that

time and place be made for weaker groups within spaces and times commanded by a dominant one. Muslims in Europe, I have implied, should be able to find institutional representation as a minority in a democratic state where there are only minorities. For where there are only minorities the possibilities of forging alliances between them will be greater than in a state with a majority presiding over several competing minorities.

But my comments also reflect an unresolved tension: between, on the one hand, a concern to ensure respect for individual 'identities', and, on the other, to seek the conditions permitting collective 'ways of life' to flourish. The latter concern is not merely a matter of 'recognition' – i.e., of the demand that one should be able to name oneself and be confirmed by others as the bearer of that name and to have one's anxieties allayed. It is also a matter of embodied memories and practices that are articulated by traditions, and of political institutions through which these traditions can be fully represented. (The constituency represented does not have to be geographically continuous.) Our attention needs to be directed not so much at how identities are negotiated and recognised (for example through exploratory and constructive dialogue, as Charles Taylor has advocated)[32] but at what it takes to live particular ways of life continuously, cooperatively and unselfconsciously. I ask whether this is possible if we are required to interrogate and deconstruct our life continuously. It may be sufficient, I suggest, that when external circumstances compel us to reassess the adequacy of our way of life we do so as fully as possible.

John Milbank's arguments for decentering are different from Connolly's, and linked to specifically medieval historical experience. His contrast between what he calls 'enlightenment simple space' and 'gothic complex space' has implications for a Europe of nation states: 'complex space has a certain natural, ontological priority, simple space remains by comparison merely an abstracting, idealizing project. . . . This is the case because there is no such thing as absolute non-interference; no action can be perfectly self-contained, but always impinges upon other people, so that spaces will always in some degree "complexly" overlap, jurisdictions always in some measure be competing, loyalties remain (perhaps benignly) divided.'[33] One consequence of this fact is that the sovereign state cannot (never could) contain all the practices, relations and loyalties of its citizens.

Milbank's idea of complex space should not, incidentally, be confused with some recent discourses about the insignificance of states and state borders in our contemporary world: for example Kenichi Ohmae's argument that since consumption patterns are based on the global flow of goods and information that override national borders, nation states are no longer important.[34] Such views are, in any case, reductionist in that they translate the heterogeneity of embodied powers into a universal essence representable as 'consumption patterns'. They are also inattentive to the different purposes for which national borders may be transcended (or defended) and to the kinds of people who can pursue those purposes successfully. For illegal would-be Asian immigrants to Britain, national borders are not only real but menacing; to American investors in Mexico, borders represent an opportunity. The Iraq–Kuwait border has had a dramatically different

quality of porousness for Saddam's army on the one hand and the United States Air Force on the other; indeed the Gulf War demonstrates how violently a border can be reaffirmed, whatever the cost – in this case of Iraqi lives and Saudi money – may be. ('Violent cultures', incidentally, are no longer congruent with simple, bounded territory, as Pocock implies; since belligerent action taken by state armies is surely part of a 'culture of violence', its reach, as exemplified by the US and its European allies in the Gulf War, is global.)

The idea of complex space, in contrast to the discourse of a borderless world, is a way of thinking about the intersecting boundaries and heterogeneous activities of individuals as well as of groups *related to traditions*. But we need to think also of complex time: of how embodied practices are rooted in multiple traditions, each drawing on temporalities that connect present and future, and of how each tradition cultivates a distinctive experience of the present and privileges some desires over others. How it facilitates particular ways for the body to experience and to become experienced, disallowing or making other ways more difficult.

The scope for 'national politics' is reduced in complex space and time – though not simply in favour of supranational or subnational structures. The question here is not simply one of devolution or of regional integration, such as is now being debated in the European Community. The scope of national politics is reduced in part for the well-known reason that the forces of global capitalism often under-mine attempts to manage the national economy – although it is necessary to stress that this is truer of some national economies than of others.[35] It is reduced also because networks that straddle national boundaries mobilise variable populations for diverse enterprises.

But there is something else: because the temporalities of many tradition-rooted practices (i.e., the time each embodied practice requires to complete and to perfect itself, the past into which it reaches and which it re-enacts and thereby extends) cannot be translated into the homogeneous time of national politics, the latter are further reduced. The body's memories, feelings and desires necessarily escape the rational/instrumental ambitions of such politics. This is not properly understood by those well-wishing critics who urge Asian immigrants to abandon their tradi-tions, to regard some of their collective memories and desires *as not essentially their own*, and to embrace instead the more modern conception of self-determination underlying the European nation state in which they now live.[36] For many Muslim minorities (though by no means all) being Muslim is not primarily an individual faith whose private integrity needs to be publicly respected by the force of law – nor even essentially a social identity to be guaranteed by the political system. It is first and foremost a way of life and death oriented by a religious tradition in which moral freedom is not conceived of as the identity of the self with itself.

I conclude with a question because decisive answers on this matter are difficult to secure. If Europe cannot be articulated in terms of complex space and time, which allow for multiple ways of life and not merely multiple identities to flourish, it may be fated to be no more than the common market of an imperial civil-isation,[37] always anxious about (Muslim) exiles within its gates and (Muslim) barbarians beyond. In such an embattled modern space – a space of abundant

consumer choice and optional lifestyles – is it possible for Muslims to be repre-
sented *as Muslims*?

Acknowledgements

Michael Blim, William Connolly, Vincent Crapanzano, Heiko Henkel, Aseel
Sawalha, David Scott, and Gerry Sider, have commented on this chapter at
various points. I am grateful to them.

Notes

1 See J. Wrench and J. Solomos (eds) *Racism and Migration in Western Europe*,
Oxford, Berg, 1993 – and especially the excellent contribution by S. Castles.
2 See A. Hargreaves, *Immigration, Race and Ethnicity in Contemporary France*,
London, Routledge, 1995, 119.
3 Many of these voices are found in recent collections: B. Lewis and D. Schnapper
(eds), *Muslims in Europe*, London, Pinter, 1994; S. Z. Abedin and Z. Sardar
(eds) *Muslim Minorities in the West*, London, Grey Seal, 1995; G. Nonneman,
T. Niblock, and B. Szajkowski (eds) *Muslim Communities in the New Europe*,
London, Ithaca Press, 1996.
4 Philip Gleason points out that the first edition of the *International Encyclopedia of
the Social Sciences*, published in 1930–35, carried no entry under that term, and
that one appeared only in the 1968 edition. See 'Identifying identity: a semantic
history', *The Journal of American History*, vol. 69, no. 4, 1983.
5 *Time*, October 19, 1992, 31.
6 Tony Judt, 'The past is another country: myth and memory in postwar Europe',
Daedalus, vol. 121, no. 4, 1992.
7 *Europe. The Emergence of an Idea*, Edinburgh, Edinburgh University Press, 1957,
113–14.
8 B. Osser and P. de Saint-Exupery, 'The UN's failure: an interview with Tadeusz
Mazowiecki', *The New York Review of Books*, vol. XLII, no. 14, September 21,
1995.
9 'In its historical practice,' writes François Thual, 'Caucasian, Balkan, Greek, and
Slav Orthodox Christianity has never known secularism based on the separation of
Church and State.' ('Dans le monde orthodoxie, la religion sacralise la nation, et la
nation protège la religion', *Le Monde*, 20 January 1998, 13.) It is a little-known
fact – and one very rarely publicised – that the Greek constitution is proclaimed in
the name of the Holy Trinity, and that it affirms that 'the dominant religion in
Greece is that of the Eastern Orthodox Church of Christ.'
10 Although the hostility of secular liberals is often surprisingly similar to that of the
extreme right. In France, for example, when the headmaster Chenière suspended
three Muslim schoolgirls for wearing headscarves on the grounds that they were in
contravention of French laws of *laïcité*, the subsequent overturning of Chenière's
suspension order by the Education Minister produced a remarkable response. A
group of leading intellectuals, including Régis Debray and Alain Finkelkraut,
compared the Minister's decision to the 1938 appeasement of Nazi Germany at
Munich: 'by implication,' observes Hargreaves, 'the Islamic bridgehead estab-
lished by the three girls in Creil now represented a comparable threat to the future
well-being of France.' The form in which the issue was publicly represented helped
the extreme right wing Front National party to win a sweeping by-election victory
near Paris, an event that in turn contributed to the adjustment of government
policy on immigration. See Hargreaves, *op. cit.*, 125–6.

11 Michael Wintle, 'Cultural identity in Europe: shared experience', in M. Wintle (ed.) *Culture and Identity in Europe*, Aldershot, Avebury, 1996, 13, emphasis added.

12 H. Trevor-Roper, *The Rise of Christian Europe*, London: Thames and Hudson, Second Edition, 1965. Described by a *Times Literary Supplement* reviewer as 'One of the most brilliant works of historiography to be published in England in this century', it has been reprinted numerous times, most recently in 1989.

13 For example, D. Hay, *Europe: The Emergence of an Idea*, Edinburgh, Edinburgh University Press, 1957; J.-B. Duroselle, *L'idée d'Europe dans l'histoire*, Paris, Denoel, 1963; R. H. Foerster, *Europa. Geschichte einer politischen Idee*, Munich, Nymphenburger, 1967; K. Wilson and J. Van der Dussen (eds), *The History of the Idea of Europe*, London, Routledge, 1995.

14 J. Locke, *Two Treatises of Civil Government*, Book II, Chapter V, paragraph 34, emphasis added.

15 Of course anti-semitism has not disappeared in Europe. But no one who aspires to respectability can now afford to be known publicly as an anti-semite.

16 'The Arabs themselves . . . *had little of their own to offer.* . . . But as carriers, their services to Europe were enormous', Trevor-Roper, 141.

17 In Trevor-Roper's picturesque language: 'Out of this union [of ecclesiastical and feudal power], would come, in due time, the combined spiritual and material counter-attack of the enslaved West against its Moslem exploiters: the Crusades' (*ibid.*, 100).

18 Hence Trevor-Roper's account of the European Crusaders who established a principality in Jerusalem from the end of the eleventh century to the end of the twelfth: 'The Christian kingdom of Jerusalem continued for less than a century. The Christian virtues, such as they were, evaporated in the East. The Christian dynasties ran out . . . [T]he sons – or rather the successors, for there was a dearth of sons – settled down to a life of luxurious coexistence in which feudal bonds were rotted and oriental tastes indulged' (*ibid.*, 104). By 'Christian' Trevor-Roper refers of course only to those who originated in 'Europe', because the Middle East at the time was largely inhabited by indigenous Christians who were central contributors to 'Islamic civilisation'.

19 On Europe's 'Faustian' identity, see Agnes Heller, 'Europe: an epilogue?', in B. Nelson, D. Roberts and W. Veit (eds) *The Idea of Europe: Problems of national and transnational identity*, Oxford, Berg, 1992.

20 P. Anderson, 'The Europe to come', *London Review of Books*, 25 January 1996.

21 J. G. A. Pocock, 'Deconstructing Europe', *London Review of Books*, 19 December 1991.

22 A. Watson, 'European international society and its expansion', in H. Bull and A. Watson (eds) *The Expansion of International Society*, Oxford, Clarendon Press, 1985, 32.

23 Marie Collins Swabey, *The Theory of the Democratic State*, Cambridge, Mass.: Harvard, 1939, 18–20, emphasis in original.

24 Joseph Heim, 'The demise of the confessional state and the rise of the idea of a legitimate minority', in J. W. Chapman and A. Wertheimer (eds) *Majorities and Minorities*, New York, New York University Press, 1990.

25 'Colonies, protectorates, mandates, intervention treaties, and similar forms of dependence make it possible today for a democracy to govern a heterogeneous population without making them citizens, making them dependent upon a democratic state, and at the same time held apart from the state. This is the political and constitutional meaning of the nice formula "the colonies are foreign in public law, but domestic in international law".' Carl Schmitt, *The Crisis of Parliamentary Democracy*, Cambridge, Mass., MIT Press, 1985 [1926], 10.

26 'Nous croyons que la France est notre patrie, que les Français y ont des devoirs

mais aussi des droits supérieurs à tous autres, et que nous avons non seulement le droit mais le devoir de défendre notre personnalité nationale et nous aussi notre droit à la différence.' *Le Monde*, 21 September 1982, cited in part, and in English translation, by Miriam Feldblum, 'Re-Visions of citizenship: the politics of nation and immigration in France, 1981–1989' (doctoral dissertation, Yale University, 1991), 48. My translation of the original is slightly different from Feldblum's.

27 Feldblum (*op. cit.*) argues that the immigration politics of the extreme right are better described as 'nativist' than as 'racist', because the latter term does not explain why many of the non-racist left also share certain crucial elements of the same position. While Feldblum's study as a whole is valuable for understanding developments in recent French ideas of national identity, she does not discuss the contradictions inherent in liberal ideas of citizenship. Her use of the pejorative term 'nativism' to denote populist denunciation of 'foreign influences' deflects her from an adequate consideration of liberal forms of exclusivism.

28 See Hargreaves, *op. cit.*, 169–76.

29 W. E. Connolly, 'Pluralism, multiculturalism and the nation-state: rethinking the connections', *Journal of Political Ideologies*, vol. 1, no. 1, 1996, 58, emphasis in original.

30 Connolly, *ibid.*, 61.

31 Connolly, *ibid.*, 70, emphasis in original.

32 See Charles Taylor, *Multiculturalism and 'The Politics of Recognition'*, Princeton University Press, 1992.

33 J. Milbank, 'Against the resignations of the age', in F. P. McHugh and S. M. Natale (eds) *Things Old and New. Catholic Social Teaching Revisited*, New York, University Press of America, 1993, 19.

34 Kenichi Ohmae, *The Borderless World: Power and Strategy in the Interlinked Economy*, New York, HarperCollins, 1990.

35 'Representatives from the world's 29 richest countries gathered in Paris last weekend to put the final touches to an agreement that will give multinationals power to sue national governments for any profits lost through laws which discriminate against them. It will . . . acknowledge for the first time that corporate capital now has more authority and freedom to act than mere national and local governments.' David Rowan, 'Meet the new world government', *Guardian Weekly*, 22 February 1998, 14. The article is less than clear about whether *all* governments were equally enthusiastic about yielding up their national authority, and whether some would gain more from this agreement than others.

36 As in Homi Bhabha's 'where once we could believe in the comforts and continuities of Tradition, today we must face the responsibilities of cultural Translation' written in a spirit of friendly advice to Muslim immigrants in Britain during the Rushdie affair (*New Statesman and Society*, 3 March 1989). Yet how innocent is the assumption that Muslim 'Tradition' carries no responsibilities, and that 'cultural Translation' to a British lifestyle in Britain is without any comforts.

37 'Europe is again an empire concerned for the security of its *limites* – the new barbarians being those populations who do not achieve the sophistication without which the global market has little for them and less need of them.' J. G. A. Pocock, *op. cit.*

Part I

Visualising 'otherness'

The authors in Part I interrogate categories of European knowledge and work, developing the project laid out in the first section and explicating the discourses underlying dominant texts. Here they broaden the focus to include visual images. They bring to bear a range of approaches for interpreting visual representation, from historical accounts of artistic form to cross-cultural accounts of film, video and still imagery.

The authors provide a rich context for exploring the work of 'othering' through the central notion that representation, visual as well as written, is culturally constructed. Each author teases out the meanings and historical and cultural associations of specific images and signs, making explicit the often implicit assumptions underlying them. The chapters, then, offer case studies of the ideological work of visual imaging, contextualising cultural codes, identifying their political ramifications and exposing the stereotyping of difference which continues to operate in contemporary society.

Mitter explores the underlying assumptions about beauty prevalent in contemporary European representations implicated in the coding of 'otherness' as inferior, sexually excessive and animal. Mitter cites examples of contemporary scientific and journalistic attempts to form a composite ideal of beauty and shows how these are based on naturalised assumptions about an 'average law of beauty'. Contrary to such a universal and objective reality, he argues that beauty is in fact culturally manufactured. He traces this ideological construct back to its source, which he sees as the Greek conception of perfect beauty in art, rationalised by philosophers as part of a whole aesthetic system and subsequently internalised in the European imagination. As Europeans encountered members of other races and cultures, they appealed to these early conceptions of beauty and of universal standards for conceptualising art and nature, to try to understand their differences. Again the representations are not always straightforward and the same European artists who deployed such stereotypes also depicted Africans with sensitivity and imagination. Moreover, some artists, such as Hogarth, challenged the whole framework and represented Africans as critical observers of European depravity whilst an alternative model of beauty rooted in variation and difference emerged to challenge the classical canon.

During the nineteenth century, however, this relativist turn was overshadowed

by the dominant force of science within which 'difference' was related to race, hierarchy and evolution. Whilst claiming 'objectivity', scientific discourse classi-fied the 'races' of mankind by external morphology and physical traits, but also invoked classical conceptions of beauty and ugliness. Whereas representations of the nude in European art helped establish norms of beauty, depictions of naked Africans linked their sexuality to an inferior animal status. As Mitter puts it, this concatenation of artistic and scientific traditions in Europe tragically 'epitomises the animalisation of the other in the nineteenth century'. Nor were these accounts limited to the depiction of the 'other' from overseas. The same attention to physical characteristics could be used to mark deviance and difference within European society: 'In this construction of the "pathology of 'otherness'", the age found parallels between the racially deviant, and the socially deviant, in other words marginal figures and outsiders, whose wild sexuality was both feared and desired'. The chapter concludes with evidence that more recent accounts of Western and non-Western beauty draw upon these earlier traditions, so that contemporary cinema and advertising likewise appeal to the classical norm and implicitly invoke the scientific theory with which it became bound up in nineteenth-century thought.

Loshitzky explores how the 'imaginative space of the "other" is constructed in the Western mind', using a case study of an Israeli text and film to analyse and expose the nuances of representation in which racial and sexual difference inter-play. Loshitzky argues that questions raised by colonial discourse assume a greater urgency when discussed in relation to filmic representations of the 'other', partly because of the visual medium's ability to play on light and darkness. Locating these representations in the wider social and sexual history of Western society in its relations to difference, Loshitzky focuses on a novel by Amos Oz, *My Michael* and the subsequent film adaptation of it by Dani Volman. She analyses the gen-dered and colonialist discourses encountered there in the context of Israeli poli-tics and in relation to further colonial texts such as Paul Bowles' *The Sheltering Sky* which was also made into a film and employed similar sexual imagery and narra-tive devices. The chapter is organised around a number of key themes: 'Oriental-ism, Zionism and 'otherness'', 'the fantasised other'; 'the other as sexual taboo', and 'women as other', concluding with the link between these discourses and the construction of 'Jews and Arabs as others'. In 'Orientalism, Zionism and 'otherness'-quo;' she briefly describes aspects of Israeli history and the relationship between political conflicts with the East and artistic representations of Arabs. Loshitzky highlights the ambivalence rather than the simple stereotyping in the embodi-ment of 'otherness' in this context: for instance, the mingling of curiosity and admiration with fear and revulsion.

Loshitzky's chapter calls on the work of Said, Kabanni and Bhabha to demon-strate the link between imagining the East as a political domain and imagining the East as a sexual domain. Here she draws together feminist and colonial studies, providing analytic insight into representations and relating them to local political conflicts and broader colonial discourse. This analysis, which attends to the differ-ences between novels and films, the role of the imaginary female, the link between

colonial others and sexual others, allows Loshitzky to conclude by acknowledging that recent 'Israeli artistic discourses on Palestinians and Arabs shows more openness towards the more contradictory and disturbing aspects of the conflict': the grand narrative of Zionism is being re-examined and space is being opened up, through analyses such as this, for subtler exploration of a conflict that in political discourse nevertheless can still only be represented 'in the language of blood'.

Reynaud examines the question of 'otherness' through an exploration of Brazilian video, providing a case study which particularises the notion of communication in contrast with dominant tendencies to universalise. Reynaud provides a brief history of video art and the development of different styles and genres, then discusses its use in contemporary Brazil, particularly through 'cause video' – videos made to present a cause or argument developing their own language and idiom that is neither film nor television. She then recounts something of the distinctive history of Rio de Janeiro, the home and video subject of Sandra Kogut whose video is discussed here: Rio has long seen itself as an inversion of the metropolis and also as a metonym for the whole of Brazil.

Kogut's video asks *What Do You Think People Think Brazil is?* and uses a series of overlaid images from commercials, magazines and films to present ways of considering the question. Reynaud locates this strategy in the larger history of 'self-exoticisation' familiar amongst Brazilian artists. The sort of images that Kogut's video constructs force us to reconceptualise what is meant by representation and how the 'other' is conceived. In particular, Reynaud is concerned with the question of what might be Brazil's 'other'. She concludes that it is Brazil itself, especially with its complex colonial history and its Portuguese/Anglo-American linguistic and cultural interfaces. Therefore, Reynaud argues, 'in the case of Brazil the representation of ourselves must include also our representation by the other'. The rapid, fragmented images, different voices and gazes, within video art explore contemporary identity as a process and highlight 'Brazil's rich palette of miraculously blended contradictions'.

Chakravarty and Gooptu, writing respectively from backgrounds in media studies and in history offer perspectives on the ways in which certain imaginations of an Indian nation are formed in contemporary India as part of larger social movements and transitions. Investigating the role of the production, transmission and reception of visual images, they argue that in this new media context the specific flow of images is produced within particular historical processes. Focusing upon popular cultural texts, including popular films, television serials, advertising commercials and election propaganda materials, the authors show how various cultural constructions of the Hindu and the Muslim, the Indian and the non-Indian, the modern and the traditional, the good and the evil, the new middle class and the poor are made and disseminated. These visual representations contain notions of 'self' and the 'other' and work to mediate certain conceptions of the nation-state and its citizenship. Here, definitions of nationalism are contested not so much through the printed text, that according to Anderson was the primary site for European nation building, but through visual images.

The authors probe the politics of these images against the backdrop of the

postcolonial history of the country and the current power formations with their specific agendas. In tracing the relationships between advertising images for the new middle class, political icons and images employed by assertive Hindu nationalism as well as the slippage of certain of these popular television images into cinema, they argue that an inclusive and exclusive conception of what constitutes the Indian 'nation' is being constructed. The major social tension against which the visual representations work is that between a reality of heterogeneity, ideological struggle and political fragmentation and the imagination of the Indian state as homogenous, a site of consumer choice rather than producer exploitation, its values rooted in middle-class family and community that derive from ancient Hindu discourses, myths and visions. These particular visions and representations are the dominant ones in contemporary India and it is against these, and the massive media resources through which they are mobilised, that alternatives will have to struggle. Chakravarty and Gooptu conclude that the India case is indicative of the role of visual representations elsewhere in the contemporary world: that media spheres do not function as apolitical and democratic public spheres offering equal access and freedom of expression to all, but that the cultural processes of marginalisation and the subordination of alternative voices are instrumental in the affirmation of power and will to control. The analysis, therefore, of such representations also constitutes an important intellectual and political act.

Sandon's chapter examines British films from the 1920s which claim to show 'native' life in Africa, situating them in relation to public displays as well as scientific and popular discourses and discussing the ways in which 'otherness' was visualised. These films have been neglected in realist and revisionist accounts of the period, but Sandon suggests that they should be viewed not simply as documents of African life but as representations of the concept of culture at this point in time. Whilst formalist accounts worry about their ambiguity as either documentary or fiction, a contextual analysis enables us to view them as examples of the continued centrality of imperialist representations in both cinema and other representational forms such as theatre and museum exhibitions, with which they were closely allied. Using sources such as trade magazines and newspapers, this chapter attempts to locate the films in this broader cultural history.

Sandon cites Kirshenblatt-Gimblett's distinction between zoological and theatrical display, the former representing people in supposedly 'natural' habitats, the latter calling on the actors to perform in an often rehearsed fashion. In both, the drama of everyday life in 'exotic' places was apparently made available to the metropolitan audience. The pursuit of realism and mimetic representations did, however, take on a different form with the development of the cinema. In museums, particularly in the use of photography to authenticate objects, the ground had been laid for a construction of spectatorship that involved 'the illusion of an experiential connection with the objects of their vision'. Furthermore, the desire for 'eyewitness' accounts, which tended to position the viewer as voyeur observing different cultures at first hand, was not reduced but enhanced as the empire itself declined. It is in this context, argues Sandon, that cinema took on the role of representing 'otherness': early cinema, with its claims to realism,

adopted a more instructional, educational tone in the representation of the 'other' and facilitated a shift in public taste away from theatrical exhibitions and displays intended for entertainment. The spectator was then located in an ethnographic narrative that derived from the scientific concerns of zoological display.

2 The Hottentot Venus and Western Man

Reflections on the construction of beauty in the West

Partha Mitter

A few years back at the University of Sussex, we had a visitation from the copy-rights authority, who were engaged in estimating the amount of photocopying done by readers using the university library. As I was waiting my turn to photo-copy the attached picture (Figure 2.1), the visiting inspector happened to glance at it. His face immediately lit up and he gave me a knowing wink. This reaction was not unexpected. Indeed Sara Bartman, the so-called Hottentot Venus, was the most famous example of African sexuality in the nineteenth century.[1] When the nineteenth-century cartoonist wished to lampoon the Prince of Wales and his mistress in Brighton, he chose the sensational image of the Hottentot Venus, a cartoon which still features among the Brighton Pavilion exhibits. Displayed around Europe as an object of curiosity, after Bartman's death, her genitals were shown off in a glass case to illustrate 'the exaggerated animality of the Negress'. The tragic life of my eponymous heroine gives me a pretext to reflect on Western ideas of beauty within the broad conception of 'cultural encounters' evident throughout this volume. Since a lot is made of this age of multiculturalism, it may lead us to conclude that things are very different today. It might be argued, with some justification, that African women are not only *not* demonised, but on the contrary, women of African origin are much sought after in the glamour business. Witness the meteoric rise of the supermodel, Naomi Campbell. However, as we shall see, things are not that simple.

The recent cybernetic revolution and advances in medical science have created a new urgency about matters concerning beauty. In fact there has been a veritable explosion of the beauty industry as well as reflection on it, fuelled no doubt by the ever-increasing prospects of altering one's physical appearance through cosmetic surgery.[2] Computers have also opened up unprecedented possibilities for manipu-lating images to produce the desired ideal, mixing and matching through the digital process. A favourite game of our age of 'virtual reality' is the creation of composite human faces, by taking bits and pieces from a selection of human beings. The artist, Nancy Burson, is famous for playing this fascinating game of 'matching' and 'making'. In 1982, she offered us a composite of a perfect beauty, blending the features of Bette Davis, Audrey Hepburn, Grace Kelly, Sophia Loren and Marilyn Monroe. It seems that the perfect woman, or the perfect cyberwoman if you like, has come to be a reality.[3] Burson is, of course, using a

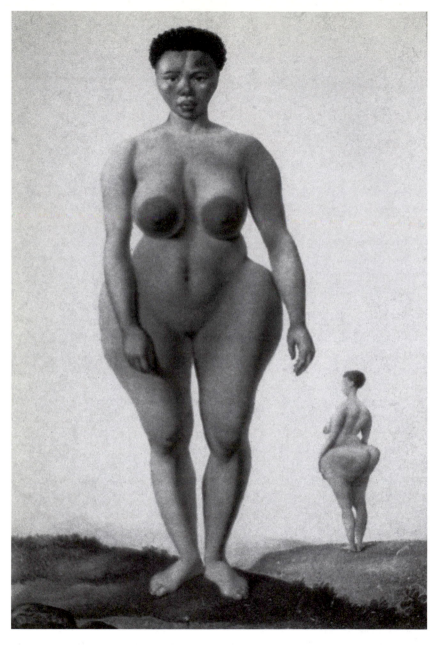

Figure 2.1 The Hottentot Venus and Western man: reflections on the construction of
beauty in the West.

Source: H. Honour (1989) *Image of the Black in Western Art*, 53.

computer as an artist, but scientists too have begun to engage in this activity, and their objective enquiry as scientists lends a certain gravitas to the subject. Cognitive psychologists, in particular, have turned to the new technology to produce these composite images for a variety of ends. Let me take three examples from various publications here.

In 1993, *The Observer Magazine* carried an article entitled 'Calculating looks'. 'Dr Alf Linney', it reported, 'has recently helped in the treatment of a young Bosnian refugee by creating computer-generated images of his injuries. He is also using this technology to establish models of "average" beauty to help surgeons reconstruct faces affected by injury or deformity'. I do not think any reader will doubt that this is a worthwhile project. But *what* was the particular facial model used to reconstitute the victim's face? The article insisted the criterion for such a model was beauty. It went on to claim that a beautiful face was synonymous with the average face and that everyone knew who was beautiful and who was not. Accordingly, a model agency was approached to send the best specimens from all ethnic backgrounds to construct a universal average.[4]

In 1994, *Time* magazine conducted an experiment in order to discover the ideal American man and woman of the future. It engaged a computer scientist to do a projection based on the composite features of fourteen American men and women from different ethnic backgrounds. From this experiment, the magazine came to the conclusion that the computer average was the future of our planet, in a meeting of cybernetics with genetic engineering. Interestingly, *The Observer Magazine*, mentioned above, offers a very different explanation for the objective view of beauty. Endorsing a universal canon of beauty, it points out that an experiment conducted in the US in the 1960s demonstrated that both blacks and whites rated 'Caucasian' features above the 'Negroid'.[5] One of the drawbacks of this experiment, we can see today, was that in the 1960s, there was hardly a black or Asian face visible in public spheres, especially in the media. (The magazine indeed goes on to admit that today things are totally different.) The photograph of the supermodel Naomi Campbell and her friends expressing their ecological concerns is a good example of the dent made by non-Europeans in the media. Yet if you look more closely, you cannot fail to notice that, whatever their origins, these models look confusingly alike.[6] Once again, the example appears to vindicate the 'law of the average' (Figure 2.2). The more the face deviates from this canon, the less beautiful it is.

In our global village today, beauty is packaged and marketed worldwide through the media, especially television. So if we wish to examine notions of beauty that are diffused around the world, we only need to turn to television. Throughout Asia, for instance, programmes like *The Bold and the Beautiful* boast an impressive fan club, thanks to Rupert Murdoch's Star TV. Some of the scientists, especially biologists, who offer hypotheses about human beauty, see beauty as *simply* sexual attraction. This was the view expressed in the *Independent* newspaper, which did not agree with the law of averages, arguing instead that beautiful women were invariably 'baby-faced'. A smooth baby-face was a biological signal, or an unconscious mating sign, if you like (Figure 2.3).[7]

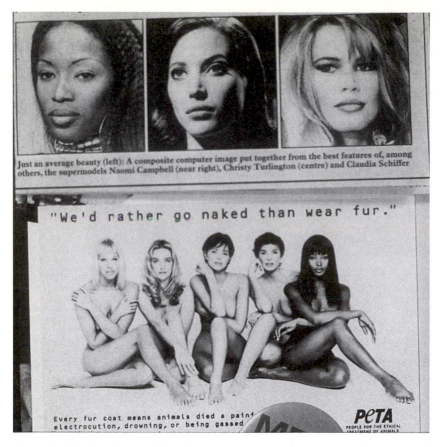

Figure 2.2 Naomi Campbell and friends.
Source: *Independent*, 17 March 1994 (top three faces), *Guardian*, 13 February 1996 (bottom).

What these three cases agree on is a universal notion of beauty, based either on the law of averages or on biological factors. The conclusion is that all of us, regardless of our background, know who is beautiful. In other words, one may legitimately conclude that standards of beauty are universally recognised, for they have an objective reality based on a consensus, because they contain an underlying biological truth. But is beauty objective, and when scientists speak of the average as beautiful, how do they reach such a consensus? Indeed the *Observer* article offers us our first clue. The writer took as his authority Western artists from the ancient Greeks to the Renaissance. As he put it, traditionally the artists' business was beauty, quoting Dürer who suggested that beauty was the harmony of the parts. The article here takes for granted what it asserts as self-evident truth, based on our primordial needs (Figure 2.4).

To remind readers of the main points raised so far, scientists argue that our

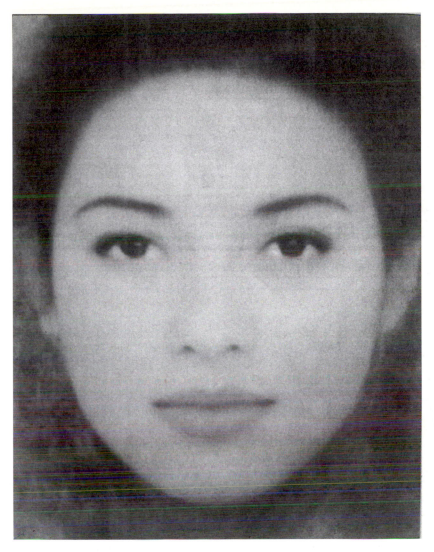

Figure 2.3 Beauty as a biological signal.
Source: *Independent*, 17 March 1994.

response to beauty is essentially biological. The baby-faced woman is beautiful because she sends out signals that have to do with mating. Ideal beauty is a blend of the average as seen in these fashion models, suggesting that, whatever the ethnic background, there is something universal about beauty. What I would like to argue is that, far from being biologically determined, beauty is, in fact, culturally constructed. (This is not to deny that biological factors play a part in the sensuous appeal of beauty.) Yet in the West such a canon of beauty is so

internalised that it is perceived to be based on common sense. On the contrary, what this canon does is to draw upon an ideal image, validated by art since antiquity. Here I shall trace this powerful ideological construct back to its very source. Naomi Wolf asserts that the obsession with the beauty of women, as a form of domination when women begin to compete professionally with men, dates from the 1830s.[8] While this is true, I would argue that we cannot fully understand modern Western preoccupations with beauty until and unless we are able to examine the historical roots of Western ideas about beauty. And it is to the Greek conception of Perfect Beauty in Art that we must turn. Perfection was first developed in the male nude; the taboo against the female nude was not lifted until much later, as Kenneth Clark's classic study explained. The Greek Polyclitos was the first artist to formulate a canon for the human body, and in the absence of consensus, certain proportions were chosen as models of perfection, and parallels drawn with the symmetry of architecture.[9]

Not only was this ideal expressed in art, it was also rationalised by philosophers who contributed to the rise of a whole aesthetic system. The concept of ideal human beauty first appeared in Plato who held that art could never match ideal beauty.[10] Paradoxically, Plato's anti-art ideas inspired the notion that art was superior to nature; for it improved on nature's deficiencies. This was explained by a story which is well known: the painter Zeuxis sent for five beautiful maidens from the town of Croton because he wished to fashion the love goddess Aphrodite by incorporating the most beautiful part of each woman in his work. This was because no single human being could attain perfection. Thus from the outset, there were tensions between the natural and the ideal in Greek thought.[11]

Such a concept of the perfect human body continued to obsess European artists. Initially, in the Renaissance, speculations on beauty were confined to personal beauty, for instance in Augustino Nifo's *De pulchro*.[12] However, when Alberti restored the Greek notion of perfect beauty of the nude, he was predictably reminded of Polyclitos.[13] Henceforth, the Platonic ideal was to pervade Western aesthetics, as, gradually, all other forms got 'swept under the carpet'. I have mentioned Dürer's stress on the Platonic harmony of the parts. Yet, Dürer was exceptional in being a relativist about human beauty. Imbued with a different, north European sense of beauty, his own works show a remarkable openness. Not only is his portrait of an African striking in its penetrating observation,[14] but significantly, in his *Four Books of Proportion*, dated 1528, he dismissed an imaginary notion of beauty. Nature was, he argued, a master in such things and the 'perfection of form was held in the sum of all men'. The great Rubens too projected a very different feminine ideal.[15]

But the scholar credited with creating the modern myth of beauty was the eighteenth-century German art historian, Johann Joachim Winckelmann. Drawing on a connection between human beauty and artistic perfection he presented the Greek *Kouros* as epitomising 'noble simplicity and quiet grandeur'. The androgynous image – the hermaphrodite, which may be taken as a blend of the average – was the widely accepted ideal. Winckelmann devised a scale of beauty

Figure 2.4 Notion of beauty based on Dürer.
Source: *The Observer Magazine*, 26 September 1993.

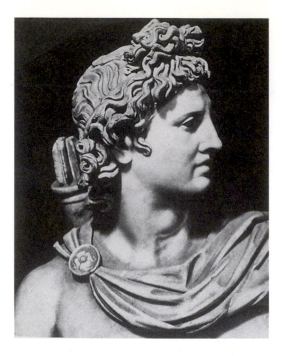

Figure 2.5 Apollo Belvedere.

Source: Vatican Museum from W. Leppmann (1970) *Winckelmann*, Alfred A. Knopf, New York (photo Alinari, Art Reference Bureau).

that singled out certain features of antique sculptures as the embodiment of beauty, in a way not unlike the computer images mentioned before. The profile, for instance, was chosen from the Apollo Belvedere. 'In youthful and particularly female heads', he wrote, 'such a profile represents a source of beauty'. The more the face deviates from this canon, the less beautiful it is, and especially ugly where the nose is depressed. An example of the latter was the realistic bust of Caracalla that recalled African features (Figure 2.6) On female form, he chose the Cnidian Venus. The bosom of the female figures, he insisted, 'should never be overly full . . . on some statues [the navel] is shown more pleasantly than it is on the *Venus de Medici*' whose navel is uncommonly deep and large.[16] Such a universal canon has had a profound effect on Western representations of non-Western art, notably Indian. By Classical standards, a Hindu goddess was a mere fertility symbol, not a reflection of a very different ideal.

It may be argued that the Platonic notion only addressed artistic perfection, for it could be claimed justifiably that human beings could never live up to such an exalted ideal. Plato's own caveat was, we may remind ourselves, 'beauty in itself is not found in living creatures or their representations, but in geometric figures. These are beautiful in themselves, for their beauty goes beyond sensual pleasure'.[17] But in fact, the slippage between art and nature constantly occurred.

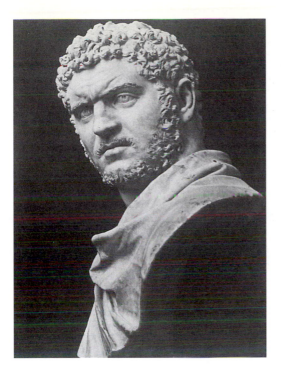

Figure 2.6 Bust of Emperor Caracalla.

Source: W. Leppman (1970) *Winckelmann*, Alfred A. Knopf, New York (photo Alinari, Art Reference Bureau).

As Winckelmann's own scale of beauty demonstrates, human beings were judged according to how close they came to this ideal. There was justification for it as well, for the seventeenth-century iconographer Bellori had stated: 'It remains to be said that since the sculptors of antiquity used the marvellous Platonic idea . . . a study of the most antique sculptures is therefore necessary to guide us to the emended beauties of nature'.[18] Any deviation from this myth was deemed abnormal in European art until recently.

Until the eighteenth century the debate on beauty was an internal one in the West, but the existence of vast numbers of peoples, different from Europeans, could no longer be ignored. In a *Treatise on Beauty* (1724), the Frenchman J. P. Crousaz claimed that beauty was not a figure of imagination but had a reality, while accepting that it was relative. He saw beauty as a balance between variety and a fixed set of proportions. The earliest perception of difference in the West was with regard to colour. Most interestingly, Crousaz says 'As far as human body is concerned, colour is necessary because it offers variety'. He takes the superiority of white skin for granted, especially over the blackness of the Moors. He proposes in a Manichean vein that white is naturally more beautiful and a healthier colour than black, which stands for darkness. The black body consists of parts that lack

tautness and a smooth surface so that light gets lost in it. The black skin, he concludes, can stand less heat than the white.[19] In 1767, in his *Essay on the Beautiful*, Father André agreed that each nation had its own preference in skin colour, citing an African who gave the crown of beauty to his own nation's colour.[20] Yet, André uses the prevalent metaphor of light for white skin, considering it as the very opposite of darkness which makes everything it touches ugly'. When the eighteenth-century French architect Étienne-Louis Boullée wished to explain the properties of architecture, he too used the analogy of the human body and the criteria of colour: 'I began my research by considering dark bodies and found them to be irregular and confused.'[21]

In the late eighteenth century Africans were portrayed with sharpness and sympathy by painters in Britain and France. One such painter was Marie-Guilhelmine Benoist, a child of the French Revolution which had temporarily abolished slavery.[22] Benoist painted, for instance, a noble portrait of a maid-servant of African origin. The leading eighteenth-century English portrait painter and the first president of the Royal Academy, Joshua Reynolds also depicted Africans with imagination.[23] But the most radical artist in this respect was William Hogarth, best known for his hard-hitting caricatures of the English aristocracy, attacking corruption at the very heart of society. Hogarth's openness towards other peoples, particularly Africans, is attested by David Dabydeen's interesting study.[24] Hogarth accepted that Africans had the right to be considered as human beings. He used them as the other and witness to the depravity in English society that he wished to expose through his engravings.

Hogarth wrote the treatise, *Analysis of Beauty*, challenging the prevailing certainties regarding beauty. His own hostility to the wealthy purveyors of Classical art turned him into a cultural relativist. He accuses them of being so prejudiced by art that they fail to appreciate natural beauty when they see one. I think it will be wrong to make large claims about his 'openness', for he had his own particular axe to grind. Hogarth's starting point was the canon. Of course, his ideas about the serpentine curve as the universal line of beauty invited ridicule from contemporary critics. But Hogarth's plea for variety and irregularity as valid aesthetic criteria fitted in well with the emerging ideas of the 'sublime and the picturesque' which challenged the Classical standards of beauty.[25] Moreover, as I have shown elsewhere, there was an *insouciant* openness among leading collectors like Richard Payne Knight and Charles Townley that had something to do with the Enlightenment.[26] It is not surprising that the late eighteenth-century explorer Mungo Park's description of Africans showed a world of difference from the stereotypes of the Victorian travellers, Burton and Speke and Baker.[27]

Hogarth was willing to accept that there could be different cultural norms of beauty. In his discussion of skin colour, he remarks:

> We shall take a view of nature's curious ways of producing all sorts of complexions, which may help to further our conception of the principle of varying colours, so as to see why they cause the effect of beauty. It is well-known, the fair girl, the brown old man, and the negro; nay all mankind, have the

same appearance, and are alike disagreeable to the eye, when the upper skin is taken away.[28]

And in yet another passage from the same text we find incipient cultural relativism:

> ... the Negro who finds great beauty in the black Females of his country, may find as much deformity in the European beauty as we see in theirs.[29]

However, if the Enlightenment view of the common origin of mankind provided the device for accommodating the other, there was also its dark side that paved the way for Victorian racism. The *érudits* of the Enlightenment placed mankind on a scale of progress with the West at its summit, attributing non-Western 'backwardness' to climate, environment or institutions. A further development in the history of thought was the concept of race, which melded biology and culture. In Enlightenment taxonomy, race, hierarchy and evolution played their part in placing the European at the top and the African at the lowest rung of the evolutionary ladder, with a host of intervening races. Finally, in the Victorian ideology of difference, looks and personality were intimately bound up.

While earlier aesthetic theories were confined to art, now science was pressed into the service of European beauty and its opposite, African ugliness. I am not suggesting that Europeans were alone in considering themselves to be the most beautiful. All cultures have preferences based on their self-image. But in *no* other society do we find taste elevated to the level of scientific objectivity as in the case of nineteenth-century Europeans. However, the earlier colour criterion was not abandoned. As a Victorian author commented, 'It is odd how persistently the supreme ideal of female beauty is fair'. By the 1850s, black had come to symbolise evil and degraded, the very opposite of chaste white.[30] The earlier metaphor of light and dark was now sought to be reinforced by the systematic classification of races by physical features, language and intelligence.

What these racial doctrines did was to also construct their own hierarchy of beauty based on the Classical ideal. Even in the late eighteenth century, the great Carl Linnaeus, for instance, categorised the African as the ugliest of human beings, whose facial features reflected his personality, even as beautiful features were a mark of the superior European character. This was endorsed by the French zoologist, Buffon. The nineteenth century embarked on a systematic exposition of physiological difference, commencing with skull measurement. Craniometry and phrenology undertaken by Blumenbach, Retzius and Camper sought to establish on scientific lines the essential difference between the European and the African.[31] As a younger contemporary of Petrus Camper reported admiringly, he was no longer satisfied with superficial evidence, but wished to give his theory a strict scientific foundation, to define racial difference by his facial angle, which proved the absolute beauty of Greek Apollo and other figures.[32]

In 1866 it was argued that if one compared 'a low-browed, flat-nosed, woolly-headed, ebony-hued, long-headed Negro with a fair-skinned, blue-eyed, yellow-haired, large-brained Caucasian ... the natural conclusion would be that types of

humanity so opposite to and distinct from one another, were not descended from the same primitive stock'. With his abnormal length of arm, prognathism and lightweight brain and ugly nose and mouth, the Negro occupied the lowest rung of the evolutionary ladder. Richard Burton, who identified the African with the gorilla, claimed that even Africans admired European beauty.[33] Arguably, the Africans were seen to be the furthest removed from the Western image of beauty, which helped reinforce the notion of difference that already existed in the cultural sphere.

The most powerful theoretician of racial doctrine was Gobineau, who put in a chilling manner what was a widespread view of the racial hierarchy of beauty. A disgruntled French aristocrat who took up his pen to denounce the democracy ushered in by the French Revolution, his basic thesis was as follows: physical features determined language, culture and intelligence; racial characteristics were inherited and immutable as was the permanent inequality among races in physical strength and intellectual and moral qualities (in the evolutionary racial hierarchy of mankind). Speaking of all black races whom he terms Negros, Gobineau writes:

> When we look at an individual of the Negro type we are involuntarily reminded of the structure of the monkey. [However] Oceania has the special privilege of providing the most ugly, degraded, and repulsive specimen of the race, which seem to have been created with the express purpose of forming a link between man and beast pure and simple. In many of the wretched inhabitants of this New World, the size of the head, the extreme thickness of the limbs, the famished look of the body, are absolutely hideous. When we finally come to the inhabitants of Europe, and South and West Asia, we find them superior in beauty, in just proportion of limbs and regularity of features. Not only are these peoples more beautiful than the rest of mankind, which is, I confess, a pestilent collection of ugliness, but they claim the glory of giving the world such admirable types as Aphrodite, Apollo, and Farnese Hercules.[34]

Elsewhere he reiterates that beauty is absolute, a fact strikingly brought out in antique sculpture. In conclusion, Gobineau points out that Europeans and their descendants are the most beautiful while the races that are further removed from the Aryan type produce incorrect forms, defective proportions, in short, excessive ugliness. In other words, inequality as far as beauty of human groups is concerned is logical, permanent and indelible.[35]

And yet among Victorians there was a morbid fascination with African sexuality which was, according to Christine Bolt, publicly deplored and privately envied.[36] African nudity, for instance, explained as a lack of modesty, was diagnosed as an absence of sexual restraint. In his fascinating work, Sander Gilman has argued how the sexuality of the African further confirmed their animal status. He suggests that initially, African women, rather than men, were the object of Western curiosity, their supposed rampant sexuality signified by their enlarged genitalia. Interestingly, the nineteenth-century view of the sexualised female concentrated on the so-called secondary sexual characteristics to highlight African inferiority.[37]

I return to the tragic case of Saartjie Baartman, the so-called Hottentot Venus, who was exhibited in European capitals in the early years of the nineteenth century and died in 1815 at the age of 27. She aroused intense curiosity because of her 'steatopygia', a condition characterised by excessive fat in the buttocks. In London, she was described as having the 'kind of shape which is most admired by her countrymen but to the English she was an intensely ugly figure, distorted beyond all European notions of beauty'. The French scientist Georges Cuvier identified her as being close to the monkeys in looks and behaviour, making the expected connection between physical features and culture.

Baartman was the quintessential African woman, on the lowest rung of the evolutionary ladder.[38] The anomalies of her organ of generation clearly showed the link between the lowest human species with the highest ape, the orang-utan. To many of us this tragic case epitomises the animalisation of the other in the nineteenth century, her private parts being subjected to the indignity of dissection after her early death. It was only with the dismantling of South African apartheid in 1994 that her remains were repatriated to her homeland. To the nineteenth-century European, she was the bizarre creature whose hideously exaggerated buttocks epitomised African beauty, the African Venus as it were. Richard Burton remarked that Somali men chose their wives by arranging them in a line, and selecting the one who projects furthest 'a tergo', a comment that was understood to refer to the Hottentot Venus.[39]

Yet paradoxically, steatopygia was considered sexually arousing and not everyone was put off by the so-called 'ugliness' of her steatopygia. The Victorian fashion for bustles and its 1995 revival by the fashion designer Vivienne Westwood bear witness to the sexual allure of large bottoms.[40] However, if the sexual appeal of steatopygia was accepted, significantly it was seen to arouse a lower kind of emotion commensurate with the racial status of Africans. Hottentot Venus 'animalis', in contrast to the Greek Venus 'coelestis', aroused simultaneously fear and desire. Aesthetic contemplation of the beauty of the nude should sublimate the mind to a higher aesthetic pleasure. Plato's homoeroticism insisted that even if young boys were desirable, the true contemplation of their beauty was intellectual and spiritual. My point here is that, less obviously, the canon which identified beauty with hermaphroditic women endowed with small breasts and buttocks, rejected the steatopygic Hottentot Venus. Her appeal ran counter to the higher form of beauty, as it only aroused lust rather than Platonic ekphrasis.

Influential thinkers made the connection between the marginal figures, the Hottentot Venus and the Western prostitute because of their propensity to arouse base lust. In this construction of the pathology of 'otherness', the age found parallels between the racially deviant, and the socially deviant, prostitutes and similar marginal figures. In fact, if either African women or prostitutes were attractive, their attractiveness was not defined by the higher Platonic aesthetic ideal, but by a baser material. In short, prostitutes and African women were placed in the same category, both as outsiders and as deviant, an embodiment of wild sexuality that was both feared and desired.[41] Philosophers from Plato onwards were ambivalent about physical beauty; if the object of beauty is acknowledged to be desirable,

nothing less than its sublimation could elevate it to a pure aesthetic pleasure, an ideal epitomised by European women in contrast to the animal attraction of African women.

This of course complicates the issue, for is beauty not sexual attraction? Today, the biological argument has its influential advocates such as Desmond Morris or the *Observer* writer on baby-faced women. It no longer has any stigma attached to it. Yet, even today, often an implicit separation is made between the nobler forms of beauty and 'mere' sexual attraction, characterised as base animal instinct. In short, while scientific racism created the dichotomy of beauty versus ugliness on the systematic listing of physical features, behind its objectivity rested a powerful aesthetic ideal. The image of ideal beauty, with Western women as its highest expression, is intimately bound up with its representation and diffusion in art. Such attractiveness had a moral implication as well. In the constant cross over between art and nature we may be reminded of the Vitruvian formula that the 'defect of the grotesque lay in its lack of moral seriousness'.

From the late nineteenth century onwards, human physical and sexual characteristics came to hold the attention of psychologists and cultural anthropologists as part of the psychopathology of sex, whose work drew upon earlier physical anthropologists. At the turn of the century no one enjoyed greater authority than Havelock Ellis, who wrote the immensely influential work, *Psychology of Sex,* in 1905. Ellis was concerned with human sexual attraction. Inevitably, he turned to the question of beauty. In his view, the difference between the civilised and the primitive lay in that the civilised looked for secondary sexual signs, such as buttocks, as an indication of beauty, whilst the primitive was crudely attached to the primary sexual organs. In this context, Ellis further argued that there was an objective scale of beauty that stretched from the Europeans, whose looks displayed a certain spirituality, to Africans and other races who betrayed varying degrees of animality. With this in mind, Ellis recast in an objective guise the classical canon of beauty.[42]

One more typical example of the period could be cited. In a work by an Austrian gynaecologist published in 1923, *Woman (Wie Bist du Weib?)*, the woman is treated as the other in her biological and cultural aspects. Dr Bernhard Bauer begins by saying that the eye always seeks what is known as beauty, for it is central to human erotic life. But what does beauty mean, he asks rhetorically, adding that it is the sum total of visual stimuli that seek pleasure, in the sense that the unpleasant is ugly. But he also accepts that beauty is relative.[43] Noting Rubens's paintings of opulent women he says that they shared the prevailing taste of their period, according to which a woman's beauty was proportional to the development of her bust and thighs. Once again the spectre of the Hottentot Venus looms large. This preference for the adipose tissue, he states, can be observed in Africa . . . 'the Hottentots, by means of a special diet, make their women so fat that it is impossible for them to walk properly.'[44] 'It is well known', he continues, 'that with many Hottentot women the posterior part of the body projects in a most wonderful manner; they are steatopygous, and Sir Andrew Smith is certain that this peculiarity is admired by the men. He once saw a woman who was considered a

beauty, and she had so immensely developed behind, that when seated on level ground, she could not rise, and had to push herself along until she came to a slope'.[45] And in this vein he adumbrates 'savage' customs before returning to civilisation and offering a few severe comments about the vagaries of feminine fashion.

Finally, the signs that such a canon began to break down with the collapse of colonial rule and modernist assaults on the academic canon are to be found, for instance, in a slim volume by the Polish writer, Frankowski, called *A Plea for Beauty*. Reproducing well-known Classical and Renaissance icons to make his point, Frankowski, who complains that modern art goes for the ugly in its defiance of the Classical ideal, pleads for the restoration of beautiful forms in art. Beauty is the imitation of nature towards which we display a natural aesthetic reaction. The theatre and the cinema, the popular media, could not survive without the 'normally beautiful women and handsome men'. Sculpture and painting cannot be divorced from the permanent canons of beauty: 'it is true that there may be works of art that depict ugly people, but such are the exception. A picture with an ugly subject never gives as much pleasure as that of beautiful people'.[46]

In conclusion, I would like to return to Naomi Campbell. Of course, it appears that now people from all cultural backgrounds are accepted and admired. Yet what strikes me when I examine a photograph of Naomi Campbell, is that the Western canon of beauty has not been dislodged in the slightest. It is rather that today people from other backgrounds are made to fit that dominant canon. The relationship between colonial power and control are valuable insights offered by critical theorists.[47] But what we should remind ourselves is that it is equally the unstated, the implicit and the ingrained aspects of Western ideology that play as important and insidious a role as overt racism. It is not only that Western ideology constructed a knowledge system in order to control the other but that the scientific discourse of the nineteenth century enabled the West to rationalise its cultural preconceptions, which, in our postcolonial age, we have not been able to shake off.

Notes

1 There is a great deal of literature on her; see for instance, P. R. Kirby 'Hottentot Venus', in *Standard Encyclopedia of South Africa*, 1, Cape Town, 1970, 6111–12.
2 Witness the samples of works as follows: 'The B-word', *The Observer*, 9 February 1997, 23: E. Haiken, *Venus Envy*, Baltimore, 1997, discusses women suffering surgery in order to attain perfect beauty. Dr Stephen Marquardt in Los Angeles offers women at a fee the perfect face based on a 'map' created by quantifying mathematically what makes women (and men) beautiful.
 Imaginaria Digital Art Exhibition 11 June–2 July 1998 at the ICA Gallery, London, dealt with creating an ideal face, based on a competition.
3 On Nancy Burson, '10 x 8', *Special Number: Digital Dialogue*, 1991.
4 R. North, 'Calculating looks', *The Observer Magazine*, 26 September 1993, 20–2.
5 *ibid.*, 22. See also the *Independent*, 19 September 1996.
6 S. Harding, 'Naked ambition, PETA's fur-protest coup', *Sky Magazine*, November 1994, 23.

7 *The Independent*, 17 March 1994, 5.
8 N. Wolf, *The Beauty Myth*, London 1990.
9 K. Clark, *The Nude*, Harmondsworth, 1956.
10 Plato, *Phaedrus*, tr. R. Hackforth, London, 1952.
11 E. Panofsky, *Idea, A Concept in Art Theory*, tr. J. S. S. Peake, 1968, 15.
12 Augustino Nifo's *De pulchro*. See E. Cropper, 'On beautiful women, Parmi-gianino, Petrarchismo and the vernacular style', *Art Bulletin* lviii (1976) 374–94.
13 E. G. Holt, *A Documentary History of Art*, 1, New York, 1957, 212.
14 See L. Venturi, *History of Art Criticism*, New York, 1964, 94.
15 Dürer. See E. G. Holt, *A Documentary History of Art*, I, 1957, 311–29.
16 W. Leppmann, *Winckelmann*, New York, 1970, 276–8.
17 Venturi, 52–3
18 Panofsky, *Idea*, 271.
19 J. P. de Crousaz, *Traité du beau*, Amsterdam, 1724, 76.
20 Y. M. André, *Essais sur le beau*, Amsterdam, 1824 ed., 17–19.
21 E. M. Holt, *A Documentary History of Art*, III, 1966, 194.
22 Honour, IV, Part 2, 8–10.
23 See H. Honour, *The Image of the Black in Western Art*, IV, part 1, Cambridge (Mass.), 1989, section III, 145–79.
24 D. Dabydeen, *Hogarth's Blacks: Images of Blacks in Eighteenth-century English Art*, Manchester, 1987.
25 Holt, II, 272–6. On the Picturesque, see C. Hussey, *The Picturesque: Studies in a Point of View*, London, 1927.
26 P. Mitter, *Much Maligned Monsters: History of European reactions to Indian Art*, Oxford, 1977.
27 M. Park, *Travels in the Interior Districts of Africa*, London, 1816; S. Baker, *The Albert N'Yanza, The Great Basin, the Nile and Exploration of the Nile Sources*, R. F. Burton, *The Lake Regions of Central Africa, A Picture of Exploration* I, London, 1961; ed. H. Speke, *Journal of the Discovery of the Sources of the Nile*, London, 1906 edn.
28 W. Hogarth, *The Analysis of Beauty*, New Haven, 1997 edn, 113–14.
29 *ibid.*
30 C. Bolt, *Victorian Attitudes to Race, Studies in Social History*, London, 1971, 133.
31 Honour, IV, Part 2, 13–16. See also S. J. Gould, *The Mismeasure of Man*, London, 1981, Chapter 3, 73–112.
32 A Comte de Gobineau, *Essai sur l'inegalité des races humaines*, introduced by H. Sain, Paris, 1967 edn, 125.
33 Bolt, 134.
34 Gobineau, *Essai sur l'inegalité des races humaines*, 124–5.
35 *ibid.*
36 Bolt, 136.
37 See S. Gilman's seminal work, *Difference and Pathology; Stereotypes of Sexuality, Race and Madness*, Ithaca, 1985, Chapter 3.
38 Honour, *The Image of the Black in Western Art*, IV, part 2, 52–4.
39 B. Bauer, *Woman (Wie Bist du Weib)*, tr. E. S. Jerdan, London, 1927, 245.
40 L. Alford, 'Shape', *Life (The Observer Magazine)*, 18 September, 1994, 14–18.
41 Gilman, *Difference and Pathology*.
42 H. Ellis, *Psychology of Sex*, 1905.
43 Bauer, 244.
44 *ibid.*, 60.
45 *ibid.*, 244–5.
46 F. Frankowski, *A Plea for Beauty*, London, 1947.
47 E. W. Said, *Orientalism*, 1978 is the seminal work in this sphere.

3 Orientalist representations

Palestinians and Arabs in some postcolonial film and literature

Yosefa Loshitzky

Because cinema provides one of the major filters for images of the world's 'other' (the so called 'Third World') it has become part of a global structure of postcolonial constituencies. It constructs the imaginative space of the other in the Western spectator's mind. Furthermore, questions raised by 'colonial discourse' assume a greater urgency when discussed in relation to filmic representations of the other. The 'perverse pleasures' of cinema and its potential for pornographic exploitation have been studied exhaustively by feminist film theory. Issues of colour, 'the epidermic schema', to use Frantz Fanon's (1986) suggestive phrase become all the more 'visible' in a visually oriented medium based on a creative play of light and darkness, the two binary elements which constitute, according to some postcolonial critics, the Manichean allegory of colonial discourse.

In this chapter I discuss some Orientalist representations of Palestinians and Arabs in film and literature with a special focus on Amos Oz's novel *My Michael* (1967) and its filmic adaptation by Dan Volman. As one of the major works of Hebrew literature, written by the internationally celebrated Israeli author, *My Michael* provides fertile ground for general reflections about the limits and problems associated with the representation of Palestinians and Arabs in general and in the Israeli context in particular.[1] Through an analysis of the possible conflation of feminist/colonialist discourses in *My Michael*, as well as its location in the context of other colonial texts (some of which have also been adapted into colonial/postcolonial films), this chapter suggests a new reading of one of the 'canonic' texts of both Israeli literature and cinema. The advantage of this exploration is that it is being embarked upon thirty years after the completion of the writing of the novel, thus allowing for some kind of historical perspective. Furthermore, in light of the proximity of the novel to the outbreak of the June 1967 war, its political dimension (epitomised by the metaphor of the Arab twins) can be seen as almost prophetic, in particular regarding the Intifada (the Palestinian popular uprising in the territories occupied by Israel).

Furthermore, Dan Volman's filmic adaptation of the book was released in 1974 after the Yom Kippur war. Israeli reality at that time was, as it is now, a reality defined by the occupation which issued from the June 1967 war. Within the context of the history of Israeli cinema, *My Michael* was made towards the close of a period which came to be known as 'Israeli personal cinema', a cinema

characterised by the conscious desire to deal with 'private-marginal' issues and to avoid both the 'grand issues' of the heroic-nationalist films, and the 'vulgarity' of the 'bourekas' films.[2] Yet, as this chapter suggests, Volman's flight into inward-ness and privatisation in the form of 'family melodrama' has not completely 'redeemed' his film from the charges against, and ambivalence of, Orientalist discourse.

My Michael's protagonist and narrator is Hannah Gonen, a young Israeli woman married to a PhD student in geology at the Hebrew University. Through her narration, the reader learns the story of her marriage, a marriage perceived by her to be dull and flat. In order to escape her uninspiring life, she indulges in fantasies composed of early memories, imaginary adventures with the heroes of juvenile travel and adventure literature, and semi-suppressed sexual fantasies centred around memories of a pair of Arab twins, Halil and Aziz, with whom she used to play as a child in Jerusalem during the British mandate.

This narrative, then, embeds many of the conflicting images and representa-tions inherited by contemporary Israeli society: Orientalism, fantasies of the other, sexual taboos, women as other, and treats each in turn as a way of locating the specific within the larger context of Israeli society.

Orientalism, Zionism and 'otherness'

The issue of Orientalism within the *Yishuv* (the Zionist settlement prior to the establishment of the State of Israel) and contemporary Israeli society is related to the question of the perception of the Middle East and the Arabs in Zionist ideol-ogy. The Zionist and Israeli perception of the East is in constant flux, reflecting, as it must, changes in Israeli self-identity as well as traumatic political conflicts with the East. The apparent charm of indigenous Orientalism was called into question early in the history of the *Yishuv* following the 1929 Arab riots and the massacre of Jews in Hebron. In the visual arts, as well as literature, different schools of art also offered a panoply of opposing views of the East. It is quite interesting to note, for example, that for the Bezalel (the first art academy in Palestine) artists during the 1920s 'the East was the foundry in which the Jewish nation had been forged' (Zalmona 1991: 69; see also Ben-Ezer (ed.) 1992).

The Bezalel artists' approach was manifested through a romantic Biblical icon-ography depicting the East as a primeval Eden, its inhabitants in harmony with nature. The Arab, the son of the East, is avoided by the Bezalel artists. When Oriental types are shown dressed as Arabs, they represent Biblical figures and not 'local natives'. For their rivals, the modernists, 'the acculturation of the Jewish people in the East' was seen 'as one of the main goals of Zionism' (Zalmona 1991: 69) and the Arab was the prototype of the new Jew. The early modernist painters like Gutman, Shemi and Rubin painted, as Yigal Zalmona observes:

> sensual, powerful and physical Arabs. They are the paradigm of rootedness and connection with nature, the absolute opposite of the stereotypical frail, ethereal diaspora Jew. As in the Hebrew literature of pre state Israel, here too

the Arab was the incarnation of the sensual, earthy Gentile of diaspora litera-
ture. The Arab as a mythical figure attracts, intrigues and arouses envy.

(ibid.)

It is interesting to note that the meeting with the Arab at the beginning of the
century aroused, as in the case of the writer and critic Yosef Haim Brenner – who
influenced Oz's writing[3] – curiosity and admiration mingled with fear and revul-
sion – 'the embodiment of "otherness"'. Hence, the Arab in the pre-state Zionist
settlement art scene of the 1920s became 'an amalgam of ambivalence' *(ibid.)*. It
is also apparent that the East, within this cultural and ideological framework, was
seen as it had been by Romantic artists in Europe, 'as unfettered and sexually
permissive, a place of freewheeling corporeal vitality' *(ibid.: 68)*.

The fantasised other

There is a tendency in Hebrew literature, much as in colonial discourse, to associ-
ate the other (the Mizrahi – Oriental Jew – and the Arab) with sexual potency and
virility. In A. B. Yehoshua's *The Lover*, which epitomises the logic of Israeli dis-
course on the other, both the mother and the daughter sexually 'surrender' to the
other. The young Arab boy seduces his boss's daughter and the Mizrahi religious
deserter (the religious Jew is also other to the 'average' Israeli) seduces the
mother, the man's wife.

In colonial discourse, the romantic nostalgia for a 'pure' civilisation – i.e. one
anterior to Western contamination – has been inherited from nineteenth-century
Orientalism. This nostalgia is joined with the hope of discovering in the
'uncontaminated' regions of the East a 'free' sexuality devoid of the repression
typical of industrialised Western societies. The fact that Orientalism constructs a
concept of the 'Orient', and in particular a concept of 'liberated Oriental sexual-
ity', emphasises the function of the East as the desired imaginary of the West. The
hypersexualisation of the East, its promise of, to use Said's words, 'excessive
freedom of intercourse' and 'freedom of licentious sex' (Said 1978: 167, 190; see
also Behdad 1990), is a European invention whose cinematic expression in the
1970s and 1980s can be found in works of directors such as Pier Paolo Pasolini
and Rainer Werner Fassbinder. (For a very interesting discussion of this issue and
related topics see Macbean 1984.) Pasolini's celebration of imaginary Oriental
sexuality, as well as of violent sexual encounters – in his cinema and life alike – was
intimately related to his proclaimed beliefs in the purity of the Third World and
the world-historical victory of 'the agricultural subproletariat of the Third World
(and the Italian South) over Europe's weakening and thoroughly compromised
bourgeois civilization' (Macbean 1984: 15). A similar view is expressed by many
colonial narratives of which *My Michael* is an Israeli echo, loaded as it is with the
specificities and problematics of the Israeli/Jewish existence.

It is quite amazing to see how, for example, Paul Bowles' novel *The Sheltering
Sky* (1949) – an interesting example of colonial narrative – resembles Oz's novel
in its treatment of the Orient and femininity (see Loshitzky 1993b, 1995). *The*

Sheltering Sky tells the story of a couple, Port and Kit Moresby, who leave America in 1947 in order to travel in North Africa. In the course of their journey in the Sahara desert Port dies and Kit is 'kidnapped' and 'raped' by nomad Tuaregs. Kit develops an erotic obsession with the Tuareg Belqassim, an obsession which can be read as analogous to the West's confrontation with the violent and vital sexual vigour of the Third World. However, instead of of being rejuvenated by the more virile 'other', Kit, like Hannah in *My Michael* is physically and mentally destroyed. Her loss of control over her own mind signifies the victory of the dark-skinned races over white decadence.

Paul Bowles' *The Sheltering Sky*, like Oz's *My Michael*, embodies all the old colonialist projections concerning imaginary Arab sexuality. The second part of *The Sheltering Sky*, beginning with Port's death, takes the form of a rape narrative rife with white male fantasies concerning the sexual energies of dark-skinned peoples. At the beginning of the novel, as Millicent Dillon observes, 'Kit Moresby is the observer, while her husband Port is the protagonist . . . But by the end of the novel, Kit is no longer the spectator outside the action. After Port's death, she goes deeper and deeper into the Sahara and descends into darkness and madness' (Dillon 1990: 47). The penetration into the Sahara and Africa, with its 'inevitable' fall into madness, engages the tradition of colonial travel literature exemplified by Joseph Conrad's *Heart of Darkness*. Kit's 'rape' in the novel by the imaginary Tuareg Belqassim follows the normative colonial Orientalist discourse in its representation of the other's sexual prowess:

> There was an animal-like quality in the firmness with which he held her, affectionate, sensuous, wholly irrational, gentle but of a determination that only death could gainsay . . . In his behaviour there was a perfect balance between gentleness and violence that gave her particular delight . . . but she knew beforehand that it was hopeless, that even had they a language in common, he never could understand her.
>
> (Bowles 1978 [1949]: 272–3)

Some of Hannah Gonen's sadomasochist sexual fantasies in *My Michael* involving the Arab twins bear an amazing similarity to the male fantasies which Bowles displaced onto his heroine's consciousness.[4] Whereas in her fantasies of domination Hannah feels an 'exquisite thrill' (Oz 1972: 18), in her fantasies of submissiveness she feels horror. The Arab twins in *My Michael*, like Belqassim in *The Sheltering Sky*, have the sexual vigour of wild animals (see for example, the description in *ibid.*: 47).

Indeed, the notion of 'the savage body', as Rana Kabbani points out, is typical of nineteenth-century European myths of the Orient which saw the 'savage man' as 'a creature of instinct, controlled by sexual passions'. The native, according to this perception, 'was more like an animal', and Richard Burton, like other European writers, 'often spoke of African and Arab man and beast in one breath' (Kabbani 1986: 63). As the examples of Bowles and Oz show, this nineteenth-century colonial view of the body of the non-European other as a 'savage body'

was carried over more or less intact into twentieth-century literature. A more salient twentieth-century demonstration of this tendency to fetishise and hyper-sexualise the 'savage body' can be traced through Isak Dinesen's writing, in which 'African natives can be collapsed into African animals and mystified still further as some magical essence of the continent' (JanMohamed 1985: 68).

The Western association of Belqassim in *The Sheltering Sky*, and the Arab twins in *My Michael*, with transgression of conventional morality and Western inhibitions follows the colonial discourse in its depiction of the Orient as a place which 'seems to have offended sexual propriety' (Said 1978: 167) and suggests 'untiring sensuality, unlimited desire, deep generative energies' (*ibid*.: 188) and the 'escapism of sexual fantasy' (*ibid*.: 90). Hence, as Said suggests, the Orient becomes 'a place where one could look for sexual experience unobtainable in Europe' (*ibid*.: 190).

The other as sexual taboo

What was perceived by some Israeli readers and critics as *My Michael*'s subversive dimension has to do with its transgression of Israeli/Zionist/Jewish taboos regarding interracial (Jewish/Arab) sexual relationships. In 'colonial discourse' the quest for the non-Western other involves as well a quest for 'another' sexuality. Indeed, the two quests are one and the same in the sense that the allure of the other is, presumably, grounded in his/her promise of 'different body/different skin colour' inviting 'different sexuality'. In fact, the most significant formal manifestation of what Abdul R. JanMohamed calls 'the Manichean allegory' in colonialist literature is the racial romance. Racial romances can vary 'from pristine fantasy versions to more mixed and problematic ones ... In all cases, however, they pit civilized societies against the barbaric aberrations of an Other' (JanMohamed 1985: 72). In *My Michael* as in Forster's *Passage to India* the interracial erotica is confined to the boundaries of the fantasised Other, and racial/national borders are never transgressed in 'reality'.

In Paul Bowles' *The Sheltering Sky*, on the other hand, sexual and racial boundaries are transgressed in the form of interracial erotica. Nevertheless, neither Bowles' nor Bertolucci's sexual politics (in the film adaptation of the novel) transgress Western ethnocentrism. The American married couple Kit and Port Moresby are trying to resolve marital problems through a travel expedition in North Africa. Both of them have sexual encounters with natives. Port has an encounter with an Arab prostitute, and Kit lives out a voluptuous affair with Belqassim, a Tuareg tribal chief. The novel's as well as the film's narrative focalisation is the white couple; the natives (Arabs, Africans and Tuaregs) are used as an 'ethnic backdrop' aimed at magnifying and sanctifying 'white angst'.

A deconstruction of the design of the major sexual encounters in *The Sheltering Sky* reveals that Bertolucci's sexual politics in this film are heavily laced with traces of colonial discourse. Port has a one-night stand with a Moroccan prostitute. Thus, her character is colonised twice – first as a subject of a colonised country under the French Protectorate, and second as a prostitute whose body has been

'colonised' by her pimp and clients. In contrast to Port's 'other woman', Kit becomes the lover of a free subject. Tuareg nomadic culture resisted the Arabisation of the Islamic crusades and the attempts of the French colonisation of the Maghreb. Furthermore, Belqassim is the chief of a Tuareg tribe; his status as a young Sahara desert prince counterbalances, to some extent, the 'inferiority' implied by his racial difference. In Oz's *My Michael*, Hannah also talks about Halil and Aziz as her 'twin princes'. This view of the other as a 'noble savage' is not far from the romantic utopian view of the Arab fighter typical of the first Zionist settlers who even adopted his 'Orientalist paraphernalia' (the *kafiya, abaya* and *shaberia*) as the attire of the fighters of *Hashomer* (the first Jewish military organisation in Palestine). It should be pointed out, however, that within the economy of desire in the filmic *My Michael* this Orientalist romanticism (which in the 1970s no longer had a grip on the Israeli collective imagination) was replaced by the fetishisation of 'low class' (both Arabs and Oriental Jews) as 'objects of desire'.

In *The Sheltering Sky*, Port's desire to escape the fate of the American 'lost generation' through fusion with mother nature ('Mama-Africa') epitomised by the 'dark African continent' (the origin of humanity according to current scientific thinking) climaxes with his actual death. This view of Africa (and the 'territorial zone' of the non-European other in general) as an alluring, destructive woman is a recurrent motif in colonialist literature. It can be found in such novels as Graham Greene's *Heart of the Matter* as well as in Joseph Conrad's much discussed *Heart of Darkness* with its portrayal of Kurtz's fixation on the dark, satanic woman.

Bertolucci utilises the pornographic potential of the cinema so as to comment on the exploitative nature of all colonial relations. When Port, the husband, returns home from the Arab prostitute to his waiting white wife he is not portrayed as an adulterer. Instead he is granted the status of 'primal explorer' – just back from a fresh/flesh trek through exotic sexual 'otherness'. Bertolucci's poetics of sexual indeterminacy in *The Sheltering Sky* subliminally suggest an ethno-porno iconography. Kit's 'mimicry' (her disguise as a Tuareg boy) allows her to enter Tuareg society. In the private chamber where she is kept confined, both sexual partners unwrap the traditional male indigo turban. Kit, by now, has been transvested, her skin blackened. All this 'camouflage' occurs so that Belqassim can enjoy her being sexually other (female) and racially different (white). The ritualistic, worshipping manner in which the African sexual partner tenderly undresses and reverently wipes the desert dust off Kit's body conjures forth an image of the American partner as a sex goddess rather than a sexual slave. This fantasy of master and slave is not far from Oz's Hannah who fantasises about herself as a cold queen lording it over dark submissive slaves. In *The Sheltering Sky*, Kit's cage/castle provides the couple, temporarily, with an intimate isolation free of the colonial outside world with its racial segregation. However, as in Bertolucci's *Last Tango in Paris*, the moment the door of this artificially constructed 'private space' opens to the 'public space' marked by racial separation, the couple's private Eden collapses, recalling Albert Memmi's comment about the illusions of exogamy. There is no 'space' free of socio-cultural contingencies (Memmi 1968). It should also be

stressed that the fact that Belqassim is stunningly beautiful and delicate fetishistically assuages the transgression which overlies the text. Indeed, fetishism structures the whole scene which gives back to Kit her white skin and racial 'supremacy'.

The potentially anxiety-inducing idea regarding contact between black manhood and white womanhood is soothed in the film by giving the Western partner an ego-reinforcing focus. Only the white male enjoys orgasm (as in the encounter between Port and the Moroccan woman) and the spectator is kept ignorant about the black male's subjectivity. Is he ravished by the delights of sexual difference, or by the discovery of Kit's white skin? Furthermore, Bertolucci's mise-en-scène reproduces cultural codes of mastery and submission taken from popular erotica, thereby establishing white racial 'supremacy'. This is most notable in the scene in the private chamber in which Kit is standing on the bed while Belqassim, sitting and kneeling, performs oral intercourse with her.

Bertolucci, just like Bowles four decades earlier, is a kind of 'colonial traveller' in Said's sense of 'displaced percipient' (Said 1986: 224). Said describes colonial texts as 'encapsulations' of the encounters between Europe and 'primitivity' where a 'vacillation' between the foreign and the familiar occurs. In *The Sheltering Sky* Port experiences precisely this kind of vacillation. He enjoys the delights of cultural differences as a freshly arrived American in Tangier while simultaneously disavowing these differences by affixing universalist rules governing prostitution to his first North African experience (the encounter with the Moroccan woman). Bhabha's analysis of colonial discourse may suggest a better insight into Bertolucci's fetishisation of the other along lines of race and sex. Bhabha reminds us that skin, 'unlike the sexual fetish, is not a secret; it is the most visible of fetishes which plays a public part in the racial drama which is enacted everyday in colonial societies' (Bhabha 1986. 146–67). In *The Sheltering Sky* the 'blackening' of Kit's skin (her newly acquired suntan) metamorphoses the white skin of the Western female from a 'visible fetish playing a public part in racial drama' into a 'secret' fetish playing a private part in sexual drama. Not only does the scopic economy of the mise-en-scène of the sexual drama enacted in the hidden room between Kit and Belqassim establish the idolisation of white skin but, also, the fetishistic textual regime of this scene leads to the sexualisation of what Frantz Fanon refers to as the 'epidermal schema'.

In the same thrust, Bhabha underlines the parallelism between sexual fetish and the fetish of colonial discourse (or of racial stereotypes). The first facilitates sexual relations. ('It is the prop which makes the whole object desirable and lovable', *ibid.*: 166.) The second facilitates colonial or interracial relations. In *The Sheltering Sky* the scene between Port and the young North African woman demonstrates how the sexual fetish (signified by the Arab woman's dazzling erotic paraphernalia) facilitates colonial relations by simulating a pornographically familiar harem-like eroticism. Similarly, the erotic scenes between Kit and Belqassim illustrate how the skin, the 'key signifier of cultural and racial difference' (*ibid.*:165) facilitates and intensifies sexual relations. Bertolucci's exploitation of racial difference through the revitalisation of tired libido (Port) or the investment

of libidinal excess (Kit) seems to follow a prevalent tendency of our age of post-modem postcolonialism regarding the representation of sexual/racial relations.[5] It can be argued that this trend is triggered by the epidermal fetish which due to its 'visibility' offers a tremendous voyeuristic potential to the scopophilic cine-matic apparatus by injecting into the sexual fetish a new vitality.

Bhabha argues that colonial discourse is characterised by the holding of mul-tiple contradictory beliefs. Bertolucci, in *The Sheltering Sky*, cultivates countless endemic contradictory beliefs about Africa and Africans/Arabs. Africa is both convivial and hostile, hospitable and rejecting, unpolluted and fly infested. Afri-cans are both ravishingly winsome and grotesquely repulsive. They have healthy, sculpted bodies or degenerate, demonised ones. They are capable of gratuitous, altruistic behaviour or can reveal themselves as money hungry and easily corrupt-ible. In short, Arab/African culture, within the economy of Bertolucci's quest for the other, is both utopia and dystopia. A similar double vision has been dis-covered, as Emily C. Bartels observes in her discussion of the Imperialist con-struction of Africa by Richard Hakluyt, by Christopher Miller, a leading scholar of 'Africanist discourse', in French texts of the nineteenth century. This ambiguity, Miller claims, 'exposes Europe's longstanding ambivalence about Africa' (Bartels 1992: 519). Hakluyt himself in his representations of Africa produced an Africa 'which is at once familiar and unfamiliar, civil and savage, full of promise and full of threat' (*ibid.*).

Bhabha's and other critics' view of ambivalence and ambiguity as the salient features of colonial discourse is challenged by others. Thus, for example, accord-ing to JanMohamed colonialist fiction is generated predominantly by the ideo-logical machinery of the Manichean allegory and not by 'ambivalence'. In fact JanMohamed claims that the Manichean allegory is so strong that 'even a writer who is reluctant to acknowledge it and who may indeed be highly critical of imperialist exploitation is drawn into its vortex' (JanMohamed 1985: 63). Vijay Mishra and Bob Hodge in their attempt to define 'what is post(-)colonialism?' claim: 'Those writers who use forms of "appropriation" recognise that colonial discourse itself is a complex, contradictory mode of representation which impli-cates both the coloniser and the colonised' (Mishra and Hodge 1991: 404).

It is interesting to note that in the recent history of Israeli cinema the more violent the Israeli/Palestinian conflict became the more frequently the taboo on interracial relationships was transgressed. The interracial relationship which, in *My Michael*, both in its literary and filmic manifestations, was confined to the realm of fantasy, materialised as a 'real' taboo-shattering event in Daniel Waxman's *Hamsin* (1982). The film depicts an erotic relationship between Halled, a Palestinian man, and Hava, a Jewish Woman. A new wave of Israeli films on interracial 'forbidden love' flourished in the 1980s, among them Nissim Dayan's *A Very Narrow Bridge* (1985), Michal Bat Adam's *The Lover* (1986) (based on A. B. Yehoshua's novel), Amnon Rubinstein's *Nadia* (1986) and Eli Cohen's *Two Fingers from Sidon* (*Richchets*) (1986). Of these, *A Very Narrow Bridge* was the only film which inverted the traditional interracial romance between an Arab man and an Israeli woman. The film revolves around a love story between a reserve military prosecu-

tor in Ramallah (in the West Bank) and a Christian Palestinian woman school librarian. The film was also the first feature to be shot in the occupied territories. (For an interesting analysis of the film and its problematic reception by both Israelis and Palestinians see Shohat 1987: 242–6.)

Women as other

Interlinked with the Oriental other is the view of women as other. Evidence for the conceptual kinship of the fields of feminist and colonial studies can be found in the degree to which they draw upon a common nomenklatura. Both critical approaches to culture make use of terms such as: fetishisation, difference, ambivalence, Manicheism, mimicry, masquerade, and the other. Moreover, recent developments in feminist critique stress how the dominant colonial discourse reproduces a system of textual practices used to conceptualise 'femininity' through the notions of 'conquer', 'penetration', 'terra incognita', 'exploration', 'dark continent', 'exoticism', 'travel', 'tourism', 'expedition', and other related terms used to describe the colonial/imperialist enterprise. After all, 'picturing the colony as female', Judith Williamson observes, 'makes it so much more conquerable and receptive' (Williamson 1986: 113). Furthermore, at a meta-theoretical level, as Robert Young suggests in his critique of Edward Said's conceptualisation of 'Orientalism', the difficulties invoked by the logic of Said's own arguments regarding the automatic reproduction of essentialism by any account of discursive 'Orientalism' 'could be compared to those encountered in feminism: if "woman" is the constructed category of a patriarchal society, how do you posit an alternative without simply repeating the category in question or asserting a transhistorical essence that the representation travesties?' (Young 1990: 128).

Women in *My Michael* are seen as being more susceptible to madness and hysteria. This vision expresses the notion of feminisation of the Orient suggested by colonial narratives. Although, for example, Kit in *The Sheltering Sky* is portrayed as a sophisticated twentieth-century woman, her being 'swept away' into irrational sexual adventure with Belqassim recalls the sexual fantasies of the heroine in *A Passage to India* whose encounter with the 'sensuality' of India engages her (actually her male narrator-creator) in fantasies of being raped. Nor is it an accident that the name of one of the Arab twins in *My Michael* is Aziz, like the name of the Indian hero of *A Passage to India* who is arrested on a charge of attempted assault.

In the novel, Oz chose to render his vision through the eyes of a first-person narrator, a young woman. Her stream of consciousness controls the narrative and conveys her obsession with sex, violence and death. The choice of a woman as a protagonist and narrator by a male author raises an interesting question which has already been raised in regard to other male authors and Flaubert in particular. Flaubert's famous claim, 'Madame Bovary, c'est moi', has been discussed at great length by critics who, as Andreas Huyssen suggests, have tried 'to show what Flaubert had in common with Emma Bovary – mostly in order to show how he transcended aesthetically the dilemma on which she foundered in "real life" '. In

such arguments, Huyssen stresses, 'the question of gender usually remains sub-
merged, thereby asserting itself all the more powerfully' (Huyssen 1986: 189). As
Huyssen observes, the question of Flaubert's 'imaginary femininity' was also
raised by Jean-Paul Sartre. Sartre says:

> Our problem then . . . is to ask ourselves why the author . . . was able to
> metamorphose himself into a woman, what signification the metamorphosis
> *possesses* in itself . . . just what this woman is (of whom Baudelaire said that she
> possesses at once the folly and the will of a man), what the artistic transform-
> ation of male into female means in the nineteenth century . . . and finally, just
> who Gustave Flaubert must *have been* in order to have within the field of his
> possibles the possibility of portraying himself as a woman.
>
> (Sartre 1965: 302)

Huyssen's claim, however, is that 'the imaginary femininity of male authors,
which often grounds their appositional stance vis-à-vis bourgeois society, can
easily go hand in hand . . . with the misogyny of bourgeois patriarchy itself'
(Huyssen 1986: 189). In the novel Oz describes Michael Gonen, the career
oriented, practical-minded husband as a representative of a new type of Jerusale-
mite bourgoisie whose numbers are increasing and whose origins are in the
Shephela (the Tel-Aviv area).

 The problematics associated with Flaubert's 'imaginary femininity', as well as
Huyssen's claim, correspond faithfully to the problematics provoked by Oz's
imaginary femininity. In Oz's novel Hannah Gonen is, deliberately, portrayed as
an Israeli Madame Bovary caught between the delusions of an internal fantasy
world and the realities of a prototypical Jerusalemite provincial life during the
1950s. Like Madame Bovary, who escapes to the delusions of the sentimental
romantic narrative in order to 'transcend' her bourgeois, provincial life, so
Hannah Gonen escapes to the sensual world of fantasy and daydreaming in an
attempt to break from her petit-bourgeois claustrophobic existence.

 In the novel, Hannah's 'imaginary femininity' is portrayed as indeterminate
in its sexual identity. Indeed, Hannah is represented as a woman who in her
childhood and youth wanted to be a man:

> When I was a child I adored the books my brother had by Jules Verne and
> Fenimore Cooper. I thought that if I wrestled and climbed trees and read
> boys' books I'd grow up to be a boy. I hated being a girl. I regarded grown-
> up women with loathing and disgust'.
>
> (Oz 1972: 26)

In the novel Hannah is represented as a self-hating woman who rejects her femi-
ninity and especially her maternal role. She is portrayed as a 'bad mother' who is
completely indifferent to her son. Her hobbies and fantasies as a child and
adolescent were clearly masculine. She liked travel and adventure literature and
despised (unlike Madame Bovary but like Flaubert himself) women's literature.

Oz's 'poetics of sexual indeterminacy', rendered through the oscillation of his heroine between male and female sexual identity/desire, conveys the male writer's ambivalence towards the 'imaginary femininity' he himself created.[6]

Themes of bisexuality and sexual disguise are common in colonial discourse. Von Sternberg's *Morocco*, for example, tells the love story of a vaudeville singer and a foreign legionnaire. The ship's captain who brings the vaudeville actresses to Marakesh calls them 'suicide passengers', explaining that they buy a one-way ticket because they never return home. As in *The Sheltering Sky* and other colonial narratives (for example Conrad's *Heart of Darkness* and Forster's *A Passage to India*) the text suggests that the alluring fascination of the other and the desire it invokes culminate in madness. In *Morocco* Amy Jolly (Marlene Dietrich) follows her lover Tom Brown (Gary Cooper), the legionnaire, into the heart of the Sahara desert. The last shot shows her kicking off her high-heeled gold sandals as she vanishes in the sand dunes. Amy Jolly, like Kit in *The Sheltering Sky*, immerses herself (literally) in the sands of the desert. Hence, the power of the desert/ Orient, the film suggests, causes women to transgress social conventions, to surrender to archaic forces (the Id). The image of the Sahara desert becomes an image of madness, uncontrollable passion and the irrationality that leads to the destruction of the white race.

The trope of geographical 'otherness' in colonial discourse is a significant one. In many colonial and postcolonial fictions the landscape is formally invested with markers of 'cultural' strangeness in order to allow the 'coloniser' to apply a different cultural code when 'decoding' the 'other', as well as to provide him with a 'justification' for his/her own 'strange' behaviour on being confronted with geographical/cultural 'otherness'. In *A Passage to India*, to give one prominent example, the landscape of India, and in particular the Marabar caves, much like the desert in *The Sheltering Sky* and *Morocco*, 'represent the fundamental, unconscious identity from which all natural and social differences emanate and to which they all return when they can escape their phenomenal manifestation' (JanMohamed 1985: 75). The unconscious realm of the caves mirrors the repressed sexuality of Adela Quested, much as the desert in *The Sheltering Sky* and *Morocco* invoke the 'return of the repressed'.

Paul Bowles' choice of the Orient as an 'elective centre' followed, to invoke Said, a long and established tradition of nineteenth-century French pilgrims who

> did not seek a scientific so much as an exotic yet especially attractive reality. This is obviously true of the literary pilgrims, beginning with Chateaubriand, who found in the Orient a locale sympathetic to their private myths, obsessions and requirements. Here we notice how all the pilgrims, but especially the French ones, exploit the Orient in their work so as in some urgent way to justify their existential vocation.

(Said 1978: 170)

Bowles, the existential traveller-tourist according to Robert Briatte, the author of the only authorised biography on Paul Bowles, had on a May night in 1947 a

dream of Tangier, the 'white city'. 'In the labyrinth of the unconscious the images of his dreams delineated a landscape of quite startling precision: narrow little alleys designed to make one lose one's way, terraces looking out over the ocean, staircases ascending nowhere' (Briatte 1990: 35). As a result of this 'vocational' dream, Briatte observes, Bowles decided to spend the summer in Morocco and to write. He left his wife Jane in the United States and that August in Fez he began writing *The Sheltering Sky*. Bowles' delirious moment of 'unconscious epiphany', and his hallucinatory vision of Tangier as a chaotic, mysterious and labyrinthine city, invoke the archaeological and geographical metaphors prevalent in colonial discourse on the Orient. Bertolucci also used a similar vocabulary to describe Port and Kit's journey into the Sahara

> . . . they go back into the past of North Africa. To reach the truth they have to go deeper into the Sahara, they have to pass through the ruins of the Kasbah and the abandoned ksour that takes them into the labyrinth of tunnels . . . somewhere very obscure and somewhere very big. There isn't anything in the world that gives you a sense of timelessness like the desert. Port and Kit's trip to the desert is parallel to their trip into the past.
>
> (Palace Pictures, publicity release, 1990: 32)

The Oriental desert in both Bowles and Bertolucci's discourse becomes the Id of Western civilisation. Here colonial, anthropological, archaeological and psycho-analytic discourses are clearly interwoven. The trip to the desert is the quest for the past, that of the individuals Kit and Port as well as that of Western civilisation in search of its Eastern roots.

In *My Michael* the city of Jerusalem itself (a historical meeting point of East and West) functions as an emblem for the realm of the unconscious. Yet the expulsion of Hannah's objects of fantasy, Halil and Aziz, from the city as a result of the 1948 war has pushed the repressed beyond the border, the symbolic wall between us and them, good and bad. Hence, the repression and demonisation of the other/enemy is emblematised by the border. And indeed *My Michael* ends with Hannah's fantasy of the 'return of the repressed', Halil and Aziz, as a pair of armed Palestinian 'terrorists', crossing the border and 'penetrating' into an Israeli-Jewish landscape.

Woman's desire in the novel is also linked to madness, a recurrent motif in melodrama. Madness in *My Michael* is, in fact, represented as an exclusively femi-nine domain. Hannah's madness is mirrored by Mrs Glick, the 'crazy neighbour' (another melodramatic motif) whose hysterical attacks, like those of Hannah her-self, incite her to 'terrorise' in return her good and patient husband. The novel, thus following a long cultural tradition of misogyny, links the notion of femi-ninity to madness, fantasy and escapism.[7] Oz seems to be implying that in Israel, where everybody is constantly required to express strong political opinions, only a 'deviant' and 'crazy' woman can afford the luxury of being uninvolved, of indulging narcissistically in an unabashedly private world. Much as Flaubert, according to Huyssen, could express his passion for the inferior romances only

through the 'inferior' character of a woman, so Oz could provide an alternative/ utopian vision of non-engagement in Israeli political reality only through a 'mad woman'.

In *My Michael* Flaubert's claim, 'Madame Bovary, c'est moi', is echoed through the novel's presumably autobiographical component. Dan Voiman, the director of the filmic adaptation, however, said quite blatantly – although he was completely unconscious of the resonance carried by his remark vis-à-vis Flaubert – 'I made the film because I felt very close to Hannah Gonen.'[8] In Oz's novel even the indulgence in a private world has a metapolitical function. It is presented as subversive in relation to Israeli reality and the general population's preoccupation, verging on obsession, with the 'big issues' traditionally associated with the public sphere.

In Volman's film, however, the metapolitical realm receives less emphasis. As one of the prominent directors of Israeli personal cinema Volman prefers subtlety to contrived symbolism *à la* Oz. His restrained and realistic, almost impressionist, style renders 'politics' through the representation of 'personal stories', and never through thick symbolism. Volman's narrative solution to the problem of the novel's 'central consciousness' was to adopt Hannah's subjective point of view as the controlling perspective of the film. As in the woman's picture, woman's subjective point of view organises the economy of the film's gaze. Unlike most mainstream films, and Israeli cinema in general, Volman's heroine activates, instead of absorbing, the gaze. The filmic Hannah (Efrat Lavi) is an active gazer; in some scenes she is even a voyeur.

Hannah's gaze in the film is utilised, deliberately, for erotic ends. Here, woman's desire is expressed unequivocally and emphatically. Given Volman's well known sympathetic treatment of homosexual themes, the desire of the filmic Hannah, like the desire of the literary Hannah, is not without ambivalence. In the film *My Michael* there is an interesting role-reversal in regard to the gaze-choreography common to mainstream cinema. In most of the erotic scenes Hannah, and not the men, is the one who activates the gaze. Hannah's 'objects of desire' are both Jewish and Arab Orientals and they are always associated with the sensuality of 'low life'. They are the opposites of her Ashkenazi, non-sensual, husband/scholar. The only exception is Yoram, her incestuous love object, whose innocent, Ashkenazi, sensitive adolescence (he is a dreamy type and likes travel literature) is a narcissistic projection of herself as a young girl wishing to be a boy. Hannah is also depicted as a voyeur in two scenes in which her husband is being seduced by Yardena, a woman with whom he carries on a light flirtation. The positioning of Hannah as the voyeur has a psychological dimension as well. Hannah observes life but cannot participate in it. Her real life is the life of imagination. She is fully alive only in her fantasies and daydreams.

The repression of the metapolitical: the film versus the novel

Within the context of Israeli literature the novel *My Michael* continues the revolution begun in the early 1960s, a revolution which established a tradition of

'meta-Zionist narrative'[9] characterised by a sense of disillusionment with the state of Israel and an attempt to challenge Zionist ideology. One of the major consequences of the institutionalisation of the tradition of the 'meta-Zionist narrative' in Hebrew literature has been a demythification of the figure of the Hebrew hero. Since the 1960s, the heroes of Hebrew literature have ceased to be mythical Sabras. Furthermore, the Sabra's 'others', the Sepharadi and the Arab, have begun to occupy focal positions on the stage of Hebrew literature. The 'meta-Zionist narrative' is responsible not only for an ideological shift in Hebrew literature, through its bringing of the 'margins' to the 'centre', but, also, for a stylistic change. Social realism, 'the most common mode of Hebrew fiction throughout the fifties and early sixties', and typical of the Generation of '48 (also known as the HaPalmach Generation), has been replaced by 'symbolic, parabolic or expressionist modes of fiction' (Alter 1977: 214).[10]

My Michael fits into the literature of the 'meta-Zionist narrative'. Not only is the novel's protagonist, Hannah Gonen, a feminine version of the *Talush* (the 'old' uprooted Jewish antihero 'who is out of place even in his own homeland') (Alter 1977: 214) but she is also, as many critics have noted, an Israeli Madame Bovary, detached and alienated from Israeli society, and completely absorbed in her inner fantasy world. In terms of style, although the novel is 'realistic' due to its precise descriptions of the Jerusalemite milieu, it is heavily laden with contrived symbolism. The plot takes place on two planes simultaneously: in the actual space (Jerusalem) and in the inner space of the protagonist's mind. In terms of genre the novel is both a psychological novel and a symbolic novel. One may even trace in it the influence of the modern Joyce-like novel with its 'stream of consciousness' techniques emulated and absorbed into Hannah Gonen's interior monologues.

It should be pointed out, however, that Oz's novel opens a space for multiple readings. Each of its parts can be read, simultaneously, as both realistic and symbolic due to Oz's tendency to use 'topographical, architectural, even institutional actualities' to allude 'to things beyond themselves' (Alter 1977: 216). Hence any one of the situations depicted in the novel can be read as realistic, 'clinical' observation of the heroine's gradual mental deterioration, as well as a metaphorisation of Israel's political and existential situation. The oscillation between the realistic and the symbolic indicates that from a political and ideological frame of reference the most important question raised by the novel is whether Hannah Gonen is mad or not. The ambivalence regarding this question has, of course, a crucial political significance within the novel's ideological economy. If, indeed, Hannah Gonen is mad, then her social unadaptability originates in her personality and not in Israeli society. But, if Hannah is not mad, then Israeli society is mad – or at least responsible for inducing Hannah's madness. On the metapolitical level of the novel the issue of Hannah Gonen's madness is linked to a latent, subversive accusation aimed by the narrator at the psychological suffocation (the 'state of siege') imposed on Israeli individuals due to the charged political situation of Israel.

The major difference between the literary source and its filmic adaptation is the

film's repression of the political. The metapolitical dimension of the novel is transformed into family melodrama, an Israeli variation on the woman's picture. Followng the tradition of Israeli personal film-making the protagonist's subjective world, rather than political events and social existence, is located at the centre of the narrative.

The novel is centred around two focal metaphors which organise it both narratively and thematically. The first metaphor is geological, and the second biological realised through the pair of Arab twins Aziz and Halil (Hanna Gonen fuses the twins into one entity she calls Halziz). These metaphors link, inextricably, the personal, the psychoanalytical and the political spheres of being. The geological metaphor is related to the figure of Michael Gonen, Hannah's husband, who is a geologist. On their ride to visit Hannah's brother in the Kibbutz, Michael tells her about the forces operating inside the earth:

> Michael said 'lithosphere'. He said 'sandstone', 'chalk bed'. He said 'precambrian', 'cambrian', 'metamorphic rocks', 'igneous rocks', 'tectonics'. For the first time then I felt that inner tension which I still feel whenever I hear my husband talking his strange language. These words relate to facts which have meaning for me, for me alone, like a message transmitted in code. Beneath the surface of the earth opposed endogenic and exogenic forces are perpetually at work. The thin sedimentary rocks are in a continuous process of disintegration under the force of pressure. The lithosphere is a crust of hard rocks. Beneath the crust of hard rocks rages the blazing nucleus, the siderosphere.
>
> (Oz 1972: 17)

On the private/personal level the hidden violent forces of the subterranean earth metaphorise Hannah Gonen's secret desire to break out from her humdrum everyday existence. As in the melodrama genre, family life in a provincial town[11] is represented as a sort of prison for the heroine. On the psychoanalytic level the metaphor recalls Freud's topographical model of the psychic apparatus. The hidden subterranean forces threatening to break the lithosphere are the metaphoric visualisation of the Freudian Id, the place where the primal instincts are waiting for 'the return of the repressed'. On the metapolitical level the 'demonic' underlying forces function as a metaphorical conversion of Palestinian nationalism.

The same contrived symbolic logic operates in regard to the metaphor of the pair of Arab twins. The name of one of the twins, Halil, is the Arabic name of Hebron. It is also the name, both in Hebrew and Arabic, of the flute, a musical instrument associated in particular with nomadic or agricultural Arab culture. The name of the second twin is Aziz meaning 'dear' or 'darling' in Arabic. On the private/personal level the twins express a sexual fantasy that cannot be fulfilled by Michael, the reliable yet unimaginative husband. Here too the melodramatic dimension of the novel is evident through the representation of familial life as sexually and emotionally unsatisfying. On the psychoanalytic level, the twins, like

the hidden subterranean forces, represent the Id, the 'dark' and instinctual infrastructure of female psychic life. On the political level, the twins, as many critics observed, are the manifestation of the other perceived as both threatening and alluring. As Gila Ramras-Rauch observes 'the outer threat of Arab hostilities is reworked into the erotic language of inner yearnings' and thus 'the outer becomes the metaphor of the inner, and vice versa' (Ramras-Rauch 1989: 164).

The novel, like Oz's other works, is characterised by extensive use of binary oppositions – a strategy typical of the 'meta-Zionist narrative'. The major binary opposition is constituted through the characters of Hannah and Michael Gonen. Whereas Michael, the male scientist, represents rationality and pragmatism, Hannah, the former Hebrew literature female student, represents irrationality and impracticality. Hence, Oz maintains the traditional patriarchal binarism of male/culture/reality–female/nature/fantasy. It is not an accident that Michael was born in Holon, a new and ahistorical suburb of Tel Aviv, whereas Hannah is a native of Jerusalem, the historical city associated with mysticism, suffering and religious and nationalistic 'madness'. When Hannah and Michael first meet, Michael immediately recognises Hannah as a Jerusalemite. Thus, Jerusalem's mystic and 'poetic' 'aura' is intended to invoke a polar opposition to the secular and 'prosaic' 'aura' of Holon. The cultural and ideological binarism invoked by Jerusalem and Holon, the two antithetical metaphors, is carried over into the personae of the protagonists themselves.

The film, unlike the novel, ignores binarism and emphasises instead the text's melodramatic aspect. The melodrama quality is rendered, mainly, through the mise-en-scène. Hannah, like the heroines of the woman's picture (and in Douglas Sirk's and Werner Rainer Fassbinder's melodramas in particular),[12] is frequently shot looking through the window trapped in her own home/prison. The horizontal and vertical lines of her 'framed' setting give the spectator a claustrophobic sense of her restricted existence. Volman's use of frames within a frame (doors, windows) becomes a visual expression of repression and confinement. The typically small Israeli apartment becomes a visual metaphor for the larger Israel 'state of siege'. Hannah is also often photographed walking in Jerusalem's narrow lanes, an image which renders the psychological suffocation felt in the city as a metonym for the Israeli 'Ghetto'.

Conclusion: representation and political discourse 'of blood'

It is interesting, but also disturbing, that Oz chose to metaphorise and embody Israeli fears through imaginary Arabs and imaginary woman. In the work of Oz, as Gila Ramras-Rauch observes, 'the Arab's sociopolitical existence is internalised in the Israeli, and the Arab becomes the focus of libidinal dreams and fantasies' (Ramras-Rauch 1989: 148).[13]

Ultimately Oz's 'binarist' and patriarchal writing distils to a projection of fears, neuroses and fantasies, to the 'other' side of Israeli society: the Arab and woman. It is not surprising, therefore, that these 'others' were selected to convey Oz's

vision of the existential situation of Israel. Volman's film, on the other hand, subverts the comforting solution of the binary opposition by preferring 'realism' to 'symbolism' and expressing latent homosexuality through the film's economy of the gaze.[14] Although Oz's novel is permeated with images of bisexuality, gay sexuality has never been the central concern of any of his works. Oz, in particular in *My Michael*, seems to be interested rather in sexual ambivalence than in 'pure' and determinate sexual identity. In fact *My Michael* is the only one of Oz's works that concerns itself with questions of sexual identity. This is due, perhaps, to the fact that a woman was chosen to generate the narrative's 'central consciousness', thus creating tension between the voice of the narrator and the voice of the author. The autobiographical aspect involved in this tension and the problems of identification it may have raised explain Oz's poetic 'politics of sexual indetermin-acy'. By contrast, Volman's engagement with homosexual subjects, an almost taboo topic in Israeli literature and cinema,[15] is well known. In *Hide and Seek* (1980), for example, set in Jerusalem in 1946, he portrays a homosexual relation-ship between a young Jew and an Arab, a sensitive issue in Israel, let alone in 1946.

Yet it should be emphasised that Volman's 'political correctness' (his preference of melodrama – a genre promoting an open-ended reading which makes room for the expression of female subjectivity, according to contemporary feminist film criticism – over Oz's metapolitical symbolism) does not make his film more inter-esting than the novel. Perhaps the opposite is true. The interest of the novel, what some of the reviewers perceived as its subversive and dangerous message, lies, on the contrary, in its ability to disturb and stir. Despite what I read as the misogynist representation of women in the novel (their proneness to madness, their irration-ality, their 'deviant sexual life, and so on), one cannot but conclude that, in the last instance, the women in Oz's novel are more 'interesting' than the men. Hannah is not only the negation of her 'uninteresting' husband but also of 'dull normalcy'. The paradox, of course, is that in his political positions and public pronouncements, Oz, like A. B. Yehoshua, is the advocate of non-fanaticism, of what came to be known in Israeli public discourse affiliated with the Left as 'sane Zionism'. Yet in his writing (both in his fiction as well as in his polemical essays) Oz, as Gertz (1980) points out, indirectly celebrates madness (both personal and political) mainly through his use of poetically charged and excessive language which makes madness look more 'interesting' than sanity. One may gauge the evolving sense of Israeli personal and political identity in this tension between madness and normalcy. After all, as Edward Said observes: 'If in a Jewish state, normality is defined by Jewishness, abnormality is the normal condition of the non Jew. The logic extends itself to history and society more generally con-sidered' (Said 1985: 43).

Recently Israeli artistic discourse on Palestinians and Arabs (including Oz's later works) shows more openness towards the more contradictory and disturbing aspects of the conflict.[16] The emergence of the Israeli 'new historians' and their revisionist reading of the history of the Israeli-Palestinian conflict,[17] the corrosive effect of the Intifada on the Israeli public, and the start of the peace process with

the Palestinians and other Arab neighbours, have synthesised the concerns of Israel's artistic, intellectual and academic communities to re-examine the space occupied by the conflict in the grand narrative of Zionism. In an age which has been called 'post-Zionist' by some Israeli scholars and intellectuals, it is only natural that the Israeli Arab/Palestinian conflict had to be publicly discussed and debated. Most of these discussions are taking place in the cultural and aesthetic spheres – so in Israel art preceded purely political debate. The political debate itself is, however, still contaminated by the language of the blood.

Notes

1 To a large extent Amos Oz projects to the international community what it regards as Israeli political conscience and moral voice. He is usually given a special stage by prestigious American and British newspapers to express his opinions regarding political events such as the assassination of Israeli Prime Minister Yitzhak Rabin, and Israel's 'Operation Grapes of Wrath' in Lebanon. See Oz 1996: 15, 1996: 18. For an interesting discussion of Oz's attitude towards the Palestinian other within the context of Hebrew literature and its conflation with Israeli politics, see Bresheeth 1989.

2 For a discussion of the genres of the heroic-nationalist films, the bourekas and personal cinema in Israeli cinema, see Shohat 1987.

3 Tragically and ironically Yosef Haim Brenner was murdered by Arabs in 1921. According to Amiel Alcalay, Yosef Haim Brenner is an early instance of the tendency in Hebrew literature to represent Arabs and non-European Jews as 'others'. This tendency, Alcalay observes, 'can be seen, as well, in the work of a contemporary writer such as Amos Oz' (Alcalay 1993: 229).

4 Oz's short story 'Nomad and Viper' in his collection of stories entitled *Where the Jackals Howl* (1963) is an even more explicit example of Orientalist rape narrative. It is the story of a young Kibbutz woman, Geula, who has a sexually ambiguous encounter with a Bedouin, is bitten by a snake and dies.

5 From the mid-1980s up to the present day one can detect the emergence of films (among others *Heat and Dust*, *The Gods Must be Crazy*, *A Passage to India*, *Out of Africa*) that portray imperialism with nostalgia (see Rosaldo 1989). Edward Said points out:

> in 1984, well before *The Satanic Verses* appeared, Salman Rushdie diagnosed the spate of films and articles about the British Raj, including the television series *The Jewel in the Crown* and David Lean's film of *A Passage to India*. Rushdie noted that the nostalgia pressed into service by these affectionate recollections of British rule in India coincided with the Falklands War, and that 'the rise of Raj revisionism, exemplified by the huge success of these factions, is the artistic counterpart to the rise of conservative ideologies in modern Britain'.
>
> (Said 1993: 21)

The 1990s, however, witness a new wave of French films (*L'Amant*, *Indochine* and *La Guerre Sans Nom*) on the French colonial experience in Indochina and Algiers. In the same vein as *The Sheltering Sky* these films look on the French colonial era with nostalgia. The plots involve doomed love affairs used to allegorise, nostalgically, the colonial experience.

6 On the autobiographical level one cannot resist the temptation to analyse Oz's

projection of his own mother who committed suicide in 1952, 'deserting' him when he was only 12 years old. Oz keeps silent about this traumatic event, but one may argue that Hannah Gonen is an amalgam of his mother and himself. In this respect, her imaginary femininity, loaded as it is with self-hate, is 'justified'. She is both man and woman, mother and deserted son, and as such she brings full circle the built-in ambivalence of the real son towards his real/imaginary mother. Two years after his mother's suicide, Oz joined Kibbutz Hulda where he attended classes in Socialism which were in sharp contrast to the Nationalist right-wing (Revisionist) education that he absorbed at home during his childhood in Jerusalem.

7 It should be pointed out, however, that in the sphere of public life Oz expresses very progressive ideas in regard to women. Both Oz and Yehoshua have declared publicly that the prime minister of Israel should be a woman. As a mother, they claimed, she would be more in tune to the situation of the son/soldier. Her ability to demonstrate affection will cause her to prefer a policy of peace to one of brute force. This 'idealist' essentialist view of women is obviously polemic in itself and certainly demands a thorough examination.

8 Volman said this in a television programme on 'Women in Israeli film and litera-ture', produced by the Open University, Tel Aviv. The panellists were Dan Volman and Yosefa Loshitzky; the interviewer and host was Miri Taimon.

9 I am borrowing the term 'meta-Zionist narrative' (*alilat-al-zyonit* in Hebrew) from Gershon Shaked. He used it in a lecture titled 'Literary and social processes in Hebrew literature' delivered in the colloquium of the Department of Compara-tive Literature at the Hebrew University on 19 March 1991. See also Shaked (1987). For a broad in-depth discussion of Israeli literature from the 1950s to the 1980s, see Gertz (1980).

10 *HaPalmach* was the combat unit of the *Ha'agana* (the Jewish underground organisation associated with the left which fought against the British mandate). The writers of the *HaPalmach* generation are veterans of this unit and most of them share the values of the Israeli Labour Movement.

11 The novel deals with the Jerusalem of the 1950s, a small town untouched by the expansion begun after the 1967 war and the subsequent annexation of Arab East Jerusalem.

12 Fassbinder's melodramas of the 1970s were much in vogue in Israel at the time of the making of *My Michael* as in the art cinemas of Europe and America's big cities.

13 Gilead Morahg claims that in the fiction of the 1960s and early 1970s 'Israel's transition from a state of war to a state of siege' is marked by 'the transformation of fictional Arab characters from realistic signifiers of national moral choices to sym-bolic embodiments of universal existential concerns'. Morahg maintains that in the literature of the Palmach generation and the fiction of the 1960s and early 1970s the fundamental mode of Arab characterisation is virtually the same. Most Arab characters in Israeli fiction until the early 1970s 'are stereotypical abstractions whose characterisation is limited to superficial externals. They are, for the most part, depersonalised figures that serve as schematic catalysts for the internal dilemmas of their fictional Jewish counterparts whose inner worlds are much more deeply penetrated and extensively portrayed' (Morahg 1989: 36).

14 Indeed, as JanMohamed observes 'the colonialist text is in fact antagonistic to some of the prevailing tendencies of realism' (1985: 68). Frederic Jameson notes, 'Nothing is more alien to the windless closure of high naturalism than the works of Joseph Conrad' (1981: 206).

15 For a discussion of the representation of homosexuality in Israeli cinema and in particular in Amos Gutman's (the only Israeli director who was open about his own homosexuality which he also expressed in his films) see Loshitzky 1993a.

16 For a more recent *Intifada*-inspired literary representation of the dynamics of

sexual and emotional ambivalence aroused in an Israeli woman as a result of her encounter with Palestinian construction workers, see Savyon Liebrecht 'Room on the roof' in her collection of stories entitled *Apples From the Desert* (1986).

17 For a further discussion of this issue see *History and Memory*, 7, No. 1 (Spring/ Summer 1995). This is a special issue devoted to 'Israeli historiography revisited'.

References

Alcalay, Amiel (1993) *After Jews and Arabs: Remaking Levantine Culture*, Minneapolis and London: University of Minnesota Press.

Alter, Robert (1977) 'Fiction in a state of siege', in *Defenses of the Imagination: Jewish Writers and Modern Historical Crisis*, Philadelphia: The Jewish Publication Society of America, 213–31

Bartels, Emily C. (1992) 'Imperialist beginnings: Richard Hakluyt and the construction of Africa', *Criticism* 34: 517–38.

Behdad, Ali (1990) 'The discursive formation of Orientalism: the threshold of (pseudo) scientificity', *Peuples méditerranéens* 50: 163–9.

Ben-Ezer, Ehud (ed.) (1992) *Bmoledet Hagaguim Hamenugadim. Harvi Basifrut Haivrit* (*In the Homeland of Competing Longings: The Arab in Hebrew Literature*), Tel Aviv: Zmora, Bitan.

Bhabha, Homi (1986) 'The other question: difference, discrimination and the discourse of colonialism,' in *Literature, Politics and Theory. Papers from the Essex Conference 1976–84*, (eds) Francis Barker *et al.*, London: Methuen.

Bowles, Paul (1978 [1949]) *The Sheltering Sky*, New York: The Ecco Press.

Bresheeth, Haim (1989) 'Self and other in Zionism: Palestine and Israel in recent Hebrew literature', in *Palestine: Profile of an Occupation*, (eds) The Khamsin Collective, London: Zed Books, 120–52.

Briatte, Robert (1990) 'The territories of the sky' in *The Sheltering Sky: A Film by Bernardo Bertolucci based on the Novel by Paul Bowles*, (eds) Livio Negri and Fabien S. Gerard, London: Scribners, 33–7.

Dillon, Millicent (1990) 'The marriage melody', in *The Sheltering Sky: A Film by Bernardo Bertolucci based on the Novel by Paul Bowles*, (eds) Livio Negri and Fabien S. Gerard, London: Scribners, 47–8.

Fanon, Frantz (1986) *Black Skin White Masks*, trans. Charles Lam Markmann, London: Pluto Press.

Gertz, Nurit (1980) 'Amos Oz: A Monograph', Tel Aviv: Sifriyat Poalim (in Hebrew).

History and Memory 7 (1) (Spring/Summer 1995). A special issue on 'Israeli historiography revisited'.

Huyssen, Andreas (1986) 'Mass culture as woman: modernism's other', in *Studies in Entertainment: Critical Approaches to Mass Culture*, (ed.) Tania Modleski, Bloomington: Indiana University Press, 188–207.

Jameson, Frederic (1981) 'Romance and reification: plot construction and ideological closure in Joseph Conrad', in *The Political Unconscious*, London and New York: Routledge.

JanMohamed, Abdul R. (1985) 'The economy of Manichean allegory: the function of racial difference in colonialist literature', *Critical Inquiry* 12: 59–87.

Jerusalem, a catalogue published by the David Museum of the History of Jerusalem.

Kabbani, Rana (1986) *Europe's Myths of Orient*, London: Pandora Press.

Loshitzky, Yosefa (1993a) 'The bride of the dead: phallocentrism and war in Kanuik

and Gutman's "Himmo, King of Jerusalem" ' *Literature/Film Quarterly* 21 (3) 110–32.

Loshitzky, Yosefa (1993b) 'The tourist/traveler gaze: Bertolucci and Bowles' "The Sheltering Sky" ', *East-West Film Journal* 7: 111–37.

Loshitzky, Yosefa (1995) *The Radical Faces of Godard and Bertolucci*, Detroit: Wayne State University Press.

Macbean, James Roy (1984) 'Between kitsch and fascism: notes on Fassbinder, Pasolini, (homo)sexual politics, the exotic & other consuming passions', *Cinéast* 13: 12–19.

Memmi, Albert (1968) *L'homme dominé*, Paris: Gallimard.

Mishra, Vijay and Bob Hodge (1991) 'What is post(-)colonialism?', *Textual Practice* 5: 399–414.

Morahg, Gilead (1989) 'The Arab as "other" in Israeli fiction', *Middle East Review* 22: 35–40.

Oz, Amos (1972) *My Michael*, London: Chatto & Windus.

Oz, Amos (5 March 1996) 'Hand in hand to hell?', *The Guardian*, 15.

Oz, Amos (21 April 1996) 'Making peace is not a military operation', *Observer*, 18.

Palace Pictures, publicity release for *The Sheltering Sky* (1990), London.

Ramras-Rauch, Gila (1988) *The Arab in Israeli Literature*, Bloomington, IN and Indianapolis: Indiana University Press.

Rosaldo, Renato (1989) 'Imperialist nostalgia', in *Culture and Truth: The Remaking of Social Analysis*, Boston, MA: Beacon Press, 68–87.

Said, Edward (1978) *Orientalism*, New York: Random House.

Said, Edward (1985) 'An ideology of difference', *Critical Inquiry* 12: 38–58.

Said, Edward (1986) 'Orientalism reconsidered', in *Literature, Politics and Theory: Papers from the Essex Conference 1976–84*, (eds) Francis Barker, Peter Hulme, Margaret Iversun and Diana Loxley, London: Methuen.

Said, Edward (1993) 'Two visions in "Heart of Darkness" ' in *Culture and Imperialism*, New York: Alfred A. Knopf, 19–30.

Sartre, Jean-Paul (1965) 'Flaubert and Madame Bovary: outline of a new method', *Gustave Flaubert, Madame Bovary: Backgrounds and Sources, Essays in Criticism*, (ed.) Paul DeMan, New York and London: W. W. Norton & Company, 302–8.

Screen 30, 3 (1989), a special issue on 'Indian and European melodrama'.

Shaked, Gershon (1987) *The Shadows Within: Essays on Modern Jewish Writers*, Philadelphia, New York: The Jewish Publication Society.

Shohat, Ella (1989) *Israeli Cinema: East/West and the Politics of Representation*. Austin, TX: University of Texas Press.

Williamson, Judith (1986) 'Woman is an island: femininity and colonization', in *Studies in Entertainment: Critical Approaches to Mass Culture*, (ed.) Tania Modleski, Bloomington, IN and Indianapolis: Indiana University Press, 99–118.

Woolf, Virginia (1977 [1929]) *A Room of One's Own*, London: Grafton.

Young, Robert (1990) *White Mythologies: Writing History and the West*, London and New York: Routledge.

Zalmona, Yigal (1991) 'The tower of David Days: the birth of controversy in Israeli art in the twenties', *The Tower of David Days: First Cultural Strife in Israeli Art*, 66–74.

4 Sandra Kogut's *What Do You Think People Think Brazil Is?*

Rephrasing identity

Ana Reynaud

We are neither Europeans nor North Americans, but lack an original culture; nothing is foreign to us, because everything is.

(Paulo Emilio Salles Gomes)

' "Hi, mother, can you see me?" notes from Brazil'

In this chapter I will discuss Sandra Kogut's video *What Do You Think People Think Brazil Is?* (1990) in order to address questions of representation, 'otherness' and identity. Video might display different characteristics from film. If in film the main principle of construction is 'montage' – cutting and juxtaposition of images – in video, due to its specific technical features, there is a principle of super-imposition in operation. In the same frame, we can have images pasted over others, passing through others, or 'windows' that open within the screen. Also, the images are not necessarily 'shots' of something real, but can be digitally created, and in that sense do not necessarily refer mimetically to an exterior reality. The aesthetics of video tend to be less realistic, since it articulates its own parameters of space and time. Sounds can also be sampled and superimposed.

Thus video, through its constructed, non-naturalistic character, is a highly suitable medium for Sandra Kogut to demonstrate the impossibility of coining a single image of Brazil or a single discourse to represent it. Video is a hybrid cultural form – its complexity, fragmentation and tendencies towards appropri-ation of already existing imagery and cultural reworking make it especially appropriate for discussing the dispersal of fixed notions of culture and identity. Here I want to examine the relationships between video and other forms of cultural representation, including textual narratives, TV commercials and cultural performances related to Carnival. I suggest that in the case of Brazil, identity can actually be found in its refractions, and propose that, because representation plays a fundamental role in the country's cultural constitution, Brazil's 'other' is Brazil itself. Brazil is largely, as Kogut's title suggests, what 'people' – from Brazil or from abroad – think it is. And it is the fluidity of this category and its internal capacity for dynamic re-creation that allows a reiterative identity to be created. In this process, strategies such as self-exoticisation, also explored in Kogut's video, play their part. The way the piece is constructed, with its aesthetics of hybridity,

forces us ultimately to reconceptualise what is meant by 'representation' and how the 'other' is constructed.

Sandra Kogut was born in Rio de Janeiro in 1965. She completed her first works on video at the beginning of the 1980s: installations, clips, performances, documentaries, television commercials. Since then she has collected several national and international prizes at video and film festivals (in Brazil, Germany, Switzerland, New York, and Spain, among others). She works mainly in Europe and gets most of the funding for her work from European and North American sources (e.g. the Rockefeller and MacArthur foundations, UNESCO, CICV/ Centre Pierre Schaeffer, the European Community, the French government, television channel France 3). Her videos and films have been shown on Canal Plus (France), Discovery Channel (England), RTBF (Belgium), and TVE (Spain), among others. She also directed a weekly television programme, 'Brasil legal', for the Brazilian television company TV Globo.

Video art in Brazil has appealed either to artists with previous experience in film who found video a cheaper and more accessible tool, or to a young generation of artists like Sandra Kogut, Eder Santos and Carlos Nader, who from the onset chose video as their preferred medium. The appropriation of video art within Brazil derives from a process of cultural globalisation through which cultural and artistic practices generated and developed in 'influential' countries like the US are made accessible and appealing to 'peripheral' countries.[1] There is a generation of Brazilian video makers who have been working steadily over the past decade with international sponsorship to produce work that reaches international audiences.

How does this video activity relate to the constant dynamic between 'cosmo-politan' and 'regional' in a contemporary setting? In an era of so-called cultural globalisation, or more intensified exchanges of cultural influences, how does pro-duction from ex-colonial, 'peripheral' countries relate to the 'centre'? (There is no doubt that there are still 'centres', at least in this stage of the process.) In an article about Brazilian video, curator Nelson Brissac addresses the question:

> In the peak of the globalisation era, what does it mean to have 'national roots'? . . . It is no longer a matter of the metamorphosis of the local into the universal – the old dialectics between the particular and the general which incited works with a regionalist and popular character. Now we see works that use their localised condition in order to achieve a global spectrum. Art-ists who, working inside the national industrial dissonance – which allies the most modern with the most precarious – manage to imprint in their artistic products a certain dimension that would hardly be found coming from coun-tries with more stable social and economic settings.'[2] (author's translation)

What Do You Think People Think Brazil Is?, made by Kogut in 1990, is an example of video works that use their localised condition in order to achieve a global spectrum. The piece superimposes on the screen several first-hand images filmed by the artist over images extracted from films, commercials and magazines. 'Windows' are opened within the frame; stripes carry other images or form

sentences, and the sound is dubbed, mixed and sampled. This is a very short piece, only five minutes long, but in its frantic yet carefully devised rhythm, it is able to 'tell' – or should we say 'ask'? – a lot. At the beginning of the video, we see a young man addressing the camera, as if speaking on the telephone: 'Hi, Mother, can you hear me? I am here at the beach – me and Beto. No, only me and Beto. Hi, Mother, can you see me?' He speaks in Portuguese but his words are translated in subtitles that appear in stripes at the bottom of the screen. A colourful stripe that repeats the phrase 'Notes from Brazil' cuts the screen. On both sides of the screen, images of tiny telephone sets ascend vertically (Figure 4.1).

Figure 4.1 Young man addressing camera.
Source: Sandra Kogut's *What Do You Think People Think Brazil Is?*

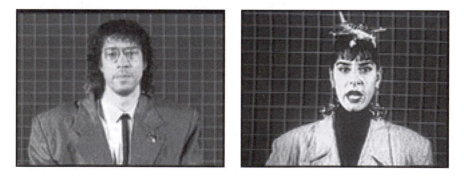

Figure 4.2 Fausto Fawcett dressed up and shown as a news anchor.
Source: Sandra Kogut's 1987 video *Juliette.*

Figure 4.3 Fernanda Abreu dressed up and shown as a news anchor.
Source: Sandra Kogut's 1987 video *Juliette.*

 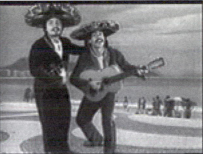

Figure 4.4 Mulata dancing the samba at Rio's carnival.
Source: Sandra Kogut's 1987 video *Juliette*.

Figure 4.5 Fake Mexican mariachis performing.
Source: Sandra Kogut's 1987 video *Juliette*.

Kogut's earlier musical video clip *Juliette* (1987) pointed to the development of an aesthetics of collage. In that piece, the musicians Fausto Fawcett and Fernanda Abreu were dressed up and shown as news anchors, and their images were intercalated with a rapid succession of other images (Figures 4.2 and 4.3). There are flashes of soccer matches filmed from a television set; figures of people and things cut from postcards, magazines, drawings and cartoons are added to live street footage; and there are images, obviously staged for the video, of mulatas dancing the samba and Mexican mariachis performing with their guitars, big hats and ridiculous, phoney moustaches (Figures 4.4 and 4.5). When the song that gives the clip its title refers to a blonde young girl (a projected fantasy in so many cultures), we see images of Madonna, the Venus of Botticelli, Cicciolina and Marilyn Monroe in rapid succession. Thus we can see that the use of commercially fabricated images as a device of appropriation was already being developed in Kogut's early musical clips. One referent – the blonde girl, for instance – detonates a cornucopia of related referential images that create visual 'sentences' which can be arranged in parallel to other, similar, arrangements.

What Do You Think People Think Brazil Is? has been described as 'a kind of anti-portrait of Brazil, made up by clichéd images of Brazilianness and of raving speeches of foreign tourists about this exotic country situated in the southern hemisphere'.[3] In this piece, images of Rio are shown in rapid succession, foreign languages are superimposed on the images, and stripes containing data about the miserable conditions in Brazil run through the screen in the manner of captioned sentences or headlines. They are written in English, as is most of what is said or shown in the video. Some of these 'stripes' give statistics: the area of Brazil, mortality rates, literacy rates. Others state what one would do if elected president, suggest the 'solutions' for Brazil's problems and give the names of the Indian tribes. Especially suggestive are the stripes that talk about 'the value of things'.

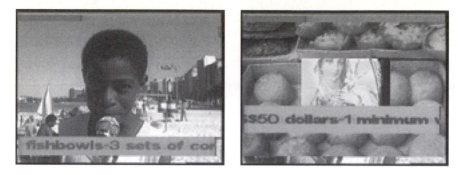

Figure 4.6a Stripes set up fictitious equivalencies.
Source: Sandra Kogut's *What Do You Think People Think Brazil Is?*

Figure 4.6b Stripes added to Catholic imagery.
Source: Sandra Kogut's *What Do You Think People Think Brazil Is?*

They show false, funny, critical 'equivalencies': 'payment for university researcher = 2 plush pyjamas = 1 kg frozen pork meat = 4 pairs of jeans = 1 minimum wage = 3 pairs of Pierre Cardin panty hose = 1/2 packet of cigarettes = 100 Cokes = 1 picture frame = 1 crystal cup' and so on. They make simultaneous allusions to globalisation, commodification, merchandising, and the stock exchange. They appear as if belonging to the barter exchange system – a 'primitive', pre-monetary economics, while commenting ironically on global capital circulation; here it is interesting to note the exchanges between Columbus and the Indians during the colonisation of America. Columbus was able to exchange small mirrors for land because, for the Indians, the beauty and attraction of gleaming objects held value. Modernity, marked by the disparity of the exchanges, Kogut mocks in telegraphic mode.[4]

Through the video, we see references to the commodification of the Brazilian woman as an export product. A man says: 'The Brazilian woman has . . .' but the sentence is never finished. We have already seen flashes of Brazilian women lying on the beach (taken from postcards) and mulatas dancing the samba. Commodification operates on various levels: the value of things permeates this negatively inflected ideal woman because, unlike her Romantic equivalent, the ideal pure or virginal woman, she can be unashamedly bought or exchanged. So it is the whole idea of Brazil itself that is given the negative connotation – like its women, the country is idealised by tourists and foreign peoples as beautiful, potently natural, sensuous – but also perfect for external consumption.

Stripes cross the screen with colourful fragments of observations or suggestions, such as: 'To save Brazil: close down Congress'. . . . 'You want to know how to get rich? Very easy. Working is suggestive and mandatory'. . . . 'Brazil, a planetary joy accumulator'. . . . 'Brazil should be covered to be discovered again', and so on.

The stripes are added to images: tourists being interviewed, Brazilians being

interviewed, a zoom of Copacabana beach, regional dances, mulatas doing the samba, Indians wearing jeans, a swirling bottle of Coca-Cola topped by a blonde Barbie doll's torso and arms dancing to the rhythm of samba drums, devotional popular icons belonging to Catholic and African imagery, the Sugar Loaf as depicted on a postcard, the head of Mickey Mouse on a plastic base, flashes of soccer matches, miners covered in mud working at Serra Pelada, ceramic traditional figures in procession, the map of Brazil (Figures 4.6a and 4.6b).

The 'interviews' are almost all fragmented. In some of them, the sound and image are coherent, as when an American tourist suggests, 'The solution? You need Reagan. Ronald Reagan, not Bush'. But on the whole, the same procedure of fragmentation and superimposition applied to the images and the written words (in the stripes) is applied to the sound. We hear pieces of sentences, and together they create a somewhat vertiginous but consistent sense. Some sentences are spoken by people we do not see uttering them, as, for example, when somebody says, 'L'image que représente Brésil le mieux: c'est un pays très sympatique, très sexy et très frustré'. The same happens with the utterances, 'The Brazilian woman has … ' or 'Where is Brazil? We're in Brazil now!' We hear a man counting in English with a Brazilian accent: 'One, two, three, four, five – ' … 'Are you talking about … entertainment?' a disembodied female voice asks.

There is also the superimposition of disjointed sounds and images. The screen is filled with the image of an Indian speaking, but the voice we hear is electronically distorted, and is saying, 'There's too many people here in Brazil. It's too crowded here'.

The frantic rhythm that results from such superimposition and layering of sound, images and words is a response to the way we perceive things at the present moment, after being exposed to the speed that marks the language of television advertisements. Understanding, after television, is ruled by different intellectual and perceptual codes.

As in *Juliette* earlier, there is a strong reference to television in *What Do You Think People Think Brazil Is?* This appears in the reference to MTV, with its rapid succession of images that together with synchronised sound create a rhythmic flow, but there is also a reference to the news format in the fragmented 'interviews' shown in the video. We do not see the invisible 'reporter', but it is clear that someone is going around asking people questions about Brazil. We can see the microphone, a big, old-fashioned metal example which subtly mocks news coverage. While the disembodied voice interviews tourists and locals, one man, clearly a Brazilian, when asked something in English inquires back, 'What do you speak? Only English? No Braz …' and here he quickly corrects himself because officially there is no such thing as the Brazilian language, ' … Portuguese?' It reminds us of the news coverage offered by CNN, in which people from 'peripheral' countries must resort to English to relate their testimonies and views.

We could trace back this aesthetics of hybridity to, for instance, Victor Burgin's use of 'appropriated images' in his 'photo-text' series called *Between*, comprising works made between 1975 and 1985, in which he aimed at establishing a

continuity of languages between the cultured tones of 'high art' and the vernacular of the mass media. By recycling advertising imagery and reproducing in his photographs the rhetoric of advertising copy, he was making use of a strategy similar to Kogut's: combining unexpected sources of images, dispensing with hierarchies traditionally established between the arts and communications and challenging the very notion of primary and secondary sources. 'Although "I" took the photographs, and "I" wrote (most of) the texts, the voices of others intrude, and even my "own" voice is inconsistent in tone across the work', claims the artist.[5] The difference is that Burgin, wishing to base *Between* in contemporary cultural theory rather than in traditional aesthetics, connected the photographs with extracts from contemporaneous talks, interviews and letters, in which he discusses the work. These commentaries, which are highly dense and theoretical, confer on *Between* a deliberately intellectual edge and academic hue that Kogut's work is not concerned with.

A more fruitful parallel could be made between the aesthetics of hybridity found in video and Rio de Janeiro's Carnival conventions. In the samba-schools' (Sambódromo) parade, people dress in attire inspired by Hollywood films and the Folies Bergères shows, rather than elaborating 'ethnic' costumes. 'Only intellectuals delight in misery. The poor long for luxury', proposes carnival artist Joãozinho Trinta.[6] Mixed in with the feathers and fake jewellery in the props, costumes and ornaments, there are elements of recycled industrial junk and similarly 'poor' or trivial materials that intervene subversively to create a whole new, and powerful, aesthetics.

The important point here is that this aesthetic of hybridity allows video to explore themes such as the fragmentation of cultural identity in a privileged way, combining form and content in a way in which one permanently engages with the other – the visuals 'talk' about Brazil's hybridity and Brazil's hybridity 'talks' about video – instead of simply commenting on one another.

Tourist views

The first image of *What Do You Think People Think Brazil Is?* shows a black street kid on the beach of Copacabana, smiling and repeating to the camera (we can see the microphone) all the scattered sentences he has learnt through his acquaintance with the tourists:

> Bonjour, monsieur. Bonjour, madame. Thank you very much. Gracias. Takananuka [a popular Brazilian mock impression of spoken Japanese, which sounds like the Portuguese for 'a slap on the back of your neck']. Get out of here. Motherfucker. Shut up. What's your name, my name is Douglas. What time is it you go? Seven clock. How are you to United States? Very nice you very nice. Okay, thank you very much.

The captioned stripes that pass across the top and bottom of the screen while he is speaking read:

Figure 4.7a,b,c Severino addresses the camera.

Source: Sandra Kogut's *What Do You Think People Think Brazil Is?*

Hi! My name is Severino [a popular working-class given name in Brazil, and one with a particular cultural resonance of regional authenticity]. If elected I'll steal like everybody else, but I'll also provide schooling and food for the poor.

The words 'I'm Severino' appear at the exact moment the boy is saying, 'My name is Douglas' (Figure 4.7a, b, c).

Rio is visited annually by some 800,000 foreign tourists, so every year nearly a fifth of its population of 5.5 million is composed of tourists. This is extremely important in understanding the dynamics of Sandra Kogut's video and how the image of Brazil is intertwined with the images Brazil is offered by visitors. The city has been chronicled since colonial times:

> There is between Rio de Janeiro and the chronicle such affinity that it becomes hard to trace the history of the city without evoking – since the first travellers who entered the Bay in amazement – the many chroniclers who, having been born or not in it, wrote about the city.
>
> (Resende 1995)[7]

> Palms go for years without bearing fruit, until one day they burst into exuberant blossom and then hurry on to die. . . . The whales are so plentiful that they brush along the beaches. From the rocky headlands, they can be harpooned from dry land. . . . The fruits swell abruptly, going from green to overripe in a trice.[8]
>
> (Latif 1965)

These descriptions are later supplemented by equally marvelling visitors such as naturalists from Europe – sent to Rio by the enlightened Portuguese emperor – or the German preceptor who knew the city in the nineteenth century and who even this early gives her account in a style we could call the modern chronicle:

> Here I am once again in this colourful, noisy tropical city. I have to admit that this Rio is fantastically pretty and marvellous, seen from the Bay as I saw it on my first arrival and again now, on my return from Petrópolis. To our humble northern German eyes, it comes into view like something out of a fairy tale: the city forming terraces up the hillsides of the Brazilian coast, within this luxuriant inlet formed by a sea of radiant light, which is broken only – or rather amplified still further – by the variety of graceful palms and broad-leafed banana trees growing everywhere.[9]
>
> (von Bizer 1982)

So we can see that Rio has always been marked by the presence of visitors and chroniclers. The travel narratives or *relatos* – accounts – that these foreigners have left during the past four hundred years are part of the documentation used by historians to study the city.

In *What Do You Think People Think Brazil Is?* the *relatos* or impressions of the

tourists or modern visitors are interspersed with the views of the 'natives', or local people. By gathering images appropriated from various sources, even from television itself – where the video is ultimately shown as the culmination of a circular process – Kogut is giving a faithful account of the contemporary city, which is made not only of things but also of images. In that sense, the video can be taken as a chronicle of the city. In fact, the contemporary city is also made of news. The fact of having changed from an artistic product to an industrial one – its general system of production having changed as well – has transformed the city, as we live in it today, into a system of information.[10] The city is full of outdoor signposts, and of the endless stream of images that unfold on television sets and in cinemas.

What Do You Think People Think Brazil Is? treats Rio as if it were Brazil, as if you could interchange them and still be talking about the same thing. In fact, this procedure belongs to a tradition, according to Beatriz Resende:

> It is evident that the fact of having been the nation's capital from 1763 to 1960, and consequently the seat of its political power and the centre of its cultural life – even while São Paulo attained economic sovereignty – contributed to this identification of discourses that in referring to the city of Rio de Janeiro one is referring to Brazil. . . . Among the main explanations of the affinity between the practice of the chronicle and Rio de Janeiro is (as pointed out by Margarida Neves) 'the expressive discursive slip of Rio de Janeiro's capitality', responsible for the fact that in many texts the two references – Brazil and Rio de Janeiro – become interchangeable.[11]
>
> (author's translation)

Rio, as an entrepôt, was obliged throughout its history to engage with a wide variety of cultures through trade transactions, receiving the broadest range of influences in religion, art and customs. It had accumulated political power like no other city in Brazil, had been a major setting for political changes and had housed the dominant elites and the poorest classes. All of this generated 'a very special critical faculty, an awareness of forming part of a world far wider than that contained within Brazil's frontiers, of being meshed with change at world level'.[12]

This position of Rio as a generator of ideas has contributed most decisively to constituting the image of a city that does not see itself as a past colony. Because Rio sheltered the Portuguese royal family during the Napoleonic wars, a sense of being Portugal's extension – or even capital city in some sense – remained. This, of course, creates a whole problematic involving the process of decolonisation. The question of what Brazil is, as Kogut shows in *What Do You Think People Think Brazil Is?*, is closely related to the question of how we are represented both by ourselves and by others. Thus, inasmuch as imaginary function is part of its composition, it is only because Rio is a specific configuration, a space with a history, that it can assume the symbolic function of representing the whole of Brazil.

The tourist views we see exposed in an ironical manner in *What Do You Think*

Figure 4.8 An American tourist offers his solution to Brazil's problems.
Source: Sandra Kogut's *What Do You Think People Think Brazil Is?*

People Think Brazil Is? are the postcolonial equivalents to the *relatos* of past centuries. We have these visitors' versions of the formula – the solution to Brazil (Figure 4.8). The young, blond, handsome American tourist suggests, 'You just have to work a little harder and spend less time on the beach, and things will be fine'. And as noted above, another English-speaking visitor asserts, 'The solution? You need Reagan. Ronald Reagan, not Bush'. There is also an Asian tourist wearing a pink turban who, when asked the question contained in the title of the video, says, 'Don't understand'. A young blond foreign male lying on the beach says (we presume when asked who is the president of Brazil), 'Collor – the president who runs all the time'. What we have is not a coherent description, but an array of voices, a collection of foreign gazes, which often are really gazing at themselves. 'You don't see this in Scandinavia', one says. Another voice says, 'Do you want me to tell you why I am not a typical tourist?'

In the case of Brazilian history, we are confronted with patterns of colonisation that are perhaps unparalleled. The Portuguese did not establish a settler's model of colonisation, but rather a more extractive one. Nevertheless, there are cases of entire groups of Portuguese colonisers learning to speak Tupi, the language of the Tupi Indians who lived on the coast, and the most prevalent native language, instead of imposing their own. The phenomena of racial miscegenation and religious syncretism contributed hugely to the configuration of a culture that was hybrid from the start and which, with successive waves of migrations, became even more so.

What would be the other to Brazil, then? Could it be the original colonisers, the Portuguese? According to Beatriz Resende, Rio de Janeiro was never a typical

colonial city.[13] What happened to Rio could be called the experience of the 'inversion of the metropolis', since during the sojourn there of the Portuguese royal family, which as noted above moved from Lisbon to Rio during the Napoleonic wars, the centre of power, culture and decision-making was transferred from the Old to the New World. And as we have seen, as long as Rio saw itself as the voice, discourse and image of the country, it could be said that the whole of Brazil did not recognise itself as a colony. In any case, Brazil was made independent in 1822, in an impulsive act by Emperor Pedro I, who had a passionate sympathy for the country, and had been living in Rio then as an almost permanent resident.

If, then, Portugal is not Brazil's projected other, what could its other be? It may be that the Africans who were brought to Brazil as slaves, and, later, the Italians, Germans, Japanese, Dutch, Spanish, Arabs, and many other peoples that have gradually emigrated to and settled down in Brazil, have created a sense of a past relation to the parts of the world they came from. But more than providing any sense of an other, this multiple background can be seen as one of the reasons for the dynamism and fast-transforming quality of Brazilian culture, its impulse towards the 'outside world', and its capacity to absorb. As the modernist writer Oswald de Andrade used to say, our cultural functioning is marked by cannibalism. Like tribal warriors who eat their enemies' hearts to appropriate their power and knowledge, Brazilians are always eating the 'other', digesting it, and making it appear in a different form. That is why in the case of Brazil, claims for cultural or ethnic purity can scarcely be made. 'Tupi or not tupi', proposes Oswald de Andrade, appropriating the modern ontological Western question posed by Shakespeare's Hamlet – 'to be or not to be' – to serve our own interests and affirmation.[14]

'I hope you understand my English'

Another important part of Kogut's video is the Portuguese/Anglo-American interface – the way in which a whole Anglo-American vocabulary permeates Brazilian culture and everyday life. This vocabulary translates itself in the video in both words and iconographic elements. Hence the Babel-like myriad of voices we hear in *What Do You Think People Think Brazil Is?*, all speaking different languages – a layering of Portuguese, English and some French. In the opening scenes of the video, when we see the young boy reciting all the English sentences and expressions he knows – which he has obviously learnt in his interactions with tourists – we also see letters of the alphabet flashing on the screen. Several times during the video a stripe containing a sequence of the letters of the alphabet runs across the screen. When a woman beggar with sunglasses, funny hat and missing teeth sings, she does so in a reinvented English, made up of mixed, incomprehensible words. 'Baaaaa-bye', she ends her improvisation, using a recurrent expression in pop songs while making it sound quirky by the way she chants and elongates it (Figure 4.9). 'Hey, Mama, look me', we hear a young voice demand in grammatically incorrect but emphatic English. 'One, two, three, four, five, six, seven, eight, nine, ten', someone counts in English, with a Brazilian accent. The last, lingering sentence we hear on the video is, 'I hope you understand my

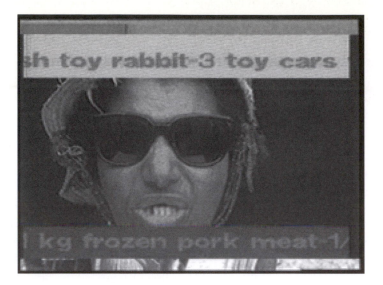

Figure 4.9 Street people speak out.
Source: Sandra Kogut's *What Do You Think People Think Brazil Is?*

English'. Before that, there is a collage and superimposition of voices speaking English and Portuguese alternately; among these, we also hear a Brazilian man trying to utter some words in Italian, but in a stereotyped manner: 'Macaroni, Pasqualino . . . '

Lately, Europe has ceased to be the mainstream cultural reference point for Brazil, which has come to have a strong cultural link to the US. We can surely identify what could be called an Americanisation of the world as an international phenomenon – although in the case of Brazil and the US the identification also comes from the shared fate of both countries as Americas.

North America is not Brazil's other, either; the other to Brazil is Brazil itself – and, of course, this is common to most peoples and nations; in Britain, people often talk about what defines Britishness. But in the case of Brazil, it is the asking of that question, 'What is Brazil?', and the ephemeral nature of the answers given, which provokes us to ask it again and again, that brings about the construction of some national identity. While other nations with a longer sense of history and more traditional patterns of colonisation may have at present, in postcolonial, postmodern times, the same difficulty in encapsulating national identity, in the case of Brazil we could say that national identity is specifically constituted by the permanent rephrasing of the question of what Brazil is. It is a question that has been obsessively asked and sung in an impressive number of Brazilian songs, films and poems, and each new answer adds to the substance of the question and prompts a new way of addressing it. A recent television programme showed Brazilians who were visiting the Amazon for the first time (and, after all, it costs

as much for a Brazilian citizen to visit the Amazon as to go to Miami or Cancún). There was an expression of amazement on these people's faces as they came out of a cave situated under a fantastic waterfall, and when asked what it felt like to be there, a man said, 'This is Brazil, folks'. With this sentence and a sweep of his arm through the air, as if trying to encompass and convey the vastness before him, he was actually taking possession of a Brazil he had not known before, by finally recognising and naming it. The signifier 'Brazil' seemed in that moment to complete and synthesise what Brazil represented to him with the addition of this new experience. As in Walt Whitman's piling up of adjectives representing the vastness of America, or the idea of America, in *Leaves of Grass*,[15] the Brazilian man was, in a less encyclopaedic way, acknowledging in an encompassing manner the cornucopian variety of the territory he had just taken symbolic possession of.

The question of what we are is closely related to the question of how we are represented both by others and by ourselves, Brazil being a land of 'exoticism' in which the whole world projects desires of joy, beauty, nature, and sexual libera-tion. So the question of Brazil is not only what Brazil is; perhaps the question really is Sandra Kogut's, 'What do you think people think Brazil is?'

What Do You Think People Think Brazil Is? refers to a historical strategy of Brazilian artists, that of self-exoticisation. Carmen Miranda is a typical example. This strategy and procedure offers a double result; despite the mocking tone that impregnates the work, a 'reality' is created out of all the projections, and that 'reality' can be projected again on the outside. By exposing stereotypes, we can – at least temporarily – deconstruct them.

'Quelles sont les images que représentent Brésil le mieux?' we hear somebody say at a certain point of *What Do You Think People Think Brazil Is?*. As usual, we do not hear the spoken answer. What are the images that best represent Brazil? In the video they are shown in such rapid succession and in such a short time that it becomes clear that there cannot be only one. We see the image of the Redeemer – the huge statue of Christ with his arms spread wide, high above the city of Rio – in a postcard-like representation of it. We see a shot of the famous pavements at the beach of Copacabana, with their black and white stones arranged in a mosaic geometrically suggesting the form of waves. We see the head of a mico-leão (a monkey that is one of the most endangered species of Brazilian fauna), as pictured in a book. We see (reconstituted in a collage-like manner, but shot with actual people on a set) a dancer attired in her flashy Carnival costume performing choreographic movements, dollar notes arranged in a cascading motif, a roasted chicken. We see a line of men dressed in suits and carrying suitcases before a background of dollar notes, mocking on the one hand the frequent visits of delegates of the International Monetary Fund (the administrator of Brazilian debt to the US) as they arrive dressed in suits and carrying suitcases, and on the other making reference to the gangster-like patrons of illegal gambling in Rio (Figure 4.10). We see a refrigerator with its door wide open and an empty interior. We see a close-up of a small transistor radio – an item widely used all over Brazil for listening to football matches and other 'popular' entertainments. We

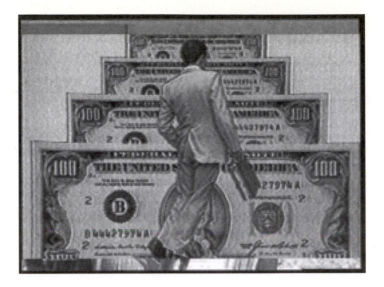

Figure 4.10 References to gangsters and the International Monetary Fund.
Source: Sandra Kogut's *What Do You Think People Think Brazil Is?*

see a skull, a Brazilian coin, a typical image of a natural science magazine depicting a bird, an image of Iemanjá – the revered spirit of the ocean in the Afro-Brazilian religion – represented as a woman in a long-sleeved blue dress coming out of the waters, a kitsch painting of a jangada (the traditional fishing boat of the north east and north of Brazil) hanging on somebody's wall. Vivid colours, popular national symbols mixed with ironic collages of these same symbols: which of these images represents Brazil the best? None of them do. All of them together, in this kaleidoscopic swirl, can only give an idea of the complexity and fragmented nature of the imagery of Brazil.

A recurrent iconographic motif is the Brazilian flag. We see it reproduced in series – a stripe of small Brazilian flags lined up like stickers crosses the screen frequently, vertically and horizontally. At a certain point there is a bigger Brazilian flag upside down; the stars that stand for the Southern Cross becoming, in the inversion, the soil where slaves used to mine gold in colonial times. 'Where is Brazil?' somebody says, repeating the question they have been posed, and answers, 'We're in Brazil right now!' Kogut's video puts in suspension the certainty of the casual statement. It is not obvious that the owner of the voice is in Brazil when he is being asked the question; when Kogut asks where Brazil is, what she really wants to know is where he thinks Brazil is.

What is Brazil?

Images of the faces of people flash in very fast succession during certain parts of *What Do You Think People Think Brazil Is?*. There are also images of crowds

walking the streets, a couple doing a regional Brazilian dance, groups of indigen-ous Brazilian Indians near a helicopter, a quick glimpse of the miners of Serra Pelada covered in mud, people in costumes dancing in the Sambódromo parade during Carnival, and people cheering at a football match. Is this Brazil?

Kogut makes use of a self-reflexive strategy, rephrasing the anthropological question itself, so that the question of 'otherness' is at stake once more. We could suggest two typical approaches to the question of what Brazil is. An anthropolo-gist, trying to arrive at a description of the society, would pose the question 'What do you think Brazil is?' in his or her investigation. 'What is Brazil?' would be the question posed by the 'native' interested in establishing his or her own cultural national identity. (This is the stereotype of the 'native anthropologist', with a simultaneously 'scientific' and sympathetic approach.) But with the question 'What do you think people think Brazil is?', posed by Sandra Kogut's video, the hierarchy of the two positions disappears, and the two questions are intertwined. Kogut is providing a multiple description of society. Brazil is not 'what it is' but how it is seen: its reality is imbued with its representation. In Kogut's work, the procedure is 'observing the observers' – be they visitors or natives.

What Do You Think People Think Brazil Is? is a reflection upon the power of representation, first in colonialism and now in a postcolonial, global world. Otherness and identity are inextricably bound up together in this video: one is not possible without the other. It may be that in its historical lack of fixed and stable cultural boundaries with regard to its 'identity', Brazil has nonetheless produced, and keeps on producing, a fluid but reiterative sense of identity. Doreen Massey reminds us that the identity of a place does not derive from some internalised history but from the specificity of its interactions with 'the outside', and this is very much the case here.[16] What 'people' think Brazil is – including foreign, 'exterior' expectations that may be strongly internalised by the 'natives' – in fact largely constitutes what it is. This fluid identity – evoked in the video by the rapidity and variety of images and by the inflection of voices, the array of fantasies and the myriad gazes – consists ultimately of so many projections, in turn project-ing itself back. We could call this a case of 'reverse cultural influence', in which the process of 'cultural' influence works in two directions because the 'place' that is projected upon also projects back. A cultural artefact or expression can go from being considered as 'original' and then as 'appropriated', and finally as 'coming back' to its site of origin with new features incorporated into it.

Examples of this process are numerous. The Brazilian film-maker Glauber Rocha evoked, in the 1960s and 1970s, the traditional figure of the infamous and heroic Brazilian outlaw, the cangaceiro, to create his Western-like epics set in the hinterlands. Despite being clearly influenced by the Russian director Sergei Eisenstein, Rocha managed to create his own brand of revolutionary cinema. In turn, Cinema Novo influenced European cinema, as amply acknowledged in *Cahiers du Cinéma*. In the realm of the plastic arts, Hélio Oiticica, who was primarily influenced by Lucio Fontana and Max Bill, explored popular Brazilian culture, mixing kitsch with constructive geometric rigour, and ultimately became widely influential in the international art scene.

In the sphere of what could be called more popular arts, bossa nova mixed Debussy, Cole Porter and traditional samba to send the 'Girl from Ipanema' swinging around the world. TV Globo, the primary Brazilian television network, has for the last twenty years been perfecting its highly sophisticated soap operas, or telenovelas, which have become all the rage in countries supposedly as distant from Brazilian realities as China; in Portugal, in a phenomenon of late inverse 'cultural colonisation', the telenovelas have created throughout the nation an aspiration for the Brazilian 'way of life'.

We could now, perhaps, add to these examples the work of Sandra Kogut, who, as noted above, has been involved in several international projects and gets most of the funding for her work from European sources. Baroquism, excess, transgression; simplicity, rigorousness, modernism, no easy explanations can account for the peculiar production of cultural strategies in countries like Brazil. But in an age of so-called globalisation, art born out of new technologies, such as video, sets out undaunted to explore in contemporaneous ways Brazil's rich palette of miraculously blended contradictions.

Notes

1 For the debate around the contemporary status of video art in relation to a broader moving-image culture which includes film, television and informatics, see J. Wyver, 'What you see is what you get', essay for exhibition catalogue of the Third ICA Biennial of Independent Film and Video, London, 1994, 6–20.

2 N. Brissac, 'A escala desmedida de Babel', *Mais! Folha de São Paulo* (14 April 1996), 7.

3 A. Machado, 'Les multiples fenêtres de Sandra Kogut', in *Monographie Sandra Kogut*, Hérimoncourt: CICV Pierre Schaeffer, 1991, 45.

4 S. Greenblatt, *Marvellous Possessions: The wonder of the New World* (Oxford, Clarendon Press, 1991), 110.

5 V. Burgin, *Between* (London, Basil Blackwell/Institute of Contemporary Art, 1986), 58.

6 A. Bellos, 'Little Big Man', *Guardian* (9 June 1998), 9.

7 B. Resende, *Cronistas do Rio* (Rio de Janeiro, José Olympio/CCBB, 1995), 38.

8 M. B. Latif, *Uma cidade nos trópicos: São Sebastio do Rio de Janeiro* (Rio de Janeiro, Agir, 1965), 23.

9 I. Von Bizer, *Os meus romanos: Alegrias e tristezas de uma educadora alemã no Brasil* (Rio de Janeiro, Paz e Terra, 1982), 147.

10 G. C. Argan, *História da arte como história da cidade* (São Paulo, Martins Fontes, 1992), 219.

11 Resende, *Cronistas*, 11.

12 A. I. F. Pinheiro, and E. C. F. Pinheiro, *Encantos do Rio* (Rio de Janeiro, Salamandra, 1995), 196.

13 B. Resende, 'Rio de Janeiro: A cidade e as comemorações de 92', in *Terceira Margem*, N. 1 (Rio de Janeiro, UFRJ, 1993), 91.

14 O. Andrade, *A utopia antropofágica* (São Paulo, Editora Globo and Secretaria de Estado da Cultura de São Paulo, 1990), 47.

15 W. Whitman, *Leaves of Grass* (New York, New American Library, 1955).

16 D. Massey, 'A place called home?', in *New Formations*, 17 (Summer 1992), 13.

5 Imagi-nation

The media, nation and politics in contemporary India

Rangan Chakravarty and
Nandini Gooptu

Introduction

The post Cold War scenario in India, as elsewhere, has been marked by market triumphalism and the weakening of the nation-state. The task of redefining India's location and destiny in a new world order, based on a global free market, has unleashed a process of major transitions affecting virtually every aspect of the country's life. The abandonment of a state-controlled model of the economy in favour of increased liberalisation and privatisation has not only led to the redundancy of specific economic and social projects, but has also posed serious challenges to the political vision that dominated the postcolonial nation-state over the last five decades. A void in ideological spaces, created by a fumbling nation-state, has generated new discourses of the nation. In the context of these ongoing social and political transitions in the country in recent years, this chapter examines some aspects of the changing nature of national imagination. It discusses, in particular, some of the issues concerning the construction of the 'authentic' Indian citizen and its 'other' in contemporary Indian media and visual representation. The aim is to explore the politics involved in the production, transmission and communication of dominant visions and images of the nation in India today and to probe their roles within the larger processes of power struggle.

The media, with their myriad forms and forums, have become one of the primary sites for the exposition of different social and political discourses in the India of the 1980s and 1990s. The unprecedented boom in media technologies, institutions and audiences in the country has been driven by the imperative to deliver to an increasingly globalised market to India's middle classes, a lucrative and growing segment comprising over 100 million people with sizable disposable incomes (Dubey 1992). Today, as various global, national and regional media industries are vying to establish control over these markets of the mind, India is facing a proliferation of cable and satellite channels and other audiovisual productions and transmissions as well as a resurgence of the print media in full colour splendour.

It should be clarified at the outset that the discussion in this chapter does not assume or argue a singular centrality for the electronic or the print media in the current social transitions in the country. We are not suggesting that the increasingly varied fare of information and entertainment provide pre-packaged identity

kits to an unsuspecting people. Nor do we believe that the growth in media industries and technologies lead to a one way process of domination and dissemination with no space for contestation, subversion or reinterpretation. Nevertheless, we feel it is important to acknowledge and analyse the role of the media in emergent public spheres for at least two reasons: first, because of the increasingly all encompassing, ubiquitous and ecological nature of the media environment in which more and more Indians live today; and second, because we do not subscribe to the view that the current media expansion marks a postmodern implosion of hyper images and creates a world where reality itself becomes a simulacrum, rendering all attempts at political analysis and social action redundant.[1] On the contrary, we believe that the specific nature of the flow of images across our media spaces is produced by certain historical processes and moments, and that the media, in their structures of production and transmission, are driven by certain imperatives of power, domination and control. The rapidly growing and deeply penetrative media spaces are far from a democratic electronic public sphere where all voices are freely represented and heard, and which apparently appeal to the free domain of popular imagination. Instead, particular visions which seek to achieve dominance are beamed out in easily digestible packages to establish control over mindsets. With this perspective, in this chapter, our specific concern is with the projection in the mainstream electronic and film media of a particular dominant image of the nation which privileges certain notions of country, community and citizenship as authentic and desirable, and excludes other visions and communities. We also adopt the analytical approach that these processes of the production and consumption of media products can be located within larger contemporary social processes – a theme to which we first turn.

Politics and the re-vision of the Indian nation

While it is now widely accepted that the nation as a community is imagined discursively, it is also the case that the imagination of the nation is historically produced through political struggles of various social groups. Thus, the construction of the idea of the nation itself is a domain of contestation in which various actors seek to appropriate its definition, and to inscribe their own space in it. Hence, the discursive forging of a nation is not only about the inclusive construction of a community but is also crucially about exclusions. The process of the construction of a narrative of the nation represents continuing ideological struggles within communities to entrench certain meanings and to achieve particular dominant identities around those meanings, in the face of heterogeneity and difference at given moments in history. National identity, as articulated and represented in nationalist discourses, is a terrain of struggle: one in which competing meanings and identities have to be resolved, marginalised, appropriated or displaced to develop and present a self-conscious and authoritative national identity.

In the last two decades in India, such contestation over the redefinition of the nation has assumed centrality. At the heart of this recasting of the nation lies the

reorientation of social forces. The 1980s registered the coming of age of a diverse, large and affluent middle class, consisting variously of urban professionals and managerial groups, commercial and entrepreneurial classes, white-and blue-collar employees as well as substantial rural landowners and farmers.[2] The expansion and growing prosperity of the middle classes occurred within an interlocking context of opening up of markets, extension of investment and credit facilities, increasing public pay packets, tax cuts, better entrepreneurial opportunities through privatisation and the removal of bureaucratic controls. Moreover, a central feature of the development of the middle classes was an increase in their purchasing powers, an expansion of consumption habits and a boom in consumer products. Between 1980 and 1989, India witnessed a consumer revolution with a 47.5 per cent increase in consumption expenditure (Dubey 1992: 150). The burgeoning, confident and assertive middle classes have now come to meet the West in the global arena of commerce, enterprise and consumption on equal terms. They are animated by the vision of setting India on a newly liberated path of progress and economic prominence on the world stage. They have also assumed for themselves the role of the makers of the nation in new ways. The discursive space for this new project of nation building has been created by the erosion of the old certainties of immediate postcolonial India about the key role of the nation-state and by the recent ascendance, in political discourse, of the market as the motor of modernisation and development. In the emerging middle class political vision, as this chapter hopes to show, the nation is a community of citizens who are enfranchised by freedom of choice, consumption and material gratification and a lifestyle of enjoyment and pleasure. The new nationalist discourse invites all Indians to partake of the bountiful and prosperous nation by supporting the project of market-led modernisation and growth. All are offered the promise of dissolution of want and of equality through participation in a vigorous consumerist economy. In this promised land, the poor are wished away, for everyone's full potential may be realised and well-being may be achieved by all.

However, there are some discordant notes in this promised ideal of the new nation of enterprise and consumption, and dissonance between the vision and the reality. The middle classes find themselves caught up in an increasingly competitive, atomised world, which is just as much a product of the liberalised economy as the promise of unfettered entrepreneurialism and consumer satisfaction. Prosperity and affluence have to be earned at the cost of others. Equally, economic mobility brings with it social costs, reflected in changing family structures, intergenerational and gender conflict, and the consequent problems of social and psychological adjustments and even destabilisation. Moreover, while the forces of globalisation have opened up the possibility of integration into Western lifestyles and consumption patterns, these have also brought the potential of cultural subsumption or subordination to the West, which the assertive middle classes can ill-brook. In order to retain a distinctive identity, they aspire to equality with the West by affirming cultural difference and autonomy as well as authenticity, sovereignty and normative priority of 'Indian' traditions (Hansen 1996). Finally, the new national dream is not only vitiated by these social and cultural factors, but

also undermined by political instability caused by growing social and class polar-isation, themselves the creation of economic liberalisation in many cases.[3] India of the 1980s and 1990s, in reality, is not an unproblematic consumer idyll but riven by regional and fissiparous political movements, and the political unrest of lower castes and classes.

A new imagination of the nation, in which the notion of an original, ancient 'Hindu civilisation' is central, has emerged within this context, for it provides the middle classes with the possibility of negotiating the dilemmas and contradictory experiences, and to bridge the gap of aspirations and reality. Hindu nationalism promulgates the supreme virtue of a powerful, disciplined and disciplining nation-state, peopled by a culturally and socially unified community of spiritual Hindus.[4] The assertion of the primacy of age-old spirituality in Hindu-Indian culture and its moral superiority can act as an antidote to the perceived threat of social dislocation and of subsumption by 'Western' culture. The invention of a mythical past – the Hindu golden age of prosperity, harmony and a cohesive community – accommodates the aspiration for a homogeneous and monolithic national community free of the destabilising forces of pluralist tension and social divergence. The imagination of the past strength and political power of a 'Hindu' nation provides the legitimising ideology for control and containment of political disorder and unrest by a strong state.

To make the national dream of prosperity possible, in the face of what are clearly fraught social, political and cultural processes, it becomes necessary to identify and then to exclude and discipline the other, primarily, the 'Muslim' other, a minority community in India. The middle classes not only imagine the nation in their own self-image, but they also need the other, their opposite, to define authenticity in Indian tradition and to grasp its supposedly pristine pure 'Hindu' civilisational core located in a putative 'historical' past, from which the Muslim other has allegedly caused the nation to deviate – a process which must now be reversed to pave the path to prosperity. At the same time, the definition of the national community in the image of the middle classes, its inability to accom-modate plurality, its social and political conservatism, and the valorisation of a strong disciplining state need to be legitimised and made acceptable to a wider constituency beyond the middle classes. The political imperative of realising this project necessitates this vision to be offered to the majority of the population as an inclusionary platform to form a national community, cutting across social divi-sions. But how does an essentially exclusivist middle class imagination offer itself up as an inclusionary vision? To unite the community internally, it becomes useful to conjure up the Muslim other, who is projected as the cause of historical depriv-ation and the stumbling block in the way of realising the national community of plenty. The nation can achieve progress and be prosperous, and the poor can become part of it, if only the evil of the Muslim other could be eliminated. This strategy of invoking the other and focusing on the exclusion of the Muslims thus helps to advance a myth of inclusion.

Although the definition of a bountiful version of the nation and the related depiction of the Muslim other as the impediment to national self-realisation in

these particular forms are recent developments, yet these notions of the Muslim as the internal enemy and authentic Indian tradition as Hindu civilisation are drawn from ideological constructs that developed during the colonial period (Breckenridge and van der Veer 1994: 1–44). An influential and ultimately dominant strand of historical and political discourse, shared by many European and Indian groups alike, located the 'essence' of the Indian nation and its golden age in a putative ancient Hindu past, before the migration of Muslim communities into India and the conversion of some segments of Indian society to Islam. The heritage of ancient Hindu India, projected also as the age of the Aryans, was argued to have been gradually undermined by the Islamic settlers, rulers and converts. In this view, true India and Indian tradition are Aryan and Hindu, and the Muslims are invaders and foreigners on Indian soil and their civilisational contributions are seen only as aberration and dilution of true and pure Indian culture (Thapar 1989a, b). It is that imagined true ancient Hindu Indian culture, along with its supposed and selectively extracted political and social ideals, that the new middle class Hindu nationalists now seek to resurrect, and they invite all Hindus to partake of the emergent powerful and prosperous nation by excluding, indeed destroying, the other – the Muslims.

Image and imagi-nation

In what ways and how far has the mainstream media been involved in communicating and elaborating this vision of the nation in recent years? For a number of studies on the discursive formation of nationalism, the analytical framework is provided by Benedict Anderson's model based on print culture. In Anderson's analysis, printed texts – the novel and the newspaper, which first developed in Europe in the eighteenth century and then spread to the Third World through a diffusion of print capitalism, came to provide the technical means to forge the idea of the nation in societies outside Europe (Anderson 1983). It is, however, now increasingly realised that this model is of limited efficacy in explaining the development of nationalism in the Third World, where not simply the printed text but also the visual image provided a central site for the definition of the nation and the national community. In India, historically, the arena of visual images, as expressed through ritual performance and the public enactment of festival celebrations, had provided the terrain of struggle over symbols of community and identity (Freitag 1989). This arena of visual representation was gradually extended by the introduction of mass-produced chromolithographs, calendar art, printed posters and pictures, followed by the emergence of the film media and more recently the electronic visual media (Chakravarty 1993; Guha Thakurta 1992; Pinney 1995). In the context of India, with its mass illiteracy and diverse linguistic population, visual media like cinema and television have far greater potential than the written text for imagining and narrating the nation and sculpting a pan-Indian identity (Bandyopadhyay 1994).

In the postcolonial period, the growing technologisation of cultural productions, the emergence of the independent nation-state as the producer and

transmitter of a 'national' culture with monopolistic control over both radio and television, the growth of Bombay as the commercial centre of a strong Indian film industry and the advent of big capital in printing and audiovisual media – all brought in significant changes in the production, circulation and consumption of images in social spaces. From the 1980s, India experienced a hitherto unseen boom in the audiovisual media. The expansion of the electronic visual media started in the country in the 1970s under state initiative, and the process rapidly accelerated towards the end of the 1980s with the growing transmission capability of the national television grid and the linking up of regions through satellite technology (Mitra 1993). In 1981, television coverage was 167 million people, but in 1987 the figure reached 500 million. By 1990, television could potentially reach an estimated 90 per cent of the Indian population (Rudolph 1993: 161). Along with the expansion of transmission, the rise of the middle classes also ensured a dramatic growth in the sale of television sets. Through the 1980s, the number of television sets in the country rose from a mere two million to over thirty million (Dubey 1992: 137), but many more people who did not own television sets surely watched television. For, alongside technological expansion and the penetration of the television networks, the serialisation of ancient Hindu epics, the *Ramayana* and the *Mahabharata* launched Indian audiences into the television age. Both these epics, watched by almost half of the nine hundred million people of the country (Rajadhakshya 1996: 30), broke all previous viewership ratings and provided a major fillip to the television industry. While generous doses of computer animation were used to portray the world of myth and miracle of the epics, for a vast majority of their audiences, television itself emerged to be a technological marvel. The greatest testament to the immense potential and new-found power of these visual media was the innovative political uses that they were soon put to. They were taken out of cinema halls and the confines of homes to the streets and the public arena of political and electoral campaigns. The organised Hindu nationalist forces, led by the Bharatiya Janata Party (BJP) and its affiliates, sought to exploit the power of the image to the full. 'Video *rathas*' (vans decorated as religious chariots) toured the remotest corners of the country, screening videos on mythological stories and Hindu nationalist versions of Indian history. Cinema not only survived the onslaught of video and television as an alternative channel of entertainment, but staged a major comeback by the mid-1990s, as film after film broke box office records. Through 1994–95 cinema audiences grew by nearly 30 per cent , bringing many more millions to the cinemas across the country (Rajadhakshya 1996: 28). Of course, the most recent addition to the audiovisual media consists of cable and satellite television with a rapidly widening reach (Crawley 1996).

What accounts for this phenomenal growth of the electronic and film media in India from the 1980s? The unprecedented boom in media technologies, institutions and audiences in the country, while initiated by the nation-state, has come to be driven to a large extent by the expansion of markets and the need to sell ever increasing varieties and volumes of commodities to burgeoning numbers of middle class consumers. The audiovisual media, with its extensive coverage,

provide by far the most useful vehicle both for the promotion of new products and for the cultivation of a consumer culture. Moreover, the new funding imperatives of the electronic media, arising from liberalised government policies from the 1980s, have crucially influenced media expansion. How and why is this so? The reasons are to be found in the very logic of changing media structures and the specific functions they are designed to perform. There are three principal ways in which media institutions and products may be supported. First, they can be financed from revenues that derive from other spheres of the economy, as in the case of state-supported and public-funded media which need not cover their costs themselves. This was the case with the television industry in India until the 1970s. Second, the media industry supports itself by producing and selling cultural commodities like commercial cinema, theatre or music, which thus become a part of material production. Third, the media also produce cultural products that support the promotion of economic products on behalf of manufacturers and advertisers. In these latter two cases, and increasingly significantly for India, a principal focus of the media is audiences. Television networks, through their programming strategies, mobilise audiences and then they directly sell their audiences to the advertisers.

The media thus support themselves crucially by producing cultural products like films or serials, which, in turn, facilitate the promotion of economic products. While advertising commercials do this directly, an increasing number of cultural products like television serials are financially dependent on their ability to deliver the right kind of audiences to their commercial sponsors. In order to produce appropriate programmes that would appeal to target audiences and make them amenable to buying consumer items, the media operatives assess the profiles and preferences of actual and potential audiences through the elaborate process of viewership ratings and demographic and psychographic studies of their audiences. The entire edifice of media funding comes to rest on this need to generate audiences, as was increasingly the case in India from the 1980s. It was from the 1980s that commercial broadcasting on television emerged as a dominant force, rivalling the state-sponsored sector, as the government gradually relaxed its control over the electronic media. With this, the structure of television programming underwent a sea change, and came to be dependent on commercial sponsorship and became oriented increasingly towards mobilising audiences as consumers of goods. At the same time, a favourable environment for the rapid proliferation of commercial broadcasting and the continued buoyancy of the film industry was provided by the expansion of markets and the need of manufacturers of consumer goods to reach potential purchasers through the media and to nurture a consumerist milieu.

From the 1980s, following a more liberal government economic policy which boosted the production of consumer goods, the advertising industry in India began to grow at a remarkably rapid pace to reach the booming middle class market and to sell the products of an expanding consumer goods industry. Advertising budget in the country increased from 2.54 billion rupees in 1981 to 12.5 billion in 1990 and is projected to reach 30 billion by the new millennium. The

advertising industry estimated that advertisers would reach 95 per cent of the urban population and 75 per cent of the rural population by 1995 (Dubey 1992: 152). With the advent of commercial broadcasting on television and the declining importance of government funding, programme producers increasingly found themselves wooing corporate houses and their advertising agencies for sponsorships. Similarly, the private houses and their agents eagerly sought out or commissioned programmes that would match the profile of their products with their potential customers. The consequence was that a large part of programming that went on the country's fastest growing channel for cultural productions, propelled by the imperative of consumer marketing, was primarily chosen for its ability to foster values that would be consonant with an emergent consumer culture and lifestyle. Serials and sponsored programmes that went on air were inserted with advertisements at regular intervals, thus also marking the exponential growth of the advertising commercial itself as a genre of cultural product that had its own appeal to the popular imagination. Title cards were placed at the beginning and end of every programme to systematically remind viewers that from the grand epics the *Mahabharata* and the *Ramayana*, to the more contemporary serials *Humlog* (Ourselves) and *Buniyad* (The Foundation), the narratives of community and statecraft, of lifestyles and families were 'Brought to you' by one corporate house or another. Anyone who has lived in India in the 1980s would recall the popularity of some of the jingles like 'Sabke pasand Nirma' ('Everyone's favourite Nirma' – for a washing powder) or 'Hamara Bajaj' ('Our Bajaj' – for a scooter) or 'I love you *Rasna*' (for a soft drink concentrate).

Importantly, the expanding domains of production and transmission of media images are, however, far from open arenas offering free entry to all interests and voices. Currently, the cost of inserting one thirty-second prime-time commercial on national television is 450,000 rupees, and that of producing an average television commercial is around 1.5 million rupees. The cost of placing one double-spread colour advertisement in major national news magazines is about 550,000 rupees, while the production expenses can run into a few hundred thousand rupees. A single round of half-page newspaper advertisements in Delhi can cost an advertiser around 50,000 rupees. A mainstream commercial film can cost tens of millions of rupees. The cost of each episode of television serials can range from 100,000 to 500,000 rupees and above, depending on their regional or national status and the star rating of their actors.[5] Clearly, the power of money determines access to the realm of commercial advertising, sponsored television programmes and films. In this world of the media, the terms of production and transmission are dictated by the needs of capital and the demands of the market.

Inevitably, this has significant and very specific implications for the ideas and values that are likely to be produced in the media. The growing market orientation and liberalisation of the media, especially television, from state control has led to the privileging of some selected, often a very narrow set of, images and ideas in the media. If in the past some sectors of the government-run electronic media represented statist visions and ideologies, now the media are driven by the logic of markets and profits, and accordingly express the dominant values of a

consumer world order. As terrestrial and satellite television, including their advertising slots, along with the cinema emerged as the central site for dissemination of social and political discourse, the visual media became a primary platform for launching an extensive 'assault on the mind', to borrow a phrase from Ries and Trout (1981). The result was an all pervasive and continuous flow of the images of a consumerist world order, in which the codes of consumption submerged within the narrative structures of television programmes or commercial cinema were punctuated with the direct and up front interpellation of advertising commercials, each reproducing and reinforcing the other.

Interestingly, however, as the following section will show, the changing media have drawn upon prevalent ideologies and ideas and then made some of those, in selective ways, grist to their own mill of commerce, consumption and markets. The media did not simply conjure up new ideas from thin air to implant them on the minds of the audience. Rather, in the process of advancing a consumerist ethos, the media reconfigured and reoriented existing ideas in particular highly decisive ways, and at the same time privileged some ideas while submerging others. In the context of 1980s India, we shall try to show in the following section that the messages of consumption and consumerism came to be linked with particular prevalent constructions of family, community and the nation. Media images became enmeshed with a specific conception of nation-building of the 1980s which emphasised national integration. With sectarian strife and fissiparous political movements besetting the Indian nation in the 1970s and 1980s, a chief preoccupation of national discourse had emerged to be the integrity and oneness of the nation, its foundations in bonds of community and the familial cohesion of its people. Alongside capitalising on this discourse, and equally significantly, the media heavily relied on contemporary Hindu nationalist imagination and, in turn, helped to fuel that imagination further. We do not, however, mean to suggest that media constructions thus had any direct link with the BJP – the Hindu nationalist political party, nor that there is any religious fundamentalist conspiracy in the media. Instead, we take the view that with the market driving the growth of the media, and the middle class forming its primary target audience, not surprisingly, media productions not only drew upon, but also reproduced and magnified middle class notions of the 'Hindu' nation in a bid to promote consumerism among these classes. For, it is by tapping into and embellishing these emerging nationalist visions and middle class preoccupations that commercial products could be sold most successfully. In the process, the media could play a crucial role in concretising, popularising and entrenching a new emerging vision of the nation, defined both by consumption and a Hindu national identity. In the following section then, we look at the changing media scene to argue that one of the important 'products', 'sold' across dominant media channels, in the crucial moments of the 1980s and 1990s, was, in fact, a specific vision of the nation and its 'other'.

Selling goods and the nation

In the 1980s, India faced a period of political instability with several changes of governments, violent regional movements in Punjab, Assam and Kashmir, assassination of the head of state and the erosion of the legitimacy of the nation-state. The government of India released a series of television and press advertisements and poster campaigns in an effort to convey a message of an integrated, stable and progressive nation. One of the most notable of these advertisements on television went under the title 'Mera Bharat mahan' (My India is Great). These commercials, shown with persistent regularity on prime-time television, tried to market a specific construction of a nation to a large national audience, mobilised, by now, through the expansion of transmission networks. The commercials featured a number of celebrities pledging their commitment to the nation, happy children and healthy and active youth, famous singers singing a common song against varied backdrops of the natural beauty of different regions of India, eminent sports personalities carrying a flaming torch – the torch of the nation, all backed by a rousing music track composed to convey the emotional surge of a nation on the move. This was also the time when national television serialised 'Bharat: ek khoj', a dramatised version of Jawaharlal Nehru's book *The Discovery of India* – a classic search for the essence of the Indian self that formed the basis of the nationalist imagination of the postcolonial Indian state, of which Nehru was the first prime minister and the major architect and ideologue. Tata Steel, a corporate giant, sponsored the programme and commissioned a set of commercials which highlighted the contribution of the corporate house to the making of the nation. The theme lyric of the commercials claimed, 'We kindle rays of hope (*aasha*) . . . and show the way to success'. The main slogan for the campaign was 'We also make steel', implying that nation building was the real or primary goal of corporate India, and steel making was an integral part of that project. This private sector view of the nation was strikingly close to the nation-state's construction of India. Visuals of promising youth and torches, of flags and people running ahead in slow motion, of nature as a source of beauty and bounty, provided the text for both. The nation here was a big, smiling, happy family of loving people in a motion of progress.

If the corporate imagination of Tata Steel came uncannily close to the nation-state's social and political vision of India, there were a whole host of others who were embellishing and animating these overt messages of the nation and packaging them into a range of commercials for consumer products, deploying cognate images. Their visual strategies drew upon and extended the media images of nation-building to offer the promise of participation in this growing and bountiful nation through the act of consumption. Thus emerged the persona of the empowered citizen consumer, belonging to the extended family of the nation. Bajaj, the leading producer of two-wheeler scooters and three-wheeler motor vehicles in India, came up with a campaign: 'Hamara bajaj' (Our Bajaj). This campaign, consisting of a very popular television commercial as well as a series of press advertisements, showed the scooter set in a series of vignettes of happy

Indian families and communities. Here the two-wheeler symbolised a desired lifestyle of upward mobility and resonated with the spirit of a nation on the move. It was also grounded in the reality of the time, when a much vaunted 'two-wheeler revolution' marked the new mobility of India's middle classes, and upheld the two-wheeler as the passport to an increasingly globalised consumer community. Indeed, the two-wheeler boom and the upturn in the consumer market that it signalled were taken to signify a major breakthrough in the Indian economy and its liberation from stagnation. Yet another commercial of this period, produced for VIP luggage and suitcases, portrayed departures and arrivals, journeys away from and returns to homes and families, and continuous movement through generations, places and times. The central metaphor here too was mobility, not only in physical locations but also in social spaces. What is interesting and important for our discussion here are the similarity and overlap of these imaginations across various kinds of advertisements, encompassing visions of the nation produced by the Indian state and images of consumer lifestyles. In this, the linking of audiovisual images of social and personal mobility with the progress and the forward motion of the nation helped to project and legitimise consumption as an act that produces national and social good. The creative strategies to communicate this message through visual images were reinforced with the use of music and lyrics. With recurring words like 'my', 'our', 'hope', 'direction', 'horizon', 'new' and 'tomorrow', and with music tracks fusing Indian and Western instruments, the advertising jingles echoed each other in their broad compositional character. Indeed, many of these tracks were actually produced at the studio of Louis Banks, one of the most successful commercial composers in India.

The commercials for consumer products were at the same time seeking to sublimate and realise the dream of the wider integrated, happy and healthy nation, such as that of 'Mera Bharat mahan' and Tata Steel, by domesticating that message through images of joyous and prosperous families and extended kin networks. Although the idiom in all these cases was that of the family and the interconnectedness of the people, yet there was a gentle but decisive shift – a funnelling down – in the commercials for consumer goods. From the public sphere of the nation-space with people from different regions and walks of life forming the national family, the sense of an integrated community was now distilled down and located in the private sphere of the home and proximate friends and relations. In the next move, the large and buoyant family then came to form not only the core of community but also the locus of consumption. The private family as the site of consumption was mapped on to emerging images of the integrated, happy national community as an extended family, thus ideologically configuring nationalism closely with consumerism. A large number of commercials produced during this period (*Rasna*, the soft drink concentrate, *Vicco Turmeric*, the herbal beauty cream, *Vicco Vajradanti*, the herbal toothpaste, *Pan Parag* betel nut spice, *Godrej* steel wardrobes, among others) showed friends and families, with children and women as key figures, steeped in an environment of happiness and bonhomie, camaraderie and celebration of social ties. A soft drink

mix, therefore, ensured successful birthday parties with overly healthy kids leaping about; the right steel cabinet safely protected a happy marital life; a fairness cream turned a woman into a desirable bride; the sharing of betel nut spice guaranteed that the chemistry between the in-laws was just right; a toothpaste made from ancient Indian medical formulae kept generations smiling and biting. In all these, 'traditional' Indian families found fulfilment through instant consumption.

The family as the basic unit of consumption was also the space where the battle for the distinctive identity of the new middle class consumer as the authentic Indian citizen had to be fought and won. The cultural coding of the lifestyle of the family, therefore, had to be clearly 'Indian' and 'Hindu'. Indeed, the image of the family itself in these commercials increasingly assumed an iconic character as quintessentially Indian. This was reinforced by the fact that some of the soap operas which the advertisements punctuated, 'Khandaan' (The Lineage), 'Humlog' (Ourselves), 'Buniyad' (The Foundation), were family sagas spanning generations, as their titles clearly signalled, which in turn dovetailed into the serialised epic narratives of the family in the *Ramayana* and the *Mahabharata*. It is telling that the Hindu nationalist political party and its affiliate organisations also call themselves the family – 'Sangh parivar'. The ambience of the families in the advertisements also sought to portray a distinctive 'Indianness' even in their acts of consumption. It is the proven power of ancient Indian herbal formulations in the Vicco fairness cream that made the modern Indian woman fair and, therefore, eligible in the marriage market. It is eating the right betel nut spice *pan masala*, an 'indigenous' and 'timeless' tradition, that enhanced sociability and amity, especially at weddings. It is the right flavoured drink mix that exhibited traditional Indian hospitality, as large numbers were invited to join in family celebrations. It is the power of indigenous medicinal concoctions in a toothpaste which fortified family health through generations. In all these, images of Hindu social ceremonies, rituals, marriages, kinship and lineage were projected as markers of 'Indianness'. Narratives of abundance and prosperity, of a new well-being and happiness were cradled in an unmistakably indigenist and 'Hindu' idiom.

We have seen so far that the world of commercials achieves, through interconnected images, a continuous transition from the family to community to a nation that is healthy, wealthy, Indian and ready for all to partake of. But these cultural spaces, resounding with tuneful jingles and peopled by the smiling middle classes are also marked by the omission of certain people. In the 1980s and the 1990s, the over-hundred million strong middle classes of India can form a very major consumer market, but they are still only a minority in a country of nine hundred million people. Where are the others? Wherever they are, they are not on television and are increasingly hard to find on celluloid. The logic of inclusion through consumption must also exclude people who cannot consume the branded products in the market. The poor as poor have no role in this new vision. They must first qualify by proving their consuming power in order to enter into this community of plenty. In these ideal social environments, citizens have the responsibility of ensuring their own happiness and the continued productivity of

the economy by making the right decisions as consumers – supporting the right brands of two-wheelers, luggage, beauty cream or government. Gone are the tasks of building the nation through hard labour and production. The farmers and workers, the mainstay of a nationalist vision for most part of the past fifty years, are now at best marginal figures.

The interchangeability and continuity of media images are by no means restricted to the limits of a single medium. On the contrary, media images work with certain dominant patterns of transference and transaction, not simply between various kinds of television commercials, but also from them across to the cinema screen. The aesthetic and structural logic of Indian commercials is translated effectively to the fictional narrative of films,[6] while the commercials, in their construction of images and icons draw from the established conventions and encoding practices of cinema and other media. This cross-media reach of the images, and their continued recurrence, repetition and mutual reproduction, help to reinforce certain dominant messages (Enzensberger 1974). Many of the themes and images of advertising appear, for instance, in *Hum Aapke Hain Koun*, a recent film that broke all box office records in the history of Indian cinema.[7] It is a film about relentless merriment and enjoyment – 'a non-stop roller-coaster of laughter, food, songs and games', as one commentator has noted (Bharucha 1995: 801). The visual images of camaraderie, eating and drinking in the film are only too reminiscent of the advertising commercials. The film itself is virtually an elaborate commercial for a utopian society based on a family with an extended network of real and fictive kinsfolk and a given state of affluence. The unmistakable message of this film, as of many commercials, is that a community of happiness is achieved through loving social bonds and good food and good life. Moreover, similar to various commercials, family life here too is emphatically and self-consciously Indian and indigenous in nature, expressed through the ubiquitous symbols of Indianness which have assumed a fetishist and iconic status through the commercials – wedding celebrations, Hindu ceremonies, home-cooked food, uncles, aunts, cousins and so on. As in the commercials it resembles, there is also in the film a normalisation of opulence in everyday family life, as far away as possible from the underlying fierce social processes of accumulation. The vision of exhilarating and overwhelming, but oppressive, happiness aggressively stamps out the images of labour and poverty that do exist in the world of reality. The poor are banished from the frame and framework of the film. The construction of this happy vision is, however, not a benign, innocent, apolitical process of creation of products of entertainment and pleasure. In fact, a violent political act of exclusion is silently committed in the realm of the image, replicating the brutal and complex processes through which the poor are marginalised and oppressed in the social and economic life of the nation, and also increasingly from the vision of the national community. The reasons why large numbers of Indians, who are poor, watched this film and partially contributed to its commercial success is not a question that we can address here, except perhaps to point at the power of a need to believe in the dissolution of want and the promise of plenty, as Bharucha (1995: 803) has suggested. It is also worth noting that the strategy to place a

brand at the aspiration level of the audience is standard advertising practice, (Ogilvy 1983) and the mobilisaton of desires and the offer of vicarious fulfilment form the underpinning logic of advertising.

If *Hum Aapke Hain Koun* is all about defining the boundaries of this new nation-space of consumer-citizens from the inside, another film, *Roja* performs the task of communicating the notion of its enemy Muslim other.[8] Billed as a patriotic love story, *Roja* was also a major commercial success. The film won an award from the Indian government for its nationalist spirit. The entertainment tax was waived by the government so that tickets would cost less and more people would be encouraged to see the film. The audiences, reported in one case to comprise mostly Hindu males from the middle and lower-middle classes, indulged in loud cheering and shouting. They were not, however, responding in this way to thrilling fights or titillating dances as often seen in many cases of commercial cinema entertainment. They were instead shouting slogans like 'Down with Pakistan' and 'Glory to mother India' (Niranjana 1994). The film begins with a distant prayer from a mosque. As the visual fades in, we see a menacing army lorry entering a pine forest. A superimposed title describes the place as 'Shrinagar, Kashmir' which, as the audience can immediately identify, is the site of a protracted and escalating struggle for greater political autonomy, waged by a predominantly Muslim Kashmiri population and directed against the Indian central state. What follows is an encounter between Kashmiri militants and the Indian Army, leading to the arrest of an armed terrorist. From the scary, grim, strife-ridden, blood-smeared and dark forest of Shrinagar, shot in blue monotone, the film then immediately moves on to an explosion of light and the gorgeous colours of idyllic rural India, this time identified as 'Sunder Bhanpur'. Unlike Shrinagar, Kashmir, Sunder Bhanpur is a fictional place, which could be anywhere or everywhere in India. It is deliberately not mapped onto any specific geo-graphical area, thus projecting it as a quintessential and universal Indian location. This is an India where the eponymous heroine Roja, drenched by a gushing waterfall, moves across visuals of plenty and social harmony, of a timeless Hindu culture and spiritual serenity, of Hindu idols and piety in everyday life, of joy and gaiety, as she sings a song of hope of the heart (aasha), of reaching out for the sky and the moon and the stars. The images of this India, the tune of the song, the editing pattern of the montage and even words like 'hope' and 'reaching out for the sky' are poignantly resonant and reminiscent of contemporary advertising commercials, both for the Indian government and the private sector. A few close-ups of a brand, and this could be turned into an effective brand commercial. Even in its given form, Roja does work as a promotional film for a certain view of the Indian nation and its authentic citizens. From scenes of rural bounty and sociabil-ity, the film moves to spaces of community and family, as Roja is married to a young computer professional from the city. Once again, an 'Indian' way of life is valorised, in which images from commercials seem to slide across to the film: celebration of matrimony, affectionate communion with Hindu gods in natural sacral landscapes and social bonding and festivities. With the newly married couple, the film then moves to the town where we see a middle class household

complete with the comforts and facilities of consumer durables and modern conveniences, similar to those in cooking oil or pressure cooker commercials. Through all this, the image of a desirable and normalised definition of a community is presented in a continuum from the village to the town. The imagined community of the nation begins to look essentially Hindu and comfortably middle class in nature.

Soon after the marriage, Roja's husband Rishi Kumar, accompanied by Roja, travels to Kashmir on an official government assignment. In Shrinagar, he is abducted by Kashmiri militants, whose primary identity in the film is that of fanatical Muslims. This kidnap by the militants signifies a double threat to the national community. The Muslim militants' attack on the nation-state from the boundaries in the northern-most state of India is not only a threat to the political and territorial integrity of the country; it is also a clear act of transgression against the family of Roja – the core of the national community. The attack is now on the homeland, home and family as conjured up by the interlocking images of *Mera Bharat Mahan* or Tata Steel, *Hum Aapke Hain Koun*, *Bajaj* or *Rasna*. This portrayal serves the double purpose of identifying the Muslim as both part of an external enemy other (as Kashmir is one of the key issues in India's conflicts with Pakistan) as well as extending this identity to Muslims anywhere in India as the internal enemy other. Moreover, to amplify and magnify the terror that this 'other' may unleash, the film, almost from the very first frame, deploys a creative strategy to portray the Kashmiri insurgents as menacing villains fired by the zeal of religion. The grim opening scene of the battlefield starts with a Muslim prayer on the soundtrack, emphatically stamping a link between Islam and warfare from the outset. The militants, combating the Indian army, look cruel and sinister. Throughout the film, Islam and Muslims are always associated with fire and bombs, dust and darkness, violence and disruption, while the Hindu places of worship are located in green and serene surroundings. In what is arguably the central sequence of the film, a fanatically calm Liaquat, Rishi Kumar's Muslim captor, is seen offering his prayers, while Rishi Kumar almost immolates himself, trying to save India's national flag, set on fire by the terrorists – an image that encapsulates the film's central equation of Islam with subversion, terrorism and a pathology of violence (Bharucha 1994).

Having created the figure of the other and fleshed out its horror, the film then proceeds to find ways and means of combating the threat. The Kashmiri militants would only release Rishi Kumar in exchange of the freedom of their leader Wasim Khan, arrested by the army in the first sequence of the film. A frantic heroine/wife now pleads with the authorities and runs from pillar to post to secure her husband's freedom. Finally, much to the chagrin of the army colonel, who points out that many lives have been sacrificed to arrest the terrorist, Roja persuades the government minister to agree to this exchange. Meanwhile, Rishi Kumar, the modern Hindu male, of course, has other ideas. The power of his patriotic passion and articulate vision of the nation finally wins over the rather misguided and fanatical Liaquat and earns him freedom. Eventually, the repentant and relenting militant, with tears in his eyes, lets Rishi Kumar go back to his homeland and

family. As Rishi Kumar crosses the bridge between the margin and the central national zone, he is embraced by a loving wife, while the army colonel and a common Indian whom Roja had befriended, both members of the extended Indian national family, affectionately look on. The Kashmiri Muslim, who can only help the definition, coherence and integrity of this family by acting as its enemy other, of course, is not included in this final embrace and must remain outside its boundaries.

If the moral and social order of this nation is grounded in the family, which is at the centre of an interrelated community, the political order and institutions must work to reinforce it and protect it against possible attacks. In *Roja*, we find the state invoked precisely to perform this function. At a moment in Indian history when the nation-state is marked by its increasing withdrawal from the economy, *Roja* calls into being the Indian state for the protection of its citizens and ascribes to it the role of a repressive machinery for enforcing law and order. While in the particular incidents in this film, Rishi Kumar's ingenious patriotism is capable of disarming the terrorists without the deployment of the military might of the state, nevertheless, the state, in the form of the army and the government minister, is poised in readiness to act if necessary. In addition, the state's humane response to the crisis of an ordinary family not only confirms its benevolent paternalistic protection of the citizen, but also masks its repression in Kashmir, legitimising its role in the region. In a film that shows the atrocities committed by the militants on the captive Rishi Kumar in great detail and the subversive, destructive nature of their movement in Kashmir, there is no hint of the extensive human rights violations systematically perpetrated by the Indian state (Puri 1993). There is only one cursory, impersonal, faceless shot of Kashmiri detainees, shown in the fashion of television newsbite. The fictional drama of one kidnapping in the film is privileged over a long history of the suffering of the Kashmiri people.

Conclusion

Our exploration of media productions in the India of the 1980s and 1990s has shown the emergence of a certain vision of the nation in the mainstream media, in which the middle class family forms the core of a community and a nation-space of plenty, and consumption provides the primary mode of enfranchisement. The imperative of an expanding consumer goods market to reach out to and embrace the burgeoning middle classes has not only propelled a boom in the audiovisual media, but also determined the nature of media images of the nation, the authentic Indian 'self' and the 'other', with the middle classes and consumption at the heart of it. Images of scarcity, poverty or labour, which sit uneasily with middle class aspirations and worldview, are largely excluded from this portrayal of the nation and citizenship. Moreover, in the media, a Hindu Indianness, often defined against Muslims, provides the cultural coding of the nation and its dominant identity. Middle class urges for discipline and order in the face of social and political instability are also expressed through the invocation of a protective and benign but powerful, law-and-order state as the guarantor of the integrity of the

nation and of the safety and security of its deserving, authentic citizens. The discussions here have also demonstrated that various segments of the media in different but overlapping ways convey the interlinked messages of consumerism, nationalism and Hindu Indianness through their images and icons with discernible patterns of continuity, recurrence and interchangeability in their discursive strategies. Our investigations in this chapter suggest strongly that the central role played by the audiovisual media in crystallising and foregrounding a middle class consumer identity anchored in Hindu nationalism helped to strengthen decisively the ideological milieu within which religious fundamentalism and Hindu nationalist politics could thrive, achieve dominance and advance rapidly from the 1980s in India. We have argued, in this respect, that media constructions of the notions of family-community-nation need to be seen as both produced by, and in turn, reproducing, amplifying and underscoring, some of the ideas emerging through social and political processes at a particular moment in Indian history.

The human mind is one of the important terrains where the battle for guaranteeing particular definitions of the nation is being fought. Not surprisingly, the media, in their role of producer of meanings, play an important role in these struggles. It is worth clarifying, however, that we do not take a view of the media as monolith and speaking in one voice with no space for alternative visions. We maintain though that the logic of the market and the politics of consumerism in contemporary India do tend to privilege particular visions and undermine others. We, therefore, hold that the middle class consumerist-nationalist vision that we have identified and analysed here has increasingly gained dominance, currency and even legitimacy through widespread dissemination and emphatic repetition in media spheres. It is further worth noting that, in arguing the above case, we do not suggest a hypodermic model where media messages can be simply injected into the mind of the audience to influence their views and visions of the world directly. The process of reception and consumption of media products is a complex one, which we have not addressed here. Nonetheless, we feel it is important to identify the dominant discourses, their modes of operation and their provenance in social processes and political economy. For these discourses do shift and redefine the parameters and boundaries of ideological debates and may even stifle the emergence of alternative visions, especially when an increasing number of Indians are being engulfed by a specific set of ubiquitous and insistent media images. As Marx noted, people do make their own meanings but not in conditions of their own choosing.[9] To recapitulate a point made earlier, the dominant mainstream media play a role in the propagation and production of discourses which aim to establish hegemony, and in this, media spheres do not function as apolitical and democratic public spheres, offering equal access and freedom of expression to all voices. The processes of the incessant hammering of specific representations, the relentless privileging of certain constructions against others within these media spaces, and the consequent marginalisation and subordination of alternative voices, are, therefore, political acts of affirmation of power, of will to control and of exclusion of certain social groups and contested ideologies.

Notes

1 See Garnham 1993.
2 See Dubey 1992 for a discussion of the recent development of the Indian middle classes. It should be noted that the middle classes, as could be expected, include many diverse social segments and are not internally cohesive or homogeneous. However, in the interest of brevity here, we have eschewed a discussion of the internal complexities of the middle classes and emphasised some general points.
3 For an interesting case study of social tensions precipitated by economic liberalisation, see Shah 1994.
4 Hindu nationalism in India is a complex and varied phenomenon, which cannot be fully discussed here. A number of recent studies have dealt with the subject on which our account is based. See, for instance, Basu *et al.* 1993; Jaffrelot 1996; Malik and Singh 1994; Nandy *et al.* 1995; Pandey 1993; Rajagopal 1994; van der Veer 1994.
5 These figures have been supplied by Mudra Communications, Bombay and the estimates were derived from the prevalent costs in summer 1996.
6 This point has been made in analysing a recent film by Bharucha 1994 and Niranjana 1994, among others.
7 The following account of this film is based on Bharucha 1995.
8 This analysis of the film *Roja* draws upon the extensive debate on the film in the pages of *Economic and Political Weekly*. See for example, Niranjana 1994; Bharucha 1994; Chakravarthy and Pandian 1994; Srinivas 1994.
9 A similar point with respect to the media is made by Angus and Jhally 1989.

References

Anderson, B. (1983) *Imagined Communities: Reflections on the Origin and Spread of Nationalism*, London: Verso.

Angus, I. H. and Jhally, S. (eds) (1989) *Cultural Politics in Contemporary America*, New York: Routledge.

Bandyopadhyay, N. (1994) 'Nation, representation and gender: "Mother India': the making of a film, a mother and a nation', unpublished MA thesis, University of Sussex.

Basu, T. *et al.* (1993) *Khaki Shorts and Saffron Flags: A Critique of the Hindu Right*, Hyderabad: Orient Longman.

Bharucha, R. (1994) 'On the border of fascism: Manufacture of consent in "Roja"' *Economic and Political Weekly*, 4 June, 1389–95.

Bharucha, R. (1995) 'Utopia in Bollywood: "Hum apke hai koun"', *Economic and Political Weekly*, 15 April, 801–4.

Breckenridge, C. and van der Veer, P. (eds) (1994) *Orientalism and the Post-colonial Predicament: Perspectives on South Asia*, Delhi: Oxford University Press.

Chakravarthy, V. and Pandian, M. S. S. (1994) 'More on "Roja"', *Economic and Political Weekly*, March 12, 642–4.

Chakravarty, S. S. (1993) *National Identity in Indian Popular Cinema*: 1947–87, Austin TX: University of Texas Press.

Crawley, W. (1996) 'Air wars: Competition and control in India's electronic media', *Contemporary South Asia*, 5 3: 289–302.

Dubey, S. (1992) 'The middle class', in P. Oldenberg, (ed) *India Briefing*, Boulder, CO, London: Westview Press, 137–64.

Enzensberger, H. M. (1974) *The Consciousness Industry: On Literature, Politics and the Media*, New York: The Seabury Press.

Freitag, S. B. (1989) *Collective Action and Community: Public Arenas and the Emergence of Communalism in North India*, Berkeley, Oxford: University of California Press.

Garnham, N. (1993) 'The mass media, cultural identity, and the public sphere in the modern world', *Public Culture*, 5: 251–65.

Guha Thakurta, T. (1992) *The Making of a New 'Indian' Art: Artists, Aesthetics and Nationalism in Bengal*, c.1850–1920, Cambridge: Cambridge University Press.

Hansen, T. B. (1996) 'Globalisation and nationalist imaginations: Hindutva's promise of equality through difference', *Economic and Political Weekly*, 9 March, 603–16.

Jaffrelot, C. (1996) *The Hindu Nationalist Movement, 1925–1992: Social and Political Strategies*, New Delhi: Viking.

Malik, Y. K. and Singh, V. B. (1994) *Hindu Nationalists in India: The Rise of the Bharatiya Janata Party*, Boulder, CO: Westview Press.

Mitra, A. (1993) *Television and Popular Culture in India: A study of the Mahabharat*, New Delhi, London: Sage.

Nandy, A. *et al.* (1995) *Creating a Nationality: The Ramjanmabhumi Movement and Fear of the Self*, Delhi: Oxford University Press.

Niranjana, T. (1994) 'Integrating whose nation? Tourists and terrorists in "Roja"', *Economic and Political Weekly*, 15 January, 79–82.

Ogilvy, D. (1983) *Ogilvy on Advertising*, New York: Crown.

Pandey, G. (ed.) (1993) *Hindus and Others: The Question of Identity in India Today*, New Delhi, London: Viking.

Pinney, C. (1995) 'Chromolithography, locality and the articulation of the 'popular': 1878–1995', paper presented at the conference on 'The consumption of popular culture in India', 19–21 June, School of Oriental and African Studies, University of London.

Puri, B. (1993) *Kashmir: Towards Insurgency*, New Delhi: Orient Longman.

Rajadhakshya, A. (1996) 'Strange attractions', *Sight and Sound*, August, 28–31.

Rajagopal, A. (1994) 'Ramjanmabhoomi, consumer identity and image-based politics', *Economic and Political Weekly*, 2 July, 1659–68

Ries, A. and Trout, J. (1981) *Positioning: The Battle for Your Mind*, New York: McGraw-Hill.

Rudolph, L. I. (1993) 'The media and cultural politics', in H. A. Gould and S. Ganguly (eds) *India Votes: Alliance Politics and Minority Governments in the Ninth and Tenth General Elections*, Boulder, CO, Oxford: Westview Press, 15–179.

Shah, G. (1994) 'Economy and civic authority in Surat', *Economic and Political Weekly*, 8 October, 2671.

Srinivas, S. V. (1994) ' "Roja" in a law and order state', *Economic and Political Weekly*, 14 May, 1225–26.

Thapar, R. (1989a) 'Imagined religious communities? Ancient Indian history and the modern search of Hindu identity', *Modern Asian Studies*, 23 (2): 209–31.

Thapar, R. (1989b) 'Which of us are Aryans?', *Seminar*, 364: 14–8.

van der Veer, P. (1994) *Religious Nationalism: Hindus and Muslims in India*, Berkeley, London: University of California Press.

6 Projecting Africa
Two British travel films of the 1920s

Emma Sandon

Introduction

I propose in this chapter to examine two British travel films which are housed as non-fiction films in the National Film and Television Archive: *Nionga* (1925), made by missionaries in an unidentified part of Central Africa, possibly Zaire, and *Stampede* (1929) made by adventurers Major and Stella Court Treatt in southern Sudan. Both films were shot on location on the African continent using indigenous performers and they claim to show native life in Africa. My purpose in resurrecting these films is to assess them in relation to other British ethnographic display practices of the period rather than in terms of whether they are authentic representations of African life which is the way in which Rachael Low and other film historians have considered them. The way in which I will approach the task of recontextualising the films is to first set them within the framework in which traditional film histories have discussed them and then discuss them in the light of more recent approaches to film historiography and spectatorship in silent cinema.[1] In the second part I will talk about the films within the broader cultural practices of their period, drawing on studies of museology to examine the relationship between the films and traditions of ethnographic performance and modes of exhibition during the late nineteenth century and early decades of the twentieth century. Before embarking on this analysis, let me introduce the two films.

Nionga was released in 1925 as one of Stoll production company's 'high class productions' and it ran in cinemas throughout the UK during 1925 and 1926 according to the trade press: *Bioscope* and *Kinematograph Weekly* (Figure 6.1).

The film follows the fortunes of a young couple of the Molungo tribe in Central Africa.[2] Nionga, 'honey of the tribe' and the daughter of the Chief Kaieye, and Masari, 'the lion's paw', a warrior of the tribe are betrothed. The innocent couple seek their fortunes from the local 'witchdoctor', Katoto, who uses them to promote his own interests. He advises Nionga to tell Masari to attack the Kimana tribe, an action which he assures her will bring them future prosperity. The chief sends messages to a number of villages to announce the wedding celebrations. Meanwhile Masari attacks the Kimana village and, when the villagers retaliate, a battle takes place in which Masari is killed. The film ends with Nionga being burnt

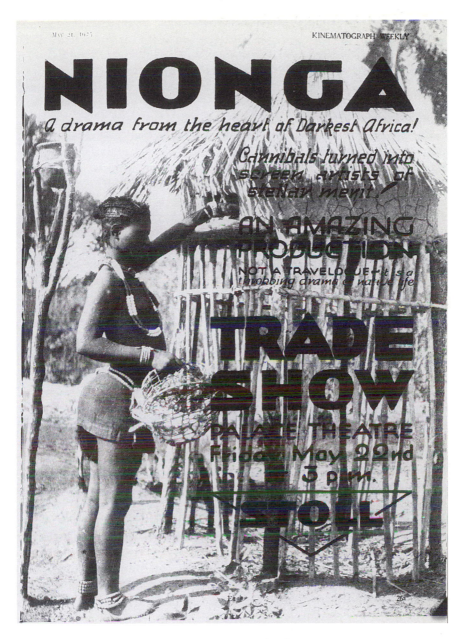

Figure 6.1 Cannibals turned into screen artists of stellar merit.

Source: Kinematograph Weekly.

as a human sacrifice to restore peace, an act sanctioned by her father Chief Kaieye to appease the angry spirits.

Stampede came out five years later. It was released by British Instructional under their distribution company label Pro Patria in 1930, and was opened at the London Hippodrome in the presence of the film-makers, Major C. Court Treatt and Stella Court Treatt. It was billed as 'an antidote for the exhibitor who has lost heart with the silent picture' at a time when distributors continued to release films in both silent and sound versions (*Bioscope*, 19 March 1930: 2) (Figure 6.2a and 6.2b).

The film is about a couple who are members of a wandering tribe in Africa. Boru is adopted into a tribe as a baby by the wife of a Sheikh of the Habbania tribe after his mother is killed by a lion. He grows up happily with the Sheikh's son, Nikitu. Loweno, a young girl, befriends them and both boys fall in love with her. One year, when the boys are grown men, the tribe suffers from a drought and decides to migrate. Boru and Nikitu locate a fertile place with water across the desert, however on the journey the tribe encounters mishap and danger. Nikitu and his father, the Sheikh, become trapped by a forest fire and they get killed in spite of Boru's efforts to save them. The adopted Boru then becomes the leader of the tribe. In time he declares his love for Loweno and at the end of the film they marry (Figure 6.3).

An analysis of *Nionga* and *Stampede* through film historiography

The films as part of an ethnographic genre

There is little to be found about *Nionga* and *Stampede* in existing histories of film, and where they are mentioned it is in studies of non-fiction or documentary films.[3] Rachael Low is the only one to have mentioned *Nionga* directly as suggesting it shows 'an interest in the local customs' of Central Africa (Low 1971: 289). She also discusses the production of *Stampede* (Low 1971: 290) and she is unconvinced by its representation of the people of Sudan, 'It is fair to question whether Stella really did know the life and customs of the people or simply imposed her own idea of a romantic story on the unfamiliar setting and people' (Low 1979: 70). *Stampede* also gets a brief mention elsewhere largely because the film-makers were known for other productions (Patterson 1992: 101) and because the film constitutes an example of filming activities in Africa (Cameron 1994: 50). In these accounts neither *Nionga* nor *Stampede* is rated as being very realistic in its portrayal of the everyday life and culture of the people it represents. The focus on the authenticity of the films, which is the motivating factor of many studies of non-fiction film and documentary, has resulted in little engagement on the part of film historians with why films like *Nionga* and *Stampede* were produced and how they were exhibited and received. A general lack of critical interest in the films has also been compounded by the issue of categorisation. The National Film and Television Archive describes *Nionga* and *Stampede* variously as documentary, ethnology and drama-documentary.[4] The label of

drama-documentary, dramas which claim to represent the real conditions of existence of people, has contributed to the tendency for the films to be placed at the fringes of discussions of non-fiction films. This is particularly the case because as silent films they were produced at a time when categories of documentary as opposed to fiction had not yet been clearly established. Examples of films like *Nionga* and *Stampede* are known to have existed from as early as 1907 and as a group, film historians have tended to discuss them as 'exotic' (Low 1971: 289, Bordwell and Thompson 1994: 202, MacDougall 1976: 138) 'hybrid melo-dramas' or 'documentaires romance'.[5]

Most historians of non-fiction, documentary and ethnographic film[6] agree that these various types of film belong within the category of a broad ethnographic genre. David MacDougall talks about them as films which are modelled on fiction films. He argues that they are important to the history of ethnographic film as it is in this genre that we find the earliest evidence of an attempt to develop ethno-graphic narrative. 'After 1910 a few films about non-European societies appeared which suggested a dawning of interest in an indigenous point of view and the portrayal of an indigenous subjectivity'(MacDougall 1995: 228). Referring to the example of *A Transformed Isle* (1908) made in the Solomon Islands, he argues that the film-makers, who were missionaries, in staging dramas about native life which used local people and real events, strove to create a subjective effect. The use of film titles which invited the spectator to 'see what the native sees' is evidence of a new perspective to the portrayal of the subject. Other writers agree that the films of this popular ethnographic genre paved the way for the emergence of documentary practice and some argue that this is the point at which we can detect a new mode of perception in film practice.[7] However, the way in which this discussion develops tends to then focus on northern American films and British examples of the genre are not examined in this context.[8] I am not able here due to space to compare or discuss the influence of the North American examples of the ethnographic genre on *Nionga* and *Stampede*. What I propose instead is to examine these two British examples of the genre in the hope that it may contribute to our conception of the emergence of the ethnographic narrative. In order to do this I think it is more fruitful to look at *Nionga* and *Stampede* through models of spectatorship rather than focusing either entirely on the question of the films' relationship to questions of realist and authentic representation of their subject matter or through debating their similarities to fiction films, though both aspects will be implicated in my overall discussion.

The films in terms of their relationship to early and silent film practice

It is difficult to assess how many people would have seen *Nionga* and *Stampede* as there are no box office figures or existing research on their reception. We only have reviews of the films in the trade magazines, newspapers and journals to refer to. *Nionga* and *Stampede* were released at a low point in British film industry in the latter part of the silent years. British films had been very successful in the early

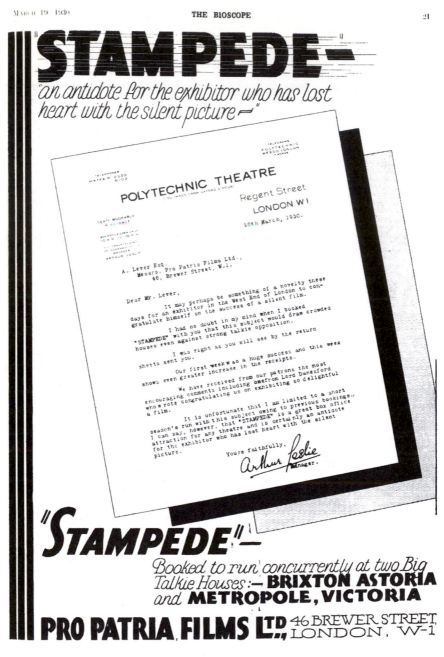

Figure 6.2a Image from the *Bioscope*, 19 March 1930.

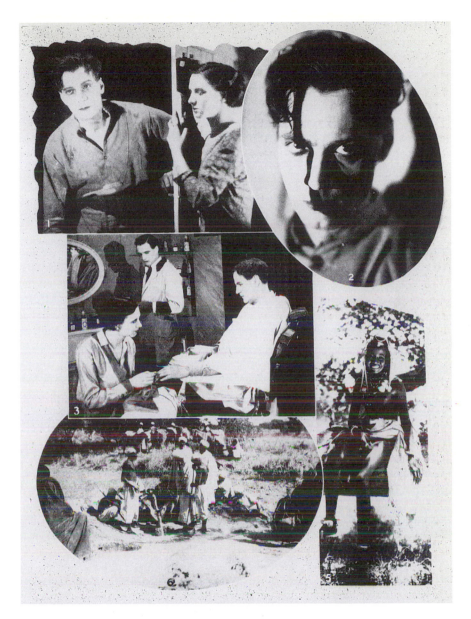

Figure 6.2b Publicity images from the *Bioscope*, 1 January 1930.

years of cinema from 1896 to 1905, however during the transitional years[9] the proportion of British films shown dropped significantly and by 1926 they made up only 5 per cent of the films shown (Barr 1997: 9). Apart from the fact that British films were no longer being exported on the previous scale, American films

dominated the British market and by 1927 the British government had been persuaded by those involved in the British film industry to introduce a quota forcing British exhibitors to show a proportion of British films. We know that *Nionga* did run for longer than *Stampede* on a theatrical release and it is clear that *Stampede* came out at a time when the advent of synch sound films was transforming the exhibition environment and Low suggests that it was probably too late for a silent film to succeed. However we also know that *Stampede* did later get distribution on the 16 mm educational circuit which meant that during the 1930s quite a lot of people would have seen it. The reviews give us some sense of the interest the theatrical release of the films may have attracted. *Nionga* was described in the *Bioscope* as, 'A great improvement upon the conventional patchwork travel productions' and the reviewer went on to praise the portrayals, 'the heroine is a comely and charming little person, and among the players of minor roles are many striking native types' (*Bioscope* 18 June 1925: 35). *Kinematograph Weekly* judged it to be well made with excellent camerawork, a film with good curiosity and novelty value which 'gives a vivid insight to the customs, rites and superstitions of primitive Central African tribes of Tanganyika and Congo districts' (*Kinematograph Weekly* May 1925: 56). *Nionga* also received coverage from the film journal *Close Up*, in a special issue in 1929 entitled 'Negro art for the cinema'.[10] The writer Hay Chowl praised *Nionga* for being one of the films that moved beyond the 'picturesque' to deal with the 'delicate fabric of humanity':

> in 'Nionga', the dramatic moulding was never obtrusive enough to parody the natives' psychology and rob us of their naivete and simple charm which has always drawn us to these films as a relief from the sexual saturation of the white man's drama.
>
> (*Close Up* vol. V, no. 2 Aug 1929: 127)

Similar reviews greeted *Stampede* five years later. The *Bioscope* reviewer praised both the portrayals and the style, 'The photography is excellent and the editing and continuity of the film makes it a subject which should prove of unusual interest . . . the female interest is capably sustained by a charming dusky maiden' (*Bioscope* 22 January 1930: 29). *Close Up* magazine published stills from the film alongside others from the films of two avant-garde film-makers, Kenneth Macpherson and Oswell Blakeston.[11] The magazine's praise of *Stampede* was for its documentation of African life: 'This British Instructional film has only a modicum of story, dealing with the efforts of the chiefs to secure a living for the tribes constantly threatened by famine and drought' (*Close Up* December 1929: 459). It also attracted coverage from *The Times*: ' "Stampede" is to be enjoyed and remembered not as a love story or a morality play, but as a film in which animals and not men, however brilliantly and unconsciously they acted, were the real heroes' (*The Times* 25 February 1930).

The picture we get from these reviews however remains a little unclear. We can see this from the way that Low argues that *Stampede* was 'highly regarded by critics' in one account (Low 1971: 290). In another he says that 'it created little

interest despite a notice in *Close Up* and has since been completely overlooked'
(Low 1979: 70). Cameron quotes reviews of *Stampede* which he says were 'not
pleased with it'. *Variety* summarised it as 'the tough times folks in Sudan have
chasing waterholes' whilst the *New York Times* (28 April 1930) said it lacked
'spontaneity and truth' (Cameron 1994: 50). What we can surmise is that, whilst
the trade press was interested in the narrative and style of the films, the critics of
newspapers and journals were more interested in its documentary value. It would
also appear that in the main it was the journalists and film critics of the United
States who were critical whilst British reviews on the whole were moderately
enthusiastic. Our reading of the latter needs to be tempered for example by the
likelihood that British critics working for the trade press were particularly keen to
promote British films at this time and that *Close Up* would have represented a
sector of the British metropolitan middle classes who were interested in promot-
ing an experimental and educational film culture at the time. According to *Close
Up* the genre as a whole was popular with London audiences:

> A point of paramount importance to the moment is that the Poly has been
> making box-office successes of these films to the extent of record runs . . .
> This is proof to the world that in London alone exists a large white public
> interested in the life of his coloured brethren.
>
> (*Close Up* vol. V no. 2 August 1929: 128)

Production details give us some insight into the motivation of the film-makers.
Whilst we know relatively little about the production of *Nionga* and it is difficult
to talk about it conclusively, we know that Stoll was one of the larger British film
production companies in the 1920s and it was likely that the film was produced
independently and sold to Stoll for editing and distribution.[12] It claims in its
opening titles it was filmed in the Lake Tanganyika district and that it took three
years to make. One of the reviews suggests it was made by missionaries.[13] This
suggestion makes sense as the narrative appears to be a variation of the 'Adam and
Eve' story; Nionga believing the 'devil' witchdoctor, causes herself and Masari to
be thrown out of paradise. This would imply that the film was produced for
a moral purpose and yet the authorship of the film was obscured in the trade
press because the distribution company was concerned that this might dissuade
potential audiences.

We know quite a lot about *Stampede*. The film-makers had already made a
successful film, *Cape to Cairo* (1925), of their car journey through British colonial
territory in Africa, which was exhibited theatrically, in home distribution in 16
mm, and was re-released in 1934.[14] *Stampede* was filmed in Sudan in a number of
locations. The dramatised sequences were filmed at Buram, which was six hundred
miles south west of Khartoum and thirty-six miles from Kubbe, a small British
government post. The game sequences including a lion and elephant hunt were
shot, according to *The Times*, at the Shaleika river 'never previously visited by a
white man'. Apart from the film *Stampede*, the Court Treatts cut another film
with the footage they shot in the Sudan, *Stark Nature*, which was released with

sound in 1930 and Stella Court Treatt published a novel *Stampede* and her account of the film making *Sudan Sand*.[15]

Major Court Treatt financed the expedition and they were offered considerable assistance by British government officials. They sold the film to British Instructional on their return.[16] The Court Treatts were accompanied to the Sudan by Stella's brother Errol Hinds. Stella Court Treatt's account of their journey makes clear that they had studied all the latest ideas in cinematography and they took out a number of cameras and a collapsible darkroom. They set out with the intentions of filming to a scenario written by Stella Court Treatt, as she had heard that a 'story' was 'essential as a peg upon which to hang an "animal" picture'(Court Treatt 1930b: 3). The Court Treatts appear to have been commercially motivated and spurred by their previous success, purely writing the narrative in order to sell their hunting and travel expeditions pictures, though it is also likely that they were inspired to produce *Stampede* as a possible British equivalent to *Nanook of the North* and *Grass*.[17]

Stella's account makes it clear that she was targeting female audiences. She was anxious to find suitable male leads who might 'thrill the hearts of a good many feminine "movie fans"' (Court Treatt 1930b: 71) and she describes one of the two men they found in the market to play the parts of Boru and Nikitu as 'a Valentino'. The racial criteria of her selection were undisguised:

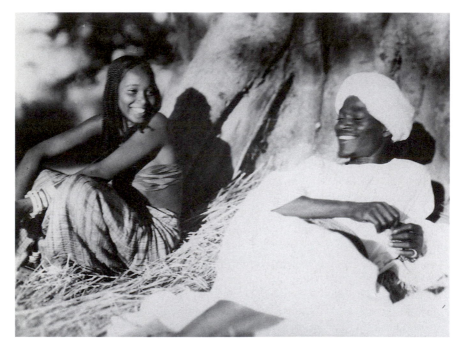

Figure 6.3 Publicity still of Loweno and Boru.

Source: British Film Institute.

These Habbania are not beautiful, because they are so mixed with negro and Fellata blood. I don't mean to say that the Fellata as a race are hideous, but the people at Kubbe and down here certainly are. Some of them are distinctly un-arab in appearance.

(Court Treatt 1930b: 81)

For the main part of the production, cast were mobilised at Buram from surrounding villages by the Nazir of the Habbania. People became unwilling to work in what were dangerous conditions and they kept leaving 'in spite of warnings, threats and fines'. They had to be persuaded financially to cooperate in some of the scenes, such as the scene of a forest fire, and on one occasion the local official sent police to ensure that the teams of people that the Court Treatts had employed to build a village and dig a river for the shoot did the work after they began to engage in go-slows. Major Court Treatt and two of his helpers were severely burnt and almost blinded when flash magnesium exploded in their faces. However in spite of these difficulties, the Court Treatts thought that the costs of filming were cheap: 'Yesterday's performance cost £24 for the use of bulls and other animals. It would have cost almost three times as much in England, no doubt' (Court Treatt 1930b: 130). They also filmed existing events such as local performances of music and dancing. The filming of the hunts, wildlife and scenic views took many weeks when they moved further south (Figure 6.4).

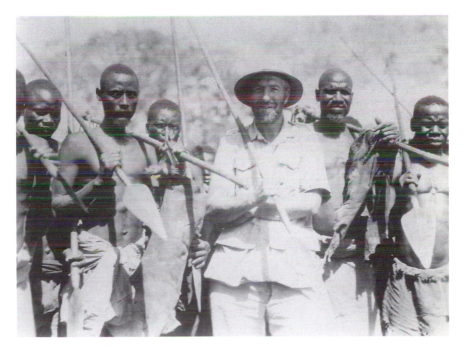

Figure 6.4 Publicity still of Major C. Court Treatt and his helpers.
Source: British Film Institute.

The films themselves are interesting in terms of how they attempt to construct the subject of African life.[18] *Nionga* operates within a Christian discourse and an evolutionist discourse and it uses a melodramatic form.[19] The moral message to the audience is that primitive life may appear appealing but as a world in which ignorance and superstition reign it offers a life that will ultimately lead to downfall, in other words a godless paradise can become hell. Structured within an evolutionist discourse which constructs African life as a primitive life, it sets its audience in a civilised world. This mode of address is achieved in a number of ways; the film-makers do not feature at all and the film erases any reference to colonial society, for example there is no evidence of a mission nearby or any Western objects or clothes used by the people. In *Nionga* the 'primitive' is inscribed in the way nature is portrayed, which is visualised in the scenic and natural landscape shots as untouched, idyllic and abundant, and in the way that culture is presented as uncivilised.

The opening titles of *Nionga* appeal to an expectant public, operating like a call for a fairground entertainment about to commence, in much the same way a showman or music hall presenter would:

> Our patrons must not look for the skill and artistry of the well known film stars in this drama of the crude life of simple people. Some idea of the difficulties overcome in producing *Nionga* may be realised when it is known that rehearsals alone occupied three years! *Nionga* was made in the almost unexplored Lake Tanganyika district in Central Africa. The players were until recently cannibals and are still unfettered, cruel and warlike.

Visually the spectator[20] is positioned as a traveller, through the device of a phantom ride, who is travelling in a boat down river into the heart of Africa. Panoramic tourist views present scenic shots of 'nature' which also act as cultural markers of Africa such as the waterfalls which we are told by titles are 'Victoria Nyanza Falls'.[21] The spectator retains the point of view as s/he passes villages on the river banks and sees boats full of men in front, until s/he is introduced to African life in the village. This type of film practice which sets up the spectator as traveller is very much in the tradition of scenics and early travelogues.[22]

Each scene is staged to show the dramas of everyday life in the village, the social relationships, the meals, the fishing, craft making, the celebrations, and sporting activities. The men of the Molungo tribe are shown smelting iron to make spear heads and then engaged in archery practice; there is extensive footage about the fishing by the Luama men (Figure 6.5) and the scaling and drying of the fish by the women. The viewer is encouraged to compare the everyday activities of the primitive with those of the modern and often through the titles the film implies that the viewer is superior. For example, the opening shots of the village present 'Kaieye the Chief of the Molungos' presiding over a clown-like dispute between the two men over bride-price, a scene which uses titles to make a joke about bride-price, wives and what they are worth. Other activities are compared to Western habits and customs such as food preparation and eating. The meal of Maca the

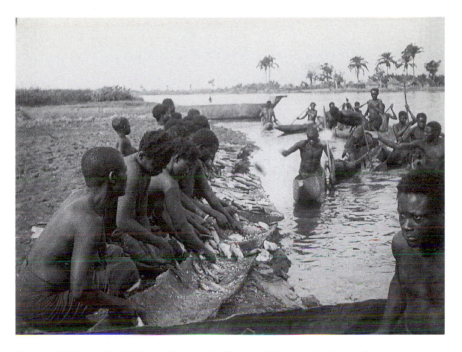

Figure 6.5 Framed still from *Nionga*, the Luama bringing in the catch.
Source: British Film Institute.

Luama chief with his family is commented on by titles: 'Dinner is informal!' because they are shown eating together from a bowl sitting outside of the huts (Figure 6.6). A scene of a celebration shows the men getting drunk together on the beverage passed round by 'a dusky waitress' as if in a beer hall. The practice of decorative art is shown to titles which comment: 'insensible to pain the girls adorn their backs with curious designs' (Figure 6.7). It is not just through the titles but visually as well that these comparisons are made through visual jokes and puns. When a scene shows Masari and his pursuers climbing a tree, it is an image familiar from imperial illustrations and early films which played on evolutionary notions of the scientific lineage of apes to man (Figure 6.8). When pursuers of Masari recognise his footprint, it is an opportunity to make a joking reference to *Robinson Crusoe*.

Furthermore the audience is appealed to through the exoticism of difference. The furniture and costumes, through the use of leopard skins, carved seats and drums, all lend an air that the portrayal is of an authentic Africa. The camera lingers on Nionga and other African women, whose breasts are bare, and the narrative makes reference to the sexual desirability of the women for the men on a couple of occasions. These sequences would have run contrary to the stringent controls of the portrayal of European women in British cinema at the time, and the fact that people do not wear many clothes, and decorate their bodies, is

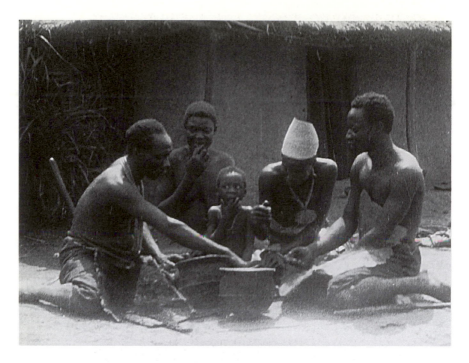

Figure 6.6 Framed still from *Nionga*, Maca and his family eating.
Source: British Film Institute.

evidence of their being 'uncivilised' and 'barbarous'. The viewer is presented with displays of spectacle and performance – in the footage of dancing which include the 'dance of the fetishes', male warrior displays and the female 'saribanda' at the Chief Kaiombo's ceremony, and action sequences – the battle scene at the end of the film and the chase scene when Masari is pursued by the Kimana (Figure 6.9).

The mixture in *Nionga* of a number of stylistic forms and strategies of address, the early travelogue narrative style, scenics, performance, drama and direct modes of address, make it an example of a transitional film which shows many character-istics of early cinema. Hansen has pointed out that composite films which mix documentary and comic dramatic styles within an overall fiction format allow for a diversity of viewer interests rather than attempting to absorb the viewer through narrative action alone. The expository titling, which directly addresses the specta-tor throughout the film with humorous comments on the content, is very much in keeping with the narration of earlier film practice with live commentary. Musser, in his study of early travel films, has criticised film historians who fail to pay attention to the role of the lecturer as the narrator in their assessments of early travel footage.

Because they have dismissed or downplayed the exhibitor's creative role, historians have evaluated the cultural significance of the genre from its

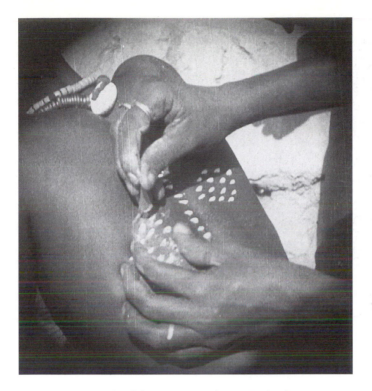

Figure 6.7 Framed still from *Nionga*, decorative body art.
Source: British Film Institute.

isolated one-shot images. Surviving lectures indicate that these images could be made to carry rich and often disturbing meanings – assumptions about imperialism, racial and cultural superiority, sexism and social Darwinism.

(Musser 1990: 123)

The text only works as inter-titles on the one or two occasions when dialogue is briefly introduced. Music would also have played a part in the presentation of the film, and although we do not know what scores were used, *Bioscope*'s advice to exhibitors on *Nionga*'s release was, 'special attention should be paid to the musical setting which should be of a wild barbaric nature' (*Bioscope* 28 January 1926: 72).

The visuals are also characteristic of early cinema practice. The scenes are shot in a tableaux form, a term Noel Burch used when defining his concept of 'primitive' cinema which later was reconceptualised by Tom Gunning as 'a cinema of attractions'.[23] Tableaux refers to a one shot scene using a presentational style of frontal display of a scene. The film is shot in natural light and stylistically the camerawork is static with pans left and right, and shot mainly from one camera height, waist level with the framing often showing the entire body of the person.

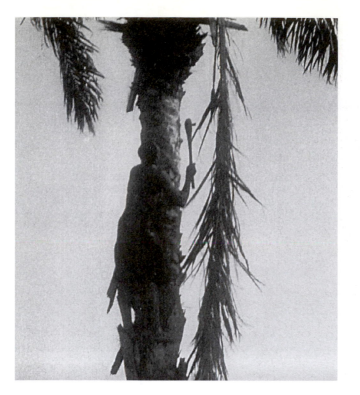

Figure 6.8 Framed still from *Nionga*, man climbing tree.
Source: British Film Institute.

The people of the village are often filmed face on to the camera, grouped as if for a photographic group portrait. When the action of a character does motivate the cutting from one shot to another, the camera movement does not serve to frame and centre the action, but the character enters and exits from diagonal sides of the frame. Fades move the viewer from one scene to the next. The presentational conception of space and address, to be found not only in theatrical staging, but also magic lantern traditions, comic strips, cartoons and postcards, does not introduce the spectator into the narrative space of the characters (Hansen 1991: 35). There is a realistic acting style effected by *Nionga*'s use of non-professional actors compared to the more exaggerated styles of acting familiar to audiences of silent cinema. Yet the characters introduced are very much stereotypes: the despot chief, the warrior, the hen-pecked husband, the honey of the tribe. Katoto, the soothsayer, is the only character who acts up for the camera, and he makes a spirited performance in his role as the villain (Figure 6.10). He is presented very much as the vengeful clown, and he performs magic tricks. He is the one who engages in direct address with the audience engaging when he is involved in trickery by making eye contact like a character from a pantomime.

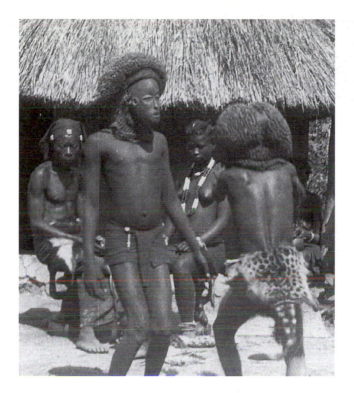

Figure 6.9 Framed still from *Nionga*, 'dance of the fetishes'.
Source: British Film Institute.

Rachael Low complains that *Nionga* had 'all the paraphernalia of the primitive travel film' and 'told the story without the smallest trace of visual or dramatic imagination' (Low 1971: 290). *Nionga* does construct its narrative through a travelogue form, setting up the spectator as traveller, through the titling, camera-work and editing; the phantom shots and the closed down lens shots used on the protagonists suggest they are to be seen from the narrational point of view of the traveller/spectator, who will then, as the opening titles promise, 'glimpse into the minds of savages'. Close-ups in *Nionga* introduce the characters and highlight such activities as scarification and do not operate as character point-of-view shots. The phantom ride was a fairground attraction which was adapted in the kinaesthetic film, a variant of the travelogue. It encourages a specifically cinematic form of reception, where the spectator identifies with the viewpoint of the camera. Its appeal is based on a fascination with cinema's ability to be mobile: its capacity to travel, witness and record phenomena. Hansen argues it betrays a distinctly primitive attitude towards cinematic illusion, one that includes the spectator in the space and process of make-believe (Hansen 1991: 31). The film mixes this with an attempt at character motivated action through the story of Nionga and Masari. It

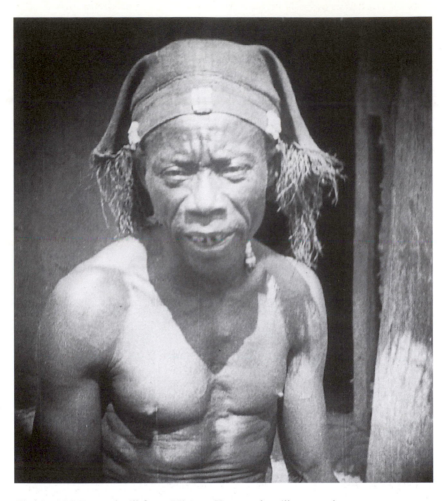

Figure 6.10 Framed still from *Nionga*, Katoto, the village soothsayer.
Source: British Film Institute.

is true that the narrative techniques used are some of the earliest narrative and editing devices to have been identified in cinema,[24] such as the flashback scene when Katoto is thinking and the chase scene, which was particularly popular between 1903 and 1906, which links two sections of the film and which uses a minimal amount of crosscutting. The chase scene in *Nionga* is typical of earlier slapstick comedy films, which featured a number of specific comic stereotypes – often racial stereotypes.

Yet *Nionga* could be seen as an example of a preferred mode of address rather than an example of British amateurishness or an anachronistic attachment to primitive modes of production. *Nionga*'s use of a more static approach to film making, whereby narrative is created through staging rather than through editing,

has been identified as possibly being more European in its aesthetic compared to film-making which developed in the United States of America. Ben Brewster has pointed out that this approach relies more on the use of mise-en-scène[25] whilst Burch has argued that the tableaux framing of Lumière films was bound up with a quasi-scientific attempt to capture a moment as in a still photographic view. As Hansen has pointed out, the boundaries between mise-en-scène and documentary were relative in early cinema (Hansen 1991: 31). It is the 'scientific' aspect of the visual style which I suggest is deliberately retained in order to portray native life in keeping with practice in earlier film-making such as the cinematograph pictures the Church Missionary Society is first reported to have used to present a 'typical life of India' to British audiences at the end of 1904. These views of 'heathen customs, idol processions and missionary work' accompanied by a lecture were shown around various venues in Britain throughout 1905 (*Optical Lantern and Cinematograph Journal* December 1904 no. 2 vol 1: 40).

Stampede has many similarities to *Nionga*. *Stampede*'s narrative operates within an evolutionary discourse, though it uses a romantic structure.[26] Its moral is different from that of *Nionga*; man's existence is shaped by the struggle for survival and the laws of nature are that the fittest survive. This theme is symbolised through hunting in the film. The film builds up an evolutionary rhetoric of comparison through its montage of visuals, but the contrast is not made directly between Western culture and primitive culture as in *Nionga*, but between

Figure 6.11 Framed still from *Stampede*, the village.
Source: British Film Institute.

monkeys and primitive man. The film's opening titles address its audience: 'Here we show you the adventures of a wandering tribe in the African forests. In their battles with fire, famine and beasts of prey you may perhaps see a symbol of Man's eternal struggle for existence'. It is difficult to write conclusively about this film as it is incomplete, however from the footage that remains there appear to be similarities with *Nionga* in that Africa is presented through scenics of landscape and wildlife, and culture is presented through the portrayal of everyday life in the village (Figure 6.11). The primitive is located in the physicality of the protagonists and civilisation by its absence. There is more emphasis on performance: the drama of horse racing, dancing and the tribe's migration across the desert, and on spectacle through stunts and special effects. A shot of a snake about to drop from a tree onto a baby is achieved in one shot, not through trick photography nor solely through editing. In the forest fire scene Boru, the hero, runs through the fire. We are also shown the ability of film to capture phenomena in the shot of a mirage, an example of a wonder of nature or a magical effect of perception.

Stampede also appeals to its audience through the exoticism of its portrayals of the people. The film opens with the footage of a woman dressed in leopard skin (Figure 6.12). There is some indication from the stills that there was a similar focus on the exoticism of the people in the missing section of the film, and from Stella Court Treatt's account of the filming we know it was central to her casting:

Figure 6.12 Framed still from *Stampede*, Boru's mother.
Source: British Film Institute.

Figure 6.13 Framed still from *Stampede*, Loweno.
Source: British Film Institute.

> Fatma, the lovely girl we have to play the part of Loweno, the heroine, is a
> positive gem. She is a poem of grace and very beautiful. All her actions are
> pretty. She dipped water from the river into a gourd, and it was one of the
> most beautiful things I have ever seen. Her braided hair fell in dozens of little
> plaits on to her shoulders, and her slender brown waist and perfect back
> rippled gently as she moved.
>
> (Court Treatt 1930b: 116)

However the beauty of the protagonists' natural life (Figure 6.13) is contrasted
with the violence of their existence. There is a scene in which a lion attacks and
kills Boru's mother, which Rachael Low rather unfairly describes as 'surely one of
the most unconvincing attacks by a lion ever filmed' (Low 1979: 69) and other
footage shows an elephant hunt.[27]

In contrast to *Nionga*, *Stampede* as a transitional film uses classical conventions
mixed with early cinema devices. Gunning has argued that the kinds of fascination
prevalent in early cinema did not disappear but persisted in avant-garde practices
and in certain components of genre films such as musicals. Here I would argue

that they also persisted in documentary forms. The classical conventions used in *Stampede* show tendencies to absorb the spectator into the illusion of reality by positioning the spectator in an ideal and invisible vantage point from which to witness a scene unseen by anyone in the diegesis. This is achieved through its use of action-driven narrative, formal continuity editing structures and montage in its narration. Much of the narration has been internalised into the visuals and the titles of *Stampede* are rarely in the form of direct address and usually convey dialogue. There is unfortunately no record or reference to what music was used to accompany the film, though *The Times* refers to the fact that music and sound effects are synchronised. The film does not use the devices of the travelogue. There are no phantom shots to imply the spectator is a traveller and the footage of the journey across the desert is motivated through the actions of the protagonist. There is often a closer framing, decreasing the distance between the camera and subject which creates the effect of a closer spectator involvement with the action. The camera angles are low and high, centre the composition and there is a use of point-of-view shots. In the editing there are shot/reverse shots, fast intercutting and flashback sequences which enhance the action and suspense of the film. The scene of a lion attacking a woman shows a use of parallel editing and close-ups. In a dancing sequence the editing builds up an increasing rhythm from slow to frenzied dancing (Figure 6.14), and the footage of women in trance-like states is cut to that of a male piper rolling on the floor playing his instrument.

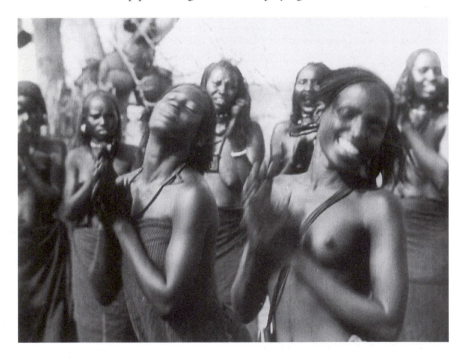

Figure 6.14 Framed still from *Stampede*, dancing.
Source: British Film Institute.

Stampede sets out to adapt its portrayal of native life through the genre of the popular adventure story, and in fact Stella Court Treatt published *Stampede* in a novel form. The film overtly draws on this literary style and the plot is framed within the language and structure of a popular romantic 'Arabic tale', very much within the literary Orientalist tradition popular in Britain at the time.[28] The dialogue uses phrases such as: 'Do you not know the cry of a forest cat, my Halima' the Sheikh asks his wife, and 'When one river fails, O Sheikh, the game seeks another' is the address by one of the men. There is a reference to a story within a story when Boru describes his journey across the desert to the villagers, where he and his men walked 'through the mirage' to the 'land of plenty'.

There are a number of ways in which Stampede retains aspects of a mode of address more associated with that of early cinema in the spectacle of the stunts and the scenics. There is at least one comic sequence when two men fight in a tug-of-war over a donkey in a slapstick style. The narrative is often an excuse to portray the people, the animals and the environment. In the staging of performance, there appears to be little attempt to integrate the dancing sequences or the horse races into the narrative of the journey, or to motivate them through the actions of the protagonists. Rachael Low points out that it is evident that the filmed sections of the dancing involve different people from those who drive the narrative, implying that the Court Treatts deliberately cheated, yet the publicity of the film makes no attempt to hide that they filmed the Dinkas as well as the Habbania Arabs known as Baggara.

If we compare *Nionga* with *Stampede*, there are many similarities between the two films in the representation of the subject and in the themes which are conveyed, yet we can see how the films have used different narrative and rhetorical devices. Whilst *Nionga*'s narrative operates through the titles, elements of the travelogue mixed with staged drama and direct address, *Stampede* uses more action and suspense and is narrated through character dialogue. Narrative devices have moved from titles in *Nionga* to visuals in *Stampede*. One approach to the films is to argue that *Stampede* has successfully adapted the ethnographic genre from *Nionga*'s approach based on a variety theatre presentational style to a fictional drama film form, in other words from a mode of address associated with stage entertainment towards a more 'mature' film language. This would confirm recent findings in film historiography. Elsaesser has argued that early cinema shows more roots in vaudeville than the theatre and the novel (Elsaesser 1990: 3) and other studies have shown how the shift from early cinema to classical cinema incorporated a move from a dominance of actualities to the ascendancy of fictional forms. *Nionga* and *Stampede* could be seen to be late examples of this shift. However this interpretation creates too much closure for any discussion of the films' relationship to the development of documentary styles and forms of film practice.[29] I would like therefore to turn to a consideration of the films as ethnographic narratives which have a relationship to other popular practices of ethnographic representation at the time.

An analysis of *Nionga* and *Stampede* through museology

The films' thematic and stylistic links with live performance and museum display

The lineage of documentary, and by implication ethnographic narrative, has usually been traced back to lantern slides. Charles Musser cites Robert Flaherty as an example of a lecturer who used slides to lecture on Eskimo life before moving to film with *Nanook of the North* (1922) (Musser 1996: 88). Hansen also traces the development of the travelogue genre through slides to cinema and she mentions the elaborate editing techniques achieved by lanternists using still photographic slides before the move to the use of film footage. The trade magazine *Optical Lantern and Kinematograph Weekly* also confirms this close overlap between photography and film during the first ten years of cinema. Whilst optical technologies may have been a major influence, it is clear, as Hansen and other commentators have pointed out, that many other forms of entertainment and commercial amusements at the end of the century supplied the cinema with subject matter, performance conventions and viewer expectations (Hansen 1991: 29). I want to argue here that these ethnographic narrative films emerged as a result of the more direct influence of live representation on early and silent film practice.[32] This is not an attempt however to exclude the influence that other forms of representation, such as literary representations,[30] and other visual modes, such as painting, print and illustrations,[31] were likely to have had on the films.

If we consider the period in which *Nionga* and *Stampede* were produced, we can see that it coincides with the time when live ethnographic narratives and performance traditions in the shape of colonial and international exhibitions in the capital and other cities of Britain were coming to an end. *Nionga* was released when the British Empire Exhibition at Wembley was running in 1925, which was one of the last to have peoples from the colonised regions of Africa presenting their native life in this manner to Londoners. Whilst the 'Won't go to Wembley' society represented intellectuals and artists who were critical of the live representations in the Empire exhibition, *Close Up* magazine was soon praising the films even though its readership would very likely to have been made up of people who were part of the society.

There are numerous examples of the live representation of African life in Victorian and Edwardian leisure activities, especially from 1890s onwards, the height of imperialism once Britain acquired territories in the African continent. Performances of dancing and re-enactments of battles were staged at certain theatres and music halls of London and other British metropolitan cities. One example which serves to illustrate the overlap between live representation and early film is a show at the Hippodrome in 1905, a venue owned by Stoll who later produced *Nionga* and where *Stampede* had its West End opening in 1929, in which Batwas pygmies brought to England by the explorer and hunter Lt. Colonel J. Harrison were featured for a season (Street 1992: 126). Another is an immensely popular show in 1899, *Savage South Africa*, staged by Frank Fillis at the Olympia Earls Court and later transformed for the *Greater British Exhibition*, where re-enactments of the Matabele wars were performed for audiences and for this purpose a troupe of

Matabele, Basutos, Malays and Boers were shipped to London from South Africa. The group included, so the organisers claimed, the captured Prince Lobengula who had led the 1896 Matabele campaign against the British.[33] The Warwick film company is reported to have filmed sections of *Savage South Africa* (Roberts 1994: 1) and we find other examples of performances like these being filmed by commercial companies. De Brigard cites the example of Edison's cameramen filming Samoan dancers at a Barnum and Bailey's Circus show (De Brigard 1975: 18). *Nionga* and *Stampede* both include long sequences of performance and dancing in their portrayals of native life. It was not just in the filming of existing events that we see the influence of live performance traditions on early film practice but in the idea of staging real events for the camera. As Hansen points out many actualities involved reconstructions not necessarily to deceive; 'as a subgenre dramatic re-enactment of current events was considered legitimate' (Hansen 1991: 31). Drawing on the theatrical tradition of staging re-enactments of colonial wars, James Williamson, whose production company was based in Hove, filmed some of his reconstruction of the Anglo Boer war on a golf course and *Attack on a China Mission* was shot in his garden in 1898 (Barnouw 1993: 24). The staged battle scene inserted into the narrative of *Nionga* is therefore typical of this style of early actualities, and although it is represented within a number of shots, these takes attempt to frame the majority of the action and they do not break the scene up into close-ups, points-of-view shots or shot/reverse shots (Figure 6.15).

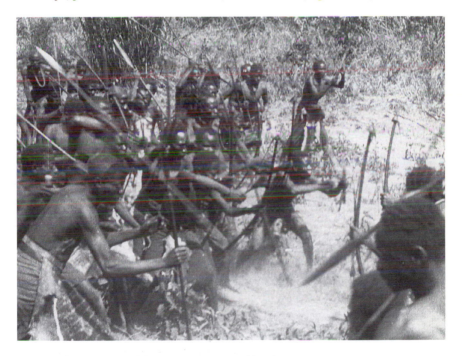

Figure 6.15 Framed still from *Nionga*, staged battle scene.
Source: British Film Institute.

If theatres at the turn of the century concentrated on displaying the spectacular aspects of native performance, museums and the colonial and imperial exhibitions from the 1850s attempted to stage broader dramas of native life, and here the overlap with the films again becomes apparent. Indigenous people were employed in museums to act either as interpreters and guides to visitors, or as participants in the representation of their culture. Performances often combined staged re-creations of weddings, funerals, hunts, wars, and religious rituals often involving dancing, with what Barbara Kirshenblatt-Gimblett terms 'the drama of the quotidian', by which she means enactments of everyday activities such as child rearing, cooking and craft making (Kirshenblatt-Gimblett 1991: 406). She cites for example that Charles Dickens wrote in 1847 about the Bushmen who were presented at the Egyptian hall, William Bullock's museum in London, acting out aspects of hunting scenes (Kirshenblatt-Gimblett 1991: 406). Another example she gives is of newspaper reports in 1852 of an African display at St George's gallery at Hyde Park Corner which created a whole drama of 'Caffre life' includ-ing meals, a witchfinding meeting, a wedding, a hunt and battles between rival tribes performed by Zulus from Natal (Kirshenblatt-Gimblett 1991: 405). These scenes of everyday life are constructed in a similar manner to the way in which village life is represented in *Nionga*, which shows meals, a proposed wedding, marriage disputes, a visit to the witchdoctor, sporting activities, crafts and fishing. *Stampede* covers less in the way of everyday activities, however the theme of hunting found in museum representation is central to the plot as the motivating factor in the story of the life of the 'tribe' of the Sudan.

This form of museum performance was developed in the colonial and inter-national exhibitions in their spectacular ethnographic displays which emerged from the 1890s and were popular up until the First World War.[34] It was after the 1889 Paris Exhibition that the British exhibitions introduced the reconstructions of native villages within which indigenous performers acted out both quotidian activities as well as staging re-enactments of colonial wars. Often between fifty and two hundred people would live in the villages, and they were given raw materials to build houses and foodstuffs to prepare, and they would be called on to perform rituals and special activities at particular times. About two hundred Zulus with their families were brought over for the Greater British Exhibition in 1899 and visitors paid to visit their kraal. At the Franco-British Exhibition in 1908 Senegalese were presented in a village in the French section of the exhibition (Figure 6.16). The Coronation Exhibition of 1911 represented people from East and West Africa and also included a Somali village. The Somali contingent, headed by Mohammed Hamid who had acted as a British interpreter during the British campaign against the Muslim resistance leader, Sayyid Muhammad Abdile Hassan, whom the British dubbed the 'Mad Mullah', performed war dances and demonstrated their sword and spear fighting techniques. The similarities with the way in which the films stage native life in villages using reconstructed sets of huts is striking, even though *Nionga* also uses existing villages as well.

It has been argued that one of the earliest cinematic viewpoints was the view of the traveller, yet these notions of travel were simultaneously being experimented

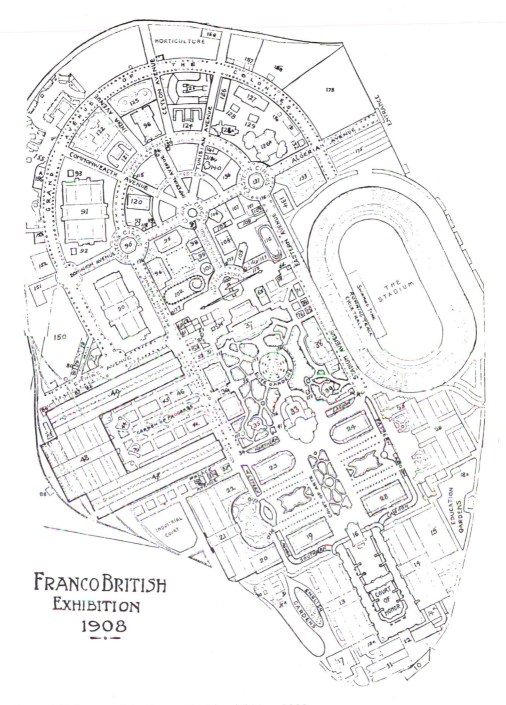

Figure 6.16 Layout of the Franco-British exhibition, 1908.

Source: Brooks, A. D. and F. A. Fletcher (1978) *British Exhibitions and Their Postcards*. Privately printed.

within these other forms of representation and parallels can be found between the films and museum and exhibition practices in the way they set up a travel experience. In the exhibitions visitors were offered a range of cultures and countries to visit, represented by different 'villages' set up in the halls. Some of the largest colonial exhibitions had trains and other forms of transport to take passengers around the sites as travellers (Coombes 1991: 192). At the Coronation Exhibition of 1911 for example, the Somali village was situated next to the 'Great mountain railway'.

The exhibitions and films both took great care to promote the realism of their representation. Both films authenticate their subject matter through opening titles assuring viewers that what they are about to see is an authentic portrayal of life in Africa, and they use scenics and mise-en-scène in an attempt to visually symbolise an authentic 'Africa'. Both films emphasise the actors are real: *Nionga* with its emphasis on cannibalism in its titles, and *Stampede* through titles and also in an exchange between Major Court Treatt and *Close Up*. When *Close Up* praised *Stampede* for its documentation of African life, Major Court Treatt replied in the letter's page in defence of their script:

> This is entirely incorrect. The facts are exactly the opposite to this. Mr. Hinds, my wife and myself went out to Africa in order to make a film written to a definite story and photographed to a definite scenario of that story. Although the tribes we used don't know 'what a camera is, or a screen', they have a definite idea of what a story is, and having no sub-conscious thought of what they are going to look like on the screen they 'act' naturally.
>
> (Court Treatt *Close Up* January 1930: 84)

He then went on to assure the reader that he and his wife were experts in the field and had a good knowledge of the life and customs of the tribe and that the film was a real story of real things that happen in the life of the tribe. Whilst *Close Up* was praising the film for its subtlety of narrative or the scientific documentary aspects, Court Treatt appears to be pioneering a realist acting style in the presentation of native performance. The exhibitions were also keen to distinguish their displays from the conventions of theatrical performance, their literature and advertising emphasising the authenticity of their portrayals of African culture and the fact that their participants were real (Coombes 1944: 66). Coombes points out that the use of the term life picture used to describe the act of the Somali Arab troupe at the French Exhibition of 1890 at Earls Court, for example, was typical of attempts by exhibitors to stress the authenticism of the re-enactments of battles, and its programme assured the audience that what was presented was not a mere imitation, or a 'show', but an illustration of 'Life in Africa' (Coombes 1994: 86).

Coombes makes an important distinction between the purpose and appeal of the colonial exhibition and that of the missionary events and this is important to our understanding of the differences in narration and mode of address of the two films. The colonial exhibitions were trade orientated; they were interested in promoting imperial interests and they had a broad appeal. The missionaries were actively

pursuing the financial and moral support of congregations and were specifically aimed at the lower-middle and artisan classes especially working class women and children. In Britain the colonial exhibitions were organised by private investors and entrepreneurs as they were not funded directly by the state as they were in France, although some of them received state aid. The missionaries' exhibitions were a particularly British phenomenon and the most active missionary groups were the Church Missionary Society and the London Missionary Society.[35] The missionary exhibitions were seen to be liberal compared to the colonial exhibitions and their supporters included prominent members of the Liberal party. The missionary groups were keen to emphasise their humanitarian purpose in serving imperial interests whilst the colonial exhibitions were a pure celebration of imperial rule.

Coombes argues that the image of Africa and Africans that the colonial exhibitions presented was different from the representation of Africa by the missionary societies (Coombes 1994: 162). The colonial exhibitions were not as concerned with establishing the authenticity of their representation as they were with creating narrative coherence to their layouts. Coombes argues that they appropriated aspects of popular colonial fiction which set their visitors up as adventurers, explorers and conquerors. Whilst they were more 'scientific' in their evolutionist outlook in that their use of displays was to provide evidence of other material cultures, they showed more interest in performance and the staged re-enactments of colonial wars within which the material artefacts were often included for their dramatic and spectacular impact.

Jan Nederveen Pieterse credits missions with the responsibility of creating the stereotype of the ignoble savage and popular narratives of human sacrifice, arranged marriage and superstition. It is clear that many missionary denominations did keep substantial ethnographic collections in the mission headquarters to display for their congregations and supporters, collections which often displayed artefacts of the medicine man, fetishes and ritualistic objects as evidence of idol worship. Missionaries also are reported to have used photographs in lantern slide lectures and also in mission displays to show evidence of practices like scarification as examples of barbarism. However Coombes tempers Pieterse's interpretation by arguing that, whilst evangelical missionaries were sensationalist and they did endorse an evolutionary perspective, they were regarded as serious ethnographers and their collections were seen to be credible by experts and ethnographic dealers. Missionaries were involved with museums as anthropologists, collectors and lecturers and they were also familiar figures in academic life. Their displays could be seen to often attempt to represent African artefacts in a social context even if that context was often wrong. The missionary shows presented Africans as skilled artisans as in the 1909 Africa and the East exhibition where the reconstruction of the African village was used to display African participants practising crafts and household activities.

I would argue that the representation of *Nionga* is better understood in terms of the tradition of the missionary exhibition, whilst *Stampede* is more in keeping with the colonial exhibitions. There is a contradictory aspect to the imagery in *Nionga* with its mixed aesthetic. While it is true to say that the themes of superstition,

witchcraft and human sacrifice are all present in the melodramatic plot of *Nionga*, the film spends a great deal of time attempting to present the everyday life and activities of the 'Molungo' and 'Luama'. The film's plot with Katoto featuring as the wicked protagonist who directly addresses the audience is clearly the film-makers' attempt to present the audience with the idea that ordinary savages are victims of their own gullibility which makes them prey to manipulative people, an approach which conveys the possibility of their redemption. *Stampede* on the other hand is more sensationalist and less interested in portraying the cultural aspects of the society. Its themes are adventure, conquest and action as well as involving more explicit sexual voyeurism. Its action sequences are more typical of the physical shows of strength which were common to the colonial exhibitions. Its narrative leaves more room to fate and destiny in its narrative use of a famine and drought to cause the migration of the tribe and in its scientific discourse that the fittest survive.

The films' narration and mode of address and their links to museum and exhibition practices

I would argue that there is a use of different 'objective' styles in *Nionga* and *Stampede* which are a result of the films' early engagement with artefact and live representation in museums and exhibitions. We also see the use of styles which construct more subjective spectator positioning, in *Nionga* in the phantom rides and the point-of-view shots which are contained by the device of the spectator as traveller. In contrast *Stampede*'s narrative often relies on classical conventions, however the story is not told entirely through identification via the protagon-ists. The spectatorship is often constructed through third party observation although the traveller is not so overtly implied, and there are points when differ-ent aesthetics come into play.[36] I would like to suggest that there are a number of ways in which the kinds of spectatorship evident in the films were similar to those that were encouraged and developed in museums and the exhibitions.

Both films use comparative structures to convey evolutionary messages. These comparative and montage approaches to representation in the films appear to draw on museum and exhibition practices which created classifications of race as well as comparing man to animals on an evolutionary ladder. In traditional private museums this presentation was in the form of a comparative and serial form of display. The collections in museums of artefacts, skeletons, bones and skulls were often arranged in displays to demonstrate that different stages of evolution were evident between races. Barbara Kirshenblatt-Gimblett gives the example of Sarti's Museum of Pathological Anatomy in London, which exhibited displays with evo-lutionary themes of the development of man from apes, using skeletons or parts of anatomies of different people and wax mannequins of racial types. One wax tableau of ethnographic scenes included wax figures of African savages with tails (Kirshenblatt-Gimblett 1991: 399). In spite of the establishment of the Museums Association in 1888, which was an attempt to set certain educational standards for museums, the Horniman Museum's displays continued to present animal skele-tons alongside human skeletons and skulls to give credence to theories of the

evolutionary development of man (Coombes 1994: 117). These displays were to be found in the exhibitions as well: at the Franco-British Exhibition and at the London Missionary Society Orient in London exhibition, both in 1908, there were anthropology sections supervised by A. C. Haddon, who was then advisory curator of the Horniman Museum. Whilst the display in the science pavilion of the colonial exhibition was overtly evolutionist in its layout arrangements, the missionary display attempted to create a more comparative approach in its display of religious objects (Coombes 1994: 183, 204). In *Nionga* it is the titles, most likely added by the production company, which direct the narration's evolution-ary message so clearly (though it is possible that there was some disparity between the intentions of the missionaries who made the film and the production company who distributed it). *Stampede* uses graphic editing to achieve this kind of visual rhetoric and its evolutionary message is more overtly racist.[37]

Framing, which draws on the early cinema presentation style, is used a great deal in *Nionga* and also in sections of *Stampede* (such as the scenics) has been described as 'scientific' in its approach. This presentational approach to film practice which implied an evidential purpose was to be found in both the entertainment and scientific usage of the film medium. So whilst the Lumière company is recorded as filming scenes of Ashanti performers at the Lyons exhibition in 1897 for exhibi-tion elsewhere (Roberts 1987: 191), Felix Louis Renault was using film as a form of record at the 1895 Exposition Ethnographique de l'Afrique Occidental for his scientific studies of the movement of man. He filmed a Wolof woman making pots, and later continued his experiments on location.[38] The exhibitions attracted many scientists and anthropologists who used the opportunity to observe 'native types' for scientific experimentation and study purposes. Other anthropologists took film equipment out to the field. A British example is A. C. Haddon who took both photographic and film equipment on the Cambridge anthropological expedition to the Torres Straits in the South Pacific in 1898 and came back with film footage of which little remains; the footage of three men dancing and attempts at fire-making can be seen as presentational scenes of performance and quotidian activities. This evidential use of film has usually been linked to the development of photography. Museums had already introduced the use of pho-tography for verification in their museum displays. Lecturers, both scientists and missionaries, who used photographs in their lantern slide lectures often incorpor-ated the use of film. However I would argue that observational and scientific styles in film practice can also be linked to museum display practices. Barbara Kirshenblatt-Gimblett for example distinguishes between a zoological approach to displaying 'live ethnographic specimens' in museums, and what she terms the theatrical approach to display. The zoological approach involved exhibiting people in their natural habitat and she argues that it arose from the traditions of displaying animals in cages or pens; habitats which were often decorated as sets supposedly representing the animals' natural environment. This way of exhibiting people arose from the zoological gardens themselves; an example is the case of Jozef Moller, a ten year old negro boy who was given to the Royal Society for Zoology in Antwerp by Captain Louis Meyer in 1845. He was allowed to roam

uncaged and was a major attraction for many years (Nederveen Pieterse 1992: 95). Greenhalgh (1988: 86) mentions how the inclusion of fourteen Nubians and six Eskimos in the Jardin d'Acclimatation in Paris in 1877 alongside plants and animals boosted attendances and in the following ten years many other peoples were exhibited there. The theatrical approach to display involved performance and often entailed the staging of the 'native' presentation within the context of a travel narrative. Museums, like the exhibitions, would strive to create the effect of a travel experience by arranging their exhibits, whether indigenous performers, skeletons, wax figures or artefacts, within the space which would be painted with a panoramic vista (Kirshenblatt-Gimblett 1991: 404). I would argue that the mix of aesthetic we identified in *Nionga* can be seen as adopting both zoological and theatrical approaches in its showing of the quotidian and the spectacular. Whilst *Stampede* also draws on a zoological approach in that it portrays both people and wildlife in the context of their daily existence throughout the film, these shots are more integrated into montage structures of editing, and there is more emphasis in *Stampede* on a theatrical approach to display.

The contexts in which people were presented, and also the ways in which museum displays attempted to construct certain viewing experiences for their visitors is similar to those the films offer. Kirshenblatt-Gimblett's examination of what she terms in situ exhibiting practices, which aim to recreate mimetically the original setting, show how different approaches to layout, the panoramic and the panoptic encourage different types of spectatorship (Kirshenblatt-Gimblett 1991: 413). The panoramic, of which the diorama was a widespread example, uses classificatory schemes and scenic effects to distance the spectator and which allow for all encompassing viewing experiences. Panoptic approaches to layout on the other hand encourage the viewer to see without being seen; these more voyeuristic viewing positions were often achieved in museums by taking out the side of a house for visitors to look in, giving him or her the chance to observe the intimacies of everyday life in a culture. In live representation this kind of voyeuristic viewing is not so easily achieved. Fatimah Tobing Rony has observed, in her study of the Exposition Ethnographique de l'Afrique Occidentale in Paris in 1895, that the forms of spectatorship invited the visitor to combine these different modes of viewing: on the one hand to observe the bodies and supposed habitats of the performers in the manner of a scientist, whilst on the other simultaneously offering them the opportunity for sexual voyeurism (Tobing Rony 1992: 269). In the films we find panoramic viewpoints are achieved in *Nionga* through long takes and pans, and in *Stampede* more frequently through a comparative editing structure. Voyeuristic viewpoints also are achieved differently in each film: the framing in *Nionga* appears to combine the scientific and voyeuristic in one shot, whilst *Stampede* on the other hand uses medium shots and close-ups to construct its scopic viewpoint. Hansen suggested that a distinction can be made between theatrical voyeurism, which is more in keeping with early cinema practice, and cinematic voyeurism. Theatrical voyeurism allows for an active complicity between the voyeur and the exhibitionist whereby the viewer is acknowledged to be watching, whereas the spectator is unseen in cinematic voyeurism.

The development of a visualist approach to narrative in cinema has been regarded as a key factor in the emergence of film spectatorship. However Mark B. Sandberg has pointed out there is a parallel shift to be found in museum viewing experiences, motivated by the pursuit of mimetic and realist representation in the new museum culture in the 1880s. He has examined how the museum involved spectators in a sense of 'the illusion of an experiential connection with the objects of their vision' through the creation of narratives, the layout of folk and ethnographic artefacts and the groupings of costumed wax or plaster mannequins which recreated scenes within a narrative (Sandberg 1995: 322). Sandberg illustrates how mannequins in museums in this period were often set in tableaux facing the viewer as if soliciting the spectator, whilst others were placed as if interacting with each other, setting a scene for the viewer, which he argues is similar to the impression in the cinema that one has stumbled onto a story in progress (Sandberg 1995: 329). Whilst the authenticity and realism of these representations of the 'past' were important for visitors of the museums, his argument is that after an initial confoundment on the part of spectators with the likeness of the mannequins to real people, accounts from the period reveal that what people enjoyed about these museum experiences was the ability to compare the past with the present. What appealed to many observers, and what Sandberg perceives as a particularly modern sort of pleasure, was the mix of identification and distance which allowed for temporary role playing at the folk museum and momentary suspension of a subjectivity (Sandberg 1995: 349). In other words it was the comparative experience which allowed a simulation of the past to be experienced rather than a literal transformation (Sandberg 1995: 353). The importance of Sandberg's observation is that people's preference was to remain in control of their viewing process.

Sandberg's argument that the general narrativisation process in early cinema is part of a larger trend towards narrative at the turn of the century, whereby visual culture is in transition from spectacle-orientated practices to storytelling, needs to be qualified with Gauldrealt's suggestion that in analysing cinema we treat both modes of address as narrative forms rather than spectacle as opposed to narrative.[39] It could also be argued that, whilst new forms of narrative emerged at this time, other modes continued to exist. Kirshenblatt-Gimblett suggests that it is useful to think of different spectorial involvements, for viewers of other cultures in museums, as coexisting rather than arguing that one form of viewing has led to the development of another in a linear transformation. This conception of different modes of address existing side-by-side is helpful to our understanding of *Nionga* and *Stampede* as providing alternative viewing experiences rather than seeing them as a linear progression of forms.

Sandberg also argues that these new storytelling practices created more complex spectator positions as far as subject/object boundaries were concerned in museum displays than was the case with direct address in that it allowed for this comparative element of viewing the past in the context of the modern to emerge. It could be argued alternatively that this comparative approach was more difficult in live encounters with other peoples, which proved to be quite unsettling

and potentially threatening to its audiences who had fears of intimate contact. Fatimah Tobing Rony highlights the level of excitement which live encounters generated in the audiences of the French exhibition and Coombes has made similar observations about the British colonial exhibitions. In the exhibitions, fences often separated spectators off from the area of the reconstructed villages, allowing for a great deal of interaction between the performers and spectators. In some cases the performers would demand money and act up for the visitors, and in the café area they often mingled uninhibited in the crowds. There were also fears and stories of miscegenation. There are a number of cases reported of performers organising to demand better conditions and wages, an issue the filmmakers of *Stampede* had not envisaged. It could be argued that cinema provided a 'safer' way to engage with other cultures and the complaints of intellectuals over the Wembley exhibition were not motivated by egalitarian beliefs after all, but by distaste and fear of peoples from other cultures.

Conclusion

I want to conclude by arguing that these British films of the ethnographic genre show that it was not just Robert Flaherty, usually cited as the key figure for the development of the ethnographic narrative, who was experimenting with the possibilities of film in representing 'otherness'. Whilst *Nionga* and *Stampede* do not show any attempt to develop a 'participatory film-making practice', both attempt to show the 'life and customs' of 'African tribes'. *Stampede* dispenses with the travelogue as a mode of narration and tells its story through character motivation and visual narrative, one which incorporates continuity editing structures and montage, rather than through titles as in *Nionga*. *Stampede* could be seen as an experiment in moving the narration from the expert to the spectator, with Court Treatt presuming that his expert status was sufficient to authenticate the representation. It could also be argued that this experiment should not be understood as a linear move from one form of narration to another, but as with the exhibitions that both modes of address were in operation. The travelogue continued to be produced. The Court Treatts cut other footage they shot on the trip to sound and released it in the form of their film *Stark Nature*, which is a travelogue of the overtly racist kind that the Johnsons epitomised in their film *Congorilla* (1929). The Court Treatts' British equivalent is narrated through the device of a colonial yarn told by the Major to a friend in a club, sequences shot in the studio, cut to footage of the natives of Sudan encountering Western products such as the gramophone.

These differences in narrative and mode of address in ethnographic narrative seem to have created some confusion amongst film critics in Britain. *Stampede* had received some critical reviews in the United States and these can be understood within the context of complaints about fake pictures being part of the campaign against primitive modes once there was a preference for the use of continuity structures and practices in film-making (Hansen 1991: 31). Practices a few years earlier that had not been questioned now became an issue: *Les mangeurs d'hommes* (1930), a drama of cannibalism set in the South Pacific, was exposed by

the bishop of Port Vila as having been filmed in a Christianised village (De Brigard 1975: 22). It could be argued that such concepts of authenticity and the issue of fakes arose increasingly in Britain at the time that notions of documentary emerged. Yet Flaherty's realist approach and use of continuity styles were not the only modes to be adopted in non-fiction film practices. The British documentarists of the 1930s incorporated both the use of direct address and to-camera presentation styles as well as developing continuity devices and montage, and with sound the use of the voice-over replaced the function of direct address titles (Higson 1986: 77, 78).

We have looked at the films mainly within the context of the films' formal development. It can be seen that in these two ethnographic narratives the discourse of primitivism shifts from one film to another, and the popular image of the ignoble savage in *Nionga* is paralleled by that of the noble savage. We need to question whether this indicates a permanent shift to a new perspective towards representing other peoples, or whether it is evidence of the dual representations of other cultures. One explanation for this duality could be that at that time the practical solutions to imperialism had changed; rather than intervene with money to convert the natives to Christianity, civilisation is only perceived to be possible through progress, science and technology, and colonial rule is very necessary to this process. The ethnographic displays and collections had emerged as a way of appealing on the part of traders, missionaries, anthropologists and scientists in Britain for popular support for colonial interests. By the 1930s trade, Christian and scientific interests found an outlet for film production through the state sponsored British Empire Marketing Board and in the setting up of the colonial units.[40] During the intervening period British missionaries of various denominations attempted to make films for theatrical exhibition as well as building up their own film libraries and *Nionga* can be seen as one of a number of such interventions during the early and silent period.[41] Indeed *Nionga* and *Stampede* can both be seen as independent initiatives to continue forms of ethnographic representation which were started in the museums and the exhibitions, and which led towards more direct state intervention in film practice in the colonies.

Recent film historiography and museology offer us new perspectives in terms of understanding non-fiction film practices. It is instructive to go beyond the classics of documentary or the search for empirical evidence of 'events' when assessing the historical value of the non-fiction sections of British film archives. As cultural historians we should take inspiration from such archive initiatives as those at the Royal Anthropological Institute and the Centre National de la Cinematographie,[42] and I would argue that it is important that we look closely at other non-fiction films to develop a broader notion of the early stylistic history of documentary.

Acknowledgements

I am very grateful to the following people for their help in the research, writing and editing of this piece: the editors, Elizabeth Hallam and Brian Street, Anne Fleming and the staff of the National Film and Television Archive, staff at

the British Film Institute library, Jim Cook, June Givanni, Andrew D. Roberts, Gabriella Romano, Ulli Sieglohr, John O. Thompson and Paul Willemen.

Notes

1 The copy of *Stampede* in the archive is incomplete. Apart from looking at the films themselves I have referred to available details about the productions. These have been difficult to locate and verify owing to the lack of paper archive on production, distribution, exhibition and audience figures for films of this period. I have found more material on *Stampede* than *Nionga*. The sources I have used include trade magazines, newspapers, journals, written accounts of the film-making, publicity photographs and other films made by the Court Treatts, as well as secondary sources on the films and on the history of the production companies involved with distributing the films.

2 The names of the tribes and the protagonists in this film are not authentic.

3 Roberts (1987) has published an invaluable study, 'Africa on film to 1940', which locates and categorises what has been made and what survives of film on Africa.

4 Whilst *Nionga* is not listed in the National Film Archive non-fiction book catalogue, it is indexed under Zimbabwe in the card index as documentary, and it can also be found under the subject listings of ethnology in British East Africa. The shotlists list it as drama documentary as well as a documentary with footage marked as showing details of 'African National Dances; Marriage customs of Africa; Human sacrifice; Tattooing' as well as 'scenic views of Victoria Falls'. *Stampede* is listed in the non-fiction book catalogue (volume 1 BFI 1980: 103) and described as 'the wanderings of the Habbania tribe in the Sudan in search of water'. It is also to be found under ethnology of Sudan and the shotlists refer to it as documentary with footage marked for attention which include that of 'a number of wildlife animals; national dances of Sudan; and forest fires'. The library synopsis on the computer catalogue lists it as 'African nature studies'.

5 This term was used by French critics who distinguished documentaires from travelogues as well as from documentaires romance, the latter being melodramas set in exotic locations (Winston 1995: 9).

6 See Barnouw (1993), Barsam (1992), De Brigard (1975), MacDougall (1976, 1995).

7 See Musser (1996) for an account of documentary and the emergence of a new mode of perception.

8 The American and Canadian film-makers who are usually discussed with reference to documentary are Edward Curtis, Robert Flaherty, Merian Cooper and Ernest Schoedsack. Bordwell and Thompson (1994) argue that the 'exotic' film was particularly important in the United States. Musser (1996) argues that these films show signs of a participatory observation approach and Fatimah Tobing Rony (1996) has talked about Curtis and Flaherty as examples of film-makers involved in 'savage ethnography'.

9 My use of 'transitional' here covers a period initially defined by film historians as between the years 1906–1917, though Barr (1997) in his discussion of British silent cinema does not suggest a cut off date of 1917. Transitional refers to hybrid forms of film practice which incorporated different modes of address which bridged the period between early cinema (1895–1907) and classical narrative cinema which emerged from 1917. Roberta Pearson (1996) defines transitional as a 'cinema of narrative integration' which no longer relies on extradiegetic information.

10 *Close Up* was founded in 1927 as a monthly international magazine edited by Kenneth Macpherson, published by Pool and printed in Switzerland. It was one of

the first critical journals on film and tended to devote its pages to avant-garde films from the continent which included films from France, Germany and Russia. The polemic guiding the writers for *Close Up* was the effort to establish cinema as a modernist art form, and British scientific and educational films were reviewed.

11 Kenneth Macpherson is best known for his film *Borderline* (1929) which has recently been restored.

12 Oswald Stoll was a leading figure in the vaudeville world before he entered film production in the 1920s, opening up a studio at Cricklewood. Stoll bought British Instructional films in 1924. However by the late 1920s he withdrew from film production having lost £200,000. For a fuller discussion of Stoll's involvement in the film industry see (Low 1971: 123–4).

13 It is most likely to be the work of evangelical missionaries. The London Missionary Society and the Church Missionary Society were both active in Central Africa; see Coombes (1994). I want to extend my thanks also to Robert Thornton who has pointed out the similarities in the hairstyles, costumes and artefacts in the film with those in the photographs and with the artefacts collected by W. F. P. Burton. The missionary W. F. P. Burton worked at the Congo Evangelical Mission at Mwamba (Zaire) and he has been recognised as an important collector and photographer of, in particular, the Luba, and he collected artefacts and took photographs for the University of Witwatersrand's Ethnological Museum. There is no definite proof of this connection. See *The Collection of W. F. P. Burton*, University of Witwatersrand Art Galleries 1992.

14 They were accompanied by T. A. Glover as cameraman and Fred Law, the special correspondent of the *Daily Express.*

15 There were other husband and wife teams who made such films, Cherry and Ada Keaton from Britain and Osa and Martin Johnson in the USA.

16 British Instructional was started up in 1919 by Harry Bruce Woolf producing actuality films. He attracted film-makers who were naturalists making a great success of the theatrical release of educational and scientific films. Woolf also supported the Film Society, which was started in 1925 to encourage film appreciation and practice, and he attracted a number of the leading young British film-makers at the time to British Instructional. British Instructional had a close relationship to the British government and was often commissioned to make films in Africa for the government, royal family and commercial trade companies.

17 *Nanook of the North* (1922) was made by Robert Flaherty. *Grass* (1925) was made by Merian C. Cooper and Ernest B. Schoedsack.

18 I will look at the films both textually and contextually, in terms of how they construct their spectatorship through their narrative structure and mode of address and at the way in which they make sense within particular discourses. For a discussion of the difficulties of using spectatorship models see Hansen (1991: 23) and for discourse models see Lidchi (1997: 197).

19 On melodrama in film see J. Bratton, J. Cook and C. Gledhill (1994) *Melodrama: Stage: Picture: Screen*, London: BFI.

20 Hansen argues that the concept of a film spectator as distinct from a member of an empirically variable audience did not come into existence until more than a decade after film emerged as a practice. It emerged alongside a set of codes and conventions known as classical Hollywood cinema (Hansen 1991: 23).

21 This titling has confused the Lake Victoria Nyanza with the Victoria Falls.

22 Hansen states that the travelogue genre is most closely affiliated with the tradition of the stereoopticon (Hansen 1991: 30). Musser has argued that the travel film was one of the most popular forms of film practice in the USA prior to 1907 (Musser 1990: 123), and Burch has written that the scenic film was popular with the European 'medium and petty bourgeoisie' prior to 1909 (Burch 1990: 53).

23 Burch (1990) argued that the Primitive Mode of Representation 1895–1915 was a different tradition of representation from that of the Institutional Mode of Representation from 1913 onwards, the IMR being a form of bourgeois illusionism. Gunning (1990) argued that the early years of cinema had a different mode of address and operated on the level of spectacle compared to the narrative form which developed later.

24 Barry Salt identified the chase as one of earliest forms of sequencing that developed the cut on action in early cinema. His work on the development of editing concentrated on the move from single-shot films to multi-shot films in narration in fiction films. The chase film was particularly popular between 1904 and 1908. Cross cutting or parallel editing, which also is considered to be one of the important developments in the use of film space in the continuity editing system, has been identified as being in use from as early as 1906.

25 See Bordwell, Thompson and Staiger (1985) on the development of continuity styles and what they term classical Hollywood cinema. Mise-en-scène, referring originally to the stage direction in theatre, is a term used to analyse the way in which actors, scenery and props are used within the film frame, including figure expression, framing, lighting, costumes and make-up, sets and props.

26 For a discussion of romantic literature in Britain in the late imperial period see J. McClure (1994) *Late Imperial Romance*, London: Verso.

27 This is a section of *Stampede* which is not in the archive print, but is a shot that was used as 'found footage' by Bruce Conner in his film *A Movie*.

28 See Said (1978) and Street (1975).

29 Bordwell (1997: 11) has suggested that the stylistic history of documentary film may differ considerably from that of the fiction film. See Winston (1995) and Nichols (1991) for new approaches to discussing documentary styles and their relationship to concepts of realism and ethics.

30 For studies which look at the colonialist representation of literature see Gates (1986), Pratt (1992), Said (1993) and Street (1975).

31 See Nederveen Pieterse (1992).

32 I am indebted to Ella Shohat and Robert Stam (1994: 106) and Fatimah Tobing Rony (1996: 36) for this observation.

33 The account of this show, the fate of Peter Lobenguela and the scandal that arose as a result of his marriage to the Englishwoman, Kitty Jewell, can be read in Shepard (1986).

34 These events were organised by private investors interested in promoting trade and commerce in the colonies and by missionaries who were already established there. They attracted huge attendances running over a period of months in London and shorter times in the provinces. Figures for attendances at the one of the most successful and widely acclaimed exhibitions, the Franco-British Exhibition of 1908 at White City, are estimated to be over eight million whilst missionary exhibitions often quoted numbers in hundreds of thousands. For a further accounts of these exhibitions see: Altick (1978), Greenhalgh (1988), Coombes (1994).

35 CMS Africa and the East exhibitions 1909, 1913, 1922, LMS Orient in London 1908.

36 See MacDougall (1995: 227) for his distinction between different modes of narration and different perspectives in ethnographic narrative: first-person testimony, second-person implication and third-person exposition.

37 Miriam Hansen has pointed out that earlier forms of parallelism in film can often be understood as a practice which enabled a conceptual or moral point to be made, and that this implies evidence of a different form of spectatorship from the forms of identification associated with the use of parallelism as used in continuity editing structures (Hansen 1991: 137).

38 For a discussion of the problems of talking about these early scientific films as records see Fatimah Tobing Rony (1992).

39 Gaudrealt (1990) has proposed that rather than see the development of narrative in cinema as a linear development from a presentational style to a narrative continuity style, it is better to call both modes narrational instead of differentiating spectacle from narrative. His notion of 'monstration' defined two levels of narration in early cinema: in the moving image itself and in any shot change. What he suggests refers to showing and telling.

40 See Smythe (1983) and Ssali (1988). The International Missionary Commission working in collaboration with the British Film Institute was involved in one of the first British Film Units in Africa. BEKE (the Bantu Educational Kinema Experiment) was the first in 1936, and on whose board sat Audrey Richards, Bronislaw Malinowski's student and major Africanist.

41 The narrative films which were made by or for missionaries in the silent period are as far as we are aware: *The Transformed Isle* (1908), *Livingstone* (1925), and *Africa Today* (1927). The latter film was made by the African Film Production Company set up in South Africa to intervene in the British film industry.

42 An example of critical archive work is that of Elizabeth Edwards and Chris Pinney on the Royal Anthropological Institute Archive; see Elizabeth Edwards (ed.) (1992) *Anthropology and Photography*, Yale. Centre National de la Cinematographie collaborated with the Association Connaissance de l'Histoire de l'Afrique Contemporaine and the Institut du Monde Arabe in 1994 to produce a film festival and conference called *Images et Colonies; Magreb et Afrique noire au regard du cinema colonial, 1895–1962*, out of which a subsequent publication was produced.

References

Altick, R. D. (1978) *The Shows of London*, Cambridge, MA and London: Harvard University Press.

Ballantyne, J. and Roberts, A. D. (1986) *Africa: A Handbook of Film and Video Resources*, London: British Universities Film and Video Council.

Barnouw, E. (1993) *Documentary*, Oxford: Oxford University Press.

Barr, C. (1997) 'Before blackmail. Silent British cinema', in R. Murphy (ed.) *The British Cinema Book*, London: BFI.

Barsam, R. (1992) *Non Fiction Film*, Bloomington, IN: Indiana Univeristy Press.

Bordwell, D. (1997) *A History of Film Style*, Cambridge, MA and London: Harvard University Press.

Bordwell, D. and Thompson, K. (1994) *Film History: An Introduction*, New York: McGraw-Hill.

—— (1997) *Film Art: An Introduction*, 5th edition, New York: McGraw-Hill.

Bordwell, D., Staiger, J. and Thompson, K. (1985) *The Classical Hollywood Cinema: Film Style and Mode of Production to 1960*, London: Routledge.

Burch, N. (1990) *Life to those Shadows*, trans. and ed. B. Brewster, London: BFI.

Cameron, K. (1994) *Africa on Film*, New York: Continuum.

Coombes, A. E. (1991) 'Ethnography and national and cultural identities' in S. Hillier (compiler) *The Myth of Primitivism*, London: Routledge.

—— (1994) *Reinventing Africa. Museums, Material Culture and Popular Imagination in Late Victorian and Edwardian England*, New Haven, CT and London: Yale.

Court Treatt, S. (1930a) *Stampede*, London: Hutchinson.

—— (1930b) *Sudan Sand*, London: Harrap.

De Brigard, E. (1975) 'The history of ethnographic film', in P. Hockings (ed.) *Principles of Visual Anthropology*, The Hague: Mouton Publishers.

Elsaesser, T. (ed.) (1990) *Early Cinema: Space Frame Narrative*, London: BFI.

Gates, H. (ed.) (1986) *"Race", Writing and Difference*, London: University of Chicago Press.

Gaudreault, A. (1990) 'Film, narrative, narration: the cinema of the Lumière brothers' in T. Elsaesser (ed.) *Early Cinema: Space Frame Narrative*, London: BFI.

—— (1990) 'Showing and telling: image and word in early cinema' in T. Elsaesser (ed.) *op. cit.*

Greenhalgh, P. (1988) *Ephemeral Vistas: The Expositions Universelles, Great Exhibitions and World fairs 1851–1939*, Manchester: Manchester University Press.

—— (1989) 'Education, entertainment and politics: lessons from the great international exhibitions' in P. Vergo (ed.) *The New Museology*, London: Reaktion Books.

Gunning, T. (1990) 'The cinema of attractions: early film, its spectator and the avant garde' in T. Elsaesser (ed.) *Early Cinema: Space Frame Narrative*, London: BFI.

Hansen, M. (1991) *Babel and Babylon: Spectatorship in American Silent Film*, Cambridge, MA and London: Harvard University Press.

Higson, A. (1986) 'Britain's Outstanding contribution to the film', the documentary-realist tradition' in C. Barr (ed.) *All Our Yesterdays*, London: BFI.

Houston, P. (1994) *Keepers of the Frame*, London: BFI.

Kirshenblatt-Gimblett, B. (1991) 'Objects of ethnography' in I. Karp and S. Lavine (ed.) *Exhibiting Cultures, The Poetics and Politics of Museum Display*, Washington, DC: Smithsonian Institute.

Lidchi, H. (1997) 'The poetics and politics of exhibiting other cultures' in S. Hall (ed.) *Representation: Cultural Representations and Signifying Practices*, London: Sage Publications in association with the Open University.

Low, R. (1971) *History of the British Film 1919–1929*, London: Allen and Unwin.

—— (1979) *History of the British Film 1929–1939. Films of Comment and Persuasion of the 1930s*, London: Allen and Unwin.

MacDougall, D. (1976) 'Prospects of the ethnographic film' in B. Nichols (ed.) *Movies and Methods*, Berkeley and Los Angeles: University of California Press.

——(1995) 'The subjective voice in ethnographic film' in L. Devereaux and R. Hillman (eds.) *Fields of Vision*, London: University of California Press.

Medhurst, A. (1986) 'Music hall and British cinema' in C. Barr (ed.) *All Our Yesterdays. 90 Years of British Cinema*, London: BFI.

Musser, C. (1990) 'The travel genre in 1903–1904: moving towards fictional narrative' in T. Elsaesser (ed.) *Early Cinema: Space Frame Narrative*, London: BFI.

Musser, C. (1996) 'Documentary' in G. Nowell Smith (ed.) *The Oxford History of World Cinema*, Oxford: Oxford University Press.

Neale, S. (1990) 'Questions of genre', *Screen* 31 (1) 45–66.

Nederveen Pieterse, J. (1992) *White on Black, Images of Africa and Blacks in Western Popular Culture*, New Haven and London: Yale.

Nichols, B. (1991) *Representing Reality: Issues and Concepts in Documentary*, Bloomington: Indiana University Press.

Patterson, J. (1992) 'The documentaries' in A. Eyles and D. Meeker *Missing Believed Lost*, London: BFI.

Pearson, R. (1996) 'Transitional cinema', in G. Norwell-Smith (ed.) *The Oxford History of World Cinema*, Oxford: Oxford University Press.

Pratt, M. L. (1992) *Imperial Eyes: Travel Writing and Transculturation*, London: Routledge.

Roberts, A. D. (1987) 'Africa on film to 1940' in *History of Africa 14*, Wisconsin: Madison.

—— (1994) 'Films on Africa in British archives', a paper presented to the *Images et Colonies: Magreb et Afrique noire au regard du cinema colonial 1895–1962*, organised by the L'Association Connaissance de l'Histoire de l'Afrique Contemporaine, les Archives du Film du Centre National de la Cinematographie et l'Institut du Monde Arabe, Paris.

Said, E. (1978) *Orientalism*, Harmondsworth: Penguin.

—— (1993) *Culture and Imperialism*, London: Chatto & Windus.

Sandberg, M. (1995) 'Effigy and narrative: looking into the nineteenth century folk museum' in L. Charney and V. R. Swartz (eds) *Cinema and the Invention of Modern Life*, London, Berkeley and Los Angeles: University of California Press.

Shepard, B. (1986) 'Showbiz imperialism: the case of Peter Lobengula' in J. M. Mackenzie (ed.) *Imperialism and Popular Culture*, Manchester: Manchester University Press.

Shohat, E. and Stam, R. (1994) *Unthinking Eurocentrism, Multiculturalism and the Media*, London: Routledge 1994.

Smythe, R. (1983) 'Movies and mandarins: the official film and British colonial Africa' in J. Curran, and V. Porter (eds) *British Cinema History*, London: Weidenfeld and Nicolson.

Ssali, M. (1988) *The Development and Role of an African Film Industry in East Africa with Special Reference to Tanzania, 1922–1984*, unpublished Phd thesis, University of California, Los Angeles.

Street, B. (1975) *The Savage in Literature*, London: Routledge and Kegan Paul.

—— (1992) 'British popular anthropology: exhibiting and photographing the other' in E. Edwards (ed.) *Anthropology and Photography*, New Haven, CT and London: Yale in Association with the Royal Anthropological Institute.

Summerfield, P. (1986) 'Patriotism and empire' in J. M. Mackenzie, (ed.) *Imperialism and Popular Culture*, Manchester: Manchester University Press.

Tobing Rony, F. (1992) 'Those who squat and those that sit: the iconography of race in the 1895 films of Felix-Louis Renault' *Camera Obscura* 28: 263–89.

—— (1996) *The Third Eye*, Durham and London: Duke University Press.

Walsh, M. (1996) 'National cinemas, national imaginaries' *Film History* 8: 5–17.

Winston, B. (1995) *Claiming the Real*, London: BFI.

Part II

Displaying cultures

Whilst the first six chapters of this book addressed othering in dominant textual forms – from written to visual – and explored the challenges to hegemonic discourse to be found in alternative forms, Part II focuses upon the ways in which culture is enacted through museum display, calling upon both textual and visual channels. The authors analyse a range of museum projects and less clearly demarcated social spaces in order to explore the ways in which the politics and aesthetics of display in the construction of 'otherness'. Just as in other domains, so museum collections are analysed for the work they do as markers of 'otherness', which the authors again locate in their social and ideological contexts, focusing upon the ways in which certain forms of knowledge are organised and privileged. Display is interpreted as a means by which authority is reproduced, including not simply overt and evident political assertions but the interplay between power and knowledge in less obvious forms, such as the erotics of museum display. Again, as with the forms described in earlier sections, alternatives to dominant representations are considered, such as the critical display strategies being adopted in some contemporary museums. The chapters in Part II share a concern with historical processes and the politics which inform the representation of cross-cultural interactions over time as well as space. Within the area of display, as in visual and textual representation, the authors recall Asad's recognition in the opening chapter that analysis of boundaries, identities and rights in the making of representation is not simply an abstract problem but a political project.

Shelton examines the social and cultural processes in which museum objects are attributed meaning and value over time, influencing the structure of the relationship between Europe and 'others' in crucial ways. Focusing on the India Museum and the Horniman Museum, Shelton resists the interpretation of museums as monolithic, arguing that the coherence of a collection is often projected in retrospect onto fragmented and dispersed historical motivations and meanings. Reconsidering colonial politics as varied, negotiated forms of administration and authority, Shelton explores the interconnected social relations and practices of institutions such as museums, libraries and learned societies from the eighteenth to the mid-twentieth century in Britain. The collection and display of 'exotic' objects represented relationships between 'otherness' and European civilisation, thereby contributing to the constitution of empire.

Shelton identifies three imaginaries underlying the assemblage of objects during this period: curiosity, evolutionism and diffusionism, and empirical functionalism. These, combined with Orientalist, nostalgic aesthetics and commercial interests shaped the often eclectic collections which, Shelton proposes, were generated around a diversity of interests rather than any 'singularity of vision and purpose'. This is not to deny the ideological effects of museum exhibitions as they rested upon concepts of race, ethnic identity and nationhood, constructing the official culture of colonialism at home. In this context the representation of 'otherness' was complex: it was visualised as raw material available for incorporation into Western commercial projects or as curiosities which were never fully domesticated and were, therefore, potentially threatening to Victorian norms and values. While Shelton examines the close complicity of ethnographic museum collecting and display with colonialism, which informed the interpretation of collections, he argues that material objects are best understood not as 'static and mechanical embodiments of discrete meanings' but as vehicles with an ability to promote 'creative chains of signification'. To avoid a reductive analysis of museum collections and the ways in which they have operated as markers of 'otherness', this chapter advances a detailed historical investigation of the epistemological and political frameworks within which objects inspired contemplation about the world.

Karp and Kratz examine the ways in which museums invent cultural 'others' as well as cultural 'selves'. They consider the political and poetic aspects of museums' cultural imagination analysing the techniques, conventions and visual languages which form representations of others. The fate of Tipoo's Tiger refers, in this chapter, to the interplay of different meanings that objects acquire over time through appropriation and recontextualising within public display. Therefore, Karp and Kratz approach ethnographic exhibiting as a process which 'emerges out of multiple, often overlapping contexts that compose a complex history'. They identify four main facets of this process: the classification systems which developed during the Enlightenment, the collection of cultural products during colonial expansion, the history of the representation of 'others', and the history of exhibiting from the nineteenth century onwards. Working with an awareness of historical patterns and relations in the shaping of display, Karp and Kratz examine the construction of museums' authority. This extends and operates through museum representations which claim accuracy, authenticity and truth. Display techniques might be drawn from other contexts (e.g. cinema, theme parks, department stores) and appropriated by museums suggesting significant relationships between museums and wider cultural and commercial spaces.

To explore the cultural politics of museums, Karp and Kratz analyse the truth claims, forms of representation, organisation of knowledge and modes of communication about other cultures in two ethnographic displays: the Hall of Human Cultures at the California Academy of Sciences in San Francisco and the Kauai Lagoons resort hotel. The former display is characterised by the suppression of history, which masks cross-cultural encounters and political and economic subordination. The spectacle of cultures in the latter display assimilates objects

(and by implication their associated cultures) into European traditions of collecting and exhibition, combining the domestic and the exotic to increase the appeal of the resort. In their conclusion Karp and Kratz emphasise the need to examine the various histories in which museum exhibits are situated and the ways in which the cultural authority of museums is reproduced through techniques of representation.

Marcus engages with debates regarding the nature and politics of contemporary museum spaces and practices. As teaching institutions or as a form of theatre, museums extend a certain seductive capacity associated with vision, illumination and knowledge. It is desire, seduction and the eroticised relation established between museum and viewer that Marcus explores with particular reference to the new Museum of Sydney which opened in 1995. Marcus proposes that within the museum truth and desire are inextricably bound up within each other and she moves on to consider two sources which give rise to the erotics of the museum – first, the moment at which a truth is recognised, and second, the deployment of power.

Marcus analyses the tensions between Aboriginal perspectives and those voiced by descendants of colonial families which developed during the Sydney museum project. She presents a critique of postmodern aesthetics arguing that, although these might have the potential to disrupt dominant truth claims and to reveal the artifice of knowledge, in the context of the Museum of Sydney they tend to mask the underlying relations of power and to reinforce the marginalisation of Aboriginal understandings. For example, the display of Sydney's colonial history was composed of disparate cultural fragments (objects and texts) to foreground cultural heterogeneity and to dislodge dominant narratives. As such it was organised and framed within a visual discourse which was familiar to museum curators but 'other' from Aboriginal perspectives. Although aiming to engage with a wider audience and to problematise its own cultural authority, the museum had again appropriated the cultural resources of marginalised groups and managed access to them by employing specialist visual codes. This chapter, therefore, examines the politics and limits of apparently critical museum strategies. Situating her analysis of museum aesthetics within a wider field of artistic production, Marcus argues that museum displays are shaped by longer term visual traditions apparent in Western iconography and that the exclusion and release of cultural meanings is central to the politics of museum projects which operate through the appropriation, organisation and exhibition of others. Marcus concludes that the visual strategies employed by museums are never free from the exercise of power and that, however subversive in intent, they are caught up in the reproduction of dominant narratives.

Jordanova's chapter explores the representation of history in various contexts – the museum, the street, the supermarket – analysing the dynamics between present ideologies and the constitution of the past as 'other'. Jordanova discusses the location of the concept of 'otherness' in relation to history as an academic discipline, making distinctions between 'otherness' in space and 'otherness' in time (she considers the latter to be of a more abstract nature since it is less accessible in

daily life). Despite historians' resistance to theory and the explicit use of concepts, Jordanova argues that 'otherness' is a useful category which, for example, might assist historians in the identification of their underlying assumptions about continuities and discontinuities between past and present. This resistance can be understood in the wider historical context of the practice of disciplines or the history of knowledge-production. Jordanova proposes that historians do not seem to have moved through a period of self-doubt or to have explored the boundaries which constrain their understanding of societies in the past. Within academic history, changes over the past twenty to thirty years have largely consisted of the incorporation of new perspectives, objects of study and source materials. Outside of the discipline, major changes have included the use of historical documents in literary analysis and the appropriation of history as a commodity in the leisure and publishing industries.

In addition to a field of academic study, history might be interpreted as 'all that is past', a 'diffused awareness of former times'. Jordanova examines these meanings of history paying attention to the different forms of closeness and distance which inform perceptions of the past. Thus she argues that the past is not entirely 'other', rather it is a fluid construct possessing varying degrees of 'otherness'. Relationships between the present and the 'otherness' of the past are represented and reinforced in museums, literary texts and popular accounts. Jordanova analyses these, drawing out the ways in which ideas about the past are widely disseminated. In museums the past is commonly represented as everyday life and in terms of monarchs often implying continuities over time which encourage the viewer's identification with the past. These displays are, however, conceptually weak, fragmented and lacking in any systematic account of past societies. As such they contrast with the intellectual aims of contemporary historians – to produce accounts of the past which engage with others' categories and practices, to identify and analyse cultural patterns and to provide models to account for them. Jordanova concludes by arguing that the abstract intellectual work involved in historical research is difficult to represent through visual images and objects. She suggests that historians need to 'rethink the relationships between historical knowledge and the artefacts and images that largely represent it in displays'. This would involve paying closer attention to the wider social and political contexts in which history and its 'forms of 'otherness'' are communicated.

Hallam examines the construction of 'otherness' in academic discourse and museum display, exploring the conventions, values and assumptions held by institutions in relation to the production and reception of cultural representations. University and museum practices, their affinities and differences, are examined with respect to the categories of 'otherness' which they deploy. Within academic discourse, notably anthropology, critical analysis of the ways in which texts exaggerate and exoticise 'other' cultures has developed. Museums have also attempted to embrace critical insights with regard to their authority in the exhibition of cultural difference. In both cases there is an explicit agenda which seeks to bring forms of representation under scrutiny and to question their

ideological implications, especially in terms of the reproduction of dominant Western concepts and perceptions.

Focusing on an exhibition co-curated by Hallam at Brighton Museum and Art Gallery, this chapter traces some of the possibilities and limitations of critical, reflexive analysis and display. The exhibition intended to address aspects of academic research processes and the representations which are collected, manipulated and disseminated in anthropology, history, geography and media studies. The displays consisted of materials, including texts (manuscript and printed) and visual images (photographs, prints, diagrams, tables, graphs, maps) produced and used by researchers in these fields. The curators presented this material in such a way as to expose the different categories of 'otherness' which were either implicit within such 'data' or construed within the academic disciplines. Therefore, the process of representation became the central focus of display, problematising the ways in which historical, cultural and gendered differences are communicated through institutional practices. In its conclusions, this chapter relates to the arguments of Marcus and Jordanova: debates about 'otherness' and cross-cultural understanding, usually conducted through the written word, are difficult to translate into the field of visual display. But the underlying work of othering and the contestation of dominant stereotypes explored through textual and visual forms in earlier chapters is pursued here too, as European knowledge and power are interrogated and opened to scrutiny, whatever their forms of representation.

7 Museum ethnography
An imperial science[1]

Anthony Alan Shelton

Contemporary theoretical perspectives view the meanings of objects and, in the present context, the indices of 'otherness', as promiscuous, and transformative. Meaning is dependent not only on its specific historical or geographical fields of usage but also on the shifts in the ownership of objects between private collectors and public institutions. Objects, however, have both an iconic and a material symbolic value which are redolent with past meanings and associations that are never totally disclaimed. This sedimentary symbolic valency always guarantees an object's potentiality, latent or actual, to create unexpected or unintentional associations either through engendering relations between signifiers or between signifiers and signifieds.[2] Despite such a proclivity, it has become customary to see museum collections as having been established and exhibited to demonstrate only one principal coherent paradigmatic position.[3] In comparing collections to narratives, Mieke Bal reminds us that the relationship between the beginning, middle and end follows no single logical compulsion.[4] The rationalisation of a collection may occur only after its formation, and then be projected back to provide a gloss that seeks to coherently incorporate and legitimate the early period of its origin. The writing of the defining catalogue provides another particularly cogent and common example of the exercise of the rationalising power of the retrospective discourse. Clearly, the motivations of collectors have become too singularly rationalised.[5] The contemporary tendency to subordinate the significance of objects to illustrations of texts encourages the assumption that objects bear no more than the determining imprint of a dominant social classification like evolutionism or diffusionism. Structure and system are identified at the expense of the singularities of events and the creative intervention of individuals.

Through an examination of the history of two merchant collections, the India Museum (1801–79) and the Horniman Museum (1860–) and a comparison of the collecting and exhibition policies of some other museums during the period 1801–1960, the dynamic relationship between structures and events, capricious will and cultural construct, and the ideological efficacy of museum representations, may be scrutinised. This may help to chart certain intellectual fields which have structured the systems of objects held by the West and provide a basis to reconsider the view that objects function like language in providing meaningful,

comprehensible and appropriate communication in an epistemologically de-centred and postcolonial world order.[6]

Imaginary empires

The much vaunted critiques of anthropology which, in the 1970s, saw it as the handmaiden of European colonialism, focused on the discipline's methodologies, practices and textual productions in order to explicate ideological subtexts, while often ignoring differences in local or regional manifestations of the colonialism which reputedly shaped it.[7] Colonialism was reconfigured as a monolithic historical process of encroachment which sought to subordinate foreign, local and regional economies and polities to a metropolitan power, harnessed to develop new market monopolies, expand revenue bases (through taxation of local populations), ensure the metropolis's access to raw materials, incorporate native peoples into a capitalist system of socio-economic relationships and extend the cultural and religious hegemony of the metropolitan centre throughout the territories and dominions it administered. Such a view of colonialism, based on a crudely synthesised overview of the nature of colonial society, ignores historical scholarship and the rich variegations of local manifestations, the relationship between colonial discourses and colonial practices, the play of intracultural mutability, and the establishment of the heterotopias that meshed colonialism's various strands together, all of which have become the subject of much contemporary debate.[8] While the complicity between anthropology and colonialism is undeniable, their historical relationship now appears far more complicated than earlier critiques were ever able to acknowledge.

It has been argued that the model of empire as an all-encompassing, centrally driven administrative machine, whose authority rested on its control over judicial procedure and its monopoly over military force, was an idealisation of a practically unobtainable reality.[9] While the metropolis preferred to see its empire as an extension of the nation, itself modelled on the structure of the Victorian family, sharing a similar set of symbols, values and institutions, reality was notably different. In much of the territory to which they laid claim, the British presence was ghettoised, regional economic dislocation abounded, political control had to be endlessly renegotiated, and military power was often overextended so it could do little more than enforce authority by intimidation rather than effectively police or wage warfare. Empire became an image, represented by the pink shadings on the map, titular claims (Victoria as Empress of India, imperial viceroys and governors), a hagiography of secular heroes (David Livingstone, Richard Burton, Charles George Gordon, Herbert Kitchener, Clive of India, Cecil Rhodes), archives, compiled, collated and attemptedly synthesised from cartographic, geographical, archaeological and ethnographic surveys, natural history expeditions, population censuses, economic statistics, all tenuously connected by repositories of information and networks of telegraph wire threading together lonely and far flung outposts.[10] In its piecemeal administration, effected through trading companies such as the East India Company, the Royal Niger Company and the Imperial British

East Africa Company, a mosaic of semiautonomous provinces (the South African provinces) and an assortment of paramountcies, viceroyalties, dominions and protectorates, as well as fiscal and military policies, British influence, while exercised to protect and expand important trade routes and markets, lacked any overall coherence.

At home, European empires were given perhaps their most cogent expression in international exhibitions. Their vast geographical reaches were miniaturised and condensed in native villages (the Antwerp Exhibition of 1894, the Franco-British Exhibition of 1908, the British Empire Exhibition of 1924, and so on),[11] vernacular styles of architecture were illustrated (Exposition Universelle, Paris, 1867 and 1889), and raw materials and products were decoratively, even fancifully displayed to an extent that prompted Raymond Le Play, the Director General of the 1867 exhibition, to compare the vast sites of exhibition halls to an encyclopaedia. The disciplinary indices of a carefully orchestrated relationship between 'otherness' and European civilisation were created not as external contingencies in support of empire, but as part of its essential internal constitution. Within this history, exoticised objects played important and changing roles, which, as with key foundation texts, not unlike Malinowskian charters, provided a rational order that helped hold the European empires together.

Between the eighteenth and the mid-twentieth century, three principal imaginaries underlying the assemblage of exotic objects can be distinguished. For the earliest period Nicholas Thomas has contrasted the trope of curiosity as a theoretically immature and infantile perception of exotic objects with the later recognition of differences between forms of objects carrying the same function. Under the rubric of curiosity, exotic objects were collected by seamen as testimonials to the voyages they had undertaken and the peculiar cultures they encountered.[12] Such objects also provided a useful source of additional revenue to comfort them on their return to their mother countries. According to Thomas 'indigenous artefacts virtually became trophies which reflected the broader experience and mastery of a passage around the world on the part of a traveller'.[13]

Curiosity provided a powerful and restless motivation, which distanced early collections from any scientific or educational project. Edmund Burke was adamant on the intellectual destitution of curiosity and, in his *Philosophical Enquiries* (1757), while acknowledging its great motivating force, he bemoaned its ineffectiveness.

> The first and the simplest emotion which we discover in the human mind, is Curiosity. By curiosity, I mean whatever desire we have for, or whatever pleasure we take in novelty. We see children, perpetually running from place to place to hunt out something new; they catch with great eagerness, and with very little choice, at whatever comes before them; their attention is engaged by every thing, because every thing has, in that stage of life, the charm of novelty to recommend it. But as those things that engage us merely by their novelty, cannot attach us for any length of time, curiosity is the most superficial of all the affections; it changes its objects perpetually; it has an

appetite which is very sharp, but very easily satisfied; and it has always an appearance of giddiness, restlessness and anxiety.[14]

Only in the mid- to later part of the eighteenth century did objects begin to assume evidential meaning which made them central to certain discourses like antiquarianism and, later in the nineteenth century, to archaeology and ethnography. The second imaginary, represented by evolutionism and diffusionism in the nineteenth century, held a totalising view of human knowledge in which anthropological discourse figured as the master narrative. The differentiation of objects according to their technical efficiency provided an early scientific criterion to enable societies to be ranked in relationship to each other. In diffusionism, objects provided the evidence for the movement and spread of cultural traits. Non-Western art history equated styles of objects with particular ethnic groups. In colonial science, such positions gave great importance to objects in establishing the stages in the evolution of societies, the direction in which civilisation grew and the markers of difference which allowed administrative authorities to identify and recognise the local affiliations of the populations under their jurisdiction.[15] Objects therefore came to constitute, for colonial science and administration, important indices of 'otherness'.

A third imaginary, empirical functionalism, marked the transition from knowledge seen as a universalising master narrative to its re-articulation as a myriad of discrete constituents of an information archive. Such knowledge depended on common methodological protocols, while presenting itself as having relinquished any prior epistemological structure except that which was strictly necessary for the formal requirements of the archive. This reconfiguration of knowledge corresponded to a transition from its symbolic or categorical usage as a means of cultural differentiation to an agent of social control.

All three imaginaries coexisted and circulated with different degrees of emphasis from the late nineteenth century to the present, and provided so many rationalities underlying the motivations for making and organising collections, rather than simply representing discrete, historically successive and deterministic monolinear paradigms. Even within that most rigorous of all classifications and arrangements of objects adopted by the Pitt Rivers Museum, Balfour, writing in 1897, acknowledged the viability of special series. Cook material was separately displayed ' . . . not only as a memorial of the great navigator, but also as to some extent illustrating the condition of indigenous culture of certain savage races before the advent of the white man'.[16]

The archival presentation of empire was not monopolised by any individual institution, but represented the product of a network which not only included museums and libraries, but universities, governmental surveys, commercial archives, journals and the proliferate learned societies. Many of the museums constructed in the Victorian and Edwardian period, provincial institutions as well as privately endowed establishments such as the Pitt Rivers Museum, the Horniman Museum, the Wellcome Historical Medical Museum or the East India Company's India Museum, also collected books and manuscripts, in addition to ethnographic

and/or natural history specimens, indicative of the close connection believed to exist between objects and texts as bearers of knowledge. Splicing them together was a shared faith in the interconnectedness and encyclopaedic nature of a transcendental knowledge that passively awaited discovery and which promised the key to understanding and controlling nature and society. Knowledge itself was conceived as a natural resource which lay dormant in the world, awaiting discovery and exploitation. Like a woman, knowledge represented by the warrior muse Athena/Britannia, was passive, but fecund in her capacity to nurture the proper revelation of the world that was indispensable for its rational and scientific organisation and administration. This metaphor was further extended, bestowing on the erudite the accolade of being described as 'mines of information', those of untutored wisdom were 'uncut diamonds', libraries and museums became known as 'storehouses of knowledge' while encyclopaedias became their 'treasuries'.

In Britain, throughout the nineteenth and twentieth centuries, the museum establishment was marked by a rigid hierarchical organisation.[17] Internally, its personnel was divided by rank and specialism which effectively controlled all matters related to the specific institution's authority and its regulation and dissemination of knowledge. Ranking between museums was asserted on the basis of their claims to authority and control over specialised knowledge. The British Museum with its claim to universal and comprehensive knowledge of world civilisations, occupied the apex of a pyramidal structure.[18] Lower down the scale were specialist museums, such as the India Museum, the Pitt Rivers Museum, the University Museum at Oxford, the Indian Institute, and the Cambridge University museums, as well as private specialist museums such as the Wellcome Historical Medical Museum, or the Horniman after 1901. These were followed by provincial museums such as Norwich, Maidstone, Brighton, Ipswich, Exeter and Hastings, which not only focused on regional history, archaeology and natural history, but also sought type objects for the education of their local populace and soon became the repositories of all kinds of collections put together by local enthusiasts.[19] Further down the scale, because of their geographical removal, but still playing an important role as 'feeder institutions', were colonial museums which displayed the local produce, history and natural history of a particular colony or province.[20] The curator of the Ipswich Museum in 1908 had no doubt about the purpose and function of provincial and district museums:

> A museum should be a centre from which should emanate all the scientific, literary, and other intellectual activities of the district. Scientific, literary, and natural history societies, field clubs, and archaeological societies should be affiliated to a museum. Their meetings, if possible, should be held there, their records should be kept there. A museum should be not only a town but a county institution, where there are more than one in a district the boundary lines should be divided. Every geological, archaeological, or antiquarian find should be duly reported to the museum as a sort of head record office, so that official records may be kept, photographs taken, and every particular duly noted for the use of the future historian.[21]

Museums within each of these divisions, but seldom those at different levels of the hierarchy, sometimes strenuously competed to acquire collections. For a time, Liverpool Museum, situated at the crossroads of the Empire's shipping lanes, held pretensions to vie with the British Museum over the breadth and quality of its collections, a rivalry extended from international trade to the domestic cultural life of the two cities which clearly expressed the political uses of cultural institutions within a competitive arena.[22] Competition between the British Museum and the South Kensington museums even sometimes became rancorous.[23]

The organisation of museums and the professionalisation of curators through affiliation to learned societies, shared membership of clubs and, from 1890, the foundation of the Museums Association, facilitated a network of institutional and personal contacts which helped supply new collections, distribute or exchange duplicate specimens and increase the documentation appertaining to this ever expanding archive. Sir Augustus Franks (1826–1897), the British Museum's energetic and much respected Keeper of Medieval and Later Antiquities and Ethnography, exercised considerable influence over ethnographic matters in museums throughout the country. Frederick Horniman (1835–1906), another case in point, kept a home in Brighton and was acquainted with Henry Willett, the founder of that town's museum who furnished him a dubiously provenanced torture chair and related instruments. The Horniman and the Bristol museums and the Wellcome Historical Medical Museum shared particularly interesting intellectual links forged under the aegis of Alfred Cort Haddon (1855–1940). Herbert Spencer Harrison (1872–1958), a close disciple of Haddon's, and L. W. G. Malcolm, one of his former students, held key curatorial appointments at various of these institutions and introduced aspects of their patron's evolutionary ideas into the reorganisation of their collections. Richard Quick (1860–1939), who left the Horniman after thirteen years service when it was taken over by the London County Council, went on to arrange the evolutionary displays at Bristol. R. E. Dennett (1857–1921), another influential collector and an early student of African religion,[24] left his collection of Kongo power objects to Exeter's Royal Albert Memorial Museum, and, like Mary Kingsley, with whom he was acquainted, he provided many of the personal contacts to enable other museums to procure similar material as well as advising on their significance.[25] Colonial administrators like Charles Hose in Borneo and R. Temple and E. H. Mann both in the Andaman and Nicobar islands distributed collections of objects and photographs widely among English museums. Thomas Joshua Alldridge's Mende collection was divided between Brighton Museum and the British Museum.[26] Commercial dealers and auction houses also greatly aided the accumulation of collections. E. Clement supplied many UK museums (Brighton, Exeter, Glasgow, the British Museum and the Horniman) with north-western Australian aboriginal artefacts. All this suggests a small, but well connected network of ethnographic collectors, dealers, curators and academics, many of whom have not as yet been properly studied, who together shaped the acquisition and formal organisation of late Victorian and Edwardian ethnographic displays.

Mercantile aesthetics: orientalism, antiquarianism and nostalgia

Based in London, the East India Company, prior to 1858, exerted political and economic control over India and, at differing periods, considerable influence over parts of the Middle East, Afghanistan, Sri Lanka, Burma, China, Tibet, Java, and Malaya. The commercial motive for encouraging agents to make collections for an incipient India Museum, although clearly and coherently articulated by the institution from the beginning, failed to describe, far less explain, the nature of the collections that came to be accumulated in the company's London head-quarters at East India House, Leadenhall Street and later at Fife House on White-hall. The company's collections included books, manuscripts and prints which established the basis of the library which, it was intended, would assist in acquaint-ing the company's officers with the people and cultures they could expect to encounter as part of their business. Later, it focused more emphatically on procur-ing collections of natural and artificial products from areas of economic interest. The proposal submitted to the company for the creation of a museum recom-mended: 'The Animal Productions should comprehend chiefly such animals, parts of animals, or produce of animals, as are objects of commerce'[27] (elephant tusk, silk worm cocoons, goats' wool, cochineal, and so on). From the vegetable kingdom the focus was to be on 'trees and plants whose produce is an article of commerce'[28] (the varieties of woods which could be used for shipbuilding and in the household, plants used in staining and dyeing, sugar cane, tea trees, cotton plants and gums and resins) and geological specimens should include 'stones,

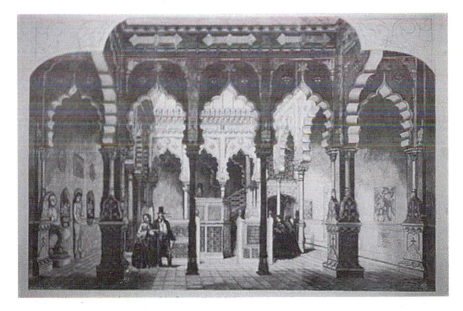

Figure 7.1 Extension to the India Museum, East India House, 1859.
Source: *Illustrated London News*.

earths, and clays as might be useful in our manufactures'.[29] Artificial products were to include articles of native manufacture, with examples showing the different stages of their production, models of machines, tools, scientific and musical instruments. The largest collection was indeed, composed of natural history specimens, reflecting the Company's commercial interests in the exploitation of such resources.

The encouragement the company gave its professional employees, surgeons, surveyors, engineers, and so on to indulge their antiquarian interests, together with the less disciplined acquisitiveness of the Museum's curators, led to the acquisition of decidedly non-commercial objects. Very early in its history, the India Museum had become the repository of such unlikely treasures as a large Roman mosaic floor and related ceramics discovered during the building and extension of its headquarters, various Egyptian mummies and even a model of a meteorite that had crashed near Bicester. After the battle of Seringapatam in 1799, part of the furnishings of the palace, including Tippoo's famous mechanical tiger, a golden footstool in the shape of a tiger's head, his howdah, armour and helmet, silk canopies and manuscripts were all brought back and deposited at Leadenhall Street. Such circumstantial serendipity helped subvert the originally defined economic interests of the museum so that by the time of its dissolution in 1879, it had become accustomed to criticism over an eclecticism that owed nothing to its avowedly pragmatic mission.

Demands for the rationalisation of the India Museum were made repeatedly during the years before its dispersal. A memorandum of 1869 emphasised that the India Museum '. . . is not a mere museum of curiosity, nor even primarily a museum intended for the advancement of science, but the reservoir, so to speak, that supplies power to a machinery created for the purpose of developing the resources of India, and promoting trade between the Eastern and Western empires of Her Majesty, to the great advantage of both'.[30] Nevertheless, judging by its increasing popularity, one would suppose that the motivation for its dramatic increase in visitor numbers, far from being any shared interest in economic botany or zoology, was a fascination with the novelties of the Orient, among which Tippoo's relics played no small part. The popularisation of the Orient, encouraged by the India Court at the 1851 Great Exhibition, sent visitor numbers soaring from 18,623 in 1850 to 37,490 in 1851.[31] Strict commercial and utilitarian functions were eclipsed in the public domain by the sense of unintended spectacle stemming from those parts of the collections that the India Museum had thought as the least important component of its displays.

Although the Museum's last director, Forbes Watson, zealously defined its research, publication and collections policy in line with its function as a trade museum, it nevertheless remained condemned as being a poorly curated, unsystematically planned eclectic assemblage put together from donations and the unwanted remains from international exhibitions.[32] While mercantile interests encouraged the accumulation of some of the earliest ethnographic and natural history collections, it was the agency of curiosity, that apparently subsisted among

curators and even flourished in the public domain, that eventually derailed any singularity of vision and purpose.

The often contradictory charms and purposive possibilities of objects were clearly expressed in Frederick Horniman's heterogeneous collections assembled between 1860 and 1900. If curiosity had worked against the rationalist organisational principle of the India Museum, it was rationalism, in the form of evolutionary anthropology, that was called to reform Horniman's instinct for curiosity and antiquarian pursuits.

The Great Exhibition had left an indelible mark on the British public, as well as on the fortune of museums like the India Museum, and perhaps on Horniman himself. Unlike his father, who had collected little on his trip to North Africa, the focus of early nineteenth-century interest in the exotic, Frederick Horniman succumbed more completely to the lure of Oriental crafts and arts. Poorly represented at this time in the British Museum, Oriental manufactures and precious materials received the highest commendations in the international exhibitions in London and Paris. Desmond, the historian of the India Museum, described the Indian section at the Great Exhibition as:

> the Aladdin's Cave of the Exhibition: the crowds were overwhelmed by the glitter of pearls, diamonds, emeralds and rubies, the intricate patterns of woven carpets, filigree work in gold and silver, elaborate carvings in stone, ivory and wood and exotic objects like flamboyant state umbrellas, silk palanquins and elephant trappings made of velvet worked in gold and silver thread.[33]

The Times, originally critical of the idea of the exhibition, gave it a thorough endorsement on the eve of its opening on 2 October 1851. Its editorial gave particular attention to the Indian section of the exhibition which it described as 'one of the most complete, splendid, and interesting collections in Hyde Park, instructive in a great variety of ways, and the merit of which cannot be too highly praised'.[34] This view was echoed by Victoria in the royal diary where she recorded how she had been 'dazzled by the most splendid shawls and tissues' and that 'the whole of the Indian section beginning with the rare products – including the splendid jewels and shawls, embroideries, silver bedsteads, ivory chairs, models – is of immense interest and quite something new for the generality of people'.[35] The India Court also carried recognisable poetic resonance which harkened back to antiquarian interests. A French visitor found himself reflecting on the 'heroic age' of human history when India had been the much desired prize of Alexander's own imperial dreams, while the historian C. R. Fay believed the section 'derived its momentum' from the image of 'a crumbling past'.[36] Like the exoticism and curiosity value inadvertently assumed by the commercially minded India Museum, the simple economic and humanitarian motivations for the Great Exhibition became, in the public mind, compounded with emotive strains of exoticism and antiquarianism as much as by the march of industrial progress, commercial expansion and patriotic sentiment.

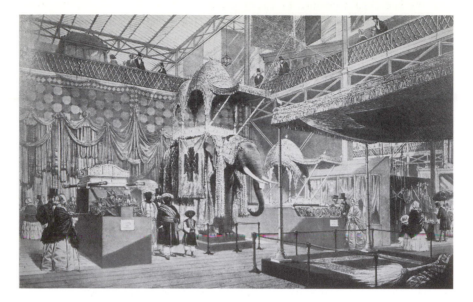

Figure 7.2 The India Court at the Great Exhibition, 1851.
Source: *Illustrated London News.*

By 1854, the exhibition building had been dismantled and re-erected in Sydenham, less than 6 km from Horniman's family home in Croydon and only 3 km from Forest Hill where he established his own household five years later. The private company responsible for its upkeep, plainly influenced by the popularity of the Indian exhibition, included a permanent display area devoted to Indian art and customs that was dominated by about twenty full-sized painted copies of the Ajanta frescos taken from caves used as a Buddhist sanctuary.[37]

Henry Cole, the chief organiser of the 1851 exhibition, had wanted to present the empire as a vast treasure house.[38] This same formula was applied to successive exhibitions, but by 1862 when the Society of Arts began preparing yet another India exhibition, the mere spectacle of 'barbaric gold and gems' had been too well rehearsed to guarantee success.[39] Subsequent annual exhibitions, between 1871–74, held in the galleries of the Royal Horticultural Gardens in South Kensington, also included Indian exhibits that were intended, eventually, to be enlarged to feature 'a collection of objects illustrative of the ethnology and geography of the various parts and races of the British Empire, including especially the races of India'.[40]

This intense period of Britain's infatuation with the Orient provided part of the aesthetic and emotional context, and perhaps even a strong impulse to Frederick Horniman's concerted collecting. Horniman's inquisitiveness over the techniques and products of exotic countries, particularly those of the East, was matched by what at first appears a strange and unrelated interest in early English furniture and European porcelain and folk art. Such a contrast was by no means

new and had already been rehearsed during the 1851 exhibition in a comparison between the treasury of the India Court and Pugin's sombre Gothic Court. More general still, and what Horniman may perhaps have alluded to, was the late Victorian nostalgia for the past. David Lowenthal has noted that no age more than the nineteenth century suffered from the schism between the arts that lamented the erosion of the past and the sciences that eagerly looked forward to the future.[41] For Ruskin and Pugin, all the great architectural achievements belonged to the ancient world or medieval world. The pre-Raphaelites, and the Arts and Craft Movement that Horniman appears to have supported, identified their art with the middle ages,[42] conflating their values with those of the pre-industrial cult. Like many Victorians Horniman was ambiguous about embracing scientific innovation (he installed electrical lighting in Surrey House and gas lighting in the 1901 museum, exhibited telegraphic wiring and silverplate, and showed interest in the use of the phonograph for recording messages, as well as exploring the economic and spatial benefits to be gained from biodegradable coffins), which he partly identified with the decline of traditional workmanship, craft and hard work. The inclusion of historical domestic interiors, seventeenth- and eighteenth-century bottles, locks and keys, finely crafted and decorated Norwegian mangles, wooden tankards, German and Austrian Meerschaum pipes and fine porcelain from across Europe, suggests a strong intention to preserve examples of traditional craftsmanship and manufacturing techniques in the face of rapid industrialisation and transformation.

Despite its apparent eclecticism, by the last decade of the nineteenth century, Horniman's collection was largely composed of natural history and objects reflecting his antiquarian and oriental interests. Oriental artefacts included Chinese furniture, paintings (showing different occupations) Japanese embroideries, dresses, metalwork, porcelain and wooden carvings and panels, Indian figures, metalwork, paintings on talc, bidri ware, Japanese, Chinese, Indian, Inuit, Swiss and African ivory carvings, while other galleries housed an armoury and a suite of early English rooms, furnished in period style and including related miscellaneous items. Elsewhere rooms housed several suits of Samurai armour and Asian, Scandinavian and Peruvian deities. Ethnographic items, by contemporary definitions, were few and the 1890 guide recounts only Zulu warriors, dress, shields, beaded clothing, weapons and beadwork, New Guinea spears, Malay artefacts, Inuit clothing and snowshoes and a 'Fiji lady's ball dress'. The Oriental collections were finally consolidated by the material acquired during the world trips he undertook between 1894 and 1896.

While we can only assume that the educational purpose of the collection was to preserve examples of pre-industrial arts and crafts and their techniques of manufacture, and provide, through natural history and ethnography, knowledge of other peoples and lands, it would be naive to think Horniman could have been entirely unaware of how such a collection could have increased his public prestige. Throughout the Victorian and Edwardian period, there was a plentiful supply of exotic objects entering Britain which provided a ready source for newly established mercantile and industrial magnates-cum-collectors who sought social

recognition. Richard and Henry Syer Cuming and later, Leverhulme, Twining and Wellcome were all enthusiastic collectors of ethnography and were able to accumulate status through good works and their commitment to the universalising Humboldtian metanarrative upholding the humanitarian value of science. Wellcome, who founded a collection that he compared directly with those of Horniman and Pitt Rivers,[43] was particularly successful at attracting academic recognition; he received an honorary doctorate in laws from the University of Edinburgh (1928), and became both an Honorary Fellow of the Royal College of Surgeons and a Fellow of the Royal Society in 1932.[44] According to the Eighth Annual Report of 1898, Horniman had achieved even greater success, having been elected a fellow of seven learned societies, being an associate of another, and holding membership of six more.

Allusions to the cult of personal fame, posterity and commemoration were in evidence throughout Horniman's museum. Horniman repeatedly demonstrated a keen sense of the importance of anniversary celebrations, and kept his family's heraldic ensign raised on land opposite to the Museum.[45] The earliest museum guide of 1890 provided further evidence of his concern over his posthumous reputation. Five volumes of letters and signatures of historical and then contemporary rich and powerful figures were laid next to the visitors' book, while the 1897 guide never fails to remind the visitor of a specimen Horniman collected, a learned society of which he had been granted membership, or a species bearing his or another Horniman's name. Horniman's interest in genealogy and commemoration, however, was perhaps best indicated by a set of plaster casts of coins depicting Roman emperors which the Museum still holds.

Despite such concern with status and prestige, which itself does not detract from the ardent sincerity of Horniman's overwhelming philanthropy, one can detect also a strong sense of irony. Mortality is acknowledged on the label attached to a female skeleton, which read 'The framework on which beauty is founded'. Furthermore, Horniman appears to have been reluctant to envisage a strategy which would have enabled him to complete and close his collection. Never did he explicitly define the parameters or precise purpose of his collections. He failed to keep registers, and apparently never contemplated the publication of a definitive catalogue. In place of any symbolic triumphalism, his displays ended with touching, sentimental humour. The 1890 guide to the Surrey House Museum records the visitor's tour ending with a live animal enclosure with two Russian bears, Jumbo and Alice, and a Brazilian monkey, Nellie. By the tenth edition of the guide (undated)[46] these had been supplemented with 'a number of comically-arranged Specimens of Animal Life: Frogs at Play, Kitten Pies, the Hospital Nurse, the Unwilling Patient, the Crab Party, etc.'[47] These may have been acquired from the same group, or workshop, as the comical creatures prepared by Hermann Ploucquet, much admired by Queen Victoria, for the Great Exhibition.[48] In place of the usually longed for statement proclaiming the definitive achieved status and closure of the collection, Horniman conjured an ironic, paradoxical even deprecating verdict on his achievement. A world turned upside down in which animals assumed human motivations and genteel manners were

replaced by monkey antics. Through these mechanisms, Horniman may have intended to express an ironic and jocular commentary on his own life's work, being confronted and only too aware that a collection has no natural point of closure and disappointed by the impossibility of ever completing his life's passion, or to achieve the full recognition that his munificence and devotion to public office deserved. He received no knighthood. No public monument was erected in his honour and his grave, now overgrown and neglected, records only his name and dates.

Imperial knowledge

In the latter half of the nineteenth and early twentieth centuries, evolutionary anthropology assumed the status of a master narrative capable of providing a totalising theory of history, archaeology, folklore and society to interpret then contemporary social realities. Many critics and apologists of the status quo alike conducted their polemics within the terms established by evolutionary discourse. Tylor, in 1871,[49] declared anthropology to be a 'reformers' science' which focused on the study of foreign customs in order to identify and expiate their equivalent survivals in the developing European states. On the other hand, for critics of capitalist society like Henry Morgan, native institutions and social mechanisms could be extolled as ethically superior to those of the West.[50] Overwhelmingly, however, interest was focused on formulating universal laws of evolution which could provide explanatory descriptions of social institutions and customs thereby enabling a rank order of societies, based on their intellectual and technical achievements, to be determined. Consequently, the collections of facts and artefacts from this period were partly, though not consistently, grounded within the principles they were thought to demonstrate and the practical exigencies of the agencies which sponsored them.

The foundation of the Museums Association in 1889 encouraged 'the promotion of better and more systematic working of Museums throughout the Kingdom', clearly distinguishing the modern ideal from the personal arrangements of virtuosos. An early article appearing in the Association's journal bemoaned how curiosity collections such as those that still survived in the Sir John Soane Museum, while 'of considerable intrinsic value, are practically useless for teaching purposes, owing to their miscellaneous character and absence of systematic arrangement'.[51] Another writer noted that, with the help of the Association, museums 'are no longer old curiosity shops, they are now educational colleges'.[52] Haddon himself observed '. . . most of the older museums bear the same relation to modern museums that dictionaries do to textbooks . . . giving the least amount of instruction beyond the bare fact of the existence of given objects . . . while if properly conducted (museums) afford the most interesting and vivid means for conveying information'.[53]

Museums had already demonstrated their worth as research and specialist educational institutions by providing the resources through which laws of technological evolution could be worked out and comparative chronologies ascertained.

As early as 1835, C. J. Thomsen, using the archaeological collections at the Copenhagen Museum, established a systematic sequencing of the Stone, Bronze and Iron Ages.[54] However, the evolutionists were not content to use material culture only to establish chronologies, but ventured to correlate it with mental aptitudes. The doyen of evolutionary museology, Augustus Pitt Rivers, opined:

> Human ideas as represented by the various products of human industry are capable of classification into genera, species and varieties, in the same manner as the products of the vegetable and animal kingdoms, and in their development from the homogenous to the heterogeneous they obey the same laws. If, therefore, we can obtain a sufficient number of objects to represent the succession of ideas it will be found that they are capable of being arranged in Museums upon a similar plan.[55]

The influence of such ideas on museum collecting, research, classification, and display cannot be emphasised enough. The British Museum's collections, including the ethnography galleries, described by Pitt Rivers in his 1888 Presidential address to the Anthropological Section of the British Association as being '. . . in a molluscous and invertebrate condition of development'[56] were, by 1910, recommended as demonstrating that 'the work of primitive hands is but the tangible expression of primitive thought'.[57] Similarly, the jumbling together of ethnography with Egyptian relics, archaeology, British china, medieval manuscripts and materia medica described in the 1876 Annual Report of the Bristol Museum, had by 1902 been transformed by the addition of a separate room reserved for ethnography alone in which the collections were divided according to their racial origins.[58]

The Horniman Museum, Liverpool, Warrington, Brighton, and the Royal Scottish Museum, to name but few, adopted the evolutionary perspective for organising their archaeological and ethnographic displays. Larger institutions like the British Museum preferred a geographical classification of objects, while smaller museums implemented Pitt Rivers'[59] typological scheme. Warrington Museum, which has retained a good number of its evolutionary displays to the present day, also used geographical criteria. The collection mainly housed in wall cases arranged around a small rectangular chamber with an upstairs balcony, exemplifies the breadth of anthropology's then comprehensive claims. Beginning with the dinosaurs, it traces the evolution of humanity from apes, through to the Stone, Bronze and Iron Ages. Comparative displays are also included, the Stone Age, represented by tools and implements from Europe and Africa, while the Iron Age includes specimens from Europe and Luristan (Iran). The Bronze Age is represented in table cases by using casts to trace the evolution of stone celts. A critical path links the Iron Age to antiquity via Egypt then to the ethnographic sections beginning with Africa, South America, North America and newer displays, which have now disrupted the sequence of the evolutionary wrap, on Asia and the Pacific. Text, though sparse, still reiterates the evolutionary ideal. The labelling of the Australian aboriginal material for example recalls: 'They had

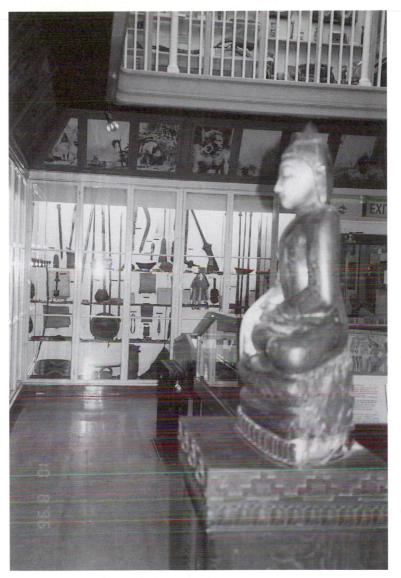

Figure 7.3 Ethnography Gallery, Warrington Museum and Art Gallery, 1997.
Source: Anthony Alan Shelton.

not advanced very far in the scale of civilisation at the date of their discovery'. Tattooing, another nineteenth-century index of barbaric custom,[60] is represented by, among other articles, a plaster cast of a tattooed Maori head, with a label recording the practice's prohibition under European rule. Above the wall cases, reaching to the balcony, are large black and white prints and photographs

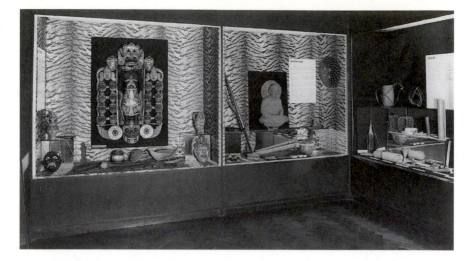

Figure 7.4 Ethnography Gallery, Brighton Museum and Gallery, 1993.
Source: Anthony Alan Shelton.

arranged to relate to the displays beneath them, depicting scenes from the Stone Age, Vikings, Assyrians, Egypt, Africa, America, Asia and the Pacific.

With Horniman's transfer of his collection, and the gift of a purpose-built building to the London Borough Council in 1901, a similar evolutionary classification, this time devised by A. C. Haddon, was gradually adopted. Through its collections, displays, and programmes of courses and lectures, Haddon sought to popularise and spread an inclusive and comprehensive view of civilisation, which he had been unable, at that time, to pursue at Cambridge where his advancement to a responsible curatorial position had perhaps been hampered by his social and financially disadvantaged position. In 1920, Haddon briefly occupied the position of Deputy Curator of the Cambridge Museum, when he arranged some evolutionary sequences in side cases for student use, but it was the Horniman on which he exerted his most concerted efforts and which 'best embodied his conception of what a Museum should be'.[61] Despite the British Museum's reputed hostility to the idea of the capital having a second ethnographic collection,[62] in 1901 the new Horniman Free Museum opened its doors to the public.

No stronger contrast could be imagined than between Frederick Horniman's original eclectic displays in his Surrey House Museum and their radical reorganisation after 1902 under Haddon's and later Herbert Harrison's direction. Haddon recommended that the Horniman become the one London museum 'set apart to illustrate the evolution of culture'.[63] By 1902 both the type of material included in the collection and the means of acquiring it were radically changed. The sources which Horniman had depended on for acquiring specimens – salerooms, international exhibitions, his personal tours of the East and friends and associates such as missionaries like the Reverends R. Davidson, H. Lansdell and

H. Spilsbury, military men like W. J. Hider and others like Sir Somers Vine, associated with the international exhibitions, were replaced by Haddon's own network of influential contacts, family and friends including his son, Ernest, Charles Seligman, Charles Hose, Stanley Gardiner, Sir Evarard Im Thurn, Emile Torday, R. Radcliffe-Brown and the Revd John Roscoe. Many of these were either professional anthropologists, trained or connected to Cambridge, or successful colonial officials with a strong interest in the peoples they administered.

To prepare the necessary evolutionary sequences, Haddon needed to augment the collection by 'filling in gaps' and extending it to cover previously unrepresented or under-represented areas like the Pacific, the Americas and Africa. This was carried out through an assiduous and careful selection of objects from donations offered by benefactors. In some cases only one or two objects would be accepted from much larger collections offered to the Museum. Haddon himself gave an Inuit and American Northwest coast collection, while, from Oceania, he provided some 'duplicates' of the Torres Strait material that had been divided between the British Museum and Cambridge. The Museum also negotiated exchanges and transfers of objects with other institutions including the Smithsonian Institution and the Royal Botanic Gardens at Kew. Notwithstanding such activity, the collections remained insufficiently complete to allow their wholesale rearrangement by systematic evolutionary criteria. Nevertheless, as early as 1904, the museum guide could boast the completion of object series on the evolution of tools from the Stone and Bronze Ages to Romano-British and Anglo-Saxon implements, the evolution of pottery forms from gourds, the evolution and degeneration of design in Oceania, and expositions of Christian, Hindu, Buddhist and various Oceanic and African animistic beliefs each arranged in their own case. A special case was reserved for the baskets, personal decoration and material culture of the Andaman Islanders who, as in other displays such as those at the British Museum[64] and Brighton Museum, were included to exemplify the most primitive rung on the evolutionary ladder. Emslie Horniman supported Haddon by funding his acquisitions and collecting material himself as recommended. Emslie's son Eric, while touring in the United States, acquired a small but excellent collection of Plains Indian material.[65]

Like his colleagues, Tylor and Balfour at Oxford, Haddon shared the view of anthropology as a master narrative that incorporated primate evolution, archaeology, linguistics, folklore and ethnography. Nevertheless, it was not the universal evolutionary perspective that interested him as much as 'the distribution of forms within a single geographical area',[66] best illustrated by his work on the evolution of decorative art in Papua New Guinea. Haddon had himself supported and participated in the Ethnographic Survey of the United Kingdom (1892–9)[67] which had attempted to reconstruct the country's racial history, before it disappeared through urban encroachment and racial mixing. His close and sympathetic association with folklorists may have deepened his interest in Tylor's theory of survivals and encouraged him to seek out domestic folk art and charms to demonstrate the survival of the pagan past at home. The relationship between ethnography and folklore, and implicitly between non-European and European

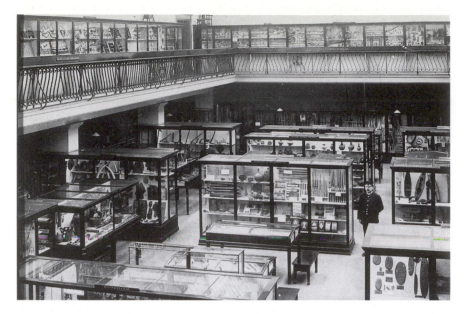

Figure 7.5 Ethnography Gallery, Horniman Museum, 1904 (South Hall). The case
containing 'The evolution of decorative art' arranged by A. C. Haddon is
flanked by the security guard.

Source: Horniman Museum.

collections, was clearly stated in a lecture Haddon delivered at the Horniman in
1911:

> The 'Folk' have a similar relation to educated people to that of savages to
> civilised communities; they are the backward people among ourselves. . . .
> Folklore is thus mainly the investigation of psychical survivals within a more
> or less civilised society, and by its means we are enabled to study the practices
> and beliefs of our forefathers, for in an attenuated form many of these
> actually persist among us.[68]

Haddon's influence on the Horniman Museum far outlived his eleven year tenure
as advisory curator. Harrison, who had met Haddon in Cardiff and who was also
trained as a natural scientist, showed himself to be an ardent evolutionist during
his long career from 1903–37 at the Museum. He was succeeded by L. W. G.
Malcolm, another evolutionist and one of Haddon's former students who
continued to hold the post until his death in 1947, ending forty-five years of
Haddon's intellectual influence.[69]

 Victorian science saw no inevitable unilinearity in society's evolution towards
greater progress, more rational forms of organisation and overall prosperity. The
survival of pre-rationalist customs in Europe and, at times, the attitude and

behaviour of the working classes, allowed them no easy faith, either in evolution's inevitability or its uniform adoption throughout the different classes. Pernicious exterior influences, if not checked, could also contaminate the ethics and behaviour of individuals or society, increasing their susceptibility to decline. In the 1900s, the fear of degeneration was exploited through propaganda when wartime German practices involving the public nailing of wooden monuments caused one British newspaper to make a connection with the 'barbaric' rites of central African fetishists.[70] In a similar ideological vein, a text label, from the same period, on Scarification, from the Horniman Museum, after noting that 'it is practised chiefly by dark-skinned people such as the Australian Aboriginal, Papuans and Africans', goes on to note 'The facial scars of the German student, though they are obtained in a kind of duel, are strictly comparable with those of savage people'.

While museum ethnography followed the lead of evolutionary anthropology in piecing together the sequential development of societies, Victorian and Edwardian literature imagined and popularised the implications of this degeneration. The source of such contamination was sometimes located as coming from the tropics, from the rebellion or habits of the European poor, or the breaching of scientific laws. The concern that the evolutionary process might somehow unravel and work in reverse to throw Europe or its subjects into barbarity, provided a rich vein in the literature of the period. Physical degeneration, mirroring moral degeneration, was the theme of Robert Louis Stevenson's *Dr Jekyll and Mr Hyde* (1886) and Oscar Wilde's *Portrait of Dorian Grey* (1890), while Joseph Conrad's *Heart of Darkness* (1902) cast Kurtz as the agent and product of moral and social decline (man returned to nature). In Conrad, as in Kipling, the identities of the savage and the civilised are bound to their integration in a particular society and their actions in a familiar environment, which, when breached, threatens the individual with personal degeneration.[71] Any thought of utopian romanticism was countered with the image of a less than perfect evocation of lost white kingdoms or realms under non-official white trusteeship, that either stood still in time or had already declined morally or socially, Burroughs' Opar in his Tarzan series, or Rider Haggard's Kukuanaland in *King Solomon's Mines* (1886). Even when European explorers found high civilisation in foreign lands, the evidence was sometimes identified as the work of mythologically advanced civilisations rather than their then contemporary or neighbouring populations. The nineteenth-century German explorer, Leo Frobenius, identified Benin with Atlantis; Karl Maunch, who mapped and discovered the first artefacts from Great Zimbabwe, attributed its construction to the Egyptians or Phoenicians (as did Cecil Rhodes, who purchased Maunch's relics). The pattern was repeated elsewhere. Another nineteenth-century explorer, Augustus Le Plongeon, reported the Maya ruins of Central America to be the remains of Atlantis. Early in the present century, Michael Mitchell-Hedges and Rider Haggard even assembled collections of material artefacts which they sold or donated to museums to confirm their respective claims to be the discoverers of mythical sites[72]. After the First World War, writers such as John Buchan did not see the threat to civilisation as coming

from foreign shores, but from the irrational side of a common human nature.[73] Fetishism, bodily disfiguration, or other degenerative customs, could be made the subject of jokes, derision, even legal prohibition, but they could not be left uncounted, any more than the conditions of the European proletariat could be ignored if they were not to constitute a threat of savagery and paganism from within the upwardly developing societies of Europe and America.

Evolutionary anthropology, as a master narrative, had wider application outside of ethnographic, folkloric or archaeological science. So convinced by its explanatory ability, Sir Henry Wellcome, in the first decades of the twentieth century, seldom even unpacked the great wealth of material that flooded into his stores, until he was satisfied that he had acquired sufficient specimens to fully illustrate the evolution of medicine. Ironically, as his permanent exhibitions began to take shape, beginning in 1913, the evolutionary paradigm had already lost much of its conviction.[74] Wellcome, with a collection of 1.5 million objects, larger than the ethnographic holdings of the British Museum and the Pitt Rivers, remained stubbornly wedded to evolutionary principles. The 1920 handbook to the collection unequivocally proclaimed that, 'in many of the practices and customs common among primitive races today in the treatment of disease we find a reflection of what medicine must have been in very early times in Europe'.[75] The 1927 guide elaborated this perspective even further: 'One of the great aims of this Museum is to connect the links in the chains of human experience which stretch back from the present time into the prehistoric period of the early ages. . . . Efforts will be made to trace the genesis of many branches of the healing art . . .'.[76]

Evolutionism provided the justification for missionary activity, hygiene and sexual mores and prohibitions, the marketing of medicine and so-called health products abroad, as well as the whole thrust towards industrialisation, urbanisation, commodified social relations and market expansion at home. It articulated and codified the unbreachable gap separating the inhabitants of other parts of the world from those of Europe, forcing the former into the roles of passive receptors of the dubious benefits of European culture and influencing the structure of the relationship between Europe and the other to the present day. It provided a powerful and inclusive scale of differences through which 'otherness' was measured.

Operational research and the colonial order

From the 1930s the institutionalisation of British anthropology, under the effect of massive Rockefeller funding, realigned itself away from museums to African research institutes and new fledgling university departments.[77] Although anthropologists continued to collect material culture, the later rupture between the mainstream academic discipline and museums had already been anticipated in Radcliffe-Brown's 1922 monograph on the Andaman Islanders.[78] The monograph, devoted to reconstructing the way of life of one of the purportedly simplest cultures on the evolutionary scale, revealed Radcliffe-Brown's continued

intellectual indebtedness to Haddon, his former tutor, but in his explanation of how the society functioned, he showed an unmistakable Malinowskian leaning. Although there was nothing particularly innovative about this staid excursion into functionalist interpretation, for the first time the organisation of the monograph incorporated what one might call the anthropology of art (a chapter on tattooing) into the interpretative body of the text, while material culture, far from being ignored, formed part of an extensive appendix. The publication in 1922 of *The Andaman Islanders* proclaimed the decisive break in British anthropology between academic and museum interests and practitioners.[79]

The imposition of discipline and system on the display and future acquisition of collections coincided with the state taking direct responsibility for territories and developing formal tutelary relationships. The new focus of academic anthropology on social organisation, political institutions and rulership was not unsurprising given Sir Frederick Lugard's[80] model of local government as best exercised, in the colonies, through existing institutions. Furthermore, after 1880, the slow reconfiguration of anthropology away from armchair speculation to the collection of data at first hand, coincided with the growing European penetration of Africa and provided a scientific and systematic gloss for what missionary and government fieldworkers like Northcote-Thomas, Rattray, Meeks and Talbot had already pioneered in Nigeria and Sierra Leone. The well tried field guides, such as the early questionnaires recommended by *Notes and Queries*, already contained much to interest colonial officials.[81] New anthropological methods provided the systematic linkages between the data so obtained. By stipulating guidelines governing the collection of field data, encouraging the collection of a textual corpus, advocating cross-referral and visual confirmation of textual data and providing a heuristic model (the organic analogy) to explain the functioning of societies, functionalism came to reconstitute the template for the formal organisation of the ethnographic monograph. The colonial eye thereby became self-legitimated by projecting its gaze onto an apparently transcendental reality, before reincorporating its sense data as the scientific narratives of a 'proper' discipline.[82]

Whereas the origins of evolutionary and diffusionist anthropology had occurred in university museums which had provided the extensive collections of type specimens through which the development of technical forms could be traced, or sufficiently large reserves of sculpture to provide the evidence for reflections on the evolution of religious beliefs or decorative art, functionalism changed the focus of anthropology to practical field research. Now, more often than not, anthropology ignored material culture[83] and concentrated on the interconnections between the social institutions contained within the 'tribe', an idealistically conceptualised, self-regulating, and enduring unit of study. Academic anthropology became particularistic, descriptive and heuristic while museum ethnography languished within conjecturally established comparative historical sequencings of societies and the empirical description of so-called 'primitive' technologies.

While most ethnographic displays in established museums lingered under the intellectually discredited sway of evolutionism, new institutions emerged to

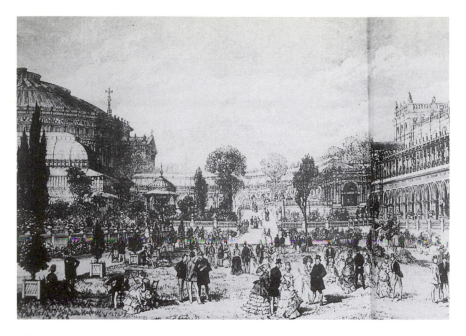

Figure 7.6 The International Exhibition Galleries, Kensington 1871. Following the popularity of Indian Art, a number of Oriental exhibitions were held here throughout the latter part of the nineteenth century.

Source: *Illustrated London News.*

embody the functionalist concept of the ethnographic archive. With the first signs of opposition against the India Museum, Lord Carnarvon, a former secretary of state for the colonies, and more guardedly statesmen like M. E. Grant-Duff, Sir Thomas Erskine Perry and even the then Prince of Wales, had urged its incorporation with the ethnographic collections from other colonies to establish a colonial museum which would gather together the arts, technology and produce of the empire under one roof.[84] Even in the 1870s the idea of constructing a strictly pan-colonial mercantile museum arranged along similar lines to the India Museum was still mooted. Such a project, different in purpose but bearing many similarities to the functionalist ideas of an archive of material culture, was therefore not new. Despite the apparent lack of support for the enterprise, indicated by the repeated disposal of the collections assembled for the various international and South Kensington exhibitions, the government in 1887 unexpectedly reversed its feelings, and in 1893 the Imperial Institute opened its gates to the public.[85] From the outset, the Institute was commemorative of empire and royalty. Victoria laid the foundation stone in the year of her jubilee, asserting her desire that the Institute would continue the work begun by her late husband with the 1851 exhibition. The organising committee saw the purpose of the Institute as being to exhibit 'the vast area, the varied resources, and the marvellous growth

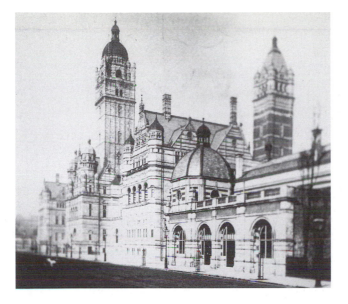

Figure 7.7 The Imperial Institute, 1893.
Source: Illustrated London News.

during Her Majesty's reign, of the British Empire'.[86] The Imperial Institute Act of 1902 'listed its purposes as being to display the resources of the Empire together with the "comparative advance made in other countries", to establish a commercial museum and sample rooms in London and throughout the Empire, to collect and disseminate information, to advance trades and handicrafts, promote technical and commercial education, further systematic colonisation, and promote conferences and lectures'.[87] More than simply providing exhibition spaces, however, the Institute aimed at being interventionist. It incorporated laboratories to research and develop the use of colonial resources and products; it provided classes in African and Asian languages. Furthermore, it was intended to house the emigration department and a trade bureau to encourage foreign investment by providing information on trade, commerce transportation and labour.

The Institute, like the Horniman and Manchester museums, was attentive to the demands for popular and mass education contained in the 1902 Education Act, although it did not fulfil its founders' ambitions until the 1920s. Among its purposes, the Institute aspired to 'strengthen the bonds of union between all classes and races in Our Dominions and to promote a feeling of mutual goodwill, of a common citizenship . . . of Empire'.[88] By concentrating its efforts on schoolchildren, attendance increased from 138,964 in 1947 to 407,000 in 1953.[89] By 1954, it could claim that it had reached 1.25 million, 80 per cent of which were children.[90] In the latter part of its existence the Institute pioneered and mastered modern propagandist techniques. Dioramas illustrated economic resources and

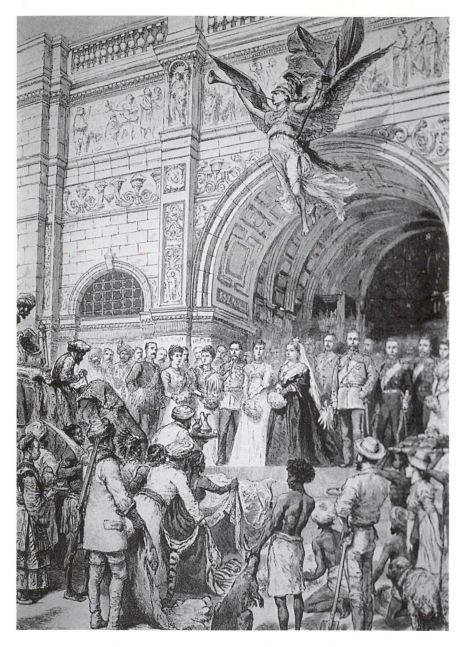

Figure 7.8 Queen Victoria opening the Imperial Institute, 1893.
Source: *Illustrated London News.*

technical skills; film was introduced as a medium to represent the cultural hetero-geneity and geographical diversity of the Empire. The Institute provided travel-ling exhibitions and displays for incorporation into international exhibitions. The intention behind the uses of these media, according to one of its directors, Sir William Furse, writing in 1926, was to diversify and increase attendance by provid-ing new displays, modelled on the reconstructions of real life scenes.[91] Models and dioramas miniaturised the Empire's subjects to a more comprehensive surveil-lance by the colonial eye. The fixation with realism has increasingly made lifeless models appear more alive than the living whom, confronted with the enormity and heterogeneity of the world displayed before them, shrink to inconsequence finding whatever meaning they can still muster in the identification with their own kin. As Coombes[92] has observed, this genre had the effect of exaggerating cultural heterogeneity in order to minimise class differences and promote the idea of British racial homogeneity. By the time the Institute was closed in 1955,[93] it had developed an effective means of communicating cultural differences by develop-ing the diorama into life-size reconstructions which were to characterise the dis-plays of the Wellcome Historical Medical Museum in the 1930s and much later ethnographic displays in the Museum of Mankind (the Ethnography Department of the British Museum) through the 1970s and 1980s. The Horniman Museum inherited some of the Institute's dioramas which it continued to use to present episodes from the everyday life of non-Western peoples well into the 1990s. The exhibitionary techniques of the Imperial Institute and the Museum of Mankind reconstructed 'the field', as a product of the colonial gaze's foreign surveillance, in the heart of London, portraying its exotic removal, its self-containment, its alienation from Western life and the Western mastery over its government and economy through scientific and technical knowledge. At the same time it ignored economic subordination and social marginalisation which had and continued to produce population movements and diasporas which challenged the fundamental concepts of race, ethnic identity and nationhood on which such exhibitions depended. Faithfully perfected as agents of cultural reproduction to continually reaffirm the habitus of colonial knowledge and sentiment, the Imperial Institute ensured the official culture of colonialism was constructed at home rather than in the colonies and helped guarantee government sponsorship and support for the idea of foreign possessions.

Similar ideological effects were also produced in provincial museums whose substitution, in the 1950s and 1960s, of evolutionary displays with functionalist presentations, mirrored the change from grand legitimating narratives to par-ticularising and essentialist representations of the other. Liverpool stood almost alone in providing an exception to these national trends. Because of the unique circumstances under which their ethnographic material had been acquired, Liverpool assembled remarkable collections of African figurative art rather than a sampling of 'primitive technology' and material culture, making them more comparable with the collections of the great continental port cities of Hamburg, Rotterdam and Antwerp, rather than those of other British provincial museums.[94] Consequently, alongside the organisation of the archaeological and

ethnographic collections following standard evolutionary narratives, the Museum sponsored a series of temporary exhibitions featuring figurative works displayed as fine art.

When, in the 1960s, museum ethnography again took notice of academic anthropology, at a time when functionalism[95] was rapidly losing academic conviction, its already suspect principles were adopted in re-designing older galleries. Functionalist displays occurred in two waves, with Manchester and Glasgow leading the trend in the 1950s and early 1960s, followed in the first half of the 1970s by Brighton, Exeter and Leeds. Displays were organised according to tribal (Africa), continental (Americas, Pacific and Asia) and national (Asia) affiliations in which artefacts were used to form metonymic associations with dehistoricised aspects of social or economic organisation and religion. The resulting displays therefore, paradoxically appeared as windows reflecting the idealised colonial gaze, precisely at the time when the European powers were relinquishing their direct colonial pretensions.[96]

Material culture and alterity

All collecting is necessarily partial and corresponds to individual reactions to particular ideologically constituted intellectual or emotional fields. The epistemological assumptions throughout the period 1880–1960 were derived from positivism, a theory of knowledge which sharply divided the subject from the object and, on the basis of perceptually ascertained facts, induced that nature was governed by transcendental laws underlying its structure and development. Humanity itself was naturalised enabling ethics, psychology and sociology to claim the same scientific status as the natural sciences. Speculative philosophy was avoided in favour of measured and controlled experimentation verifiable through sense impressions. The factuality of the world awaited discovery and collection to eventually provide the comprehensive field of knowledge that would enable humanity to exert its control over environment and society alike. Facts and artefacts (archives and museums) were thus considered to share a similar status. Joined by a shared epistemology, they were seen as meaningful denominations, which had their own logical connections that enabled them to form natural fields of meanings which might have didactic if not always immediately practical functions. The samples of dyes, woods, animal products, plants and native manufactures that were shipped back in such great number to form the natural history repository of the India Museum were meant to have practical commercial value rather than curiosity interest. Throughout the history of the India Museum, practical considerations became more and more focused, leading to the suggestion of a rational organisation of collections, with the master archive located at its London headquarters, supplying sample collections to the provinces and elsewhere for industry to consult and employ in the development and improvement of manufactures. The use of collections to stimulate market demand even led the last director of the India Museum to cut up its fine 'surplus' textile collections to form an edition of twenty eighteen-volume sets comprising 700 examples of native cotton, silk and

woollen articles which were distributed to chambers of commerce throughout the country.[97] This model provided an early example of mass communication and marketing within a globally integrated capitalism. The Imperial Institute followed a similar course by using its collection in a mass communication exercise (exhibitions, travelling displays, lectures, films) to propagate a sense of pan-national citizenship and belief in a necessary economic integration between Britain and her colonies. In both examples collections were used as convertible commodities with their own exchange values and ratios; in the first case they were re-articulated as mass reproduction textiles which in turn were converted into financial capital, while in the second example, hand-produced commodities were converted into symbolic capital destined to reproduce the cycle of economic production and reproduction.

Under the auspices of Alfred Cort Haddon and the management committee of the London County Council, the Horniman Museum also underwent rationalisation, with time, shedding a large part of its European decorative art collections to the Jeffrey Museum and, later, part of its weapons collection to the Imperial War Museum to enable it to better propagate a rationalist discourse on the principles of cultural and biological evolution. Provincial museums throughout the country reorganised their ethnographic exhibits first according to evolutionary and then functional criteria. Museums with insufficiently large ethnographic collections disposed of their material by donating them to other institutions or by other means.

From the beginning of the twentieth century, museums were intended, at least in the area of ethnography, to abandon their status both as research centres and emporiums, and to become repositories of applied and useful knowledge.[98] Within this new semantic field ethnographic and foreign artefacts were divided into three categories according to their use and significance for the Victorian and Edwardian mind. First, models of domestic and religious architecture or means of transport, as well as tools and scientific and technical instruments could be surveyed for their adaptability to particular situations. Second, collections containing the different stages in the manufacture of specific products were used to illustrate processes. At this level therefore, the inclusion of 'otherly' objects such as those in the India and Horniman museums and the Imperial Institute collections was probably motivated by near identical, practical concerns.

The ideal collection, as Forbes Watson recognised, was that formed by a complete survey of a particular manufacture.[99] The closest any nineteenth or twentieth century museum succeeded in attaining such goals was the raw materials contained within natural history collections or the textile samples amassed by the Bankfield Museum, Halifax, which, as we have seen, were believed to have potential economic benefits. Watson's ideal, based on the organisation of the international exhibitions, was however, realised with the rise of trade catalogues and commercial patterns and samplers which may be linked to the contemporary general purpose mail-order catalogues as an ubiquitous part of Western consumerism. These first two categories of museum objects were not intended

to constitute an exotic 'otherness', but to acknowledge the existence of skills, products and raw materials that might be usefully incorporated into a Western capitalist system which increasingly sought a field of global operations.

Within the field of technology, material culture and manufacture, it was assumed there existed a neutral and intelligible descriptive language that existed outside of the realm of cultural mediation – a belief maintained by much of museum-based material culture studies to the present day. The social aspects of these collections were represented by such ubiquitous objects as dioramas of village, religious and economic life; casts of heads representing indigenous types and clay models exemplifying the traits of members of different castes. These possessed a didactic function of distinguishing the marks of 'otherness' and ranking them according to an indigenous system, albeit one that could be understood first in terms of distinct tribal entities and later through Western class distinctions.

The third and most problematic category of objects were those that demanded a more sustained attempt at cultural mediation. It is these that formed the so-called treasures of museum collections, which gave rise to elaborate discourses such as those on the 'fetish', the 'ju ju', the 'gregre', the 'idol' or the 'charm'. These were the beguiling and irresistible curiosities that were imprisoned by museums and provided the strongest markers of an 'otherness' that was never satisfactorily domesticated within metropolitan generated classifications. It was not gratuitous that, in the 1890 guide to the Surrey House Museum, Horniman cryptically advised his visitors that before entering the African and Japanese Room '. . . it would be as well to look in the two Mirrors to make sure of your identity . . .'. Unlike other categories this class of objects questioned rather than answered; they were thought to express the fearsome and dark side of human consciousness rather than evince purposive and rational action or proof of ethical goodness. They constituted the museum's Gothic, even though such categories may have historically evolved from European practices.

Horror, in the cinema, was equated with the practices of exotic cultures that manipulated objects belonging to this third category of classification (*West of Zanzibar* 1928, *The Mask of Fu Manchu* 1933, and *The Witch of Timbuctoo* (released as *The Devil Doll*, 1935)).[100] It was almost by a process of contamination, that the institutionalisation of these objects tinged museums with a similar menacing image that became the subject of innumerable novels and, in our own century, a whole genre of horror films in which museums played a prominent role (*The Mummy* 1932, *Mystery of the Wax Museum* 1932, *Horror of the Black Museum* 1959, *Q. The Winged Serpent* 1982, and most recently *The Relic* 1996). Nineteenth-century aesthetic discourses classed the masks and figures contained within this classification as deformed, crude, degenerative and ugly renditions based on presumed, unsuccessful, copying of natural subjects. Withers-Gill's introduction to the 1931 guide to Liverpool Museum's African Collection attributed their crudeness to the commonly assumed premise that the ethical and aesthetic torpor of African sculpture was a product of environmental conditions that were writ larger in the colonies than elsewhere.

In the fetid swamps, the dense jungles and the gloomy forests of Africa, Nature has ample room for displays of violence. Thunder is louder, lightning more vivid, rain more torrential, tempests fiercer than with us; beasts of prey and poisonous snakes are always in evidence; poisonous insects abound – insects so deadly that they can destroy whole populations . . . It is therefore, not difficult to understand either why the African living in close contact with Nature seeks a power that will protect him from evil Nature forces . . . or why through the ritual of fertility Cults he strives to secure the essentials to human existence.[101]

He went on to argue 'the reason why Pagan African mythology was gloomy, earth-bound and without elements of beauty'[102] was because the gods belonged to the soil rather than the sky. Allegory was used to conjure a frightful claustro-phobia, a gigantic threatening mire, the isolation and lugubriousness that charac-terises the cult of the earth as opposed to the clarity and upliftingness it associated with the sky, before consigning the worshippers of this religion to barbarism and inescapable wretchedness:

Such tribal annals as there are of those parts of Africa, to which the exhibits in the museum relate, are annals of aggressive immigration, of violence and disturbance, of slave raiding and human sacrifice, and of the rise and fall of transitory negro kingdoms. Their tale of years is scarred with bloodshed, rapine and slavery.[103]

With less poetic licence similar views were reaffirmed in other museum guides. The handbook to the British Museum Collections, for example, noted the corre-lation of so-called 'animistic' beliefs to forest regions, while rain-making rituals were seen as more pronounced in open areas where water was scarcer.[104] If nineteenth-century Europe needed any polarised artefact in which to crystallise the antithesis of its ideals, beliefs and aspirations, it found them in the 'idols' and 'fetishes' that gazed out from museum cases. Their presence was therefore a reminder of all that Victorian culture stood against, while at the same time their capture affirmed their inefficacy against its imperial thrusts. Furthermore it was this class of objects that were usually the focus for military plunder. In the Repub-lic of the Congo and the Democratic Republic of the Congo, the Portuguese, Belgians and British routinely took by force or destroyed power figures, nkondi, as much because of their role in crystallising and organising opposition and revolt against colonial powers as for their brazen embodiment of all that missionaries saw as pagan and evil.

Examples of these three object categories replete with their specific meta-narratives were all contained in the India and Liverpool museums as well as Horniman's early collections. They provided different indices or lenses through which 'otherness' could be viewed. At one level 'otherness' was visualised as viable for commercial incorporation and political tutelage, but upholding its exotic strangeness demanded it be subjugated or contained so as not to contaminate

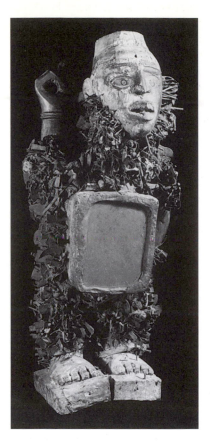

Figure 7.9 Nineteenth-century Nkisi figure, Kongo peoples, Democratic Republic of the Congo (formerly Zaire). Large nail figures like this were considered to embody the very antithesis of Victorian values and sentiments.

Source: Horniman Museum.

Figure 7.10 Nineteenth-century Nkisi figure, Kongo peoples, Democratic Republic of the Congo (formerly Zaire). These figures acted as containers for efficacious substances which were stored in hollows in the abdomen or head. In place of the abdominal cavity, this figure has a crudely executed watch face, indicative of a European colonial material cultured.

Source: Louise Tythacott.

Victorian norms and values. Indian products, many of which had been known to Europeans since the seventeenth century, appear to have been easier to domesticate and incorporate into European classifications than African objects which began to enter collections at an accelerated rate after 1880. Both Asia and Africa exercised a compelling and threatening fascination through 'residual' objects like 'fetishes' and 'pagan idols' which remained external to utilitarian classifications and domesticating discourses.

The close complicity between colonialism and ethnographic museum collecting, interpretation and display, has not only helped determine the categories of objects which have entered Western collections, but also established an indigenous manufacturing market that produced objects that reflected native perception of the focus of intrusive European demands. Today, detached from the narratives of evolutionism, diffusionism or functionalism, which determined their presence as well as meaning to the West, such artefacts might appear to have little more value than curiosity collections had for the scientific museum movement at the end of the nineteenth century.

Much anthropology as well as museum ethnography has interpreted objects as analogous to language in their purpose and ability to communicate knowledge. It has been assumed, in Boasian anthropology as well as by the Anglo-Australian School,[105] that either objects or the specific designs decorating them have their own discrete meanings, structurally arranged in narrative sequences which are recognisable by a particular visually literate community. In this view object and narrative are fixed. While it has been assumed that there is no equivalent crisis of meaning or representation in any of the indigenous communities that have produced, used and understood such objects, their insertion into Western discourses exposes them to the indeterminacies that characterise our own concepts of knowledge.

An alternative way of looking at objects is not as bearers of discrete meaning, but as interlocutors of praxiological possibilities. Objects encourage the contemplation of meaning. As multitextured and sensory they can work at different levels, promoting thought about touch and feeling, texture, the sensuality of shape, the allusions of colour, even their smells can trigger associations through memory. Their existence provides a means for the contemplation of the world, a medium through which the possibilities of form and techniques can be understood and developed, a stimulus for abstract thought about a thing or phenomena represented. In this view they are vehicles for the promotion and exploration of the world and not static and mechanical embodiments of discrete meanings. As this historical overview and analysis of the multiple and shifting meanings that artefacts have exerted demonstrates, museum objects are performative tools that are endlessly connotative, rather than static linguistic denominations that are determinative and narrowly denotative.

Paul Ricoeur has argued that to avoid false objectivity and superficial individualism, we must 'tackle an event-filled history and a structural history at the same time'.[106] Ricoeur insists that ideologies, like all cultural productions, are the products of thinkers, and that all individual psychological motivations and

circumstances coexist together with the social strictures that press collections into cultural service. The relationships between the different periods in an individual's construction of a collection, as well as the connections between any such period of a specific collection and its intersection with other collections, produces different and sometimes apparently contradictory meanings which may be partially hidden by rationalist glosses. It is this inventiveness and their ability to promote revision and creative chains of signification that must be regained from the mechanistic rationalism that has reduced collections to paradigmatic representations contained by the straitjackets of simply constituted knowledge fields.

Notes

1 I am grateful to George Bankes, Sue Giles, Nicky Levell, Antonia Lovelace and Louise Tythacott for generously sharing information about the various ethnographic collections in their care. I would also express my gratitude to all the students in the 1997 Critical Museology seminars at the University of Sussex with whom parts of this work were critically discussed.

2 See C. Castoriadis, 'The imaginary institution of society', in J. Fekete *The Structural Allegory. Reconstructive Encounters with the New French Thought*, Manchester: Manchester University Press, 1984, 7–8.

3 See for example W. Chapman, 'Arranging ethnology: A. H. L. F. Pitt Rivers and the typological tradition', in G. Stocking (ed.), *Objects and Others. Essays on Museums and Material Culture*, 1985; A. Shelton, 'The recontextualising of culture in UK museums', *Anthropology Today*, 1992, 8, 5.

4 Mieke Bal, 'Telling objects. A narrative perspective on collecting', in J. Elsnor and R. Cardinal (eds) *The Cultures of Collecting*, London, Reaktion Books, 1995, 110.

5 See for example W. Muensterberger, *Collecting: An Unruly Passion: Psychological Perspectives*, Princeton, NJ: Princeton University Press, 1994 and S. Pearce, *Museums, Objects and Collections. A Cultural Study*, Leicester and London, Leicester University Press, 1992.

6 It must be remembered that wartime action destroyed or damaged the integrity or coherence of some important museum collections. Among the greatest loss was the destruction of almost the whole of Liverpool's Oceanic collections (it was catalogued by Jameson, Haddon and Speicer in 1941, the year before it was destroyed). Despite major postwar acquisitions from Norwich, Taunton Archaeological Society and part of the Beasley collection, the coherence of the Liverpool collection was never again achieved. Part of Brighton's ethnography collections were de-accessioned in May and August 1939, while other material displayed in the archaeology gallery went missing in 1945–46, before the gallery was refurbished for the 1946 Museums Association Conference in the town. Wartime action in 1941 also resulted in the destruction of a large part of the building and collections of Leeds Museum.

7 Nicholas Thomas, *Colonialism's Culture. Anthropology, Travel and Government*, Cambridge and Oxford, Polity Press, 1994, 3.

8 Thomas Richards, *The Imperial Archive. Knowledge and the Fantasy of Empire*, London: Verso, 1993.

9 Thomas Richards, *The Imperial Archive. Knowledge and the Fantasy of Empire*, London, Verso, 1993, 3–4. The special issue of the *Daily Mail* commemorating Victoria's Jubilee referred to her reign as a period of small wars (these can be taken as an index of the political stability of the empire) which included China 1837 and 1856, Afghanistan 1838 and 1879, Crimea 1854, Persia 1856, India 1857,

Abyssinia 1867, the Asante Wars 1874, the Zulu Wars 1878, the Boer War 1879, Egypt 1882, Sudan 1896. See also D. Judd, *Empire: The British Imperial Experience from 1765 to the Present*, London, Harper Collier Publications, 1996, 207. In contrast to Richard's argument, James Morris noted that while it had not always taken force to acquire the empire, it took constant force to hold it together (James Morris, *Pax Britannica. The Climax of an Empire*, London, Faber & Faber, 1975, 403–4.

10 Richards, 4.

11 In his opening speech to the 1924 British Empire Exhibition, King George V noted: 'This great achievement reveals to us the whole Empire in little; containing within its grounds a vivid model of the architecture, art and industry of all the races that come under the British flag'. In Judd, *op. cit.*, 276.

12 Nicholas Thomas, *Entangled Objects. Exchange, Material Culture, and Colonialism in the Pacific*, Cambridge, MA and London, Harvard University Press, 1991, 141.

13 *ibid.*, 143.

14 Quoted in Thomas, *op. cit.*

15 Philip Ravenhill, 'The passive object and the tribal paradigm. Colonial musiography in French West Africa', in M. J. Arnoldi, C. Geary and K. Hardin, (eds) *African Material Culture*, Bloomington, IN, Indiana University Press, 1996.

16 Henry Balfour, 'Notes on the arrangement of the Pitt Rivers museum. Report of Proceedings, Eighth Annual General Meeting', *Museums Association*, 1897, 54.

17 One that can often still be found today. See Angus Wilson, 'The British Museum: the dilemma of a 19th century treasure house', in the *Sunday Times*, Colour Section, 6 January, 1963.

18 Thomas Greenwood in a chapter entitled 'The British Museum and its place in the nation', proudly wrote: 'This is our national institution par excellence, and we need not yield the palm to any country for having a finer and better Museum than we have at Bloomsbury' (T. Greenwood, *Museums and Art Galleries*, London, Simpkin, Marshal and Co., 1888, 216).

19 According to Greenwood writing in 1888, provincial museums followed the nationals as next in importance. Their hierarchical relationship is however, never doubted. As he notes 'There has probably never been in the history of the British Museum a more earnest desire on the part of those in charge to aid provincial Museums, and thus to realise its legitimate place as the head of these institutions' (*ibid.*, 223).

20 Despite repeated proposals for a colonial museum, it was not until 1893 that the Imperial Institute was established which had comparable functions to the Tropenmuseum of the Netherlands or the Bremen Museum.

21 Frank Woolnough, 'History of Ipswich Museum', *Museums Journal*, 1908, vol. 8, no. 6, 198.

22 See R. Robinson, John Gallagher and Alice Denny, *Africa and the Victorians. The Official Mind of Imperialism*, London and Basingstoke, Macmillan, 1961, particularly Chapter 6.

23 Over the transfer of material from the India Museum, in 1879, for example.

24 See N. Levell, 'The Royal Albert Memorial Museum. An effective history', dissertation, University of Sussex, 1996.

25 A long descriptive label attached to the Pitt River's nkisi figure was written by Dennett, while correspondence between him and curators can be found at the British Museum and the Liverpool Museum.

26 In recent years some of Alldridge's photographs have found their way to Cambridge.

27 Quoted in Ray Desmond, *The India Museum, 1801–1879*, London, Her Majesty's Stationery Office, 1982, 9.

28 *ibid.*

29 *ibid.*

30 *ibid.*, 94.

31 *ibid.*, 41.

32 *ibid.*, 192.

33 *ibid.*, 72.

34 *ibid.*, 73.

35 *ibid.*

36 A. Briggs, *Victorian Things*, London, B. T. Batsford Ltd, 1988, 62.

37 Desmond, 75.

38 Paul Greenhalgh, *Ephemeral Vistas. The Expositions Universelles, Great Exhibitions and World's Fairs, 1851–1939*, Manchester, Manchester University Press, 1994, 53.

39 Desmond, *op. cit.*, 103.

40 *ibid.*, 106–7.

41 D. Lowenthal, *The Past is a Foreign Country*, Cambridge, Cambridge University Press, 1985, 104.

42 His collection was said to have included Rossetti's writing desk. His taste is also seen in his appointment of Charles Harrison Townsend, a leading exponent of Free Style, as architect for his new museum building.

43 Helen Turner, *Henry Wellcome. The Man, His Collection and His Legacy*, London, The Wellcome Trust and Heinemann, 1980, 41.

44 *ibid.*, 27.

45 Marion Wood, *ibid.*

46 Sometime before 1897.

47 *Gratis Hand-Guide for use of Visitors to The Horniman Free Museum and Pleasure Gardens*, 1897, 16.

48 A. Briggs, *Victorian Things, op. cit.*, 1988, 67–8. Those on show at the Exhibition included 'a frog shaving his companion', 'kittens at tea', 'longtail teaching the rabbits arithmetic' and 'frog carrying an umbrella'. This genre appears to have been popular among collectors. Charles Waterton the eccentric collector and owner of Walton Hall, made his own taxidermic curiosities which included set pieces like 'John Bull and the National Debt', 'The English Reformation Zoologically Illustrated' and 'Nondescript' (L. Barber, *The Heyday of Natural History*, London, Cape, 1980, 104).

49 E. Tylor, *Primitive Culture. Researches into the Development of Mythology, Philosophy, Religion, Language, Art and Customs*, 2 vols, London, 1871.

50 Sally Falk Moore, *Anthropology and Africa. Changing Perspectives on a Changing Scene*, Charlottesville and London, University Press of Virginia, 1994, 15.

51 T. Southwell, 'Notes on an early eighteenth century museum at Great Yarmouth, Museum Boulterianum', *The Museums Journal*, October, 1908, 117.

52 Frank Woolnough, 'History of Ipswich Museum', *Museums Journal*, 1908, vol. 8, No. 6, 199.

53 Quoted in A. Hingston Quiggin, *Haddon The Headhunter. A Short Sketch of the Life of A. C. Haddon*, Cambridge, Cambridge University Press, 1942, 142.

54 Ghislaine Skinner, 'Sir Henry Wellcome's Museum for the Science of History', *Medical History*, 1986, 30, 389.

55 Augustus Pitt Rivers, 'The principles of classification', in J. R. Myres (ed.) *Augustus Pitt Rivers. The Evolution of Culture and Other Essays*, Oxford, Clarendon Press, 1906, quoted in Skinner, *op. cit.*, 392.

56 A. H. Pitt Rivers, Address as President of the Anthropological Section of the British Association, Bath, 6 September 1888, *Reports of the British Association for the Advancement of Science*, 827.

57 *British Museum Handbook to the Ethnographic Collections*, 1910, Oxford, Oxford University Press, 43.

58 R. Quick, *Guide to the Museum Collections. Bristol Art Gallery and Museum of Antiquities*, 1909, 13–5. Also the *Annual Report*, 1902, Bristol Art Gallery and Museum of Antiquities. The collections were rearranged by L. W. G. Malcolm, who succeeded R. Quick in 1922 to demonstrate 'cultural series'.

59 Annie Coombes, 'Ethnography and the formation of national and cultural identities', in S. Hiller (ed.) *The Myth of Primitivism. Perspectives on Art*, London, Routledge, 1991, 196.

60 The handbook to the ethnographical collections of the British Museum noted 'Scar-tatuing (cicatrisation) is usually practised only by the dark-skinned peoples' (1910: 21). See also Andrew Lang, 'Savage art', *Arts Magazine*, 5, 1880.

61 Hingston Quiggin, *op. cit.*

62 A charge made by A. H. Pitt Rivers during his 1888 Presidential Address when he accused certain authorities within the British Museum of mounting opposition against the acquisition of his own collection.

63 In A. C. Haddon, 1904, 'Report on some of the educational advantages and efficiencies of London museums, envelope 3067, Haddon Collection, Cambridge University Library. Quoted in Douglas Cole, *Captured Heritage*, 1985, 112.

64 The British Museum's handbook to the ethnographical collections lists the absence of knowledge to kindle fire, the use of stone and shell implements, under-development of pottery skills, rudimentary shelter, lack of clothing, the practice of cicatrisation and their 'constant fear of evil spirits' as indices of their primitive state (1910: 77–9).

65 N. Levell, personal communication. This was the same time that Alderman Griffith made his American collections for Brighton Museum.

66 G. Stocking, *After Tylor. British Social Anthropology 1888–1951*, London: Athlone Press, 1996, 105.

67 *ibid.*, 104–5.

68 A. C. Haddon, 1911, 'The teachings of folklore. The Horniman Museum syllabus of a course of 10 lectures', London, London County Council, Horniman Museum Archive, Archive Box A52.

69 Malcolm was succeeded by Otto Samson, a curator originally attached to the Hamburg Museum für Volkerkunde. As a result of Nazi persecutions before the Second World War, Samson came to England where he was befriended and supported by Charles Seligman, a fellow member with Haddon of the 1898 Torres Strait expedition.

70 A. Shelton, 'The chameleon body. Power, mutilation and sexuality', in A. Shelton (ed.) *Fetishism. Visualising Power and Desire*, London, Lund Humphries, 1995.

71 A. Sandison, *The Wheel of Empire. A Study in the Imperial Idea in Some Late Nineteenth and Early Twentieth Century Fiction*, New York, St Martin's Press, 1967, 132.

72 Haggard's collection in Liverpool Museum (formerly in Norwich Castle Museum), Mitchell-Hedges divided between the British Museum and Natural History Museum, New York.

73 A. Sandison, *The Wheel of Empire. A Study of the Imperial Idea in Some Late Nineteenth and Early Twentieth Century Literature*, New York, St Martins Press, 1967, 162.

74 The public display of the collection had a patched history as a result of space constraints, its heterogeneity, wartime action and the character of Wellcome himself.

75 Handbook, 1920, 6. Quoted in Skinner, *op. cit.*

76 Guide, 1927, 14, Quoted in Skinner *op. cit.* Malcolm and Wellcome's layout of the displays opened with comparative ethnography (Hall of Primitive Medicine) before focusing on the evolution of type objects like trepans, lancet, surgical knife, stethoscope, toothbrush, enema and gas masks.

77 G. Stocking, *After Tylor. British Social Anthropology 1888–1951*, London, Athlone Press, 1996, 400. See also H. Kuklick, *The Savage Within. The Social History of British Anthropology 1885–1945*, Cambridge, Cambridge University Press, 1991, 211–12.

78 R. Radcliffe-Brown, *The Andaman Islanders. A study in Social Anthropology*, Cambridge, Cambridge University Press, 1922, despite the monograph being dedicated to Haddon and Rivers.

79 Practitioners such as Daryll Forde and Leach always retained an interest in material culture and aspects of the anthropology of art. Even Evans-Pritchard and Gluckman wrote sparingly of the subject, but their principal interests lay elsewhere.

80 The influential first Governor of Nigeria (1914–19).

81 See J. Coote, 'Notes and queries and social interrelations: an aspect of the history of social anthropology', *Journal of the Anthropological Society of Oxford XVIII*, 1987, 3, 255–72.

82 See A. Shelton, 1997, 'The future of museum ethnography', *Journal of Museum Ethnography* 9, 33–48 and 1997b, 'My others' others' other. The limits of museum ethnography', *Antropologia Portuguesa* 14, 37–62.

83 A notable exception included Daryll Ford who maintained a strong material culture component in anthropology at University College, London and who trained many students of the postwar period who later became ethnographic curators.

84 See Desmond *op. cit.*, 139, 147 and 151.

85 This did not preclude the 1896 Liverpool conference of the British Association recommending the establishment of a Bureau of Ethnology for Greater Britain. Sir Hercules Read of the British Museum returned to the theme of making systematic collections according to a 'uniform method' on subsequent occasions even reserving a room for the Bureau at the Museum and winning the support of the Prime Minister, Lord Salisbury, to instruct the Foreign Office to direct to him suitable reports. These were not, however, forthcoming (Stocking, *op. cit.*, 372–3).

86 In John MacKenzie, *Propaganda and Empire. The Manipulation of British Public Opinion 1880–1960*, Manchester, Manchester University Press, 1984, 123.

87 MacKenzie, *op. cit.*, 128.

88 MacKenzie, *op. cit.*, 125.

89 MacKenzie, *op. cit.*, 141.

90 MacKenzie, *op. cit.*, 140.

91 These included the clove industry of Zanzibar, tin mining in Malaya, cotton in the Sudan, cocoa and manganese in the Gold Coast, tobacco in Southern Rhodesia. MacKenzie, 133.

92 A. Coombes, 'Ethnography and the formation of national and cultural identities', in S. Hiller (ed.) *The Myth of Primitivism. Perspectives on Art*, London and New York, Routledge, 1991.

93 To be demolished to make way for the expansion of Imperial College. It was rehoused in a new building constructed near Holland Park and renamed the Commonwealth Institute.

94 L. Tythacott, 'Trade, travel and trophy: a biography of Arnold Ridyard's African collection 1895–1916', paper read at the conference, Collection and Innovation, Horniman Museum, March 1997.

95 It is interesting to note that anatomical museums, like the Hunterian Museum of the Royal College of Surgeons, despite former comprehensive displays arranged in 1813, relating the functions of the body to its structure, exercised no apparent influence over functionalist anthropological displays. Functionalist museology had its origin in Durkheim's intellectual exposition of the organic analogy rather than through its visual expression in sister institutions.

96 A. Shelton, 'The Recontextualisation of Culture in UK Museums', *Anthropology Today*, 8, 5.

97 Desmond, *ibid.*, 97. The sets were entitled 'Collection of specimens and illustrations of the textile manufactures of India (1866)'.

98 Not dissimilar from one contemporary vision of the uses of ethnographic data: 'ethnography becomes an instrument for constructing a global archive of social observations, a knowledge bank of the great range of human social inventions in their enormous variety, a vast collection to expand the fragmentary story we now have and try to understand' (Falk Moore, *op. cit.*, 125). See also N. Levell and A. Shelton, 'Text, illustration and reverie: some thoughts on museums, education and new technologies', *Journal of Museum Ethnography*, 1998, 10, 15–34.

99 Desmond, 102.

100 See D. Skall, *The Monster Show. A Cultural History of Horror*, London, Plexus, 1994.

101 J. Withers-Gill, *Handbook and Guide to the African Collection of Liverpool Museum*, 1931, 13.

102 *ibid.*, 14. Interesting in this context is that outside London and Edinburgh, Liverpool was the only museum with African collections of sufficient quality to enable them to be exhibited as art. The first exhibition on Primitive Art was held in Autumn 1926. In 1930 African sculpture was shown next to the Spenser-Pryse collection of West African paintings (Andy West, 'Notes on the history of the ethnology collection', unpublished manuscript, Liverpool Museum). In 1973 the then curator, Charles Hunt, curated 'A still ecstasy. African sculpture from Liverpool Museum' at the Walker Art Gallery. New permanent ethnographic galleries were constructed and opened in 1976, which were originally intended to show the collections as art. Between 1964–70, Richard Hutchings focused the department's collecting policy on the category of art objects, many acquired from New Guinea and French-speaking Africa (Notes, 25).

103 *ibid.*

104 British Museum, *Handbook to the Ethnographic Collections*, 1909, 193.

105 Represented by the work of Anthony Forge, Ross Bowden or Francis Korn for example.

106 Paul Ricoeur, *History and Truth*, Evanston, IL, Northwestern University Press, 1965, 39.

Bibliography

Anon, (1910) *Handbook to the Ethnographic Collections, British Museum*, Oxford: Oxford University Press.

Bal, M. (1995) 'Telling objects. A narrative perspective on collecting', in J. Elsnor and R. Cardinal (eds) *The Cultures of Collecting*, London: Reaktion Books.

Barber, L. (1980) *The Heyday of Natural History*, London: Cape.

Briggs, A. (1988) *Victorian Things*, London: B. T. Batsford Ltd.

Castoriadis, C. (1984) 'The imaginary institutions of society', in J. Fekete (ed.), *The Structural Allegory. Reconstructive Encounters with the New French Thought*, Manchester: Manchester University Press.

Chapman, W. (1985) 'Arranging ethnology: A. H. L. F. Pitt Rivers and the typological tradition', in G. Stocking (ed.) *Objects and Others. Essays in Material Culture*, Madison and London: University of Wisconsin Press.

Coombes, A. (1991) 'Ethnography and the formation of national and cultural identities', in S. Hiller (ed.) *The Myth of Primitivism. Perspectives on Art*, London: Routledge.

Coote, J. (1987) 'Notes and queries and social interrelations: an aspect of the history of social anthropology', *Journal of the Anthropological Society of Oxford XVIII* 3: 255–72.

Desmond, R. (1982) *The India Museum 1801–1879*, London: Her Majesty's Stationery Office.

Greenhalgh, P. (1994) *Ephemeral Vistas. The Expositions Universelles, Great Exhibitions and World Fairs 1851–1939*, Manchester: Manchester University Press.

Greenwood, T. (1888) *Museums and Art Galleries*, London: Simpkin, Marshal and Co.

Haddon, A. C. (1911) 'The teaching of folklore', *The Horniman Museum Syllabus of a Course of 10 Lectures*, London: London County Council.

Hingston Quiggin, A. (1942) *Haddon the Headhunter. A Short Sketch of the Life of A. C. Haddon*, Cambridge: Cambridge University Press.

Hunt, C. (1972) 'Africa and the Liverpool Museum', *African Arts*, Spring 1972, 46–51.

Hunt, C. (1974) 'Ethnography in Liverpool 1800–1900', *Museums Journal* 1.

Judd, D. (1996) *Empire. The British Imperial Experience from 1765 to the Present*, London: Harper Collier Publications.

Kuklick, H. (1991) *The Savage Within. The Social History of British Anthropology*, Cambridge: Cambridge University Press.

Levell, N. (1996) 'The Royal Albert Memorial Museum: an effective history', unpublished dissertation, University of Sussex.

Levell, N. and Shelton, A. A. (1998) 'Text, illustration and reverie. Some thoughts on museums, education and new technologies', *Journal of Museum Ethnography* 10.

Lowenthal, D. (1985) *The Past is a Foreign Country*, Cambridge: Cambridge University Press.

MacKenzie, J. (1984) *Propaganda and Empire. The Manipulation of British Public Opinion 1880–1960*, Manchester: Manchester University Press.

Moore, S. F. (1994) *Anthropology and Africa. Changing Perspectives on a Changing Scene*, Charlottesville and London: University of Virginia Press.

Morris, J. (1975) *Pax Britannica. The Climax of an Empire*, London: Faber.

Muensterberger, W. (1994) *Collecting: An Unruly Passion. Psychological Perspectives*, Princeton, NJ: Princeton University Press.

Pearce, S. (1992) *Museums, Objects and Collections. A Cultural Study*, Leicester: Leicester University Press.

Pitt Rivers, A. H. L. F. (1888) Address as President of the Anthropological Section of the British Association, Bath, 6 September, 1888, *Reports of the British Association for the Advancement of Science*.

Pitt Rivers, A. H. L. F. (1906) 'The principles of classification', in J. R. Myres (ed.) *Augustus Pitt Rivers, The Evolution of Culture and Other Essays*, Oxford: Clarendon Press.

Quick, R. (1909) *Guide to the Museum Collections. Bristol Art Gallery and Museum of Antiquities*, Bristol: Bristol Borough Council.

Radcliffe-Brown, R. (1922) *The Andaman Islanders. A Study in Social Anthropology*, Cambridge: Cambridge University Press.

Ravenhill, P. (1996) 'The passive object and the tribal paradigm. Colonial museology in French West Africa', in M. J. Arnoldi, C. Geary and K. Hardin (eds) *African Material Culture*, Bloomington: Indiana University Press.

Richards, T. (1993) *The Imperial Archive. Knowledge and the Fantasy of Empire*, London: Verso.

Ricoeur, P. (1965) *History and Truth*, Evanston, IL: Northwestern University Press.

Robinson, R., Gallagher, J. and Denny, A. (1961) *Africa and the Victorians. The Official Mind of Imperialism*, London and Basingstoke: Macmillan.

Sandison, A. (1967) *The Wheel of Empire. A Study of the Imperial Ideal in Some Late 19th and Early 20th Century Literature*, New York: St Martins Press.

Shelton, A. A. (1992) 'The recontextualisation of culture in UK museums', *Anthropology Today* 8 (5).

Shelton, A. A. (1995) 'The chameleon body. Power, mutilation and sexuality', in A. Shelton (ed.) *Fetishism. Visualising Power and Desire*, London: Lund Humphries.

Shelton, A. A. (1997) 'The future of museum ethnography', *Journal of Museum Ethnography* 9.

Skall, D. (1994) *The Monster Show. A Cultural History of Horror*, London: Plexus.

Skinner, G. (1986) 'Sir Henry Wellcome's museum for the science of medicine', *Medical History* 30: 389.

Southwell, T. (1908) 'Notes on an eighteenth century museum at Great Yarmouth. Museum Boulterianum. And on the development of the modern museum', *The Museums Journal*, October: 110–23.

Stocking, G. (1996) *After Tylor. British Social Anthropology 1888–1951*, London: Athlone Press.

Thomas, N. (1991) *Entangled Objects. Exchange, Material Culture and Colonialism in the Pacific*, Cambridge and London: Harvard University Press.

Thomas, N. (1994) *Colonialism's Culture. Anthropology, Travel and Government*, Cambridge: Cambridge University Press.

Turner, H. (1980) *Henry Wellcome. The Man, His Collection, and His Legacy*, London: Wellcome Trust and Heinemann.

Tylor, E. (1871) *Primitive Culture. Researches into the Development of Mythology, Philosophy, Religion, Language, Art and Customs*, 2 vols. London.

Tythacott, L. (1993) 'Trade, travel and trophy: a biography of Arnold Ridyard's African collections 1895–1916', unpublished manuscript.

Withers-Gill, J. (1931) 'Handbook and Guide to the African Collections of Liverpool Museum'.

Wood, M. (1972) 'A Historical Study of the Ethnographical Collections of the Horniman Museum, London', unpublished dissertation, University of Leicester.

Woolnough, F. (1908) 'History of Ipswich Museum', *The Museums Journal* 8 (6).

8 Reflections on the fate of Tippoo's Tiger

Defining cultures through public display[1]

Ivan Karp and Corinne A. Kratz

Oscar Wilde once observed, 'the whole of Japan is a pure invention. There is no such country, there are no such people' (1971: 684). Museums and exhibits are instruments of such invention. Through them, imaginary Japanese are invented along with imaginary cultural selves to accompany them. All reside cheek-to-jowl within universal survey art museums or the various museums of man [sic] created by that other invented entity, 'the Western World': imaginary Japanese, artificially constructed 'American Art', capriciously named 'Renaissance painting' and 'Halls of Western Civilization', that enshrine the customary, narrow use of 'civilization', for Western cultures (e.g., in the National Museum of Natural History in Washington, DC).

The placement of these halls of culture within museums is neither arbitrary nor inconsequential: the invented Other is often placed downstairs from the upstairs domicile of European and American art 'traditions' which museums and exhibits invent and claim. In museum exhibits as much as in other cultural forms, the construction of cultural identity is achieved through two simultaneously occurring processes: (1) the use of exaggerated differences or oppositions that can be alternately a mode of exploration and understanding or an act of discrimination and (2) the use of varied assertions of sameness or similarity between audience and object of contemplation (Barthes 1984). The way these exaggerations and similarities are used are relevant materials for understanding ideologies of cultural identity and their links with other sets of representations (Boon 1982).[2]

Consider the fate of Tippoo's Tiger (Archer 1959) (Figure 8.1). Originally constructed by Indian Sultan Tippoo as a sign of resistance to the extension of British imperial rule, it was captured in the sack of his city. Taken to the Colonial Office, it finally came to rest in the most British of British museums, the Victoria and Albert, part of a two-sided colonial image of self and other, there seen as an imperial trophy. For children, the highpoint of the school visit to the Victoria and Albert was making the tiger (which was a barrel organ) roar by pulling its tail. Destroyed during the Second World War bombing of London, it has since been restored and put back in its 'rightful' place, now more British self than colonial Other. Recently it has been reinstalled in the Victoria and Albert as part of a permanent exhibition titled 'The imperial courts of Southern India'. At one and the same time Tippoo's Tiger stands for the exotic, the imperial and the same. It

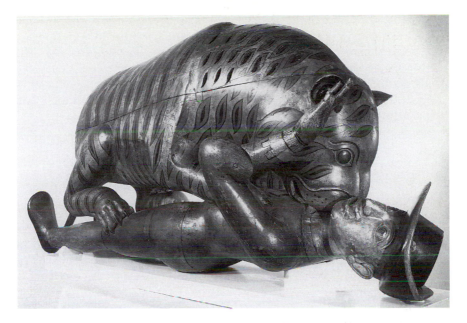

Figure 8.1 Tippoo's Tiger, a barrel organ now on display in the Victoria and Albert
 Museum, illustrates the complex and changing interpretations and displays
 to which objects may be subject.

Source: Victoria and Albert Museum.

is, after all, an Indian representation of an Englishman, an assertion of independence by a 'native ruler', and a trophy of the conquest of a strange and faraway place. In its new display setting it may imply that Commonwealth nations share the imperial experience with one another. The multiple contextualisations and recontextualisations of this image of an Englishman subdued by an Indian tiger show some of the semiotic devices through which displays can present cultures as assimilated to one another or as different.

Inventing *Self* and *Other* through exhibition

'How did you come to invent yourself?' asks a character in the English film version of *Les liaisons dangereuses*. No doubt, we may reply, while inventing the Other. Such contrasting inventions are an inevitable and integral part of the formation of cultural and personal identities, simultaneously combining relationships of identity and difference (Barthes 1984; Said 1984; Turner 1978). The cultural materials out of which identities are fashioned are the rhetorical, poetic and visual devices through which people understand their world.[3]

In museums as elsewhere, the cultural imaginations that give meaning to artefacts are clearly as political as they are poetic. Through displays, they have a tendency to harden and assume the aura of the uniquely real and natural,

sometimes to become representations of domination. One prominent example of museum representation of the dominated Other is the delicately fig-leaf covered Canova that dominates the stairs of Vienna's Kunsthistorisches Museum (Figure 8.2), an early imperial collection set within a self-consciously imperial city. The Canova statue portrays Theseus clubbing a centaur into submission. Centaurs – exotic, mythic savages residing on the outside edge of the imaginary geography of Classical Greece – are represented with half-bestial bodies that reflect their 'half bestial nature'.[4]

The Kunsthistorisches Museum is an example of the most commonly recognised relationship of same and other, where the audience and exhibit makers define themselves as a homogeneous entity counterposed to an exotic Other. But even the centaur of Classical and Viennese imagination shares half its nature with the audience that views it. What about representations in which the object or image is wholly human? If the Kunsthistorisches Museum portrays its Classical continuity through depiction of the subjugation of savages, what is the American equivalent? One example is a sign for a door handle, depicting the seated figure of the last independent king of Dahomey, defeated by the French and exiled to Martinique (Figure 8.3). The unidentified picture may originally have been a

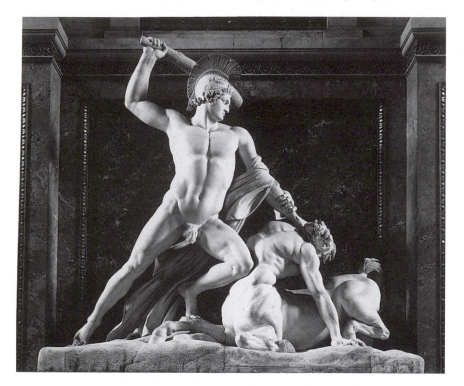

Figure 8.2 This Canova sculpture shows Theseus subduing a centaur, a creature from Greek mythology that was half human, half horse.

Source: Kunsthistoriches Museum, Vienna.

Figure 8.3 The man shown on this comic door sign was the last independent king of Dahomey.

Source: Vintage Images.

colonial postcard. The origin of both picture and sign is as much an artefact of an imperial political system as the Canova. Customers who purchase the sign learn no more about the king of Dahomey than they learn about the Dahomean art exhibited in the Musée de l'Homme. These images and objects operate as indices, pointers that define Western cultural patrimony, or as material for ironic commentary about ourselves. The door sign says 'Back in an hour', but the figure is not presented as the king of Dahomey. Rather he is a generalised exotic savage, America's own centaur. The differences between audience and image are not situated here in differences in human form, but in costume, context and, perhaps, skin colour.

Political and ideological messages in exhibits that portray exotic Others are based on the construction of opposed categories: the familiar and the exotic.

These become particularly effective when familiar and exotic are set in a temporal framework in which 'they' precede us (Fabian 1983). Again, consider the example of the National Museum of Natural History and its solitary Hall of Western Civilization. The overall organisation of Smithsonian museums[5] reproduces a classificatory scheme in which people of colour are encapsulated in a museum dedicated to mirroring the order of nature (National Museum of Natural History), while the generally middle class products of Americans are honoured in a museum that tells the double story of American history and technological advancement (National Museum of American History, formerly called the National Museum of Science and Technology). Colonial history, the very context within which many Natural History collections were acquired, is given little place in this structure. Even the Smithsonian's new National Museum of African Art, opened in 1987, exhibits its Benin bronzes without reference to the so-called 'punitive expedition' which initially brought them into European and American collections.

The actual distribution of exotic objects amongst the various Smithsonian Institution museums reflects the history of their collection, reception, and classification. Africana collections, for example, are found in both the Museum of Natural History and the Museum of African Art. Though different museums might show the same objects, they typically have different representational aims. The first usually aspires to tell stories about exotic cultures, while the second usually assimilates exotic objects to a specific set of Western aesthetics (cf. Bal 1996). Exhibition design reinforces their different messages, but even the differentiating and assimilating goals of the two museums draw on their opposites to produce their effects.[6] Natural History museums may exoticise cultures, but they assimilate them all to a story of nature. Art museums may obliterate cultural specificity in the service of setting up the sacred category of art, but they inevitably differentiate between artists and others when they do so (Karp 1991b).

The distribution of museums and collections in the Smithsonian complex illustrates the opposition between messages of difference and similarity and implicitly displays their many political resonances in exhibitions and display techniques. Stressing similarities produces an assimilating impression, creating both familiarity and intimacy with representations and their subjects. Assertions of unbridgeable difference, on the other hand, exoticise by creating relations of great spatial or temporal distance, perhaps the thrill of the unknown. This opposition takes a variety of forms in different exhibition settings, ranging from the elaborate systems of cultural classification found in natural history museums to the untenable distinction between 'naive' and self-conscious art on which the modernist aesthetic of the contemporary art museum thrives (Karp 1991a, 1991b).[7]

Ambivalence and uncertainty about 'ethnographic' or 'non-Western' objects (and those who make them) are apparent in the strikingly different ways that similar objects are treated in different museums, or even in one object's different treatment over time.[8] The collection and exhibition history of one classic object of ancient Mesoamerican culture provides a striking and instructive illustration: the great Coatlicue, Aztec representation of a goddess, known as the 'Lady of the

Serpent Skirt' (Figure 8.4). Discovered on 13 August 1790, during a municipal excavation in Mexico City, she was first taken to the Royal and Pontifical University of Mexico as 'monument to Mexico's past'. Rejected by the university administration as unsuitable for exhibiting next to Greco-Roman materials, she was shortly thereafter ordered to be reburied after fears were expressed that the object might incite the subjected native population to rebellion. In 1804, at the request of the assiduous Alexander von Humboldt, the Lady of the Serpent Skirt was disinterred, examined by him and immediately reburied – surely one of the oddest 'private showings' in the history of art. At the start of the nineteenth century the figure was once again uncovered and placed in the university court-yard, and was subsequently put in a corridor behind a screen 'like an object that provoked both curiosity and embarrassment', as Octavio Paz would later write (1990: 18). Today the figure occupies a place of honour atop a pedestal in the National Museum of Anthropology in Mexico City.

Fear, embarrassment, curiosity, secret veneration, object of national pride, specimen of science, example of great art – this is the history of just one object. Perhaps when we know more about how others regarded the figure we might be able to add 'icon of oppositional culture,' and 'occasion for ironic commentary' to our list of the complex and often contradictory attitudes so frequently expressed towards this exotic object.

As these examples demonstrate, the poetics of similarity and difference, of assimilating and exoticising, in exhibitions is not entirely the product of differences among genres of museums. Ethnographic displays are not confined to natural history museums, ethnographic museums or culture history museums. They are part of almost all cultural displays, including displays of the ethno-graphic, the folk, and the Other in art museums and outside museum contexts altogether. Our chapter shows how this opposition organises the exhibition and display of 'ethnographic' material in a variety of settings.

Ethnographic display as the certification of knowledge

The 'ethnographic', the 'tribal', the 'ancient' are more than specific topics for some museum exhibitions. They are also background categories against which most museum displays are made meaningful. These categories of ethnographic exhibiting emerge out of complex histories and ideological contexts that include at least four elements. The first is the dark side of the Enlightenment inheritance that combines its encyclopaedic project to explain everything with the assertion that both nature and other cultures can be known by the same principles. Classi-ficatory schemes that 'naturalize the primitive' (Marouby 1985), and relegate exotic cultures to natural history museums, are aspects of this Enlightenment inheritance. The Enlightenment asserted the universality of reason while it found reasons to deny universal capacities to some peoples (cf. Bennett 1996).

The second element is the history of imperial and colonial expansion through which other peoples and their cultural products have become known and col-lected in museums. Collections have histories and they are often histories of

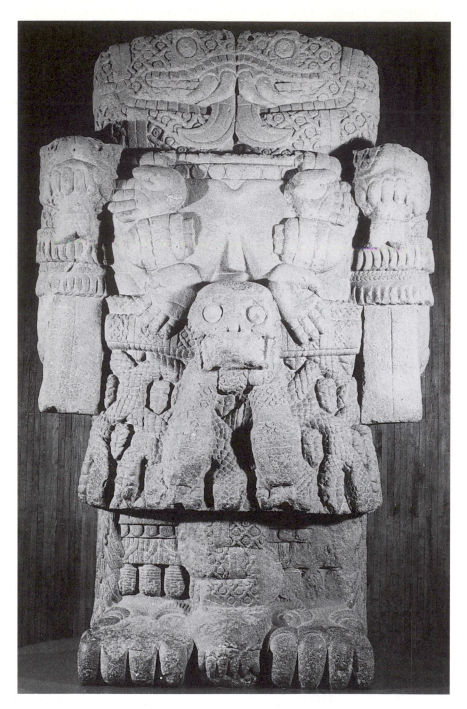

Figure 8.4 Coatlicue.

Source: National Institute of Anthropology and History, Mexico City.

appropriation (Hartog 1988; Bann 1994). The third element is the history of representing the Other itself. This complex phenomenon includes various ways of denying the existence of culture among conquered and exotic peoples, projection of class imagery onto other cultures, and the incorporation of images and stories from other cultures into our own systems of representations (Mason 1990).

The fourth element is the specific history of exhibiting exotic cultures in various contexts. Most important is the emergence of what Tony Bennett calls the 'exhibitionary complex' (1988), formed through the variety of nineteenth- and twentieth-century display settings, ranging from temporary events (such as world fairs and international expositions) to permanent institutions (such as museums and zoos). Bennett concludes that the 'exhibitionary complex' set the exotic Other up as a category of visual spectacle that in turn encouraged an audience to imagine itself in contrast as homogeneous, predominantly white and European in culture. This spectacle depends on the construction of two categories of cultural display: exhibitions of the exotic and exhibitions of the Euroamerican self (in which distinctions of class conveniently become irrelevant). As Lawrence Levine has shown – in the United States, at least – the lower classes were systematically disciplined in the appreciation of 'high' culture (Levine 1988).

This brief sketch shows that the terrain of ethnographic exhibiting extends across space and time. It encompasses different types of museums, styles of display and museum-like settings outside the museum. The history of museums tells us that museums not only develop out of earlier forms of collecting and display, such as cabinets of curiosity, but that they are also affected by the cultural institutions with which they often compete. In the 1930s, in a period of declining museum attendance, the Rockefeller Foundation supported a survey of display techniques found in the great emporia by a Buffalo, New York museum director so that museums could use the techniques to draw visitors (Harris 1990). This is a continuing history in which commercial displays, defined as entertainment, legitimise themselves with museum-like displays at the same time that museums continue to seek 'audience share' by borrowing the techniques and technologies developed in commerce and entertainment. Epcot Center's World Showcase contains seven museums, and Natural History museums build Imax theatres and charge admission for 'Dynamation' dinosaur exhibits (Kratz and Karp 1993).

The history of display, including commercial display, is written into museums. Museums, including art museums, do not take their techniques of display simply from other museums and organs of high culture (Yamaguchi 1991; Greenblatt 1991). The process of recycling 'low' into 'high', and vice versa, is not restricted to the making of art; it is also an element in the display of art and artefacts (Karp 1991c). What happens when the techniques of merchandising are adapted to the poetics of the art museum setting, when objects are displayed as if they were jewels in a shop – a form of display customarily used by art museums?

There is a fascinating history that remains to be written here, one that shows how techniques and strategies of display pass back and forth among museums, museum-like and non-museum settings, how those techniques and strategies construct implicit classifications which are taken as real, and how they may be part

of continuing transformations of the exhibitionary complex. This history works in every possible direction, but we present only two examples. Although he had done research in Kenya for ten years, the first time Ivan Karp saw *vigango*, funeral posts made by the Giriama people of Kenya, was in the Paul Stewart clothing store in midtown Manhattan. Guardian lions, our second example, are ubiquitous figures used in diverse cultural settings and periods. They are, perhaps, one of the most prevalent instances of quoting used in public displays. When we look at the guardian lions in Figures 8.5 and 8.6, it is difficult to know which stands inside the Honolulu Academy of Arts, which in the Westin Kauai Lagoons resort hotel, and which outside the neighbourhood Chinese restaurant (Figure 8.7). As the cartoon in Figure 8.7 recognises, the display of exotic objects – even reproductions – can lend an aura of authenticity that pervades an entire experience. As we will show later, commercial settings from shops to theme parks to hotels appropriate and reformulate the authority of the museum to enhance their appeal, but in doing so they also challenge museum claims to be sites for experiencing authenticity.

'Authenticity' assumes that authorities somewhere can distinguish 'real' from 'fake', fully verify the 'historical' and expose the 'fiction'. The word 'authentic' is often used as if it describes a quality inherent in an object, but such attributions are the outcome of complex processes and contestations.[9] 'Authentication' is a process by which an exchangeable item, or in this case reproduced experience, 'is invested with social value, where only an "expert" can tell if it "really" is what it purports to be' or reproduces what it is "really" like' (Irvine 1989: 258). But as Irvine points out, authenticity rests 'not just on a single testimonial statement, but on a chain of authentication, a historical sequence by which the expert's attestation . . . is relayed to other people' (*ibid.*). We would add that chains of authentication are also institutionally embedded at various points along the chain.[10]

Such testimonials also depend on the development of particular expert languages and concepts.[11] Philip Fisher describes the art historian as one of those who 'must authenticate – to set economic value, to date, to reach precise historical sequences . . . [and] develop sophisticated keys to style and period, perhaps the most cerebral of concepts' (1975: 595). Museum curators are also enmeshed in these processes. They serve as final links in the interpretive chain that underwrites the authentication and authority of museum displays. They are experts that declare identifications, categorisations and representations to be accurate and 'authentic'. The museum itself is part of the institutional and cultural background that legitimises their testimonies.

Ethnographic authority

Every exhibition context and display technique embodies particular claims to authority, though all draw on culturally shared evaluations and assumptions about truth, reality, representation, and differences among cultures. In considering the processes involved in such exhibitionary claims, we make an analytical

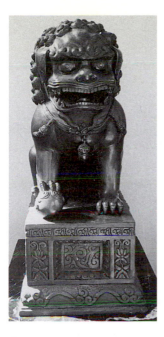

Figure 8.5 Guardian lion at the Kauai Lagoons resort hotel.
Source: Corinne A. Kratz.

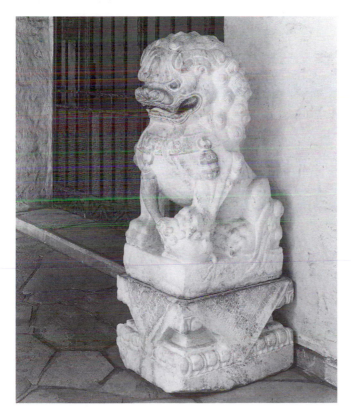

Figure 8.6 Guardian lion at the Honolulu Academy of Arts.
Source: Honolulu Academy of the Arts, gift of Mrs Charles M. Cooke (2502a, b).

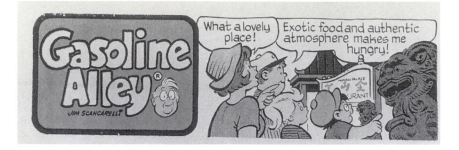

Figure 8.7 Guardian lion as 'authentic atmosphere' for a Chinese restaurant.

Source: Tribune Media Services. All Rights Reserved. Reprinted with permission.

distinction between two kinds of authority, inextricably combined in every exhibition: ethnographic authority and cultural authority.

The notion of 'ethnographic authority' was developed particularly in relation to written texts, especially genres of ethnography and travel writing. In translating intensive research experience into descriptive and interpretive representations of social life, ethnographic authority is claimed and created through the use of particular stylistic devices, metaphors and analogies, patterns of tense, person, voice and address, as well as recurrent scenes dispersed throughout the text. Together these create and signal the author's expertise (Clifford 1988; Fabian 1983; Pratt 1986; Marcus and Fischer 1986). These devices simultaneously contribute to the creation of imaginary Others, vis-à-vis expert author and reader, and to relations of power and authority between them. Shifts in the patterning of stylistic devices are related to and implicated in changing relations of power, domination and control (Fabian 1986).

James Clifford describes four ways of defining ethnographic authority in anthropological texts: experience, interpretation, dialogue and polyphony. The first two – experience and interpretation – are prominent, longstanding strategies for claiming and creating ethnographic authority, often combined. Both draw on paradigms of scientific objectivity, observation or objectification. 'Experiential authority is based on a "feel" for the foreign context, a kind of accumulated savvy and a sense of the style of a people or place' (Clifford 1988: 35).

Experiential claims centre on communicating 'I was there', 'I speak the language', 'I have a panoramic or broad conceptual view' (Mitchell 1989; Pratt 1986). They appeal primarily to an observer's authority and need not include the experience and interpretations of those who are described in the text. Hence, they reproduce the epistemological stance of naturalism: a knowing subject examining an unknowing object. Interpretive claims to authority treat culture and experience as texts that researchers are uniquely situated to read and interpret, again, because of their experience.

The other two strategies of ethnographic authority – dialogue and polyphony – are more recent, according to Clifford. They encode attempts to recognise the

inevitably political contexts of research, an enterprise that includes agents with unequal power. They emphasise the interpersonal, communicative and reflexive basis of research and knowledge of other cultures. Including long quotations and dialogues in the text is only one device these strategies use, though Clifford notes that this device may only simulate dialogue within a text created by the 'expert' author (*ibid*. 50).

Appeals to ethnographic authority figure as much in museum displays as in texts. In the museum context they become multimedia presentations, drawing on objects, music, space, and performance as well as texts. Labels and verbal explanations are critical for defining the attitudes and interpretations of an exhibit, but many other design elements figure in the representation of other cultures and in claims to ethnographic authority in museum exhibitions: the selection and exclusion of objects, their combinations and arrangement in cases or on stands, lighting techniques and emphases, other media included, choice and use of photographs, the floor plan and sequential ordering in paths through the exhibit and so on.[12]

The shifts towards dialogic and polyphonic strategies of ethnographic authority that Clifford noted in anthropological texts also have parallels in museum displays over the past twenty to twenty-five years.[13] The late 1960s and 1970s saw a movement towards more interactive and experiential, media-oriented, hands-on exhibitions. This began chiefly in science museums and children's museums, but then spread to natural history and ethnographic museums. At times the authority of familiar ethnographic displays based on curatorial categorisations and interpretations and on scholarly textualisation and contextualisation of objects can be interpreted politically as paternalistic, racist or as culturally hegemonic. But in light of these shifts, they are also seen by some as deadly boring, 'book on the wall' exhibits that assume one mode of learning for all visitors and a relatively undifferentiated public. Exhibits now seek to engage a variety of ways of knowing, to give visitors the experience of other cultures rather than to lecture from the authority of experience and present interpretive results didactically. They seem to give visitors the authority to know from personal experience while they democratise the basis of ethnographic knowledge.

This shift in exhibition strategy, however, can be more apparent than real. Claims and struggles over ethnographic authority have often gone behind the scenes, hidden by a facade of populist assertions that justify the exhibition in terms of shared experience and decision making: this exhibition will initiate you into the secrets of this culture, and then we will all know about it. But we still have to ask who orchestrates the experience? Who decides what is included, what is real, since it is not experience but representation of experience? This kind of exhibition, itself sometimes stereotyped as 'touchy-feely' or a 'kiddy exhibit', seems more in line with dialogic and polyphonic claims to authority (Gurian 1991). But again, the dialogue is often simulated.

This simulated quality becomes overt primarily in situations of social conflict, where implicit principles are made explicit in contests that take on ideological and categorical overtones. Then the contested nature of exhibit making can go public,

never more so than in an age when museums are arenas for contests over the nature of institutions and community relations in civil society (Karp 1992). Exhibits are contested terrains and curatorial authority and control can be questioned in exhibition development, as it was in disagreements over The Field Museum's exhibition 'Travelling the Pacific' (Honan 1990). If visitors are given authority through their experience, it follows that specialists in exhibition techniques could develop an ethnographic exhibition as well as specialists in culture and ethnography (e.g. museum curators). Further, they might create one more entertaining and appealing to the public.

This was the premise behind The Field's development of the Pacific exhibition. Specialists in exhibition development and 'audience advocacy' designed the hall, creating a 'Pacific experience'. It begins with videos and interactive displays on volcanic activity and Pacific island formation, then leads into a representation of human cultures in the Pacific centred on canoes. Curatorial staff were consulted on the accuracy of label copy and object identifications, but were not involved in overall conceptualisation and interpretation. Bitter disputes resulted. The internal politics of exhibition development were articulated in idioms that resonated with the external politics of representation. Concerns about ethnographic authority, realism and representation were voiced.

We do not want to leave the impression that we stand with the exhibition developers against the curators. The exhibition was didactically excellent, but its content reproduced the naturalising and totalising message of the natural history museum. It portrayed the peoples of the Pacific as though determined entirely by their need to adapt to the natural forces of the great ocean 'highway'. The result was an exhibition claiming to present cultures in their totality, but obliterating differences of language, history, and belief, and virtually ignoring active members of these societies not primarily involved in ocean travel, such as women. The Chicago audience may have been empowered by the interactive displays, but the agency of Pacific Islanders was as missing from this exhibition as it was in the ethnographic dioramas of the National Museum of Natural History in Washington, DC, or in the severe modernist installations favoured by the National Museum of African Art, also at the Smithsonian.

Experiential, interactive exhibition display strategies have penetrated art museums far less, but even there, challenges to the curatorial basis of the authentication process have arisen. Who is involved in creating exhibits? How should the voices involved and the criteria of evaluation be diversified? An important effort in this direction was the curatorial process used by UCLA's Wight Gallery for 'Chicano arts: resistance and affirmation'. Extensive committees and consultations were part of an attempt both to open up exhibition curation and object selection and to resist the appropriation of objects of aesthetic *and* political appeal to the apolitical aestheticising context of the art museum (Gonzalez and Tonelli 1992). Yet the open-ended quality of the selection process did not extend to the installation. Were reception issues addressed in curatorial practice? Did either the Anglo audience or the Chicano audience understand the political basis to the aesthetics and objects displayed in the exhibition, or did they leave the museum believing

they had seen an exhibition of beautiful, but not political, Hispanic-American arts?

Attempts to question ethnographic authority are as subject to subversion in art museum settings as they are in other kinds of museums, and for the same reason. All such exhibitions draw on the overpowering cultural authority of the museum. They may question what museums include, perhaps only to fit themselves into the canon, but they often reproduce the underlying structure of assumptions about other cultures and how we understand them in our own society. Whether we domesticate or exoticise others, we still interpret cultural differences in terms of our own familiarity, comfort or distance from what we are viewing. Often we do both at the same time. The cultural and epistemological claims of museums certainly do.

Cultural authority

In these examples, our focus has been on the exhibit itself. Hence we stressed how ethnographic authority was produced and debated. But cultural authority figured prominently in the production and experience of the final product. We treat these two types of authority separately because they focus on different aspects of exhibitions and underline perspectives that face in different directions. 'Ethnographic authority' in texts and in museum displays involves the means through which cultural others are represented. The 'cultural authority' of museums, or of texts, builds on and encapsulates 'ethnographic authority', but involves larger claims and aims as well.

Cultural authority is an aspect of how authority is asserted and claimed in texts and institutions that Clifford omitted from his account of ethnographic authority. It may be that his initial focus on texts blinded him to the institutional and discursive claims that were part of the contexts in which they are read. His emphasis on writing,[14] as useful as it is, ignores the professions, universities, classrooms, libraries, bedrooms and studies where writing is disseminated and received. In other words he defines authority as more a matter of the production of texts than anything else, and he fails to provide a sociological and situational dimension to the acts of writing and reading. Nor does he pay sufficient attention to how patterns of circulation affect authoritative claims.

Cultural authority involves broader institutional *self*-representation and museums' self-appointed missions as scientific, artistic and educational institutions. Cultural authority can also be interpreted sociologically, in terms of the historical circumstances and internal diversity of societies where museums and other forms of display emerge. Cultural authority itself includes 'native' interpretations of these circumstances. Claims to cultural authority justify the museum or museum-like forum by constructing a privileged place in history and society for museums. Sometimes, they deny that these institutions are a product of historical and social circumstances. Cultural authority is a fundamental resource that museums use to produce and reproduce themselves, precisely because it motivates audiences to attend museums and legislatures and donors to support them. The

science that museums do and exhibit, the art they collect and show, the diversity they document are all justifications for their existence and reasons for going to them.

Cultural authority is more difficult to describe than ethnographic authority because it is dispersed and diffuse.[15] It is embedded in educational curricula, part of inchoate attitudes formed through school trips and family holidays, manifested in museum architecture, and claimed in assertions of personhood. Claims to cultural authority are not simply claims about knowledge and the 'accuracy' of representations. In institutions they take the form of more direct claims about who controls the distribution of knowledge (usually curators and museums), and about the ranking and relations of types of knowledge and types of society. These claims help define who will set standards for what is worth knowing about world cultures. They make museums into the repository of truth and error, able to sort things out and tell us which is the best, what to look at, and how to relate to people in other parts of the world. The cultural authority claimed by museums also includes more ambitious and encyclopaedic claims to knowledge, claims which are intrinsically evaluative and hierarchical, and very much a defining feature of institutions (Duncan 1991; Duncan and Wallace 1978).

Cultural authority is objectified in ethnographic (and other) displays but not contained in them. It relies on its sociological embedding and links with other cultural institutions. Nonetheless, claims to cultural authority do draw on devices like those of ethnographic authority. Museums present themselves to the public not only through their exhibitions, but in founding ceremonies, in brochures, in fund drives, and in catalogues and guides. The language and stylistic devices of these self-portrayals provide important clues to the cultural authority claimed by museums and the ways it is constructed. At one and the same time, then, cultural authority is a defining feature of genres of discourse, the type of institution, and a way of channelling the circulation of images, ideas and things.[16]

The constructed realism and representation so prominent in our discussion of ethnographic authority here also become the rhetoric of self-presentation. The brochure from the California Academy of Sciences in San Francisco, for instance, tells us how the California Academy

> has pursued the mission envisioned by its founders [for more than 137 years] – to explore and document the diversity of life, and provide science education of the highest quality . . . We hope that work such as ours will lead to wiser management of our world's resources and the preservation of our natural and cultural heritage.

They claim the right and ability to tell you about the world and what you should value and preserve in it.

The most recent *Guide to the Metropolitan Museum of Art* tells us that:

> The Metropolitan Museum is a living encyclopedia of world art. Every culture from every part of the world – from Florence to Thebes to Papua

New Guinea – from the earliest times to the present and in every medium is represented, frequently at the highest levels of quality and invention.

(1983: 6)

And, of course, the guide identifies the 'highest levels':

This work . . . is one of the finest American primitive paintings.
In its effect of realism this picture surpasses even the masterful portraits of Christus' teacher.
This outstanding prayer rug . . .
The passionate pursuit of collectors and the skills of scholars have assembled at the Metropolitan Museum an encyclopedic treasure.

(*ibid.*: 18, 174, 310, 7)

Museums' claims to cultural authority derive from their basic activities: collecting, documenting, conserving, displaying, researching. Two of the most important are the collective research experience and expertise of their curatorial staff, and the 'authenticity', quality and scope of their collections (again defined, verified, and certified by the staff's interpretation of academic conventions and their connections within chains of authentication). The scholarly products and ethnographic authority created by each staff member, then, add to the institution's cultural authority as well. In a sense, the collection is a product that encompasses and represents collective staff expertise over the life of the institution, the status and prestige of donors who have added to the collection (boosting the museum's definition as repository of culture and knowledge), and the institutional power to appropriate and control objects, selectively exhibit them, and define their audience and their exhibition experiences.

Museums justify their right to evaluate and rank with claims to encyclopaedic knowledge, even if they acknowledge that the encyclopaedia always needs to be expanded.[17] Their educational mission justifies the incorporation of display techniques developed in all kinds of other contexts, but it is a mode of incorporation which is simultaneously conservative and voracious. Techniques from department stores, fairs, theme parks, or cinema might be used in museum exhibitions, but the recontextualisation must somehow free them of their most obviously commercial associations. Put to edifying museum purposes, they must be incorporated into the criteria of authenticity and accuracy that the museum imposes and upholds for its exhibitions.

Museums are not unique in using multiple display techniques, but they put those techniques to the hierarchical service of cultural authority in their exhibitionary strategies. Because of their institutional claims to cultural authority, the museum context may be subject to constraints and limits that are irrelevant in more blatantly commercial settings. Eco's *Travels in Hyperreality*, for example, took him to settings which were attractive, effective and commercially successful precisely because they skilfully blurred real and reproduction (1983). Certainly, those commercial settings also exercise cultural authority. They help to shape and

define our images of other cultures, and of relations and hierarchies among them – perhaps even more than museums do today. But because they do not claim the museum's cultural authority in the same way, they are freed from its constraints of didactic representation of 'authenticity' and 'truth'. Instead, they rely more on the 'authenticity' of recreated experience, supposedly sharing the authority of experience with their visitors. Furthermore, these settings can play quite self-consciously on the cultural authority of museums. Resort hotels in Hawaii, such as the Kauai Lagoons and the Westin Maui, quote and replay the history and techniques of art museums in their display of reproductions in sumptuous sur-roundings. They also offer glossy coffee table catalogues of the hotel and its displays. The Kauai catalogue declares 'The hotel is an art piece', 'The hotel is an art gallery', explains 'The art of collecting art', and ends with a tantalising section 'About the collection' that obfuscates the status of the pieces on display. The Maui catalogue makes the hotel's goal and claim quite clear, 'The vision: you must be overwhelmed' (Hopkins 1989). The Kauai hotel catalogue explains:

> Our destination resorts are created to heighten one's fantasies, to bring back the romance of life. We attempt to restore the grandeur that King Louis XIV must have experienced at Versailles. We attempt to understand people's dreams and expectations and develop experiences that turn them on. We attempt to exceed those expectations.
>
> (Hopkins and Fuller 1990: 79)

Kauai Lagoons combines several fantasies for its primarily American and Japanese patrons: they are simultaneously living on a colonial sugar plantation, in an emperor's palace, and in a museum. But as Eco recognised in his discussion of Disneyland, the creation of a total fantasy environment that coaxes you into a prolonged, safe stay within the resort complex is also intended to make you 'buy obsessively, believing that you are still playing' (Eco 1983: 43).

The California academy of sciences

To explore further the ways exhibitions develop and draw on ethnographic and cultural authority in different display settings, we will juxtapose the Hall of Human Cultures in the California Academy of Sciences and the Kauai Lagoons resort hotel.[18] Both share the exhibiting goal of illustrating diversity, but they differ in the way that one draws on the conventions of natural science and is situated in a museum and the other draws on the conventions of the art museum but is a museum-like attraction rather than a museum. We will look particularly at what the exhibits communicate about other cultures, how they do so, how ethnographic authority is grounded in display techniques, and how they convey the hierarchies and relations fundamental to claims to cultural authority. These exhibitions can be interpreted on various interconnected levels. As we will see, hierarchies that help constitute and legitimate claims to cultural authority often emerge from specific ethnographic displays in several ways. They emerge

simultaneously as components of overall interpretive frameworks and as meta-messages that are conveyed as exhibition strategies are translated into details of label text, lighting and arrangement of objects.

The Wattis Hall of Human Cultures at the California Academy of Sciences in San Francisco is an extremely attractive, well designed, comprehensive, and long term exhibition that attempts to describe cultural diversity on a worldwide scale. Installed about 1980, it uses multiple exhibiting techniques to illustrate its grand theme: how cultures adapt to the environment. We will examine just a fragment of this complex and costly installation, summarising a few major design elements in the displays: general floor plan, diorama design, object selection and presentation, label text, and use of photographs.

The large rectangular hall contains eleven open dioramas with a major entrance at one end (Figure 8.8). Each stage-lit diorama has glass cases along its base, uses backlit photographs, and most have extensive wall texts providing general information about the culture depicted.[19] The hall is arranged along two grids to illustrate its environmental theme, adaptation to climate. A hot to cold axis runs the length of the hall, with a dry to wet axis crossing its width. The eleven cultures are arranged in this Cartesian matrix according to their adaptation to these two climatic features.[20]

This exhibition is an extreme example of the naturalisation-of-the-primitive theme so characteristic of natural history museums, and virtually universal in exhibitions about certain cultures.[21] The naturalisation theme, which assimilates culture to nature, here reduces culture to a means of ecological adaptation. Other

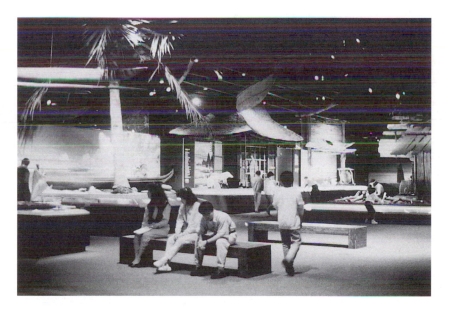

Figure 8.8 Open dioramas in the Wattis Hall of Human Cultures.
Source: Corinne A. Kratz.

assumptions, familiar from the environmental movement, accompany this reductive celebration of cultural ecology and create implicit contrasts with other, absent cultures who are not so finely attuned to the natural environment. For instance, the assumption that these cultures are closer to nature is subtly conveyed in virtually all these dioramas by showing people in close association with animal species, often holding or touching an animal. The Australian man has a dingo lying on him (Figure 8.9). The Gabra woman holds a goat and has a camel nearby. The Navajo man is shown with a sheep, the Hopi woman with a large bird, the Highland Peruvian man with a llama, the Netsilik Eskimo with a seal, the Dani woman in New Guinea with a pig (Figure 8.10), and the Caroline Islander is roasting fish.[22]

The exceptions are instructive: the 'extinct' Northwestern California Indians and 'Traditional Japanese Rice Farmers' are not shown in clear association with animals, though their texts tell us they could have been. The Japanese raised fish in their rice paddies and the Indians hunted animals and had a 'Predominantly marine-based diet'. We will soon see that these exceptions are also distinguished in other ways, and that, taken together, these differences communicate an implicit evaluative hierarchy.

These cultural exhibits suggest that all these peoples are roughly equivalent in their dependence on the environment, and that their differences can be explained by environmental factors (e.g. temperature, precipitation, altitude). They imply a contrast with cultures not contained within the hall, cultures known to have elaborate archaeological records, that can be shown to change over time, and that

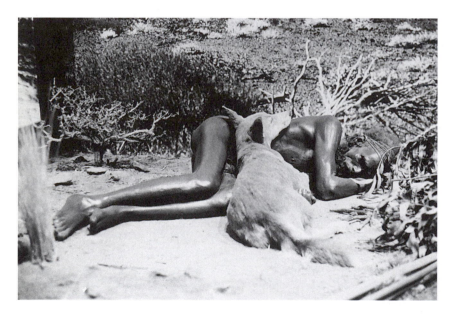

Figure 8.9 Diorama showing an Australian man and dingo resting together.
Source: Corinne A. Kratz

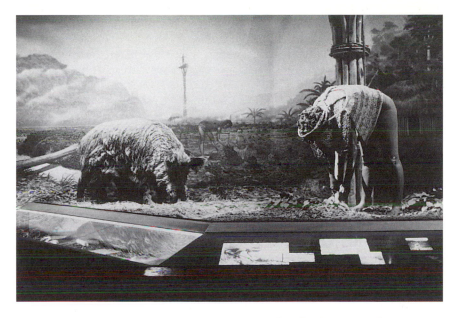

Figure 8.10 Diorama showing a pig associated with a Dani woman of New Guinea who is working in her garden.

Source: Corinne A. Kratz.

are usually grouped under the category of great civilisations. Once again a hierarchy is set up between canonical cultures that comprise the 'inheritance' of Western civilisation and a fragmented world of equivalent other cultures.

The glass cases around each diorama hold objects considered typical, intended to enable visitors to compare different cultures. These include tools related to major economic activities that show how culture adapts to environment, food processing objects, often a type of exotic money (showing how exchange systems work), an ornament that illustrates social differentiation, and an object of cere-monial or religious life. There are no sequences of objects that might illustrate change or adaptation to different circumstances. As a result, the cultures are frozen in time, but each at a different moment in world history. Thus cultures portrayed in a pre-Western contact period are compared with colonial societies, while extinct societies are compared with contemporary societies. The Gabra people of Kenya are depicted in diorama in 1970, Navajo and Hopi Indians of the American Southwest at the turn of the century, the Japanese during the Toku-gawa period (1600–1868 AD). The peculiarity of these historical juxtapositions is not mentioned in texts or selection of objects. Each culture is treated as a whole unto itself, perhaps set in regional context. Only the scientific grid of comparison brings them together.

We know something of the circumstances and times during which material for at least one diorama was collected, that of Gabra in Kenya.[23] It is striking to us

that Western-style clothing and the use of objects derived from industrial materials are almost entirely omitted from discussion, even though the Gabra diorama includes mass-produced cloth. At that time, Gabra also used plastic water carriers, aluminium pans and similar products ubiquitous in Kenya, though such artefacts are not 'cultural' or 'traditional' enough to be displayed. But industrial material *is* the subject of comment in one case, revealingly so.

The glass cases for Gabra include two women's necklaces with the following labels (Figure 8.11):

> NECKLACE: A woman wears this string of blue beads when she bears a male child.
> WOMAN'S NECKLACE: The aluminum is obtained from melted-down cooking pots.

The presence and recycled use of an aluminium cooking pot is the only aspect of the second necklace selected for comment, regarded as the most remarkable information to convey, as if pans are a unique outside intrusion into Gabra life.[24] Note also that the 'intrusion' is not portrayed as direct or intentionally selected, i.e. someone went to the shop, bought a pot, boiled tea in it for several years, and reused it when it was worn out. Rather, the description suggests a scavenging mentality that reinforces both the image of isolation (by distancing the initial economic transaction) and the adaptive attitude to nature stressed in the hall (by making the pot into a found object like other natural resources). This adaptive

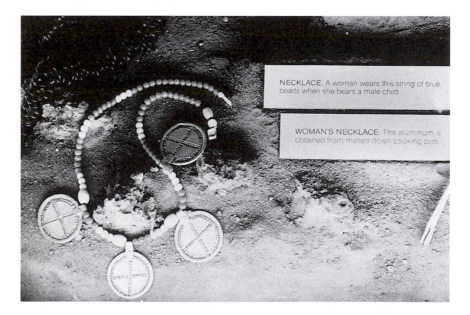

Figure 8.11 Exhibit case with necklaces worn by Gabra women in Kenya.
Source: Corinne A. Kratz.

reworking is what makes it remarkable, otherwise labels focused on the source of materials could read:

> NECKLACE: The blue beads are purchased in shops.
> WOMAN'S NECKLACE: The aluminum is obtained from worn cooking pots, which are melted down and reworked. The red and yellow beads are purchased with money from milk sales.

This mode of presenting people is characteristic of the natural history animal diorama, which presents an ideal picture of perfect specimens, uncontaminated by historical and situational considerations. Applying this type of display to human cultures often has the consequence of eliminating history from consideration, especially the history of contact and political and economic subordination. The suppression of history, of time and of worldwide interconnections is conspicuous in this exhibition.

The floor plan, dioramas and object selections in the hall emphasise and create similarities between the eleven cultures displayed by treating them in more or less the same way. Common treatment assimilates them to each other and differentiates them as a group from cultures (modern and Euroamerican) which supposedly are not determined so immediately by natural environment. There have been hints of differentiation within the common treatment, however, and of a hierarchy that is communicated more directly by the last two design elements we consider, exhibit texts and photographs.

Exhibit texts reinforce the messages of other design elements. All texts are written in the omniscient third person of scientific observation, with no comments or voices from the cultures described. African and Pacific cultures are described consistently in the present tense. Past tense is used for Native Americans, switching to present for Navajo and Hopi after historical narratives of their migration and cultural adaptations bring them up to the turn of the century. Japanese are consistently described in past tense, and are the only culture whose display is qualified as 'Traditional' (having since transcended their environmental limits). Their historical narrative takes them back to the third century BC (!) and their glass cases are full of long texts about rice taxes, class differences and social complexities.

Some of these patterns of tense might be 'factually' motivated, e.g. Japanese lives are now very different. But surely Australians, Gabra and others also have historical narratives that could be included. Have the Australians no self-appellation, no language to name (other than 'Aborigine')? Why are Hopi and Navajo frozen into present tense at the turn of the century? At whatever time they are shown, none of these people are depicted as engaged in national politics, land claims, and so on. Texts thus reinforce the suppression of history, politics, contact, and coevalness (Fabian 1983). But the patterns of tense, historical narratives and information provided also tend to organise world cultures in a hierarchy that is strongly implied but not overtly stated. Peoples of Africa and the Pacific, without history and without change, are portrayed as furthest from the American audience and the most primitive, despite their chronological proximity.

Traditional Japanese Rice Farmers are at the top, most like the audience, despite their greater historical distance. Native Americans are somewhere in the middle – not quite like the audience, but hard to distance in light of contemporary American politics and the generally positive attitude many middle class Americans now have towards Native American culture.[25]

Photographs and wall murals further amplify these textual messages. Japan is again singled out, this time by the use of Japanese self-representations. The Japanese scene is set by drawings by 'Hokusai, an artist who rendered aspects of *rural* society during the time'.[26] All other dioramas have background murals of environmental scenes, with photographs included inside their glass cases. Dates and locations for some photographs and dioramas provide a sense of ethnographic verisimilitude, as does portrayal of mannequins in interaction with others painted in the murals. Some photographers and individuals are named, but only for the Navajo and Hopi displays (e.g. 'Migaleto, medicine man' by G. P. Baldwin 1931; 'Brushing meal from a metate' by Floyd Evans 1945). Yet we know from our own research and talking with one of the consultants to the hall that vivid personalities are represented in other photos and murals here as well. However, authoritative ethnographic devices are used to illustrate typicality in this exhibit, not individuality. Even the photographs of named individuals fit them into a framework of typicality, slotting names into social categories or activities. The unique detracts from the typical and the ideal in a generalising exhibition such as this one.

The ethnographic authority of this exhibition draws on a variety of devices of realism, only some of which we have discussed here: artefacts that represent fragments of reality and serve as indices of authority (Kirshenblatt-Gimblett 1991), diorama reproductions, textual patterns. The eleven representations are united by parallel uses of the same devices, creating mutually reinforcing claims. Their individual and collective ethnographic authority is reinforced by the organisation of the overall floor plan in terms of a 'scientific' model of environmental determinism, playing on the received wisdom that brute facts of nature are more epistemologically secure than interpretive conclusions. But this hall is just one component of the museum's broader message of cultural authority, which also depends in part on the exaltation of scientific understanding and the control it allows. Parallel to this hall is an exquisitely crafted hall of animal dioramas named 'African Safari'. In true postmodernist fashion we were asked by a couple dressed in safari clothing to take their pictures while they posed in front of a diorama in that hall. The diorama was as anonymous as the people in the Human Cultures hall, but we recognised it as a brilliant recreation of Ngorongoro crater in Tanzania. There were no pastoralists in the Ngorongoro diorama, but somehow it seemed fitting.

As the cultural authority of this museum incorporates the scientific paradigm, it also creates an implicitly evaluative message that elevates nature over culture for some peoples and subordinates interactive involvement and interpretive understanding to observation as a means of knowing.[27] The omission of some cultures and the inclusion of others reproduces the cultural scheme of such Victorian museums as the Pitt Rivers in Oxford, where some cultures were shown to evolve

from early to late, while others were unable to make the transitions achieved by those in the implied audience (Keuren 1984). The Pitt Rivers' message differs from that of the California Academy of Sciences primarily to the degree that it makes its case directly rather than by inference.

The museum's claims to cultural authority entail the communication and wider legitimation of this message (and itself) as well. As part of the exhibitionary complex, the museum is involved in 'inscribing and broadcasting messages of power . . . throughout society' (Bennett 1988: 74). Attendance by many school groups (often at once, and finding other messages in displays as well) helps to create and continue this aspect of the institution's authority, providing a steady and impressionable audience for the cultural hierarchies portrayed.

The Kauai Lagoons

We turn now to a resort hotel to show how the authoritative claims of museums are present in non-museum settings, how non-museum settings frame themselves as museums[28] and how visitors learn about museum experience from them. Our focus is the spectacle of cultures represented in the Hawaiian resort hotel already mentioned, the Westin Kauai Lagoons, whose catalogue presents the resort in a self-conscious play on issues related to cultural authority and museums.[29] Its parallel claim to authority allows us to view it through the very elements we examined at the California Academy's Hall of Human Cultures: floor plan and paths through the exhibit, dioramas, selection and display of objects, and use of texts.[30]

The resort's layout and paths are slightly labyrinthine. Unlike most hotels, the entrance does not lead into the lobby, but down an escalator to an enormous courtyard and reflecting pool, with hallways and garden paths leading off in various directions (Figure 8.12). The first impression, then, is like coming into an imperial home or a large public building and park (not unlike a museum). One turn leads down a half flight of sweeping stairs to the lobby. Beyond that, paths continue and expand again around a spectacular swimming pool. Paths are punctuated by displays of exotic art objects and by spacious, comfortable sitting areas. Unlike the scientific grid of the California Academy, which provided a map to locate any culture of the world by temperature and precipitation, these paths emphasise comfort, freedom, adventure, and whim.

Native Hawaiians are represented only by a large sculpture of a poi pounder and by the hotel's sole diorama-like display, a late addition to the decor showing a canoe of historical and local significance in the centre of the lobby.[31] This is the only use made of natural history museum realism. The rest of the hotel complex invokes art museum settings, with exotic objects on display that show the art of Thailand, Burma, China, Indonesia, and an occasional Sepik River mask. These are not arranged in artefact groupings or vitrines, but tastefully arrayed along the magnificent, broad walkways and around the expansive sitting rooms. Objects are displayed in art museum mode: isolated on stands and specially lit. Some displays also make extensive use of mirrors, an elaboration that fits quite well with the

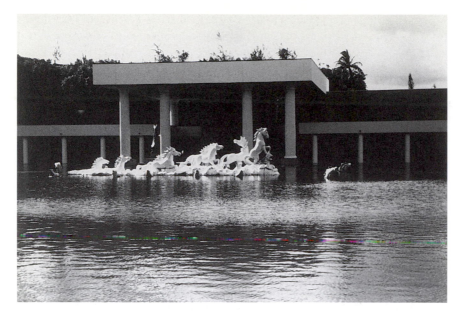

Figure 8.12 Reflecting pool and sculpture at the courtyard entrance of the Kauai
 Lagoons resort hotel.

Source: Corinne A. Kratz.

other conventions and perhaps even exaggerates their effect (Figure 8.13).
Object labels also follow art museum conventions. They describe an object's
national origin, its materials and occasionally provide bits of iconographic
information.

Though the manner of display and interpretive labelling says 'art museum', this
is also an art-in-the-home mode of experience – provided your home is a palace
or plantation. The hotel's public rooms are on a grand scale surrounding palatial
courtyards. The settings manage to invoke both royal and imperialist and colonial
nostalgia at the same time (Rosaldo 1989).[32] The mix of home and museum adds
to the atmosphere and the fantasy. You can touch these objects, if you can over-
come your museum training. No alarms go off. You can enjoy the sense of fine art
at home, the profligate extravagance of having 'art objects' exposed to the elem-
ents for your enjoyment in such surroundings, and also have the thrill of defying
museum guard authority.

But Oscar Wilde is right: there is no such place as Japan. Not a single Japanese
object is displayed in the hotel collection – not even 'traditional' Japanese rice
farming. Nothing detracts from the Japanese clientele's sense of visiting the exot-
ic. Surroundings encourage Japanese and American guests alike to imagine them-
selves as anything else; their own artistic traditions remain implicit as contrasts or
comparisons.

But whether you are the fantasy owner or an actual guest, the hotel conveys

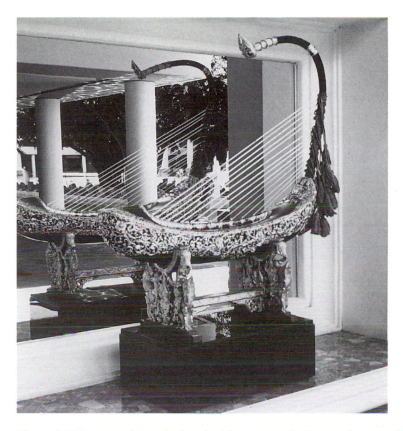

Figure 8.13 Burmese harp displayed with a mirror background at the Kauai Lagoons resort hotel.

Source: Corinne A. Kratz.

implicit hierarchies through the way it selects, displays, places, and labels its collection. In some sense, the nations whose art it gathers are assimilated to each other, and also assimilated to European collecting and artisanal traditions (as when occasional nineteenth century reproductions appear in sitting areas). The hotel is less explicitly concerned to rank the world's cultures than to assert a hierarchy of art over non-art, collector-connoisseur cultures over maker-cultures. Of course it is also concerned with more overt hierarchies of class, wealth and power that are familiar from art museum displays of exotic arts.

The hotel conveys the 'authenticity' of its reproductions in ways that draw on the visual language of the art museum and gallery, but argues along different lines. Value is conveyed less in terms of the expert's research time and knowledge of what is real, or by the history and heritage of the 'context' left behind. Rather, value is instilled by talking about the incredible work and care that went into shaping each part of the resort: its collectors spared no expense when they

travelled all over the world to find authentic places and people to make reproductions.[33] The best of everything, at any effort, is claimed – even for the Clydesdale horses that pull visitors in carriages.

Perhaps what is most ingenious about the Kauai Lagoons' claims to cultural authority is the way that it combines the authoritative stance of two types of art museum. First it is an exotic encyclopaedia of the Pacific Rim, but second, it is also a palatial home of the collector-connoisseur, not unlike Boston's Gardener Museum.[34] There are echoes within echoes here, in which museums echo the homes from which they derive, while resorts echo the museums echoing palatial homes.

The appeal of the resort also lies in the artful way that it combines domestic and exotic in order to create what it calls a 'total experience'. This is its overt justification. The catalogue explicitly asserts that you are simultaneously at home and visiting a museum, a plantation and a nature preserve. A unique variety of experience is assembled, creating another criterion of value and authority. At the Westin Kauai visitors can even see zebras or African monkeys on island zoos in the lagoons. This, the catalogue adds, is a unique environmental experiment. By the end, this returns us to the encyclopaedic claims of the great art museum or the thirteen-bureaux Smithsonian complex.

The destination resort is a further extension of both the tourist industry and the exhibitionary complex. It is a special development of the move to democratise collections that opened private, princely collections to the public in museums, and then conferred upon museums an educational mission. Collections at Kauai Lagoons are once again experienced as if in a palace, but with museum-like techniques of authentication, such as labels, and with the additional museum apparatus of a catalogue. They are experienced by a public composed both of guests who can afford to stay in the hotel and guests who can only view it. Thus temporal experience of the resort ranges from temporary resident to temporary visitor.[35] Visitors capture their experience in photographs. At the same time museum visitors back home – on school trips or holidays that a wider public can afford – photograph themselves in front of museum dioramas, looking as if they were in an exotic luxury resort or on a safari adventure, too. But we should also remember that many museums are set in what were formerly palaces or great homes and that museum architecture is designed to invoke the palace and the temple itself. Even the genres quoted within other genres are blurred.

The resort hotel is as comprehensive in its set of implicit categories as the California Academy of Sciences. Instead of distinguishing cultures that have escaped the domination of nature from those that have not, the resort hotel and, by extension, the art museum distinguishes between those who can appreciate art and those who cannot. The resort hotel systematically confuses the ability to afford the experience with the art museum's claims to possess the attributes of taste.

Conclusion

Ethnographic displays – displays about cultural similarity and difference – are found in every genre of museum, even those that exclude the ethnographic object. Nor are ethnographic displays confined only to museums. The settings where ethnographic displays are found, the ways that the ethnographic is used to invoke identity, the manner in which forms of display resonate with one another (as well as with other cultural forms) – all are means through which people create, objectify and legitimise their sense of themselves, their cultural inheritance, their differences from people of other cultures, and the relations between cultures.

As means for the construction of identity, ethnographic displays have systematic and historically determined features, which we described above and briefly recapitulate here. The rise of museums has been accompanied by claims to comprehensive and encyclopaedic coverage of culture and cultures that set up some cultures as the heirs of civilisation and excluded others from this line of succession. These hierarchical and encompassing claims are made in multiple sensory idioms in exhibitions in museums and other settings. At the same time they establish their effects though rhetorical and visual devices that cast the viewer as the second-order consumer of expert knowledge. Intertwined claims to ethnographic and cultural authority undergird these evaluations and representations. While some products of other cultures become assimilated into the domesticating contexts of the exhibitionary complex, the people of those cultures often remain exoticised, objects rather than participants.

This is not an inescapable condition. The problem is not 'otherness' itself. Cultural diversity is as much a part of life as biological diversity, and as worthy of understanding and interpreting. Cultural diversity is an inevitable fact of life, a necessary condition for change. The problem is that the construction of cultural diversity within Euroamerican cultural traditions has more often focused on what the Other lacks than on the complex dialectic of similarity and difference that operates in all display settings at one the same time.[36] Museums have too often represented cultures in a hierarchy that reproduces inequalities of power.

The solution is not to deny diversity and 'otherness' but to recognise that all peoples, even museum curators, are members of other cultures – an 'other among others', as Paul Ricoeur says.[37] In his words, 'it becomes possible to wander through civilization as if through vestiges and ruins. The whole of mankind becomes an imaginary museum: where shall we go this weekend – visit the Angkor ruins or take a stroll in the Tivoli of Copenhagen?' (Ricoeur 1965)?[38] Ideally, exhibitions created with such recognition would not only tell visitors about cultural diversity and include several perspectives, but also show the process through which curatorial judgements were made, that those judgements are contingent and contestable rather than final, and that there are other stories that were not included but might have been.

Notes

1 The first version of this chapter was prepared as a public lecture for the series 'How Museums Came to Display the History of Art' at the Getty Center for the History of Art and the Humanities in 1991. We thank the following for help in assembling the photographs and other resources: Mary Jo Arnoldi, Connie Cortez, Christraud Geary, Honolulu Academy of Arts, Jeanie Kortum, Robert Leopold, Susan Vogel, and staff at the Getty Center for the History of Art and the Humanities. Johannes Fabian discussed the paper with us at length; we also benefited from discussions with Joann Berelowitz, Suzanne Blier, Sabine MacCormack, Mario Torelli, and Hayden White. Futher thanks to those who commented on versions presented in 1992 at seminars sponsored by the Anthropology Department at Northwestern University and the Art History Department at Emory University.

2 Museums and exhibits, of course, are not the only sites and instruments available for the construction of imaginary lives and identities. Consider the following. The Santa Monica National Public Radio station (KCRW), as part of its around the clock coverage of the Gulf War in 1991, devoted an hour long programme to exploring the 'vast cultural differences between the Christian West and the Islamic Middle East.' Confronting a newly born-again Muslim, Saddam Hussein, was the resurgent monolith of the recently secular but now solidly 'Christian' West. When will this side of the war also be referred to as a crusade?

3 Holquist argues that stereotyping is 'a universal strategy for seizing the other' (1988: 460) that is inherent in use of language. '[Stereotypes] are a function of the nature of the sign itself and precede any particular subject or experience; but this general condition is specified into particular stereotypes in different times and places' (*ibid.*: 468).

4 This phrasing is from the Oxford English Dictionary.

5 The thirteen-bureaux Smithsonian Institution complex includes a zoo and research institutes as well.

6 Yet domesticating and exoticising exhibiting styles are not inexorably married to specific museums, for even the Natural History museum occasionally 'domesticates' exotic objects in its displays by emphasising universal aesthetic appeal. In the 'Splendours of nature,' exhibition, for example, Native American feather work and a Hawaiian feather cape are displayed in the same vitrine-encased, boutique-lit style as objects in the National Museum of African Art, or the Rockefeller Wing of New York's Metropolitan Museum of Art.

7 Cf. Varnedoe and Gopnik's exclusion of tribal art, children's art, imagery of the insane, visionary amateurs, and rural folk from consideration in *High and Low* (1990: 15).

8 Kratz (2001: Chapter 4) discusses this ambivalence and tension in relation to ethnographic photography.

9 Literature on the notion of 'authenticity' and 'the fake' is extensive, crossing fields from art history and history to folklore, literary studies and anthropology. The following are a few useful citations: Adorno (1973), Dorson (1976), Eco (1983), Kasfir (1992), and Errington (1994).

10 Gable and Handler discuss the management of 'authenticity' and authority at the heritage site, Colonial Williamsburg. They consider how the chain of authentication and impressions are managed to allow 'for the dream of authenticity to remain viable even in an environment in which all available empirical evidence could easily be perceived as supporting constructivist paradigms or alternatively as undermining authenticity-based claims to truth or value' (1996: 569).

11 Briggs's recent articles on metadiscursive practices in academic writing are wonderful analyses of how academic authority is created in the presentation of

texts, the formation of genres, and in questions of history and tradition (1993, 1996).

12 Kratz (2001) discusses the way different texts and installations figured in interpreting an exhibition of ethnographic photographs.

13 These shifts in ethnographic texts and museum exhibitions are related to changes in world politics. Previously, field research experience was one primary claim to knowledge and authority, as it still is. But claims to such authority are now more problematic and less automatically accepted as legitimate.

14 His emphasis on texts begins with a focus on participant observation as a key anthropological method and the question of how the intense, intersubjective relations of anthropological research become descriptions of other cultures.

15 In formulating our notion of cultural authority and its dispersed nature, we draw on the concept of discursive formation that Foucault develops in *The Archaeology of Knowledge* (1972: 3144).

16 The concept of cultural authority bears family resemblances to Voloshinov's discussion of 'official ideology', draws on Stuart Hall's valuable discussion of the importance of keeping the production, circulation and reception phases of media communication separate and Foucault's studies of how discourse defines personhood and allocates authority. Most important, however, is C. Wright Mills's account of what he called 'the cultural apparatus' the set of institutions and personnel that provides interpretation for people in society. These are, Mills tells us, 'the observation posts, the interpretation centres, the presentation depots' which define the grounds out of which interpretation of everyday life and exceptional events are made. In order for this set of institutions and personnel to work, they must define themselves authoritatively. Bourdieu's concept of the field of cultural production has parallels with the way we use the concept of cultural authority. As he points out, acts of cultural production are accompanied by discourse about production itself. But Bourdieu lacks the sense of institution and context so clearly manifested in Mills's writings.

17 The claims of museums differ; we emphasise here the 'great' museums whose ambitions are encyclopaedic and world encompassing. But even community museums often draw upon the same Enlightenment ideology and encyclopaedic project to justify their missions. The history of colonial natural history museums is instructive. They often spent considerable resources trading their locally collected materials in order to obtain comparative collections that would put them in the same class as metropolitan natural history museums (Sheets-Pyenson 1988). The four elements we discussed above – Enlightenment ideology, imperial and colonial history, the history of representing the Other, and the exhibitionary complex – are all elements in the historical and social formations out of which museums fashion their claims to cultural authority.

18 Our documentation of these sites began in 1990 and 1991. We have visited the California Academy hall several times since, but the Kauai Lagoons was devastated during hurricane Iniki in September 1992. After being closed for several years, the property was divided and the hotel sold to Marriott International. Redesigned to a 'traditional Hawaii' theme, it was eventually reopened as the Kauai Marriott Resort and Beach Club. Our description of Kauai Lagoons is based on the pre-Iniki Westin period; we will consider the contrast between the two versions of the hotel elsewhere. This is part of a larger research project on the representation of cultural diversity in a range of display settings. Thanks to the Smithsonian Institution for research support.

19 The exceptions to this were dioramas depicting the Dani ('Farmers and Warriors of Highland New Guinea') and the Caroline Islanders of Micronesia ('Sailors and Gardeners of the South Pacific'), which included no overview wall texts.

20 Some dioramas bring in supplemental features of the environment to explain features of the cultures they display. The Peruvian peasant diorama, for example, stresses the highland nature of their culture.

21 Southern African hunters and gatherers, for example, are almost always portrayed in terms of their paucity of material culture and ingenious adaptation to a harsh environment. Their complex social organisation and expressive culture is often absent from display.

22 We do not include the West Coast Alaskan Eskimo diorama because it was under repair and had no mannequin when we saw it.

23 Karp has been doing research in Kenya since 1969; Kratz has been working there since 1974.

24 See Kratz (1995) for a discussion of the recent vogue of recyclia and how it is represented.

25 See Constance Perin's account (1992) of the vast difference that race made in the attitudes of visitors to the National Museum of Natural History, and how this emerged in attitudes to Native Americans versus Africans in the focus groups she conducted.

26 Emphasis added. The label suggests a rural/urban distinction which is again absent from representations of the other cultures.

27 Across the road in the Golden Gate Park is the California Academy of Science's sister museum. The DeYoung Art Museum, a museum of primarily Asian, European and American arts, is advertised in San Francisco hotels as 'illuminating the Western inheritance from the time of the Pharaohs to the twentieth century'. We could not have selected a more telling contrast in claims to cultural authority, though the two share the same hierarchy of cultures.

28 The cross over is two-way; museums emulate hotels for commercial survival.

29 Our description of Kauai Lagoons is based on its 1990 state, before Hurricane Iniki. See Note 18.

30 Unlike the California Academy of Sciences, photographs and murals have no place in the Kauai Lagoon's formal displays. Naturalistic murals are unnecessary; the destination resort is not two dimensional, but a fantasy world into which visitors step. The entire scene is one visitors themselves photograph, placing themselves into the scene in a way that shows 'I was there'.

31 When we were there in 1990, it was labelled 'Exhibit in progress' with a typed page of information about the canoe and its history (once owned by Hawaiian royalty, later used by the Kauai Canoe and Racing Club, damaged in Hurricane Ewa, and restored for display). This is one part of the Kauai Lagoons that was retained and elaborated by the new management, quite appropriate for their new 'traditional Hawaii' theme. The canoe is still ensconced in the middle of the hotel lobby, in a slanted mount, accompanied by a case with a paddle. Several labels explain the boat's importance.

32 See Kratz (2001) for a critique of Rosaldo's notion of imperialist nostalgia.

33 Of course the distant lands where reproductions were made were often places where labour costs were low as well.

34 Many of the Great American art museums are actually the living spaces of the wealthy who collected the art in them. One consequence of the way in which the living spaces of the rich become museumified is that museum audiences are led to think that the context of acquisition is the initial context of production and appreciation. This is a process which has parallels to the elevation of the collector over the maker in the display of 'primitive' arts.

35 The new version of the hotel under Marriott does not include all the grounds of the Westin version. They have been made into a park where visitors can pay to ride on the carriages or on boats through the lagoons, making the day visitor a more explicit category for marketing as well.

36 But this kind of representation of cultural diversity is hardly unique to the US and Europe.
37 Karp (1996a) develops the notion of public scholarship in relation to museums and museum curators, emphasising the cultural and communicative boundaries that must be traversed in making exhibitions.
38 Our solution is Ricoeur's nightmare. His essay attempts to construct grounds on which authenticity can be asserted, whereas we tend to look critically on assertions of authenticity, from whatever source.

Bibliography

Adorno, T. (1973) *The Jargon of Authenticity*, Evanston, IL: Northwestern University Press.

Appiah, K. A. (1991) 'Is the post- in postmodernism the post- in postcolonial?', *Critical Inquiry* 17: 336–57.

Archer, M. (1959) 'Tippoo's Tiger', *Museum Monograph No. 10*, Victoria and Albert Museum.

Bal, M. (1966) 'The discourse of the museum', in Greenberg, Ferguson and Nairne, (eds), *Thinking About Exhibitions*, London: Routledge.

Bann, S. (1994) *Under the Sign: John Bargrave as Collector, Traveller, and Witness*, Ann Arbor: University of Michigan Press.

Barthes, R. (1984) 'The great family of man', in *Mythologies*, New York: Hill and Wang.

Benjamin, W. (1969) *Illuminations*, New York: Shocken Books.

Bennett, T. (1988) 'The exhibitionary complex', *New Formations* 4: 73–102.

—— (1996) 'Museums and their constituencies: citizens, publics, audiences, and Communities', Keynote address to Museums and Communities Conference, Dunedin, New Zealand.

Berlin, I. (1977) *Vico and Herder*, New York: Vintage.

Bhaskar, R. (1979) *The Possibility of Naturalism*. (The Philosophy of the Human Sciences 1), Hemel Hempstead: Harvester.

Boon, J. (1982) *Other Tribes, Other Scribes: Symbolic Anthropology in the Comparative Study of Cultures, Histories, Religions, and Texts*, New York: Cambridge University Press.

Bourdieu, P. (1993) *The Field of Cultural Production*, New York: Columbia University Press.

Briggs, C. (1993) 'Metadiscursive practices and scholarly authority in folkloristics', *Journal of American Folklore* 106(422): 387–434.

—— (1996) 'The Politics of discursive authority in research on the "invention of tradition"', *Cultural Anthropology* 11(4): 435–69.

Canova, A. (1976) *L'opera completa del Canova*, presentazione di Mario Praz, Milano: Rizzoli Editore.

Clifford, J. (1988) *The Predicament of Culture*, Cambridge, MA: Harvard University Press.

Crimp, D. (1980) 'On the museum's ruins', *October* 13: 41–58.

Dorson, R. (1976) *Folklore and Fakelore*, Cambridge, MA: Harvard University Press.

Duncan, C. (1991) 'Art museums and the ritual of citizenship', in I. Karp and S. D. Levine (eds) *Exhibiting Cultures: The Poetics and Politics of Museum Display*, Washington, DC: Smithsonian Institution Press, 88–103.

Duncan, C. and Wallace, A. (1978) 'The Museum of Modern Art as late capitalist ritual: an iconographical analysis', *Marxist Perspectives* (Winter 1978): 29–51.

Eco, U. (1983) *Travels in Hyperreality*, New York: Harcourt, Brace, Jovanovich.

Errington, S. (1994) 'What became of authentic primitive art?', *Cultural Anthropology* 9(2): 201–26.

Fabian, J. (1983) *Time and the Other: How Anthropology Makes its Object*, New York: Columbia University Press.

—— (1986) *Language and Colonial Power*, Cambridge: Cambridge University Press.

Fisher, P. (1975) 'The future's past', *New Literary History* 6(3): 587–606.

Foucault, M. (1972) *The Archaeology of Knowledge*, New York: Harper Colophon Books.

Gable, E. and Handler, R. (1996) 'After authenticity at an American heritage site', *American Anthropologist* 98(3): 568–78.

Geertz, C. (1973) *The Interpretation of Cultures*, New York: Basic Books.

Giddens, A. (1976) *New Rules of Sociological Method*, London: Hutchinson.

Gonzalez, A. and Tonelli, E. (1992) 'Compañeros and partners: the CARA project', in I. Karp, C. Kreamer and S. Levine, (eds) *Museums and Communities*, Washington, DC: Smithsonian Institution Press.

Greenblatt, S. (1991) 'Resonance and wonder', in I. Karp and S. D. Lavine (eds) *Exhibiting Cultures: The Poetics and Politics of Museum Display*, Washington, DC: Smithsonian Institution Press, 42–56.

Gurian, E. (1991) 'Noodling around with exhibition opportunities', in I. Karp and S. D. Lavine (eds) *Exhibiting Cultures: The Poetics and Politics of Museum Display*, Washington, DC: Smithsonian Institution Press, 76–100.

Hall, S. (1992) 'Encoding/decoding', in S. Hall, D. Hobson, A. Lowe and P. Willis, (eds) *Culture, Language and Media*, London: Routledge.

Haraway, D. (1984) 'Teddy bear patriarchy: taxidermy in the Garden of Eden, New York City, 1908–1936', *Social Text* (Winter): 20–64.

Harris, N. (1990) *Cultural Excursions*, Chicago: University of Chicago Press.

Hartigan, L. R. (1990) *Passion: The Hemphill Folk Art Collection in the National Museum of American Art*, Washington, DC: Smithsonian Institution Press.

Hartog, F. (1988) *The Mirror of Herodotus: the Representation of the Other in the Writing of History*, Berkeley, CA: University of California Press.

Holquist, M. (1988) 'Stereotyping in autobiography and historiography: colonialism in "The Great Gatsby"', *Poetics Today* 9 (2): 453–72.

Honan, W. H. (1990) 'Say goodbye to the stuffed elephants', *The New York Times Magazine*, 14 January 1990, 35–8.

Hopkins, J. (1989) *The Westin Maui*, Honolulu: Hemmeter Publishing.

Hopkins, J. and Fuller, G. (1990) *Kauai Lagoons: the Westin Kauai*, photography by William Waterfall, Honolulu: Resort Publishers International.

Irvine, J. (1989) 'When talk isn't cheap: language and political economy', *American Ethnologist* 16(2): 248–67.

Karp, I. (1991a) 'Other cultures in museum perspective', in I. Karp and S. Lavine (eds) *Exhibiting Cultures: The Poetics and Politics of Museum Displays*, Washington, DC: Smithsonian Institution Press.

—— (1991b) 'How museums define other cultures', *American Art* (Winter/Spring 1991) 5 (1–2): 1–15.

—— (1991c) 'High and low revisited', *American Art*, (Summer 1991) 5(3): 2–7.

—— (1992) 'Museums and communities: the politics of public culture', in I. Karp,

C. Kreamer and S. Lavine (eds) *Museums and Communities*, Washington, DC: Smithsonian Institution Press.

—— (1996a) 'Public scholarship as a vocation', Keynote address to Museums and Communities Conference, Dunedin, New Zealand.

—— (1996b) 'Real objects, simulated experiences and cultural differences: paradox and tensions in the making of exhibits', paper presented at the School of American Research Seminar on Material Culture: Habitats and Values.

Karp, I. and Kendall, M. B. (1982) 'Reflexivity in fieldwork', in P. Secord, (ed.) *Explaining Human Behavior*, Los Angeles: Sage, 249–73.

Karp, I. and Lavine, S. D. (1991) 'Introduction: museums and multiculturalism', in *Exhibiting Cultures: The Poetics and Politics of Museum Display*, I. Karp and S. D. Levine, (eds) Washington, DC: Smithsonian Institution Press, 1–9.

Kasfir, S. (1992) 'African art and authenticity: a text with a shadow', *African Arts* XXV(2): 40–53.

Keuren, D. van (1984) 'Museums and ideology', *Victorian Studies* (Autumn): 171–89.

Kirshenblatt-Gimblett, B. (1991) 'Objects of ethnography', in I. Karp and S. D. Lavine (eds) *Exhibiting Cultures: The Poetics and Politics of Museum Display*, Washington, DC: Smithsonian Institution Press, 386–43.

Kratz, C. A. (1995) 'Rethinking recyclia', *African Arts* 28(3): 1–12.

—— (2001) *'The Ones That are Wanted': Communication and the Politics of Representation in a Photographic Exhibition*, Berkeley, CA: University of California Press.

Kratz, C. A. and Karp, I. (1993) 'Wonder and worth: Disney museums in world showcase', *Museum Anthropology* 17(3): 32–42.

Levine, L. W. (1988) *Highbrow Lowbrow: The Emergence of Cultural Hierarchy in America*, Cambridge, MA: Harvard University Press.

Marcus, G. and Fischer, M. (1986) *Anthropology as Cultural Critique*, Chicago: University of Chicago Press.

Marouby, C. (1985) 'From early anthropology to the literature of the savage: the naturalization of the primitive', *Studies in Eighteenth Century Culture* 14: 289–98.

Mason, P. (1990) *Deconstructing America: Representations of the Other*, London: Routledge, Chapman and Hall.

Metropolitan Museum of Art (1983) *The Metropolitan Museum of Art Guide*, art works selected by Philippe de Montebello, text by the curatorial staff of The Metropolitan Museum of Art, edited by Kathleen Howard, New York: The Metropolitan Museum of Art.

Mills, C. W. (1967) 'The cultural apparatus', in *Power, Politics and People; The Collected Writings of C. Wright Mills*, London and New York: Oxford University Press.

Mitchell, T. (1989) 'The world as exhibition', *Comparative Studies in Society and History* 31(2): 217–36.

National Museum of African Arts, n.d. 'Visitors' brochure'.

Nochlin, L. (1971) *Realism*, New York: Penguin.

Parkin, D. (ed.) (1982) *Semantic Anthropology*, (Association of Social Anthropologists Monographs 22), New York: Academic Press.

Payne, H. (1981) 'Malinowski's style', *Proceedings of the American Philosophical Society* 125: 416–40.

Paz, O. (1990) 'The power of ancient Mexican art', *New York Review of Books*, vol. XXXVII, no. 19 (6 December 1990), 18.

Perin, C. (1992) 'The communicative circle: museums as communities', in I. Karp,

C. Kreamer and S. Lavine, (eds) *Museums and Communities: The Politics of Public Culture*, Washington, DC: Smithsonian Institution Press.

Pratt, M. L. (1986) 'Fieldwork in common places', in J. Clifford, and G. Marcus, (eds) *Writing Culture*, Berkeley: University of California Press, 27–50.

Price, S. (1989) *Primitive Art in Civilized Places*, Chicago: Chicago University Press.

Ricoeur, P. (1965) *History and Truth*, Evanston, IL: Northwestern University Press.

Rosaldo, R. (1989) 'Imperialist nostalgia', *Representations* 26: 107–22.

Said, E. W. (1984) 'Orientalism reconsidered', in *Literature, Politics and Theory: Papers from the Essex Conference 1976–84*, Barker, F. P. Hulme, M. Iverson and D. Loxley (eds) New York: Methuen, 210–29.

Sheets-Pyenson, S. (1988) 'How to "grow" a natural history museum: the building of colonial collections, 1850–1900', *Archives of Natural History* 15(2): 121–47.

Stocking, G. (1983) 'The ethnographer's magic: fieldwork in British anthropology from Taylor to Malinowski', in G. Stocking, (ed.) *Observers Observed*, Madison: University of Wisconsin Press, 70–120.

Turner, B. (1978) *Marx and the End of Orientalism*, London: Routledge.

Varnedoe, K. and Gopnik, A. (1990) *High and Low: Modern Art, Popular Culture*, New York: Museum of Modern Art.

Voloshinov, V. (1973) *Marxism and the Philosophy of Language*, New York: Seminar Press.

West, C. (1990) 'The new cultural politics of difference', *October* 53: 93–109.

Wilde, O. (1971) 'The decay of dying' in H. Adams (ed.) *Critical Theory Since Plato*, New York: Harcourt, Brace, Jovanovich, 673–86.

Yamaguchi, M. (1991) 'The poetics of exhibition in Japanese culture', in I. Karp and S. D. Lavine (eds) *Exhibiting Cultures: The Poetics and Politics of Museum Display*, Washington, DC: Smithsonian Institution Press.

9 Towards an erotics of the museum[1]

Julie Marcus

Within the literature exploring the nature of the museum, one can discern two broad strands of thought regarding its origins. One of them sees in the modern museum a clear departure from the pre-Enlightenment model of a cabinet of curiosities; while the other draws attention to continuities between those older cabinets of curiosities and their wondrous collections, and the great collections and collection houses of the nineteenth century. The genealogies proposed through both strands of that literature mask a set of concerns with what the museum is, and does, today. Is the museum a teaching institution aligned with the universities, or, is it more appropriate to see the museum as a form of theatre, which can best be approached through analyses of performance and spectatorship? Yet the question of the museum is a broader one.

Successful museum displays and exhibitions conjure into existence particular visions of the nature of the world. In doing so, they provide at least some of the spectators, as well as museum curators, with those moments of illumination which could be thought of as resembling the Heideggerian 'flash' of insight that offers a glimpse of a truth. That truth is not, of course, necessarily 'true'. But in those flashes of understanding which bring in to light an unseen order which bears upon the worlds of daily life, there lies a moment which both offers truth *and* a way towards the truth, a moment of new knowledge. It is this moment, always visual in the museum, where offer and promise, the power of looking, and the approach of 'truth' are collapsed within a poiesis which is so seductive, and so pleasurable.

This moment of pleasure and wonder is the sense of the marvellous that traditional genealogists of the museum associate with the pre-modern museum, with the cabinets of seventeenth-century curiosities now so well-documented and critiqued. Yet the ordered display of natural and cultural objects found in the great modern museums of the nineteenth and twentieth centuries presented marvels no less wondrous for being ranged in modern taxonomies of one kind or another. While ordered differently, that new order produced and represented new relations, new knowledges and new possibilities to a broader audience, but the distinction between the old and new museum orders is not as fixed as some have imagined. It is incorrect to think of the old cabinets of curios and wonders as either necessarily heterogeneous or as existing only in the past. Neither is it

correct to think of those well-ordered Linnaean taxonomies exemplified through natural history displays as being either homogeneous or entirely absent from the collections of the past. In particular, the visual conventions of the older forms have carried on into the new in very interesting ways. In the museum both forms of displays worked within the recognisable and specific visual conventions found in painting and it is this that I shall explore shortly.

But where *does* the wonder of the museum come from? Perhaps Brecht was wrong in saying that 'Facts can very seldom be caught without their clothes on . . . they are hardly seductive' (Crew, Spencer and Sims 1991: 159). Objects in museums might well be thought of as facts without their clothes on. And this capacity for revelation is why collections and museums are so seductive. The museum's object is often thought of as revealing the naked truth, as making visible some essential detail of the truth that would be hard to grasp through words alone. Among the propositions explored in this chapter are those that within the museum, truth and desire are inextricably bound up within each other: that the pleasures of the museum are essential to it; 'facts' collected in it in the form of its collections and presented through visual display are immensely seductive, and that both the pleasure and seduction of the museum constitute an erotics which arises from two sources. First, that erotics arises from the electric flash of a comprehended truth that comes with the moment of enlightenment, a flash which is procreative and charged with desire; and second and equally significantly, that erotics emerges from the relations and deployment of power itself, power's relation to the creation of truths and to the ordering of the collections which museums contain. The question here is one of how a particular aesthetic and visual order is established to represent either the museum's heterogeneity or the museum's epistemologies of homogeneity, its claims to rationality, order and completion. It is in this context that questions concerning the essential nature of the museum, visual pleasure and the pleasures of looking must be set.

Donato's work on the origins of the museum and its fundamental and compromising epistemological contradictions is well known. It forms the basis of a number of commentaries, including Douglas Crimp's (1983: 43–56) which focuses on the art museum, its discipline of art history, and photography. Through these essays, Flaubert's work *Bouvard and Pécuchet* has again become familiar to a broader English-speaking readership. Flaubert's tale of the attempts of two retired copy clerks to grapple with representations of the world in the early part of the nineteenth century, their eventual construction of a museum and the gathering and writing of the fragments of the world they seek both to understand and to write into a 'Book', can be read as constituting a critique of representation and of the ordering of knowledge. Donato's reading of Flaubert's novel and its characters points to the ways in which the erasure of difference and time ensure the essential heterogeneity of the project of the nineteenth century museum. The 'Book' that Bouvard and Pécuchet wished to write would contain all knowledge and is never written, but their lives were filled with the collecting of material for it. What they could not, or would not, do, was discriminate or understand the differences between representations and reality, between information and

content, between homogeneity and heterogeneity. Theirs was a world of difference erased, value-free and thus inevitably incomprehensible.

I should like to have read Flaubert's unwritten second volume of *Bouvard and Pécuchet*, which was to be the 'Book' that his two asexual bachelor characters wanted to write, the book which was made entirely of a collage of quotations (Donato 1979: 213–38). The new Museum of Sydney uses what might be called the Bouvard-and-Pécuchet principle in presenting its displays and labels, in its collages of quotations, its erasure of distinctions and the absence of evaluation. With those erasures and absences go both desire and the erotics of enlightenment which have always been essential to the success of the museum, so that it is particularly appropriate that Flaubert's two old bachelor boys have no sexuality. And with them goes the possibility of comprehension and evaluation. In their absence, there will remain only the values of heterogeneity, of no-value; but because there cannot be a cultural domain outside or without power, the relations of power which create the absence of value turn back upon themselves, to make the question of the nature of the Museum of Sydney perverse.

The Museum of Sydney

In 1995, a new museum opened in Sydney. Set on the site of Australia's first Government House, the museum was a troubled project from its inception. The Aboriginal owners of the Sydney region wanted a museum which reflected their history; the descendants of the colonial families wanted a museum reflecting 'settlement' rather than 'invasion'. Amid considerable public controversy, a form of 'reconciliation' emerged which saw the commissioning of a major public art work from both an Aboriginal and non-Aboriginal artist for the courtyard of the museum and the introduction of Aboriginal displays in the museum's gallery space. This troubled project offers insights into the ways in which aesthetics and certain postmodernist philosophies produce a poetics which, in the final analysis, blot out desire and slip easily into a non-confrontational and reactionary nihilism.

At the Museum of Sydney, the heterogeneity which curators place at the heart of the museum and at the heart of knowledge itself is carefully displayed through an enormous display case containing hundreds of beautifully hung fragments of domestic pottery and rural machinery. The truth of that heterogeneity is used to reveal the artifice of knowledge, the absent space of truth and to devastate narratives of space and time. What is not displayed is the guiding hand which determines what knowledge shall be revealed, the hand of power. The display of fragments focusing on Sydney's foundation and its colonial culture therefore constitutes a lie – the lie that because truth is ever fragmentary, evaluation and narrative are impossible, because the truth can never be known let alone reconstituted from a vast distance, that there are no regimes of truth. And the really big lie that follows from these is that you-the-spectator do not need to know what curators and designers know about you. This is the museum as theatre, the author hidden, with the actors speaking about theatricality and their relations to it – the audience left in the dark.

The display of fragments of colonial Sydney which cannot be reconstituted by the viewer, the use of unrecognisable objects from an undated past and unknown location, the ordering of objects according to an aesthetic convention which breaks any links between them, the highlighting of the fragment and the concealment of the whole, and the removal of written text from display is an effective way of breaking up narratives of time and place relating to colonialism and colonisation. The massed presentation of beautifully placed archaeological fragments is also an effective way of creating a truly Flaubertian unreadable visual text. At the Museum of Sydney, this display is supported by panels of text which consist entirely of quotations.

Such an approach is an effective way of evading the moment of colonisation and of presenting the claim that truth can never be properly known, that the story of what happened when Sydney was founded will vary so much according to who is speaking, that its only truth will lie in the gathering together and presentation of its multiple fragments – make what you will of them. In this way, knowledge and the power to constitute it are each denied to those who most need to have it – those who have come to see and learn something of the past other than what they already know, and those whose pasts and knowledge of them has been denied them. This is to say that Aboriginal people, lesbians and gays, women and other marginalised sectors cannot recognise themselves or their experience and cannot discover it within the fragmented colonial narratives presented through collage, pastiche and irony. Representations of heterogeneity hold no promise because they need to be reconstituted into a homogeneity which, in the absence of opportunity, can only be that which already exists.

Bricolage and pastiche, disruptions of time and place, and hyper-aestheticisation – all of which offer radical political interventions – in this case, seem to work to open up racialised readings of past, present and future that are very difficult to subvert. When these techniques are applied to the objects of Aboriginal culture, the impact is even more worrying. Because of the racialisation of Australian culture, the bitter contests over land ownership and human rights for Aboriginal Australians, all museum displays referring to Aboriginal culture are necessarily difficult and contentious.[2] In the Museum of Sydney, it seems to me that the radical refusal to evaluate is underpinned by conservatising notions of balance and equality which, in other contexts, curators might wish to disavow. In referring to the aesthetics of high art, the use of objects to create a field without value and a text which is intelligible only to a small elite familiar with the interests and concerns of high art, the display refuses to engage with the bulk of its audience.

The Museum of Sydney therefore offers a view in which European settlement in the Sydney region is dealt with through disruption and fragmentation to the extent that most visitors cannot read the text being presented and, if they can, they see that the bric à brac of colonial life has no truth-value and museums less; and furthermore, that Aboriginal history and culture is dealt with through Aboriginal objects illuminated and displayed in ways which leave Aboriginal people where they have always been, on the margins and outside history.

Fiona Foley's sculptures, carried out partly in conjunction with Janet Laurence, illustrate this point. The courtyard or forecourt to the building contains the Fiona Foley sculptures. These magnificent poles combine references to either Aboriginal history, colonisation and Aboriginal life and culture in the present – some are of wood, some of burnished rusted metal, and each bears a reference either to colonisation or Aboriginal culture. Foley and Laurence have combined the shells of middens with concrete in one of the anti-historical panels embedded in the pole. In another there are swathes of the hair that had to be removed from Aboriginal heads before Aboriginal people could be admitted into the more hygienic colonial presence. A number of the poles contain sound, Aboriginal voices speaking, reciting remnant words of Aboriginal languages, names of colonists. You wander in and around 'From the edge of the trees' in a small powerfully evoked sensory landscape that is lodged against the noise of the street and the urban backdrop to it. At least you would, if you stopped or even glanced that way. Most visitors to the museum walk straight past. The poles are tall; they are set in a small space to one side of the approach to the entrance, and most adults simply do not register their presence. Children, however, with their sharper ears and their complete lack of interest in the mechanics of getting family from car to museum to ticket office and with their propensity to simply run away from their minders, hurry into 'the forest' and catch the muted voices. They pause and listen, hug the wood and touch the metal, try to remove the shells, climb up the footholds until called to come inside to go to the museum.

Had the museum been serious about recognising Aboriginal culture – Aboriginal claims to be first in the history of Sydney, Aboriginal claims to own the

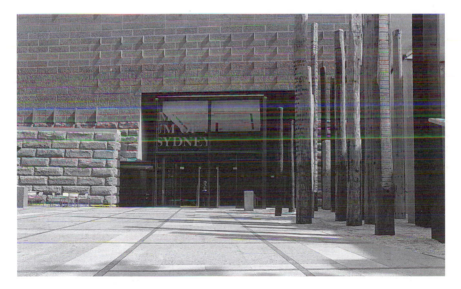

Figure 9.1 Museum of Sydney entrance. 'The edge of the trees' stands to the right of the entrance foyer.

Photographer: Catherine Rogers.

land – then Foley's forest of poles could have been placed across the front of the museum so that visitors had to pass through them to get in the doors. Instead, the poles stand marginalised, as ever, leaving the heavy paving of the empty forecourt as a Nuremburg style approach to a temple of doom. The museum's concept brief places the space for the sculpture as intersecting with the entrance foyer of the museum. In the course of development, this intersection shifted further from the foyer until even this slight recognition of who owned the land was lost.

The initial concept brief for the public art work states that the museum required a work which would allow visitors to approach the entrance to the museum along the 'edge of the trees', along a line conceptualised as being on the edge of contact. The phrase used to title the public art work being commissioned, 'Edge of the trees', is taken from an essay of Rhys Jones: '. . . the "discoverers" struggling through the surf were met on the beaches by other people looking at them from *the edge of the trees*. Thus the same landscape perceived by the new-comers as alien . . . was to the indigenous people their home, a familiar place, the inspiration of dreams'.[3] There is no Aboriginal voice in the theme of this project of 'reconciliation'; the description naturalises Aboriginal bodies, again, and the concept of 'contact' enshrined within a fragment of text, presents a benign and slippery language which camouflages its facts in the process of presenting them.

Visitors were to approach the museum along the edge of the trees, but the open plaza design ensures that only a random minority of visitors will follow the trajec-tory of the concept. Were visitors to approach the museum along the 'edge of the trees', there is nothing to make them remark upon them. The labelling is inconspicuously placed so that it is immediately behind the backs of those enter-ing. Those few who leave the museum along the 'edge of the trees' need to be very observant to spot the reasonably large metallic sheet which blends so well with the granite in which it is embedded.

The problem is this. I love museums and have always done so. Especially the old-fashioned ones. But when I visited the new Museum of Sydney I found myself in a quandary. First, this very new museum that had been built on a very large budget, had access to state of the art technology, and had hired very distinguished staff and advisers appeared, at least at first sight, to have paid little attention to Aboriginal claims to be represented within it. And a second puzzle arose from the displays within the museum which seemed, again at first sight, to veer from brico-lage to pastiche, and from muddle back to traditional and very familiar narratives of colonialism. Had the big budget, high technology, intellectualised museum turned out to be a cabinet of curiosities, a hall of colonial fragments referring, after all, only to itself? It was all so good looking: it had Fiona Foley's wonderfully imaginative sculptured poles at the front of the museum and which seemed to lay out an Aboriginal land claim; it had Aboriginal voices and faces on video inside; it had used sound as well as sight in order to grab the visitor's attention, and at several points the visitor seemed to be invited to question the concept of the museum itself. What was wrong with a museum which aspired to get so many things 'right'? Why did I feel it did not actually work? Could the problem be located in its aesthetics, pedagogy, architecture, technology, epistemology, his-

tory, cultural politics or government? An analysis of the visual strategies of the museum helps to indicate where an answer might lie.

Visual strategies

To appreciate some of the elements of the visual strategies involved and their relation to desire, it is important to recall that those older, fustier museum collections and displays which laid out the order of a natural history of the world were intricately involved in what Foucault referred to as the triumph of the visual (Jay 1988: 187). The visualising of knowledge and the play of visual politics with power and its manifestations in objects is therefore one of the critical aspects of the success or failure of museum displays. Aesthetic conventions informing museum displays can be linked into those informing other areas of artistic production.

The paintings made by the Dutch in the seventeenth century, the century of curios and cabinets, provide a useful starting point for exploring the visual order of the museum. Those well-known landscapes, domestic scenes, still lifes and lively portraits with their shimmering detail and odd perspective can 'best be understood as being an art of *describing* as distinguished from the *narrative* art of Italy' (Alpers 1983: xx). The question of narrative is important because of the ways in which the destruction of the master narratives of Western histories is placed at the heart of so many radical attempts to work outside their discursive constraints. The distinction between narrative and descriptive painting proposed by Svetlana Alpers is helpful, I believe, in providing ways of considering narrative within the museum and can offer insights into the visual tradition of museum displays.

If the visuality of the narrative space of the museum is a *descriptive* visuality, the principles of which were well understood and enunciated in the descriptive picturemaking of the Dutch from the seventeenth to the late nineteenth centuries, then the conventions of narrative picturing will mislead. Alpers distinguishes the descriptive tradition by pointing to the absence of a specific viewing position, a play with great contrasts of scale, the absence of a prior frame so that the world within the work is either cut off by the edges of the picture or extends beyond its bounds, a sense of the picture as surface (rather than as a window) on which words and objects can be replicated or inscribed, an insistence upon the craft of representation so as to recraft surfaces and finally, little stylistic development. Such pictures are not telling the tale of history; they are non-narrative and static. They stand in contrast to the principles of Italian painting during the Renaissance where the picture shows a strong narrative content and aesthetic, and picturing involves the representation of a few large objects which are modelled by light and shadow rather than by surface detail, where the image is framed and where the viewer is strongly positioned as a result of particular conventions of perspective which place both the viewer's and the artist's eye very specifically.

While the Italian form has been the norm for Western iconography and art history, with the Dutch seen as a secondary tradition, it is the descriptive

picturing of the Dutch which seems to be particularly relevant to the natural history and history museum (Alpers 1983: xxv and 44). Were this so, then it would follow that Crimp's claim that art history was the discipline and discourse of the museum could be accepted as appropriate for understanding the visuality of both the art museum and the natural history/history museum (Crimp 1983). This is because the Renaissance notions of perspective underpinning what Martin Jay refers to as the 'visual régime of the modern' are worked out in traditional histories of art in conjunction with Cartesian ideas of subjective rationality (Crimp 1983). The perspective he is referring to are those developed in Italy rather than the conventions of the Dutch painters, but it is the link between perspective and subjectivity which is important, for the exclusion of subjectivity puts into place the hierarchy which makes Dutch painting secondary to the modernism of narrative forms and museum displays 'objective'.

Some of these factors can be seen at work in the museum's *diorama*, for example, a very specialised and technical form of picturing that might be compared with the great panoramic paintings of the Dutch in the seventeenth century.[4] Its deceptive perspective, its large foregrounded figures, often large birds or mammals, and tiny background figures; the absence of a frame, a meticulous concern with surfaces and detail, and of course the parallel interests in text, mapping and mirroring are commonly found in the Dutch panorama. Similarly, the flat display cases of insects, stones and artefacts of old-fashioned museums could again be seen as descriptive picturing. While the objects are in cases, the display itself is generally unframed, the objects are rendered so that surface detail and richness is clear and highlighted, with no modelling by shadow and light, and no positioning of the viewer. The surface qualities are the qualities which mattered as they were the bases of the taxonomic series into which each object fitted. The use of traditional *descriptive* picturing in the Museum of Sydney displays of fragments uses a nostalgia without recognising the quite different narrative form that is being both recalled and destroyed.

Alpers (1983: xxi) points out that because the Dutch paintings were not made within the narrative tradition of the south, because they did not narrate a text, they were considered meaningless. Their meaninglessness also derived from the static nature of some of the pictures. In their stillness they play with space rather than with time, and this too, fits well with the tradition of museum aesthetics, the visuality of the display case, the diorama or the whale skeleton set on a platform, unframed and three dimensional.

Let me summarise my argument so far. It is that the characterisation of Dutch art of the seventeenth century as 'descriptive' (in the sense of their rejecting the framing of the picture, the focus on surfaces, the absence of a constrained viewing point, and their preference for a static image) points to an alternative tradition of representation which can be traced through to the present in museum displays. This tradition offers a way of understanding the aesthetics of museum displays of natural and historical objects in display cases as well as a way of understanding the displays found in art museums. It draws ethnographic, historical and natural history museum displays into the realm of art history and its traditional concerns,

and it offers some insights into current debates about aesthetics in history museums.[5] While the descriptive tradition has been seen as generally unconcerned with desire and erotics, this is not necessarily the case.

Discussions now taking place around the erotics of art, particularly in rereadings of the Baroque and the conventions of perspective, are particularly relevant to understanding the erotics of the visual strategies of the museum.[6] Martin Jay (1988: 8), for example, points to the role of Renaissance perspective and its relation to the single eye as ushering in a new 'de-eroticising of the visual order'. 'The moment of erotic projection in vision – what St Augustine had anxiously condemned as "ocular desire" – was, Jay says, 'lost as the bodies of the painter and viewer were forgotten in the name of an allegedly disincarnated, absolute eye' (Jay 1988: 8). While the developing rationalism of what we construe as the dominant tradition provides the basis for a range of theories of the disembodied eye, the gaze and hegemonic visuality, I suspect that the eroticising moment was never lost from art in quite such an absolute way. Rather, the rationalisation of the body was never convincing, particularly in the nude, so that the shift was to a dishonest voyeurism which is absent from the perspective of Dutch descriptive paintings but very much a characteristic of Western constructions of difference, sexuality and modernity. In other words, eroticism and desire were not lost as rationalism advanced, but displaced (as in the Baroque) and reconfigured into a disembodied form. It is the secrecy and its power, the pleasure of the hidden eye that sees intimacy through the window of the picture; it is the power of looking that is thenceforth eroticised, rather than desire itself.[7]

This brief reference to the conventions of the Baroque, then, concerns the distinction I want to make between the erotics of vision, visualising, picturing and art on the one hand, and the erotics of the creation of knowledge itself with its sexualising of relations of power and bodies, and their interplay in the institutional space of the museum on the other. I now return to the museum itself, to consider how best to think about it.

Death, desire and redemption

The museum is often theorised as a space of death or ruination. Douglas Crimp (1983: 43–5), for example, cites Adorno's etymological equivalence of 'museum' and 'mausoleum' and Adorno's view that 'Museums are the family sepulchres of works of art'; he also cites Hilton Kramer's claim that art museums have 'death-dealing capacities'. And Baudrillard (1994: 13) proposes that the completion of the collection would be the death of the collector, a fact of which I wish I had been aware when I was in charge of the National Museum of Australia's social history collections. In a different way, Alpers suggests that the transformation of the object effected by its introduction into the museum, what she calls 'the museum effect' and its way of seeing, might also be construed as the death of the object in order that the object might live, but this is the museum as a space of redemption, a space peculiarly suited to an era of commodity fetishisation (Alpers 1991: 25–7). Are museums so deathly, and if so, why then are museums so

seductive, at least to some? Is it the stillness of death, the fascination with the absolutely unknowable, that made the museum such a wonderful place to visit? Should we follow Alpers, and see it as a redemptive space, or at least a space of reification? Should we note that Freud's death drive is tinged with eroticism and pursue an analysis that sought out analogies between classifying, death and erotics? Or is it, as some have suggested, the relief that comes from being able to see the world frozen, as in a single still from a moving film? Or perhaps the satisfaction of the eye? Or the ultimate satisfaction of order itself?

Foucault, Heidegger, in-sight

Foucault (1980: 98) claims that from the sixteenth century, sex and the revelation of truth came to be linked together so that the apparatus of sexuality was articulated onto power. In thinking about the implications of Foucault's proposal as it relates to the museum and the academic knowledges it eventually represented, it is particularly important to reflect upon that section of his work in which he relates the pleasure that comes from exercising a power which questions, watches, spies out and brings to light that which it seeks to show is truly there (Foucault 1978: 45). It is the visuality, the invasive quality of the disembodied gaze, and the power of sight to bring truth in to light that is significant in his understanding of power. And it is the sexualisation of the order of knowledge that set in with the Enlightenment, that provided the power and pleasure of an increasingly normalised heterosexual gender order.[8]

Foucault's shift away from phenomenological modes of thinking make the realigning of Foucault and Heidegger an adventurous task. In discussing Heidegger's phenomenology of Being, I note his opposition to the particular kinds of seeing that are concerned with the discourses of objectivity and rationality which inform so much of Western knowledge. However it is precisely the procreative moment of coming into illumination that brings forth knowledge and understanding that is theorised in Heidegger that creates the space in which Foucault's analysis of the centrality of sexuality and the eye can be placed to produce an understanding, of desire and the erotics of knowledge.

In this configuration, Foucault's analytics brings to Heidegger's phenomenology the dimension of power; it brings Being back to bodies and subjectivity. This is because, in Foucault's view, the individual is conceptualised as the product of a relation of power and truth exercised over and through bodies. That is to say that truth is produced through power onto bodies, and power cannot be exercised except through the production of truth.

There are other ways of approaching erotics, of course, particularly in the visual arts. Pemiola (1989: 237), for example, sees eroticism in the 'figurative arts' as 'a relationship between clothing and nudity' and as conditional upon movement or transit between one state or another. But what I am configuring here is the eroticising of knowledge itself, and more specifically, the eroticisation of the moment of illumination at which knowledge, understanding or truth comes into light and into sight.

In making a distinction between the erotics of knowledge, of coming to know, and the sexualising of an order of knowledge, I am pointing to what I see as a relation of power which informs an ontology and an aligned epistemology that can be seen as being deployed within the practices of daily life. This is one reason for sexual difference becoming so central to philosophy and metaphysics at the present time, for the Western sexual order which claims to be, as I have said, essentially heterosexual.[9] When Foucault discusses the productive capacities of power, and points to the ways in which it induces pleasure, forms knowledge and produces discourse, he brings us to a position where we can consider the production of knowledge as pleasurable in itself (Foucault 1980: 63).[10]

In order to consider the proposition that the enlightenment offered by the museum is eroticised, I leave aside the museum for a moment in order to examine the pleasures of knowledge and knowing. I begin with a cautious reading of the metaphysics of Martin Heidegger. While it might be objected that Heidegger's phenomenology contains a strong attack on the ocularcentrism of Western philosophy and science, I think that his concern with illumination and the generation of in-sight can be carried into the discussion of the ontology and epistemology of the museum and its forms of representation.[11] In his discussion of technology and its mode of knowing and being, he proposes that a knowing is always a *poiesis*, a bringing forth. That 'bringing forth' (and here I use Heidegger's own terminology) occurs when something which is concealed comes into what he labels as unconcealment (Heidegger 1977: 47). As Heidegger develops his understanding of the nature of technological knowledge, the most important proposal from my point of view is that the revealing and the unconcealing of knowledge is always simultaneously an excluding and a concealing. The control of this moment must be of immense importance and is the moment of power and genesis.

In the essay called 'The turning', Heidegger sets out the view that within the danger surrounding knowledge of the true, lies also what he calls the saving power. What is required is for the 'turning' of the danger so that it can be made to reveal Being. This 'turning' is experienced, he suggests, as a lighting up, a sudden flash which is the glance. This is the moment and circumstance of in-sight. But the origin of the flash in the unlighted is concealed so that again, there is a bringing into light that is simultaneously part of a darkening or concealing (Heidegger 1977: 47).

The simultaneous disclosing into light and casting into darkness that in-sight and new knowledge imply, offer a way of approaching the relations of power that inhere in knowledge itself and the ways in which the creation of a truth is always shadowed by its necessary exclusions. In the creation of natural and historical taxonomies, for example, the bringing in to light of the similarities on which their order is to be based will never be exhaustive, can never register the totality, and will simultaneously exclude similarities in order to create the differences upon which taxonomic categories are based. This order is present and recoverable from cabinets of curiosities as well as from nineteenth-century museum displays. The appreciation of this hidden order, its bringing in to light, is an aspect not only of

the museum's displays and their aesthetic, but also of the spectator or viewer's experience of them.

In the moment of illumination that exposes the order that was hidden, lies the promise and seduction of the taxonomies on display. The taxonomies and keys to the order of nature and human nature offer not only a truth but the totalising possibility of closure. In other words, they offer the possibility that the persistent and overwhelming diversity of the world can be ordered in total, that limitless systems can be bounded and limited. It is this aspect of the museum that causes them to be seen sometimes as absolute heterogeneity and sometimes as totally homogenising. And it is both the homogeneity and its narratives which constitute the big lie. Yet in a sense, that moment of illumination which brings into view the taxonomic order of the world does not lie. For it appears to bring into view the principles of that order, whether they be true or false. It is the claim of those orders and the claim that vision (their seeing) guarantees their truth which is false, not their conjuring into view. In order to leave behind something less than the seventeenth-century cabinet of curiosities from whence we came, the *very* modern Museum of Sydney, of course, does away with taxonomies altogether. Techniques of pastiche, collage and irony present an informed and aestheticised political statement about the nature of the museum itself but nothing about the

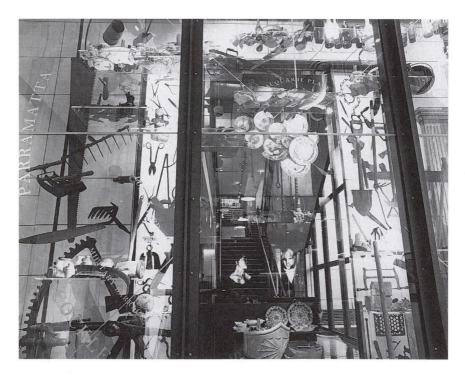

Figure 9.2 Display case, collage of historical objects.
Photographer: Catherine Rogers, courtesy of the Museum of Sydney.

nature of the world or its histories – that so much difficult theoretical work should take the Museum so far!

Conclusion

The museum's poiesis, however, is explicitly pictorial. The unframed nature of the museum exhibit or display and the unpositioned viewer are critical elements in creating, the conditions for this bringing forth, this unconcealing of order. The flash of in-sight that comes with the objectifying gaze of the spectator is therefore specifically visual. This moment of seeing and knowing, a moment of bringing into light is a moment of power. As a moment of subjection and control, within Western knowledges it is always sexualised, gendered, eroticised.

The proposition explored in this chapter is that the pleasures of the museum are essential to it, that the 'facts' collected in it and presented through visual display are immensely seductive, and that both the pleasure and seduction of the museum constitute an erotics in which race and sexuality are never absent. In the Museum of Sydney, the pleasure of the order of knowledge has been restricted to a point where it becomes accessible to a tiny minority who believe that a nihilistic emptiness is somehow miraculously emptied of power, race and sexuality, to leave a purified aesthetic which is thought to be subversive.

These are the failings that leave the Museum of Sydney in something of a cultural, political and aesthetic mess, failings which are illustrated particularly clearly in the visual choices being made in the display of Sydney's foundational colonial moments. The visitor follows a carefully defined trajectory, entering not along the edge of the trees, at a moment of contact no matter how evasive that might be, but rather across the plaza of governance, moving from a glimpse of the original foundations of Government House, to a further glimpse of foundations displayed at the street level entrance, and then on to a first floor gallery that utilises postmodern theory in ways which replicate the colonial narrative they seek to subvert. The Museum of Sydney collapses into a traditional tale of urban foundations, an essentially European dream of reconciliation based on the continuing marginalisation of Aboriginal people, their rights and their concerns.

Notes

1 I should like to thank the convenors of the theme year in the Graduate Research Centre for Culture and Communication at the University of Sussex for the opportunity to join them and for the stimulus to begin to prepare an essay on a topic that had been endlessly deferred. I am particularly grateful for the assistance of Catherine Rogers, who made the images for this essay, in drawing relevant literature to my attention and for the opportunity to discuss aspects of art and art theory with her, and to Andrea Malone for bearing with me while it happened.
2 Most Australian museums have Aboriginal advisers to assist with displays and exhibitions relating to Aboriginal culture. Institutional politics and personal relationships make for some very difficult decisions, out of which emerge self-justifying defences against critique. The Museum of Sydney utilised Aboriginal advice for this display.

3 This passage is taken from Rhys Jones (1985) 'Ordering the landscape' in Ian and Tamsin Donaldson (eds) *Seeing the First Australians*, Sydney. It is engraved close to the Laurence and Foley sculptures. Given the author's ambiguous relationship to some of the most critical aspects of Aboriginal views of their own history and the ownership of cultural property, the use of his phrasing in this context is not particularly appropriate.

4 Panoramic picturing has an interesting history with photographers taking up some of the earlier problems it poses. It is widely used in ethnographic and scientific texts. For a recent commentary, see Peter Emmett's (1996) exhibition catalogue. Compare Ann Reynolds (1995).

5 Martin Jay (1993: 52–3) also refers to this point: ' . . . it [perspective] functioned in a similar way for the new scientific order. In both cases [painting and science] space was robbed of its substantive meaningfulness to become an ordered, uniform system of abstract linear coordinates. As such, it was less the stage for a narrative to be developed over time than the eternal container of objective processes. It was not until the time of Darwin that narrative regained a significant place in the self-understanding of science'.

6 Compare Stafford (1991).

7. Kenneth Clark's (1956) attempt to define the nude illustrates the point: 'In the greatest age of painting the nude inspired the greatest works.' (*ibid.*: 1) 'We do not wish to imitate [the body]; we wish to perfect it. (*ibid.*: 4) 'No nude, however abstract, should fail to rouse in the spectator some vestige of erotic feeling, even although it be the faintest shadow – and if it does not do so, it is bad art and false morals.' (*ibid.*: 6)

In Sir Kenneth's work we see at work the nexus between power, sexuality and gender which is partly traced out by Foucault in his account of the history of heterosexuality, perversion and power from the Enlightenment to the present. Secrecy is critical to Foucault's analysis and it is precisely this which forms the viewing eye as a voyeuristic one.

8 How else to explain Queen Victoria's apocryphal puzzlement over what on earth lesbians could actually do, and how, too, to account not only for the complete ignorance of students and the media over how women could possibly have sex with each other without a dildo, let alone find it stunningly erotic.

9 Compare Monique Wittig (1992), Luce Irigaray (1984 and 1985), Elizabeth Grosz (1994).

10 'A discursive formation must be grasped in the form of a system of regular dispersion of statements', Foucault (1980: 63).

11 See also Martin Jay (1993: 273–5).

References

Alpers, Svetlana (1983) *The Art of Describing. Dutch Art in the Seventeenth Century*, Harmondsworth: Penguin.

Alpers, Svetlana (1991) 'The museum as a way of seeing', in I. Karp and S.D. Levine (eds) *Exhibiting Cultures. The Poetics and Politics of Museum Display*, Washington DC: Smithsonian Institution Press.

Baudrillard, Jean (1994) 'The system of collecting', in J. Elsner and R. Cardinal (eds) *The Cultures of Collecting*, Melbourne: Melbourne University Press.

Bernal, Martin (1987) *Black Athena. The Afroasiatic Roots of Classical Civilisation*, London: Free Association Books.

Carter, Paul (1987) *The Road to Botany Bay. An Essay in Spatial History*, London: Faber & Faber.

Clark, Kenneth (1956) *The Nude*, Harmondsworth: Penguin Books.

Cohen, Margaret and Prendergast, Christopher (eds) (1995) *Spectacles of Realism. Gender, Body, Genre*, Minneapolis, MN: University of Minnesota Press.

Cooke, Lynne and Wollen, Peter (eds) *Visual Display. Culture Beyond Appearances*, Seattle, WA: Bay Press.

Crew, Spencer R. and Sims, James E. (1991) 'Locating authenticity: fragments of a Dialogue', in I. Karp and S. D. Lavine (eds) *Exhibiting Cultures. The Poetics and Politics of Museum Display*, Washington, DC: Smithsonian Institution Press.

Crimp, Douglas (1983) 'On the museum's ruins', in Hal Foster (ed.) *The Anti-Aesthetic. Essays on Postmodern Culture*, Seattle, WA: Bay Press.

Crimp, D. (1993) *On the Museum's Ruins*, photographs by Louise Lawlor. Cambridge, MA: MIT Press.

Donato, E. (1979) 'The Museum's furnace: notes toward a contextual reading of "Bouvard and Pécuchet"', in J. V. Harari, *Textual Strategies. Perspectives in Post-Structuralist Criticism*, Ithaca: Cornell University Press.

Elsner, John and Cardinal, Roger (1994) 'Introduction', in J. Elsner and R. Cardinal (eds) *The Cultures of Collecting*, Melbourne: Melbourne University Press.

Elsner, John and Cardinal, Roger (eds) (1994) *The Cultures of Collecting*, Melbourne: Melbourne University Press.

Emmett, Peter (ed.) (1996) *Sydney Vistas. Panoramic Views 1788–1995*, Sydney: Museum of Sydney.

Feher, Michel (ed.) (1989) *Fragments for a History of the Human Body*, part 2, New York: Zone Books.

Foster, Hal (ed.) *The Anti-Aesthetic. Essays on Postmodern Culture*, Seattle, WA: Bay Press.

Foucault, Michel (1978 [1976]) *The History of Sexuality. Volume 1: An Introduction*, Harmondsworth: Penguin.

Foucault, Michel (1980) *Power/Knowledge. Selected Interviews and Other Writings 1972–1977*, edited by Colin Gordon, New York: Pantheon Books.

Grosz, Elizabeth (1994) *Volatile Bodies. Toward a Corporeal Feminism*, Sydney: Allen & Unwin.

Heidegger, Martin (1977 [1954]) *The Question Concerning Technology and Other Essays*, New York: Harper Colophon Books.

Heidegger, Martin (1993 [1927]) *Being and Time*, Oxford: Blackwell.

Irigaray, Luce (1984) *Ethique de la différance sexuelle*, Paris: Minuit.

Irigaray, Luce (1985) *This Sex Which is not One*, Ithaca NY: Cornell University Press.

Jay, Martin (1986) 'In the empire of the gaze: Foucault and the denigration of vision in twentieth century French Thought', in D. C. Hoy (ed.) *Foucault. A Critical Reader*, Oxford: Basil Blackwell.

Jay, Martin (1988) 'Scopic régimes of modernity', in Hal Foster (ed.) *Vision and Visuality*, Seattle, WA: Bay Press.

Jay, Martin (1993) *Downcast Eyes. The Denigration of Vision in Twentieth Century French Thought*, Berkeley and Los Angeles: University of California Press.

Karp, Ivan and Levine, Steven D. (eds) *Exhibiting Cultures. The Poetics and Politics of Museum Display*, Washington, DC: Smithsonian Institution Press.

Marcus, Julie (1992) *A World of Difference. Islam and Gender Hierarchy in Turkey*, Sydney: Allen & Unwin.

Nead, Lynda (1992) *The Female Nude. Art, Obscenity and Sexuality*, London: Routledge.

Pemiola, Mario (1989) 'Between clothing and nudity', in Michel Feher (ed.) *Fragments for a History of the Human Body*, part 2, New York: Zone Books.

Petro, Patrice (ed.) (1995) *Fugitive Images. From Photography to Video*, Bloomington IN: Indiana University Press.

Reynolds, Ann (1995) 'Visual stories', in Lynne Cooke and Peter Wollen (eds) *Visual Display. Culture Beyond Appearances*, Seattle, WA: Bay Press.

Scheibler, Ingrid (1993) 'Heidegger and the rhetoric of submission: technology and passivity', in Verena Andermatt Conley (ed.) *Rethinking Technologies*, Minneapolis: University of Minnesota Press.

Stafford, Barbara Maria (1991) *Body Criticism. Imaging the Unseen in Enlightenment Art and Medicine*, Cambridge, MA: MIT Press.

Wittig, Monique (1992) *The Straight Mind and Other Essays*, Hemel Hempstead: Harvester Wheatsheaf.

10 History, 'otherness' and display

Ludmilla Jordanova

History is everywhere, and by that token it is both on display and an integral part of daily life. But what is 'history'? It is usual to distinguish between two meanings: the past and the study of the past. To these I would add a third – a non-academic, often barely articulated sense of other times, a 'history' shaped by emotions, fashion, style, personal experience and popular memories. Whether you interpret history as all that has gone before, as a field of academic study or as a diffused consciousnessofpreviouseras,itistotallyboundupwithcommunicating'otherness'-quo;. I shall explore the relationships between history, display and 'otherness' from the vantage point of a practising historian. The discipline of history is awkwardly placed at the moment, but it exists in professional and institutional forms, and these constitute the main arena in which issues surrounding the nature of history in all its senses are debated. Debates about history can be usefully conducted using ideas, such as 'display' and 'otherness', that have previously been associated with literary and art-historical studies.

Admittedlyitisnotusualtothinkofhistoryintermsofcommunicating'otherness'-quo;. Two reasons for this spring to mind. Many historians still feel uncomfortable with notions of 'otherness', possibly because they are unfamiliar with the pedigree and resonances of the term. At the same time it is widely assumed that we possess profound kinship with our forebears, even if we rarely conceptualise its precise nature, hence 'otherness' is not felt to be an apt metaphor. Thus, as a concept, 'otherness' itself can seem alien and inappropriate in relation to the study of the past. Although 'the other' is hardly a new notion in Western thought, its current vogue is relatively recent and associated with fields, such as subaltern studies, feminist literary criticism, film studies, and anthropology, with which most historians have little acquaintance. Notions of 'otherness' can, however, be more widely applied, since the dynamic between self and other, at individual and at collective levels, is constitutive of all human relationships. Otherness serves as a constant reminder of difference. Admittedly, it sometimes seems as if these ideas are treated as sacred and talismanic; they appear to offer protection from the worst kinds of intellectual imperialism. Historians, however, have not been conspicuously eager to embrace them – later on I will suggest ways in which they might do so.

Underneath 'otherness' lie some difficult issues about what human beings in

different times and places have in common. The term implies that we should take as little as possible for granted about people in other eras and locations. Yet scholarship is scarcely possible without some sense of a shared human nature. Over the last twenty years or so, however, most of the humanities and social sciences have been uncomfortable with the implications of acknowledging a common human nature; they have actively embraced ideas of 'otherness', although often in quite woolly ways. Some disciplines, anthropology above all, have been willing to examine this issue directly, to test to its very limits the contention that understanding other cultures in their own terms is impossible. There is a kind of courage in this quest, which has the potential to undermine the very basis upon which we build a knowledge of other cultures, but there is also a kind of despair, resulting from a peculiar kind of collective self-doubt, which, in my view, is rarely productive, either intellectually or politically. One element in this despair is certainly guilt; anthropologists have been particularly alive to the conditions that have generated this sentiment and to the ways in which they can be most sensitively handled. Historians have not worried about these matters in quite the same way, and on the whole a doubting mode has not overtaken the field. On the one hand, this is a missed opportunity, since used creatively, anxieties and challenges are spurs to re-evaluation, while on the other, it is a boon, since excessive introspection can lead to a fruitless loss of confidence.

There are areas of history where questions of a shared humanity have been more openly debated. For example, in the history of the family they have been unavoidable, since any work on the family inevitably involves assumptions about patterns of intimacy in material conditions vastly different from our own. These palpably different facts of life are sufficiently shocking to prompt historians to address directly questions such as: in times of high infant mortality do people love, care for and mourn their children in a distinctive manner, did people choose spouses, interact with their relations, behave in their homes, quite differently? It might be thought that these questions have empirical answers, and it is certainly true that vast amounts of evidence on these subjects exist. Yet it is striking that historians tend to divide into two groups, those who stress the continuity in human reactions and those who stress their discontinuity – it is as if the evidence itself is so labile that it can be made to fit either position. It is equally striking that in debating these matters historians rarely go to an explicitly theoretical level or even avow what their main assumptions actually are. One exception is psycho-historical work: there are, particularly in North America, groups of historians working on the family, and especially on childhood, who have an explicit theoretical agenda – the application of psychoanalytic theory to the past.

Over the very same period during which the concept of 'otherness' was increasingly being used to express a desire to do justice to the growing sense of the profound differences between people, there has been a dramatic surge of interest in psychoanalysis, which is predicated on a shared human nature. Practitioners in fields most responsive to psychoanalytic theory, such as art history and literature, clearly feel relatively at ease with the explicit use of theories that posit widespread, if not universal, psychic patterns. On the whole, psychology in general and psy-

choanalysis in particular, make historians feel intensely anxious. Naturally there are exceptions, but they represent a tiny proportion of those calling themselves historians, who tend to feel a kinship with those they study without expressly conceptualising that kinship. The language of 'otherness' does not slip easily off most historians' tongues, just as their brains do not readily change into theoretical gear. Thus, as a field of study, history fits into neither of the patterns I have outlined – it has not gone through re-evaluation and self-doubt, nor has it theorised its sense of a shared humanity. It is a rare occasion when historians are open about either their psychological assumptions or limits to their capacity to understand other societies. Maybe they do not often consciously apprehend the situations they work on as other. Historians of Western societies are the direct heirs of those they study, existing in some palpable form of continuity with them. This continuity is an unusually complex phenomenon, and it makes 'otherness' an exceptionally tricky idea for historians who study their own cultural traditions.

It is often said that history and historians have been going through a crisis lately. I will comment briefly on this point in order to set up the later discussion about the display of history. There can be no doubt that history, both as a subject that is taught and written about and as a profession, has changed markedly over the last twenty to thirty years. But these changes have largely consisted of accommodating additional perspectives and of giving more explicit recognition to marginal issues. For example, new approaches have been added and developed, such as social history and oral history; new objects of study have been included and given weight, such as in women's history, gender history and black history, and new categories of sources have been admitted, such as images and material objects. Some of these innovations were highly charged politically, in that women's history without feminism was as unthinkable to many of its practitioners as black history without a civil rights movement, or history from below without socialism. In practice, however, the political dimension, while it has not been lost, has certainly been accommodated. Furthermore, there were well-established traditions for the politically-engaged study of the history of poverty, labour movements, class and so on, long before the 1960s. Since the 1960s the weight of interest in the discipline has shifted towards the more recent past, especially the late eighteenth century onwards. Other trends in the practice of history have gained a kind of modish prominence, but are not in fact particularly novel – small numbers of practitioners have long been interested in other disciplines, in non-Western societies and in theoretical questions. It is arguable, for instance, that cultural history, which is often associated with a 'new' approach, and with an openness to theory, to inter-disciplinary work and to a wide range of sources, is in fact one of the older branches of history, given that it was fairly widely practised in just these ways in the eighteenth century. When we speak about the history of disciplines, we often use a remarkably shallow chronology, and a good sense of the history of knowledge-production and of discipline formation is lacking. Most historians have incorporated new trends in a gradual, piecemeal fashion. They continue to focus on well-established historical issues, and they have not felt the

foundations of their discipline to be rocked, even if some of the more politically overt challenges of recent years have appeared a little threatening.

The genuinely dramatic changes affecting history come from outside the discipline. Two such changes are especially pertinent to my main theme. First, cognate fields have taken a special interest in the discipline of history in ways that produce tensions. There has been a tremendous growth, especially among literary critics, in the use of sources that would previously have been thought of as historical. Legal, scientific, medical and economic writings, to take only the most notable examples, have become staples for literary analysis. One result of this trend is that people in other disciplines have acquired a stake in the way history is practised, indeed such people often produce work that becomes the standard historical account. At the same time, these very fields have been highly critical not just of what is identified as establishment history, but of a whole orientation to the world and its past, that is taken to be redolent of a bankrupt political order. Tensions inevitably result, since history is at once a terrain of useful resources to be occupied and an ideological enemy, and the situation is compounded by the very slipperiness of the word 'history', which can carry, simultaneously, the idea of a past weighing guiltily upon the present and hence in need of reparation, of a conventionalised and politically-motivated master narrative, of a narrowly-defined, old-fashioned discipline dedicated to assembling facts. Of course, history carries many other connotations, but I want to point out that history can be taken to be both too empirical and too ideological, both too interesting to be left to historians and too conservative to be saved. Naturally, there is something to these criticisms just as there is a great deal to be said against them. The pertinent issue here, however, is that they make history contentious; they prompt re-evaluation, including of how it is displayed.

The second major change that has affected history has also come from without. It is now perfectly clear that history has become a commodity, indeed it is a major commodity for the leisure and publishing industries. The so-called heritage industry is only one part of what is a huge phenomenon comprising shops, museums, galleries and special exhibitions, magazines, organisations, fashions in clothing and interior decorating, and so on. The notion of public history is increasingly evoked of all kinds of history that are either presented to the public or raise issues of public, that is broadly political, import. Those who earn their living as historians have rarely been instigators in this area, although a small number of contemporary historians are important participants in discussions of the recent political past, discussions that would continue whatever the state of academic history. By contrast, recent trends in museums, re-enactment, living history and so on tend to have a rather problematic relationship with professional history. Schools are probably the main mediators between these larger trends and those who originate historical knowledge. Museum professionals, like teachers, draw on historical scholarship, but are not necessarily at all close to the production of advanced research in history. In the fine arts, the relationships have long been far more intimate. To note these trends is not to condone the separation between history as leisure industry and history as academic production. However, it is

undeniable that they generally are separate, and that commercial and ideological forces outside the historical profession have been the prime movers in processes of commodification of the past.

I have sketched in some general points about 'history' in our time, in order to suggest that in the ambiguity of that term lurk some major issues. Thinking about notions of 'otherness' can be helpful in clarifying them. The imperatives behind much thinking about 'otherness' have been not just political, but also specifically ethical. The acknowledgement of difference, even if it had complex, sometimes unexamined entailments, was about giving cultures other than our own some kind of due. A sense of distance was deliberately created as a device to help Western scholars recognise their own limitations. It prompted us to work far harder to imagine worlds not our own, not just because this would produce richer insights but because it was a more responsible and respectful stance. The significance of such a stance was reinforced by passionate debates about sexism and racism. While this orientation has had some impact upon the practice of history, it has been limited. Otherness in time is qualitatively different from 'otherness' in space, and the idea of giving the past its due lacks the urgency that lay behind the need to respect racial, sexual and class differences. Furthermore, we think of the past as our own, a view which is sustained by an implicit emphasis on the continuity of historical traditions. Otherness in time is harder to imagine than 'otherness' in space – for one thing it is more abstract. The scholar as traveller can go to vastly different places in fantasy and virtual reality if not in person, she or he can visit, meet people from and see television programmes about distant places – visual evidence provides sensual immediacy in a manner not possible for distant times. Mobilising strong identifications with individuals in the past is perhaps the closest historical equivalent, yet this has its limitations. It is presumably in order to overcome these difficulties that visual images are often treated as if they were mirrors, windows, or stills from a video giving direct access to earlier worlds rather than as complex cultural mediations. While it is an illusion to suppose that journalism, documentaries and tourism give unproblematic access to other places, my point is that this sense of illusion exists, has deep roots and is daily sustained. To provide it for the past is far harder, although there are now numerous attempts to do so. It is no coincidence that so many of the attempts to make history come alive use the idea of travelling back in time; they deny or seek to efface the distance of time and they ignore the abstract elements necessary for historical understanding. They pretend to recreate sensual immediacy, and to draw on intuitive rather than analytical responses. What is lost in the process is precisely what makes historical understanding distinctive and important.

In using notions of 'otherness' scholars have had a further set of issues in mind. Since 'otherness' is always actively made rather than given, it emphasises the social construction of reality. The very effort involved in constructing others as such indicates a resistance to identification – sometimes this is a knowing response, a deliberate device for making strange, to serve the political and ethical imperatives I have mentioned. Then 'otherness' is an analytical tool. More often, however, these processes occur unselfconsciously, for instance, in situations where there is a

genuine fear of being too like, blending with or collapsing into another type of human being. Because self and other are mutually constitutive, identification and objectification go hand in hand. Otherness is as much about the construction of oneself, as it is about creating distance. Indeed the sense of distance is generally made, manufactured, and then treated as if found, discovered, as if, in other words, it was a natural object rather than a social construction. It is helpful to observe when and how some of the key categories that we use – the West, the East, the frontier, the nation-state – were forged and then made natural, reified. Here 'otherness' refers to social processes that need to be unravelled. Otherness, then, has two facets: first, as a shorthand for ubiquitous historical processes whereby categories of difference are forged, and second as a concept that creates a productive sense of difference by acting as a brake on facile assumptions about continuities between cultures and about human sameness.

Historians could use 'otherness' in both its facets to a much greater extent than they have done so far. Recent work on identity formation, especially in relation to nationhood, assumes the importance of cultural processes for generating types of 'otherness', and building on such insights, the usefulness of 'otherness' in historical work will be considerably extended. Using 'otherness' as an analytical tool, historians could profitably take a critical look at the ways in which periods are defined and characterised. These often assume the universal appropriateness of terms derived from a single culture, and contain implicit claims about the homogeneity of past societies. The use of the name of a single ruler to describe many geographical areas over a significant span of time exemplifies the point. We need to consider and to deconstruct the processes by means of which the past has been organised and classified, and how these shape the identity of both historical actors and of historians. We would do well to consciously make strange the societies we study, in order to see what has been inappropriately taken for granted, what was not previously brought up for critical inspection, and what is taken to be unproblematically like us. Assumptions underlying periodisation could be reworked so that the 'otherness' of the past is given its due.

One of my themes, then, is the ways in which historical continuity is generated, sustained and displayed. Sometimes such continuity is actively constructed; at others it is simply assumed. I want to think about how the past is simultaneously exoticised and incorporated, how it is made other and familiar at the same time. Although this is a feature of many fields of study, it has taken on distinctive forms in history. I am suggesting that it can be useful deliberately to imagine the past as other, a contention that can be developed through the theme of display.

If we return to the three meanings of history with which I began, we can note that two of them, all that is past and a diffused awareness of former times, imply that history is everywhere on display. And this is part of the problem – the boundaries between, on the one hand, artfully constructed displays of a consciously conceptualised past, and on the other, the ordinary past that is just there, visible to more or less everyone, are maddeningly fluid. Every built environment is a historical display, and seen as such by some people, but not by others. Activities such as reading, going to museums and galleries, watching television and films

and so on all involve the display of history – sometimes apprehended as such, sometimes not, and when not, aspects of history are probably being absorbed unconsciously nonetheless. It is important to build up models of the settings in which different kinds of attention are paid to the past, of the factors that influence them, and of the contexts in which historians practise. Once we can imagine how in everyday life people constantly move in and out of paying conscious attention to the past, the simultaneous feeling of distance and closeness that is characteristic both of professional historians and of the general public can be appreciated better.

We can usefully distinguish between six different kinds of closeness. The sense of affinity with the past takes a number of the distinct forms. First, there is the belief that, in the human qualities that really matter, contemporaries share much with people in former eras. The second form is the perception that we live with traditions and institutions that are continuous with the past, in respect of shared values, worldviews, beliefs and so on. Third, there is the physical proximity of remnants from the past, which, although not always in focus, generates a quotidian intimacy with former times. The fourth kind of closeness derives from the adoption of styles and fashions explicitly linked with earlier eras. Fifth, in the conduct of politics and in debates about current affairs, the direct relevance of the past is constantly if selectively affirmed. The strategic invocation of precedents, especially in relation to the conduct of public figures, and the use of historical experts to comment on contemporary issues, reinforce the sense that the past is immediately relevant to and serviceable for the present. Finally, historical novels, radio, television and films combine to generate an unprecedented degree of illusion that we can, if only vicariously, participate in the lives and loves, thrills and spills of the past, which is thereby made much closer to the present. The powerful emotional responses that historical novels and dramas engender among audiences is testimony to the ease of identification they permit.

These forms of closeness have certain traits in common: they tend to be more felt than thought; they appeal to a sense of pleasure, rightness or aptness and they have a significant normative dimension – aesthetic as well as moral. In practice, old objects, images and ideas may be inconveniences, to be actively rendered obsolescent, and offering occasions for generating distance and distain. But such deliberate, labour-intensive estrangement is necessary precisely because what is old retains the capacity for closeness, to touch us now, otherwise why expend effort on managing it? Thus, history, loosely defined, is treacherously ubiquitous, perpetually moving in and out of focus, it is slippery, always available for uses that are hard to capture and to develop coherent critiques of, slithering between different levels of consciousness. This is the context of all historical display, at least in the societies that I am familiar with. The insidious qualities of these forms of closeness, and the baggage they carry with them, make it all the more important to concentrate on the past as other, not just to insist on its difference, but as a heuristic device.

The idea of the past as other has its own history and dynamics, especially in fiction. I am not referring here to the traditions of historical-novel writing that followed Walter Scott, but to the efforts made, more in the manner of science

fiction, to imagine deeply distant worlds, to imagine travelling back in time. Their non-fictional counterparts may be found, not in historical writings as these are usually defined, but in geology, prehistory and archaeology, which have in common the conspicuous effort of retrieval, whether of objects, languages, or other kinds of information. It is worth noting how separate archaeology and history generally are, although there are clearly pockets, such as medieval history, where this is less marked. On the whole, both at a professional level and in the minds of the general public, they are two very different endeavours, and the former, because of the obvious effort required to recapture a distant or buried past, is distinctly more glamorous. While in principle the archaeology of any period can be studied, the discipline was formed around and continues to be associated with the study of distant, ancient civilisations. Even as a metaphor, archaeology has special allure, doubtless Foucault's *The Archaeology of Knowledge* has had something to do with this, as does the currency of the idea that human consciousness is composed of layers, which associates excavation with memory, with working through strata to retrieve a distanced past.

The glamour of archaeology derives from three of its facets. First, it is associated with adventure, danger, physical challenges and a certain exotic mystique deriving from the locations in which early heroic archaeology was practised. Second, it displays conspicuous mastery, especially of difficult, often extinct, languages, and hence a specifically intellectual form of prowess akin to cracking codes for espionage purposes. Third, the objects retrieved, especially those that are more spectacular, trigger imaginative effort and awe. Precisely because they are material objects, they invite an attention, a deliberate focusing, that makes viewers aware of a lost world, now apparently dramatically revealed. Archaeology as a discipline and museums that display archaeological objects readily create a sense of the past as other, and sustain it through a sense of the rarity of ancient, well-preserved and pleasing objects.

Historians who work on postmedieval Western societies have no such advantages. Although sometimes mentioned as a joke, the biggest problem seems to be excess of materials, whether texts, images or objects. Furthermore, historical work is relatively untechnical – for example, only a relatively small proportion of professional historians routinely use other languages, there is little sense of adventure to be derived from working in dusty French archives, noisy English record offices, or major libraries, especially since the materials deposited there have either been found by others or given in relatively unromantic circumstances. Few historians work seriously with objects, even fewer with those possessing great rarity value and obvious aesthetic merit. These words might be thought to make the practice of history sound humdrum. Doubtless many individual historians do indeed feel thrilled, adventurous and romantic just as many archaeologists do not. As constructed cultures, however, archaeology and history are different, and in ways we need to pay attention to. The widespread cult of the archive among historians can be read as a defensive invention designed to produce an aura of glamorous detective work (and of self-sacrificing labour) where it would not otherwise exist. When historians enthuse about their work with primary sources, it is often

couched in terms of emotional contact with people in the past, and hence depends on a sense of continuity with other times. The forms of socialisation within academic disciplines are partly compensatory – they serve to give a sense of value to practitioners, even when their field is not held especially high in the esteem of the public and/or their peers. There is a widely held view that, although the general public has a considerable appetite for (some kinds of) history, as practised by professionals it is generally dull stuff. It may be that the past, especially the recent past, is seen as too cosy, too accessible and insufficiently distanced from the present to make it interesting. I have suggested that devices widely available for creating a sense of allure have served the interests of archaeology much better than they have those of history. What makes the historical as opposed to the archaeological past accessible, and in certain forms attractive to a wider public, renders it, and the discipline that studies it, mundane.

The claim that history often seems rather bland, even mundane, would seem to be confirmed by the special place given to those episodes widely acknowledged to possess high drama and strong human interest – the two world wars, the holocaust, fascism and so on. I suspect we are unusually concerned with these phenomena partly because some of the participants are still alive and demanding recognition, acknowledgement and reparation. The result is a political and emotional minefield. It is difficult to see how creative distance will be gained when the stakes remain so high. Here the drama of the events overrides the image of the discipline – it is not accidental that so many A level students have studied and feel powerfully drawn to the history of the twentieth century and to themes such as fascism, dictatorship, totalitarianism, nor that, by contrast, historians are increasingly concerned to avoid simple, moralistic accounts, and to emphasise the varied and complex reactions of the ordinary people who lived under such regimes rather than simple moral polarities. Perhaps the tendency of much history to appear dry and bland accounts for the huge interest both in historical fiction and in recent dramatic episodes of epic proportions, which satisfy cravings for the past more effectively. Most people's historical sensibilities – whether they are professional historians or not – have been shaped more by reading fiction and watching historical dramas than by anything else. If I am right, and others, such as David Lowenthal, have made just this argument, history as an academic discipline finds itself in a peculiar dilemma – it is associated with a special kind of romance, with a gigantic leisure market, but also with dull facticity and tiresome narratives – so what place is it to occupy? Clearly not everyone associates history with these qualities, but I contend that enough people do to cause problems, problems that are exacerbated by the fact that the past is a peculiar kind of common property, a world brought ever closer by the widespread enthusiasm for consuming novels, dramas and by the constant use of historical examples in the media. Perhaps there is just too much of it around – it lacks scarcity value. Furthermore, the very quality that gives the study of history a special kind of value – synthetic analysis – is not easily put on display.

This is only part of the story. I have touched on the different, treacherous kinds of closeness the past possesses for us now. It also possesses diverse forms of

distance, and just as we found that there were distinct types of closeness to be distinguished, so there are of distance. One of the most common ways in which we apprehend the distance of the past is through the concept of progress – the greater the number of discernible steps or stages between ourselves and a given aspect of the past, the further away it seems. This is particularly true of aspects of everyday life, especially those associated with modern comforts, that is, with technologies, so that, for instance, societies regulated by the availability of sunlight and possessing only simple forms of artificial illumination, seem light years away. The model of historical change built around stages of development also allows for remote kinds of kinship to be created, and this is often what is emphasised in museums of technology and everyday life, using series of objects in chronological sequences. But precisely because the differences are embodied in everyday life, are so intimate to quotidian existence, the sense of distance easily predominates. Life on other terms than the ones we currently enjoy seems almost unimaginable, even bizarre, especially in relation to the meeting of basic needs. Nothing seems more comic than old-fashioned domestic appliances, underwear, food and advertisements.

A second form of distance relates to belief systems. While it is distinctly unfashionable for historians to think in terms of the 'irrational', this notion in fact lies behind many reactions to past modes of thought. In labelling a phenomenon 'irrational', that is, outside the speaker's own belief system, it is held at a distance. More specifically, anxieties about lack of rationality inform responses to religious belief and to witchcraft, where a measure of distance, often with a moralistic undertow, may be a necessary defence against the troubling implications of forms of behaviour that now appear strikingly anomalous. The widespread fascination with the supernatural has a strong historical dimension, presumably because advanced industrial societies are no longer suffused with magic. Thus magic, like miracles, contains a certain allure, but largely because it has been safely distanced. A third form of distance is more directly aesthetic; it mobilises a sense of the past as ugly, smelly, disordered, repulsive. The prevalence of serious illnesses and high mortality rates at other times is frequently used as a trigger for this particular form of distancing, which is particularly common in writings for children, who are encouraged to find the Victorian period, for example, as one characterised by dirt, disease and death. A fourth related form is the attribution of barbarous emotions and practices (torture, the death penalty, child labour and so on) to those in the past, from which we can then legitimately distance ourselves by passing judgement on their cruelty. In all these forms of distancing, there is an element of the 'progress' model, and like types of closeness, they are more felt than thought, more moralistic than analytical.

Many of the themes I have mentioned can be illustrated by examples from museums, writings for children and from popular accounts. I shall suggest that the creative distance I have alluded to is not being used, that confusing relationships, which oscillate between distance from and closeness to the past, have been set up and that the images of the past that are being deployed do not serve the interests of the discipline of history particularly well. It is not that historical dis-

plays should have the needs of professional historians at the forefront, but rather that historians should be using forms of display for getting their ideas across more effectively. Finally, I will turn to the nature of historians' interests.

Museums clearly constitute one of the main ways in which visions of the past are communicated to the general public. Whose visions these are is less clear, but they respond to broad cultural trends, in museology, in the teaching of history, in the leisure industries and in more diffused collective senses of the past. Museums, in other words, are important sources for understanding models of the past and the enthusiasms history generates. Professional historians might pay closer attention to museums as one way of thinking through the image of their discipline. The sheer number and diversity of such institutions is remarkable, and they pose formidable problems of interpretation precisely because the imperatives of commercialism, ideology and cultural change are so tightly interwoven in them. One of the most striking developments is the growth of interest in the display of everyday life. Working farms and workshops, days when children can dress up and spend time in an authentic historical setting, opening up kitchens and servants' rooms in country houses, the display of the accoutrements of domestic and working life, and the use of individuals in costume to role-play or speak to visitors, are all examples of this trend.

What does it mean? It places history precisely at a mundane level: we can appreciate the past best, according to such displays, through what is ordinary, widely shared, the staples of everyday life. The ordinary is presented as a people's past; it is figured as a democratised vision, as a world with which we can easily identify, because, so it is assumed, there is shared quotidian humanity, that is further reinforced by the ties and memories of generations of kin. At the same time, the distance from the past can be appreciated, but it is a particular kind of distance – a distance measured by steps on a ladder, which, if it is not always represented in terms of some simple notion of progress, at least suggests a series going from 'less like us' to 'more like us'. Children's history books work in a strikingly similar fashion.

Next to this trend towards the past as everyday life is the continuing tendency to present it in terms of political regimes, not so much of prime ministers and governments, although this persists in some school history and undergraduate teaching, as in terms of monarchs – a feature that is particularly marked in Britain. The Victorians is now a major topic for primary school children, and it is treated in a way that is quite consistent with the emphasis on everyday life – somehow it is possible to present Victoria herself both as an epitome of Britain and empire and as an ordinary woman, wife and mother. This use of the monarchy as a vehicle for imagining a continuous history is noteworthy and it contains a special kind of personification. To know a ruler and her or his dates, to know something of their character and style as well as of their times, is to conjure up a past age as a particular kind of totality. Because these are individuals, with known tastes, whims and preferences, they are thrust forward as suitable objects of identification – and this remains true whether the monarch in question was, if I may express myself in a '1066 and All That' fashion, a good thing or a bad thing. Indeed it is precisely

because monarchs have marital problems, difficulties with their children, suffer and grieve that they can both sum up an era and evoke a sense of its mundane qualities – both require our identification. Because there is ample visual evidence, at least for postmedieval rulers, monarchies generate attractive forms of historical display, especially in terms of portraiture. The faces of monarchs are indeed a form of coinage – they are tokens that can stand in for virtually anything without losing their specificity. Because individual monarchs and the monarchy as an institution can perform so many functions in terms of historical display, because the exhib- itions of everyday life are generally so full, so empirically excessive, so suggestive of the variety and scale of ordinary objects, because so many facts and details exist, for the recent past especially, that can be poured, albeit selectively into edu- cational materials, it is hard to imagine alternatives. But this is an important task to which historians should address themselves. Why is that so?

History as the study of bygones, which is what museums of everyday life effect- ively are, is conceptually weak in that it is anecdotal and under-theorised – it has no coherent view of the role of objects in building up a systematic account of past cultures. I am thinking here of British museums; the contrast with other societies, where folklore occupies a prominent and legitimated place, is striking. Further- more, there is a facile politics here, that to retrieve what is common is somehow inherently democratising, that the mundane past belongs especially to the people, who are thereby being given a presence. I find this rather patronising, and can see no reason why, if we have to use the language of ownership, all the past does not belong to everybody. Nor can I see any obvious reason why the woman or man in the street would be naturally more interested in old washing machines than in old books, prints or private papers. Creative distance is also lacking in displays of royal history. The invocation of monarchs is simply a way of, on the one hand glamorising the past, and on the other of suggesting its coherence, without having to do any of the work of showing how past societies may be understood as wholes or of explaining the complex roles of kings and queens. I am not, inciden- tally, claiming that historical material should be displayed in such a way as to suggest a seamless integrated past – that would be a gross distortion. But history as a discipline is committed to intellectual coherence, to showing how bits of the past fit together, and there is no reason why these insights should not be more widely transmitted and displayed.

Historians at the present time could be said to have two overriding commit- ments. The first is to an understanding of the past that does it justice – this means, in so far as this is possible, taking actors and their categories seriously, giving due weight to diverse evidence, which may be conflicting or inconsistent, and trying to make sense of it. Historians have ethical responsibilities; they work to mobilise sufficient empathy to represent other forms of being as fully as possible in histor- ical writings. The second commitment is to fitting pieces together, to finding patterns and links across different types of evidence, to building models that account for the patterns they find, which is emphatically not to say that the past is made up of simple social systems. These commitments are characteristic of history as a discipline, and they exist in manifest tension both with history as displayed,

whether in museums or in looser cultural practices, and with popular historical culture, which is built on the forms of simultaneous closeness and distance discussed earlier. Among other things, historians are committed to abstract thinking and analysis. Yet the relationships between such thinking and what is *visible* in objects and images, as distinct from texts, which are more easily understood abstractly, is profoundly problematic. Herein lie history's dilemmas.

Finally, I want to consider the interests of the discipline of history. I am assuming that it is simultaneously possible to want a field to become more open and alive to other perspectives and to believe that it serves or has the capacity to serve particular purposes. I have had comparisons between history and a number of other disciplines in mind when hinting at what may be distinctive about it. My argument imples that history as a field is concerned with a specific kind of abstraction, although this is veiled and suppressed for a number of reasons, among them, popular demand for a visually interesting past, the need for figures with whom to identify, a general appetite for facticity, and the persistent use, especially in political contexts, of history as a serviceable resource. This situation poses problems for historians, who do not after all want to criticise public demand for and interest in their subject, even if the logic of that demand runs counter to the conceptual core of their field. What can be done? Historians could become more active in shaping the public uses of history, for example, in museums. They could work towards identifying what is distinctive about the discipline. They should not pretend it can be reduced to images, objects, or events, but search for fresh ways of conceptualising the relationships between what is available for display and historical knowledge itself. It is undoubtedly a special challenge to find ways of satisfying a growing and insistent demand for the past to be laid bare. If historians give up on the goal of communicating the distinctiveness, not of *what* they study but of *how* they do so, if they lose confidence in their capacity to have visions of their own, then the field itself will inexorably decay. And it will do so because, in its public face, it will have been reduced to a cult of bygones, a data bank for cheap political points, a leisure industry that makes money out of historical commodities.

It is then in a fighting spirit that we can turn to the idea that the past is truly other, that understanding it involves huge intellectual effort, that it is both shaped by us and that it must be given its due. Far from being easy, far from being an elaborate assembling of remnants, this is an essentially theoretical endeavour. Putting it this way has, I believe, a number of advantages, but it also suggests one rather daunting challenge. It means that we have to rethink the relationships between historical knowledge and the artifacts and images that largely represent it in displays. Given the strength of commercial and political pressures, it may be naive to suppose that we can shift current display practices. But the more important job of re-imagining the links between history as knowledge and history as a visible past can be attempted, indeed it has already begun. In a sense this is an old problem, almost as old as history as a form of human endeavour, which has come into fresh prominence with the debates about heritage and the heritage industry. Yet it is remarkable that relatively few professional historians have entered these debates or shown an active concern for the relationships between a specific

academic discipline and the wider world in which it exists. I say this not in the spirit of wanting to advocate that history become an imperial discipline, but neither do I want to see it colonised or devalued. It exists as a discipline, and it would be craven not to see what can be done to make it more alive – intellectually, politically and in popular culture. The vitality that comes from current attitudes to history and its display is in truth no vitality at all. History as it is displayed now is a largely sentimental, politically shallow and undertheorised endeavour. In seeking to remedy the situation, historians should make common cause with those in other disciplines who have faced similar if not identical problems. Anthropology, art history and museology are likely to be of most use. Conceptualising history as a particular kind of cultural encounter, and paying attention to ways of communicating its distinctive forms of 'otherness' are likely to be productive ways forward.

References

Listed here are some of the publications that I have found useful in thinking about these themes, and also that extend the points made here.

Anderson, B. (1991) *Imagined Communities. Reflections on the Origin and Spread of Nationalism*, London and New York: Verso, revised edition.

Aries, P. (1973) *Centuries of Childhood*, Harmondsworth: Penguin.

Berger, P. and Luckman, T. (1967) *The Social Construction of Reality*, Harmondsworth: Penguin.

Bowler, P. (1989) *The Invention of Progress. The Victorians and the Past*, Oxford: Basil Blackwell.

Colley, L. (1992) *Britons: Forging the Nation, 1707–1837*, New Haven, CT and London: Yale University Press.

Cooke, L. and Wollen, P. (eds) (1995) *Visual Display: Culture Beyond Appearances*, Seattle, WA: Bay Press.

de Beauvoir, S. (1972) [1949] *The Second Sex*, Harmondsworth: Penguin.

de Mause, L. (ed.) (1976) *The History of Childhood. The Evolution of Parent–Child Relationships as a Factor in History*, London: Souvenir Press.

Foucault, M. (1974) *The Archaeology of Knowledge*, London: Tavistock.

Gay, P. (1985) *Freud for Historians*, New York and Oxford: Oxford University Press.

Gender and History (1994) vol. 6, n. 3, special issue on public history.

Gillis, J. (ed.) (1994) *Commemorations: the Politics of National Identity*, Princeton, NJ: Princeton University Press.

History of the Human Sciences, (1996) vol. 9, n. 4, special issue on identity, memory and history.

Hobsbawm, E. and Ranger, T. (eds) (1983) *The Invention of Tradition*, Cambridge: Cambridge University Press.

Horton, R. and Finnegan, R. (eds) (1973) *Modes of Thought: Essays on Thinking in Western and non-Western Societies*, London: Faber.

Jordanova, L. and Porter, R. (eds) (1997) *Images of the Earth: Essays in the History of the Environmental Sciences*, Chalfont St. Giles: British Society for the History of Science, 2nd edition.

Jordanova, L. (1995) 'The social construction of medical knowledge', *Social History of Medicine* 8, 361–81.

Jordanova, L. (2000) *History in Practice*, London: Arnold.

Kelley, D. R. (1996) 'The old cultural history', *History of the Human Sciences* 9 (3): 101–26.

Lowenthal, D. (1985) *The Past is a Foreign Country*, Cambridge: Cambridge University Press.

MacCormack, C. and Strathern, M. (eds) (1980) *Nature, Culture and Gender*, Cambridge: Cambridge University Press.

Robertshaw, A. (1992) ' "From houses into homes". One approach to live interpretation', *Social History in Museums*, 19: 14–20.

Roberts, J. M. (1995) [1976] *The Penguin History of the World*, London: Penguin.

Roper, L. (1994) *Oedipus and the Devil: Witchcraft, Sexuality and Religion in Early Modern Europe*, London and New York: Routledge.

Said, E. (1979) *Orientalism*, New York: Vintage.

Scarre, G. (1987) *Witchcraft and Magic in 16th and 17th Century Europe*, Basingstoke and London: Macmillan.

Smith, R. (1997) *The Fontana History of the Human Sciences*, London: Fontana.

Steedman, C. (1988) *The Radical Soldier's Tale: John Pearman, 1819–1908*, London and New York: Routledge.

Stone, L. (1977) *The Family, Sex and Marriage in England, 1500–1800*, London: Weidenfeld and Nicolson.

Strathern, M. (1992) *After Nature: English Kinship in the Late Twentieth Century*, Cambridge: Cambridge University Press.

Tosh, J. (1991) *The Pursuit of History. Aims, Methods and New Directions in the Study of Modern History*, London and New York: Longman, 2nd edition.

Tosh, J. (1999) *The Pursuit of History. Aims, Methods and New Directions in the Study of Modern History*, London and New York: Longman, 3rd edition.

Vergo, P. (ed.) (1989) *The New Museology*, London: Reaktion Books.

Wilson, A. (1993) *Rethinking Social History: English Society 1570–1920 and its Interpretation*, Manchester: Manchester University Press.

11 Texts, objects and 'otherness'

Problems of historical process in writing and displaying cultures

Elizabeth Hallam

Introduction

This chapter explores relationships between texts and objects as configured in certain fields of academic research and in museum practices. The main focus of this discussion addresses possibilities and limitations in critical or reflexive approaches to cross-cultural encounters, particularly in anthropological writing and display. Both written and visual forms of representation have been analysed in terms of their authority and effects in the communication of 'otherness' (Clifford 1988; Karp and Levine 1991). Central to these debates are analyses of the cultural politics of ethnographic texts, the ways in which objects (both material and conceptual) are constituted and the relations of power that are conventionalised or institutionalised through textual and visual representations. As Cruikshank observes:

> Museums and anthropology are undeniably part of a western philosophical tradition, embedded in a dualism which becomes problematic as a conceptual framework for addressing issues of representation. Entrenched oppositions between 'self/other', subject/object', 'us/them' inevitably leave power in the hands of the defining institution.
>
> (Cruikshank 1992: 6)

Within the discipline of anthropology and in critical museum studies there is a growing body of work which seeks to explore the construction and reception of representations and to question the ideological implications of these processes, especially in terms of the reproduction of dominant Western concepts and perceptions. One of the prevailing strategies in this work is to provide *historical* analyses of the formation of academic disciplines and the consolidation of institutional authority through documentation, collection and display (see Clifford 1988). Attempts to address the problems associated with the construction and subordination of 'others' are couched in terms of the historical emergence of anthropology and the historical conditions within which museum collecting and exhibiting have taken shape. The making of ethnographic texts and the definition of ethnographic objects, as well as the relationships between these forms of representation, are

then interpreted within specific historical contexts. Representations of cross-cultural encounters are understood as part of processes unfolding within and structured by socio-political relations, dominant intellectual frameworks and established codes, conventions and values which work to constitute representational forms. The institutionalisation of cross-cultural understanding in the academic discipline of anthropology and in museums, together with associated assertions of authority through particular textual and visual representations, stand as central issues in critical approaches to 'otherness'.

This chapter examines aspects of this current critique of anthropological and museum representations, foregrounding issues of cultural and historical process, with reference to anthropological writing and exhibiting. It explores the construction of 'otherness' in relation to temporality and conceptions of history as embedded in anthropological writing and exhibition. Crucial here are the debates surrounding the cultural politics of representation in which the relationships between texts and images (as culturally constituted forms) are analysed to reveal ideologies which prioritise certain forms above others. Within these debates there is a distinct lack of consensus with regard to hierarchies of textual and visual representations as recent work on anthropological writing and display argues in both directions for a critique of, on the one hand, the use of visual images and material objects and, on the other, the prioritising of certain texts as a means to represent cultural difference. The studies discussed throughout this chapter point to the problems involved when either texts or visual/material forms are constituted as dominant within anthropological and museum discourses. More specifically, in identifying some of the ways in which the cultural politics of anthropology and museums proceed through the elevation of certain representations as modes of access to cultural difference, we often find an ideology of 'otherness'. In seeking to address this particular operation of cultural dominance, reflexive strategies in anthropological writing and display seek to represent cultural processes which expose the historical nuances of cultural encounters. Anthropologies of cultural representation which trace the relationships between the textual and the visual in social and historical contexts are a positive move in this direction.

For Fabian, a central problem in cross-cultural understanding is 'anthropology's allochronism (its inclination to constitute the Other as a scientific object through the denial of co-temporaneity)' which, he argues, is tied to an emphasis on 'visualism' as a dominant mode of knowledge (Fabian 1991 [1985]: 201). As Jenks notes, there are relationships between modernity and 'ocularcentrism', the elevation of sight as a primary sense, evidenced in commonplace assumptions about seeing and knowing as well as in institutionalised discourses (Jenks 1995). With regard to sociological understanding he states that:

> 'self' and 'other' in sociological work has subsequently settled into the sanitised methodological form of 'observation'. 'Observation' has become a root metaphor within social and cultural research, and an extensive vocabulary of 'visuality', applied in an almost wholly unreflexive manner, has become

instrumental in our manoeuvres for gaining access to and understanding the concerted practices of human communities.

(Jenks 1995: 3)

The predominance of observation within social theory is problematic not simply in that it reduces social experience to what is visually perceived, but conceptually in that it relies upon the notion of a distanced, disengaged vision which is brought to bear upon, and indeed contributes to the definition of 'others' as though they were the objects of visual perception. The asymmetrical relations of power implied through such encounters have been critically addressed in anthropological work which argues for a shift from a visual to a discursive paradigm: 'from the observing eye and toward expressive speech (and gesture)' (Clifford 1986: 12). This is apparent in reflexive studies which situate anthropological texts themselves as objects of analysis. As later sections of this chapter show, the interrogation of text is part of an attempt to historicise the discipline of anthropology, as well as to disrupt the problematic self/other hierarchy.

Representations of different cultures, in the form of written accounts tend to deploy concepts of time and history that reinforce non-Western 'otherness'. As Fabian demonstrates, anthropological studies have assumed the temporal distance of the 'other' and similar problems of temporality are also present in the exhibition of 'others' in museums. Clifford identifies these problems in the institutionalised writing *and* display of cultures:

> The two domains [museums and anthropology] have excluded and confirmed each other, inventively disputing the right to contextualise, to represent these objects. [. . .] Both discourses assume a primitive world in need of preservation, redemption and representation. The concrete, inventive existence of tribal cultures and artists is suppressed in the process of either constituting authentic 'traditional' worlds or appreciating their products in the timeless category of 'art'.
>
> (Clifford 1988: 200)

While anthropology has largely relied upon writing practices as its main form of communication, museums are understood to be primarily concerned with three-dimensional material objects and their visual display in exhibitions. Following Clifford, textual and visual modes of representation, come into play within anthropological and museum discourses. Both are similarly implicated in processes of othering in that they relocate different cultures in time either through an implicit allusion to the past or through concepts which deny temporality. Stocking also points to the temporal dimensions of museum collecting and exhibiting practice. Objects are taken out of their 'original contexts in space and time' and held in museums where curators attempt to preserve them. Furthermore, museum visitors will view objects as 'survivals' from the past and this leads Stocking to highlight 'forces of historical inertia' which are difficult to resist in museum institutions (Stocking 1985: 4).

There are, therefore, complex relationships between anthropological and museum representations, dimensions of temporality, history and the problem of 'otherness'. These relationships are, themselves linked to wider historical processes:

> Whatever the contingencies of their specific histories, the three-dimensional objects thrown in the way of museum observers from out of the past are not placed there by historical accident. Their placement in museums, their problematic character and, indeed, their 'otherness', are the outcome of large-scale historical processes.
>
> (Stocking 1985: 4)

Inadequacies in anthropological and museum representations, including their conceptual bases and methodological apparatus which misconstrue temporal dimensions, are linked to longer term historical processes including European economic, industrial and political developments, especially those relating to projects of colonial power, emerging from the nineteenth century onwards (*ibid.*). Emphasis on this historical process, as an analytical focus, is, then, crucial in cross-cultural understanding and interpretation, a perspective that is central to many of the chapters in this volume.

This chapter examines histories of anthropology as well as the ways in which dimensions of time and history have been marginalised within this academic discourse. In the work of Fabian and Thomas there is a critique of anthropology's emphasis on the visual and a shift of focus towards textual forms. The prioritising of anthropological texts as objects of analysis is then examined, especially in the work of Clifford and Sanjek. The chapter moves into a discussion of the relationships between visual and textual materials in museums before considering the ways in which critical exhibition strategies have attempted to address issues of 'otherness', history and cultural representation. This discussion provides a framework for the interpretation of one particular exhibition, *Cultural Encounters*, co-curated by Elizabeth Hallam at Brighton Museum and Art Gallery in 1996. Through a case study based on this exhibition, this chapter traces some of the possibilities and limitations of critical, reflexive analysis and display.

Histories of/in anthropology

The construction of 'otherness' in anthropology, understood as an emergent set of politically implicated concepts and practices, has been analysed as a deeply rooted historical issue. Notably, Fabian and Thomas explore dimensions of time and historical process in the production of anthropological knowledge. These authors argue that the denial or marginalisation of these dimensions gives rise to problematic, hierarchical relations with 'others' as expressed within anthropological projects. In addressing the inequalities of power and the problems of cross-cultural understanding that follow from these, Fabian and Thomas address the historical formation of the discipline of anthropology and the need for

thorough discussions of historical processes in anthropological analyses. Their critical approach to 'otherness' then becomes an exercise in the contextualisation of anthropology in longer term intellectual history and an interrogation of the ways in which concepts of history and time are (inadequately) deployed within anthropological studies.

With reference to the intellectual history of anthropology, Fabian notes that during the later nineteenth century there was an awareness of the 'pragmatic and, indeed the political nature of anthropological "knowledge"' (Fabian 1991 [1985]: 194). For instance, he cites Adolf Bastian's public pamphlet (1881) that, during the early stages of German colonial activity, made a 'necessary connection between knowledge, domination and, ultimately, destruction' (*ibid.*). Bastian's argument, identifies 'primitive societies' as 'ephemeral' in that 'At the very moment they become known to us they are doomed' (quoted in Fabian, *ibid.*). Here Fabian shows how Bastian made public claims in support of the founding of ethnographic museums as institutions with an important role in research: 'Not observation of primitives alive [. . .] but documentation of primitive societies dead or dying, deserved priority in the ethnological enterprise' (*ibid.*). Such arguments articulated a particular conception of culture which was primarily focused on the past. Fabian points out that although histories of anthropology have tended to disregard this 'archival, museal orientation' in the emergence of the discipline, it needs to be addressed as part of an underlying conceptual structure within anthropology of civilised/savage, present/past, subject/object which has persisted since the eighteenth century (Fabian 1991 [1985]: 194–5).

> It seems strange and certainly counter-intuitive, but remains a historical fact: in anthropology, a set of theoretical problems had congealed into a 'science', and an object for that science had been constituted by means of antithetical oppositions (see above) *before* field research became institutionalised as a requirement for professional certification and as a criterion validating knowledge of other societies.
>
> (Fabian 1991 [1985]: 197)

Crucial to Fabian's argument is the assertion that the oppositions 'civilised/ savage, present/past, subject/object' were based upon assumptions of spatio-temporal distance:

> Generally speaking, anthropology appears to have been a field of knowledge whose discourse requires that its object – other societies, some of them belonging to the past, but most of them existing contemporaneously in the present – be removed from its subject not only in space but also in time. Put more concretely, to belong to the past, to be not yet what We are, is what makes Them the object of our 'explanations' and 'generalizations'.
>
> (Fabian 1991 [1985]: 198)

Fabian refers to 'temporal distancing' as an effect of 'conceptual and rhetorical

devices' which disregard process in the formation of social relations, actions and knowledge. Furthermore, he associates this with the predominance of visualism defined as 'a cultural bias towards vision as the "noblest sense" and toward geometry qua graphic-spatial conceptualisation as the most "exact" way of communicating knowledge' (1983: 106). The persistence of a visual-spatial 'logic' within anthropology can be traced back through the long-term development of Western science out of Greek and Roman arts of rhetoric and memory. Visualisation and spatialisation were foundational in the discipline of anthropology informing, in the nineteenth century, the exhibition of 'exotic others' in illustrated travel books and museums. With the professionalisation of anthropology and the requirement of field research, the practice of observing was further reinforced as a mode of access to knowledge of 'others'. Furthermore, in Fabian's analysis, the 'hegemony of the visual' also resides in anthropological writing: 'whereby writing should include everything from prose to the use of illustrations, tables, diagrams, but also rhetoric, the choice of expressions, analogies, metaphors, and so on, has been dominated by sight' (1991 [1985]: 202). Detrimental effects emerge as reductive, objectified perspectives. In this respect, Fabian refers to Ong:

> Persons, who alone speak (and in whom alone knowledge and science exist), will be eclipsed insofar as the world is thought of as an assemblage of the sort of things which vision apprehends – objects and surfaces.
>
> (Ong 1958: 9, quoted in Fabian 1983: 119)

The construction of 'otherness' within anthropological discourse is approached here as part of theory of knowledge which tends to privilege the visual and the spatial, leading to an objectification of persons. Attempting to address this politically damaging construct then becomes an agenda which aims to build time into the production of anthropological knowledge: 'to recognise subjectivity and intersubjectivity as epistemological prerequisites results in "temporalization" [. . .] as an emphasis on events occurring in con-subjective time frames' (Fabian 1991 [1985]: 200). Solutions to these problems are presented through the definition of fieldwork as a 'communicative praxis' together with the exploration of different textual strategies in anthropological writing, including 'dialogical accounts' which 'acknowledge that Self and Other are inextricably involved in a dialectical process' (Fabian, 1991 [1985]: 204–5).

While Fabian explores the formation of anthropology's object (the 'other') through an historical study of the discipline, Thomas conducts his examination of the anthropology/history conjuncture, and the continuity of ahistorical anthropological work, through a consideration of 'what it means for anthropological texts and comparative discussions to be "out of time"' (Thomas 1989: 1).

> Failure to address this question can only lead to an implicit perpetuation of the flaws of earlier work. It is apparent that history is often introduced in order to deny its significance. History has not been neglected simply through

an oversight, but for complex conceptual and discursive reasons. Only an analysis of the conditions of anthropological writing which set the discourses out of time can enable us to transcend these constraints.

(ibid.)

The 'flaws of earlier work' are here understood as 'theoretical errors' as well as 'substantive misinterpretations' of social, cultural and political relations (Thomas 1989: 9). Thomas' project amounts to more than an analysis of the subjective involvement of the ethnographer in the production of ethnographic knowledge as it draws wider social, cultural and ideological factors into the account (Thomas 1989: 3). He is concerned with

> the absence of historical time, and with the explicit or implicit negation of the notion that history has any constitutive effect in the social situation under consideration. It is possible for marginal reference to be made to history or the 'historical context' [. . .] without there being any interest in the significance of historical processes in the system being examined.
>
> (Thomas 1989: 5)

This is a direct critique of the ways in which certain anthropological studies have deployed the concept of history, particularly in their allusion to 'historical context' without a systematic incorporation of time and change into analyses. Instead Thomas calls for forms of historical understanding which

> raise fundamental issues about the nature of the standard objects for anthropological discussion, as well as the research and writing practice which keeps these studied things in intellectual circulation.
>
> (Thomas 1989: 10)

Necessary steps within this reorientation include not only ahistorical analysis of anthropology, but also the valuing of 'other' forms of evidence, namely those produced by persons 'lacking professional ethnographic credentials' (Thomas 1989: 15). Archival sources, for instance those written by explorers, missionaries and colonial administrators have often been 'derided and rejected' as 'biased' in comparison to 'data' compiled by anthropologists for whom 'personal ethnographic understanding' provides the basis for 'satisfactory description' (Thomas 1989: 10, 14). Such an emphasis on particular categories of evidence leads to the marginalisation of patterns of longer term change and the privileging of certain (dominant) views within the fieldwork setting rather than an 'assessment of the development of particular interpretations' within historically specific settings (Thomas 1989: 10, 13). For Thomas, the integration of historical processes into anthropological accounts requires shifts in methods and analysis, particularly in terms of an emphasis on historical context, the uses of historical evidence and, most significantly, the decentring of ethnographic fieldwork as the source of anthropological knowledge (Thomas 1989: 17).

Such a shift would place greater emphasis on the critical interpretation of archival, museum and library sources, drawing these materials into the centre of the analysis alongside the texts produced by anthropologists themselves. Thomas calls for the revaluing of archival sources and studies which 'situate their objects of discussion as outcomes of historical process' (Thomas 1989: 6–7). Both Fabian and Thomas identify the historical analysis of texts, produced within and beyond the fieldwork setting, as key in critical anthropological approaches to 'otherness'. This would involve a reconsideration of anthropology's objects of analysis, shifting the focus to forms of textual production and dissemination.

Ethnographic texts as objects

Reflection on the practice of writing and the production of texts has come to occupy a significant position in analyses of the formation of anthropology as a distinct and authoritative discipline. Clifford argues that writing during ethnographic fieldwork and in the presentation of anthropological accounts is central to the work of anthropologists. The recognition of such writing practices has emerged through anthropological reflexivity and critical analyses of 'an ideology claiming transparency of representation and immediacy of experience' (Clifford 1986: 2). By examining the involvement of the anthropologist in the shaping of images of 'others', Clifford asserts that a 'focus on text making and rhetoric serves to highlight the constructed artificial nature of cultural accounts' (*ibid.*). Furthermore, the production of such texts is always culturally embedded and historically specific.

Ethnographic writing practices which lead to particular representations of cultures should be interpreted in relation to cultural and, more specifically, literary processes: 'metaphor, figuration, narrative – affect the ways cultural phenomena are registered, from the first jotted "observations" to the completed book, to the ways these figurations "make sense" in determined acts of reading' (Clifford 1986: 4). Through analysis of the production of cultural accounts, Clifford highlights context, rhetoric, institution, genre, politics and history as they impinge on ethnographic writing (Clifford 1986: 6). Alongside this emphasis on the construction of anthropological texts is the argument that

> 'culture' is not an object to be described, neither is it a unified corpus of symbols and meanings that can be definitively interpreted. Culture is contested, temporal, and emergent. Representation and explanation – both by insiders and outsiders – is implicated in this emergence.
>
> (Clifford 1986: 19)

In this formulation of culture as process (cf. Street 1993), there is also a recognition of relations of power and how they operate in the textual representation of 'otherness'.

writing includes, minimally, a translation of experience into textual form. The

process is complicated by the action of multiple subjectivities and political constraints beyond the control of the writer. In response to these forces ethnographic writing enacts a specific strategy of authority. This strategy has classically involved an unquestioned claim to appear as the purveyor of truth in the text.

(Clifford 1988: 25)

The notion of the trained 'professional ethnographer', practising participant observation and claiming direct experience, constituted an authority which was reinforced through particular textual strategies:[1] '[a]n experiential "I was there" element establishes the unique authority of the anthropologist; its suppression in the text establishes the anthropologist's scientific authority' (Rabinow 1986: 244; see also Karp and Kratz, this volume). Despite the specificities of encounter and dialogical interpretation in the field, the ethnographic account is afterwards presented in the form of a monologue – an assertion of control over the representation of 'others'.

Further exploration of ethnographic writing, for example that involved in the production of fieldnotes, reveals the centrality of texts in the work of anthropologists. Sanjek identifies a 'vocabulary for fieldnotes' which encompasses scratch notes, fieldnotes, fieldnote records, head notes, texts, journals, diaries, letters, reports and papers (Sanjek 1990: 92–121). These are produced and used in different social settings, for a range of research purposes at different stages of the research process. Through an examination of various anthropologists' uses of such texts, Sanjek aims to render ethnographic method 'visible' (Sanjek 1990: 385). To expose such texts to scrutiny reveals something of the complexities of interpretation and negotiations of meaning which are part of the process of cross-cultural representation. It also situates ethnographic writing at the interplay between the ethnographer, the social/historical contexts in which she works and the production of histories to which her interpretations give rise. As Bond argues:

Fieldnotes are an anthropologist's most sacred possession. They are personal property, part of a world of private memories and experiences, failures and successes, insecurities and indecisions. They are usually tucked away in a safe place. To allow a colleague to examine them would be to open a Pandora's box. They are, however, an important key to understanding the nature of what anthropologists do; they are records of our findings, if not our own self-discovery as artists, scientists and – more accurately – *bricoleurs*, assembling cultures from the bits and pieces of past occurrences.

(Bond 1990: 273)

These studies of text making thus acknowledge subjective involvement in the representation of 'others' and the historical processes through which representations emerge. The positioning of 'others' within these texts is complex given that, in the case of fieldnotes, '[t]hey are the products of multivocality, the creation of a number of voices' (Bond 1990: 286). Sanjek also shows how fieldnotes 'as

objects' are sometimes read by a diversity of 'others' including anthropologists, the people whom they describe, and 'other "others" in the society studied but outside the immediate ethnographic range' (Sanjek 1990: 324). The interpretation of these texts is then dependent upon the social relations within which they are circulated and read. Texts, within reflexive anthropological studies, become meaningful as objects of analysis. They form a crucial part of the research process, an investigation of which is seen as necessary in tracking the cultural politics of anthropological representations. Texts are then viewed as constructions shaped by cultural codes and conventions with material and visual dimensions. Furthermore, the materiality of written documents including, for instance, paper, which possesses its own signifying properties, is emphasised in material culture studies (see Pellegram 1998).

Texts in museum spaces

This analysis of texts can be applied to museum representations – firstly in terms of the uses of texts in museums, but also in the uses of material objects to convey notions of 'otherness'. Here the representation of 'otherness' in museums can be explored through analysis of the relationships between texts and objects in particular exhibitions. With regard to ethnographic museums in the later twentieth century, Lidchi states that '[e]xhibitions are discrete events which articulate objects, texts, visual representations, reconstructions and sounds to create an intricate and bounded representational system' (Lidchi 1997: 168).[2] While the relationships between texts, objects and visual images, such as photographs, work to produce specific cultural meanings in the context of exhibiting, it is often the textual components which predominate in the communication of the displays' aims and themes. Within museum spaces texts have been deployed in the form of introductory text panels, labels, captions, leaflets and catalogues all of which guide the viewer in their interpretation of the objects and images on display. Text panels make authoritative statements regarding the exhibition with the function of establishing the 'parameters of representation' in terms of its narrative and sequence, while labels make claims on the identification and description of particular objects (Lidchi 1997: 170, 175). Clifford makes a similar point in demonstrating that the central messages of an exhibition are conveyed through introductory text panels, the selection of particular objects for display and the 'maintenance of a specific angle of vision' through the juxtaposition of images (Clifford 1988: 193).[3] So, despite the explicitly critical approaches to colonial ideologies within certain museum exhibitions, the effect is often to reinforce dominant concepts and histories.

The uses of texts in museum spaces tend to function as part of a cultural politics which reproduces certain forms of power relations with regard to 'others'. Texts are central to the cultural translation involved in museum discourse. Lidchi claims that such texts 'impart information' as well as forming 'economies of meaning, selecting what they would ideally like the visitor to know – what is important' (Lidchi 1997: 176). The predominance of text, in imparting information and knowledge, again appears to have been established within Western epistemology:

> Contemporary Western common sense, building on various traditions in philosophy, law, and natural science, has a strong tendency to oppose 'words' and 'things.' Though this was not always the case even in the West [. . .] the powerful contemporary tendency is to regard the world of things as inert and mute, set in motion and animated, indeed knowable, only by persons in their words.
>
> (Appadurai 1986: 4)

The current politics of representation are conceived in terms of a hierarchical relationship between texts and material objects where texts dominate in the constitution of knowledge. It is worth exploring Appadurai's allusion to a historical moment in which this text/object hierarchy was not so pronounced. During the fifteenth and sixteenth centuries there was a significant expansion in European musei (rooms dedicated to the display of objects), archives, libraries and academies which were largely undifferentiated in that they were all intended as repositories of 'curious' objects, including manuscripts and books (Stagl 1995). Alongside the emergence of musei were compendia, books containing collections of written material which made similar claims to represent the world in microcosm. Here words and material objects were of equal importance and, as Stagl notes, 'both forms of collection could, moreover, be "translated" into each other': musei became books when they were described in catalogues, and, conversely, books became musei with the incorporation of extensive illustrations (Stagl 1995: 115). Similarly in Dutch Renaissance art, texts were placed in an equal position to images. Texts were often incorporated into paintings and, as Alpers argues, 'Rather than supplying underlying meanings, they give us more to look at' (Alpers 1983: 187), i.e. the relation of text and image appears to have been complementary. Furthermore, texts such as letters appeared in paintings, and it was not their content which was emphasised but their visual, material dimensions: a text 'as an object of visual attention, a surface to be looked at' (Alpers, 1983: 196). These relationships of equality and continuity between textual and visual forms appear, however to have been reconfigured with the development of Enlightenment thought which attempted to effect, in the context of museums, a 'shift from sensory impact to rationalising nomenclature' (Stafford 1994: 266). Material objects came to be defined through textual forms such as catalogues and this contributed to the 'reification of print-based language as the master paradigm for all serious signification' (Stafford 1994: 284).

The dominance of textual forms in the ordering of material objects acts as a means through which concepts and categories rooted in post-Enlightenment rationality and scientism are reinforced. The text/object hierarchy has a number of implications for the ways in which texts are deployed in museum exhibitions. They tend to appear as 'neutral', objective information in the form of exhibition titles, text panels, object labels and captions. This renders their visual and material dimensions 'invisible' – they are not part of the display, rather they structure the interpretation of it although, again, their ideological dimensions remain hidden. Again, issues of temporality come into play. Recalling Fabian's discussion of time

in anthropological studies, Clifford notes the 'temporal incoherence' of museum captions. Small texts, used to describe images of non-Western peoples and their material objects scramble past and present with the inconsistent uses of tense:

> Beyond such questions of accuracy is an issue of systematic ideological coding. To locate "tribal" peoples in a nonhistorical time and ourselves in a different, historical time is clearly tendentious and no longer credible.
>
> (Clifford 1988: 202)

Recent approaches to cultural encounters that see them as embedded in historical processes have attempted to challenge a politics of representation that reinforce certain forms (in this case texts) over others, and instead have rethought the organisation and content of museum spaces. The following sections of this chapter examine recent attempts to bring historical perspectives into the visual order of anthropological exhibitions, through the 'opening' of archives (including the collections of institutions and individuals), and the critical reflection upon relationships between texts and material objects.

Critical exhibitions: opening archives

Within critical museum studies, a re-evaluation of 'what constitutes an object' in the context of museum collection and display has taken place (Cruikshank 1992: 7). This has been necessary in addressing the ways in which museum exhibitions reinforce conceptions of 'otherness' as exotic, primitive and subordinate. In the analysis of the politics of museums and in studies of material culture, attention has been directed towards collecting practices, the social relationships involved in the circulation and display of objects, as well as processes of commodification (*ibid.*). Academic work in these areas has had an impact on exhibition strategies in museums, as Lidchi claims:

> We have seen that changes in the academic discipline, itself affected by larger cultural movements (such as post-modernism), have created new boundaries for exhibiting: to name but three, the inclusion of self-reflexivity, or dialogue or polyvocality (many voices, interpretations of objects); the move towards incorporating hybrid and syncretic objects; and a right for those represented to have a say in exhibition construction.
>
> (Lidchi 1997: 201)

Such exhibition strategies aim to reconfigure the hierarchical relationships between 'self' and 'other' that were characteristic of colonial encounters. To this end, exhibitions which explicitly attempt to expose these inequalities of power often aim to interject historical approaches which contextualise ethnographic materials within longer term processes of colonisation and Western exploitation. This necessarily involves the reconsideration of display techniques, especially a renegotiation of what constitutes appropriate 'objects' for visual contemplation

within museum spaces. Acute problems in ethnographic display emerge through tensions between the need to address the complicity of museums in the politics of othering whilst maintaining the contemporary relevance of, and public interest in, their collections.

As one instance of these changing approaches within museum exhibiting, 'The Impossible Science of Being. Dialogues between Anthropology and Photography', provided an exploration of anthropological representations which were contextualised through their historical relationships with other technologies of visual production. This touring exhibition opened in London, Leeds and then at Brighton Museum and Art Gallery in August 1996. Its aims were at once critical and creative, tracing the links between early anthropology and photography, questioning the representational capacity of these practices and highlighting the relations of power involved in their development. As one review of the exhibition stated, 'the curators bounce questions of representation between the parallax of anthropology and photography, between the interstices of image and writing, and in what they call "a dialogue"' (Hughes-Freeland 1996: 17).

In the accompanying exhibition publication, Jonathan Benthall, Director of the Royal Anthropological Institute, emphasises the importance of anthropology in enhancing the 'understanding of human societies', whilst alluding to the 'errors of anthropology' in reinforcing 'inhuman ideologies' (Charity *et al.* 1995: 4). Furthermore, he notes that 'Contemporary anthropologists see academic enquiry as inseparable from a commitment to critical examination of the history and current role of their discipline' (*ibid.*). Exploring the history of anthropology and engaging the public in assessments of the 'role' of this discipline are fore-grounded. The historicising of anthropology, through textual accounts and visual images in the public space of the museum, is pursued as a means to address the cultural politics of academic production. Such a project requires the public exposure of the formerly secluded archival collections generated in the practice of anthropology. Thus Benthall describes the archive of the Royal Anthropological Institute as a place of 'dust and silence' which then becomes a source of 'inspiration' and 'reflection' (*ibid.*). Archives holding historical documents and photographic images (mostly from 1860–1920) become repositories of hope containing materials which will allow critical reflection on the politics of early anthropology, and thus a means to openly confront the problematic values and assumptions which are part of the discipline's history. They also provide historical materials which can be used to mark the difference (distance?) between earlier as opposed to contemporary anthropology. As Pinney, Wright and Poignant claim in the exhibition publication: 'The critical and interpretative anthropology of the late twentieth century is the antithesis of the nineteenth century concern with the play of light over the surfaces of bodies and objects' (Pinney *et al.* 1995: 7).

'The Impossible Science of Being' aimed to trace relationships between an anthropological archive, museum exhibition and installation. Within this Pinney, Wright and Poignant identify a continuity between visual image and written text in early anthropology. Once central to the documentation of other societies, the photographic images, produced by late nineteenth- and early twentieth-

century travellers and missionaries and stored in the archive, were displaced by ethnographic fieldwork. However, Pinney *et al.* argue that anthropologists had internalised the 'idiom of photography within the production of its texts' (Pinney *et al.* 1995: 8). In the field, the anthropologist became the 'negative' through exposure to data which was then 'processed' into the 'positive' through the writing and publication of the monograph:

> It is in this sense that photography and a metaphorisation of its technical and ritual procedures have, perhaps, informed the nature of written texts which anthropologists now often privilege over visual documentation.
>
> (*ibid*).

The exhibition thus suggests continuities, as well as hierarchies in the mobilisation of word and image that structure the representation of 'otherness'. Early visual technologies persist in the processes of textual production which then become the predominant means to represent 'others'. The exhibition's use of the anthropological archive is further elucidated in Davis' contribution to the exhibition publication, drawing attention to the act of confronting both early photography and anthropology in terms of their involvement in colonial and racist ideologies:

> In opening the archive, we may encounter a past brought too directly and vividly into the present. [. . .] The shock that we feel when we encounter the ethnographic archive is the zero-degree of photography's dangerousness; its disturbance of civilisation. In this instance, it is also ethnography's willingness to be disturbed in itself.
>
> (Davis 1995: 41)

To provide interpretations of this archive from different perspectives, contemporary artists from the Association of Black Photographers were commissioned to create work in response to it. Faisal Abdu' Allah, Zarina Bhimji and Dave Lewis provided work which addressed issues of knowledge, experience and power linked to race, colonialism and anthropology. Here, problems in the uses of historical materials within the exhibition emerge. As Dave Lewis states in his interview, provided as part of the exhibition publication, he was denied access to aspects of the collection and refused permission to photograph them (Bhimji 1995). As Hughes-Freeland notes, this difficulty arising from restricted access to historical documents and images was not represented within the exhibition (Hughes-Freeland 1996: 19). There are dimensions of institutional control here which limit access to historical materials and therefore define boundaries of historical research. Hughes-Freeland has suggested that, in this case, the artist was denied access because of the taboos surrounding historical images with potentially pornographic connotations (*ibid.*). Whilst claiming to explore the related histories of anthropology and photography, and to provide contemporary, critical responses to anthropological archives, the exhibition moved up against the

limitations of display. These limitations are related to the difficulties involved in the visual display of historical process, including the practice of historical inter-pretation with the use of institutionalised archival material. The dialogue between the contemporary artists and the archival material is structured through insti-tutional relations of power which extend control over the archives' materials. Further problems are raised through attempts to convey responses to historical documents through the display of visual images. In this respect, Hughes-Freeland considers the display of the artists' images without extended textual commentary to be insufficient in providing them with a voice in the 'exhibition-as-event' (*ibid.*). With reference to these images she asks:

> is it enough to simply show them? Or are the photographers being imprisoned in their images and denied a voice? was it their choice? or the organizer's? The criticism could be made that their eyes have been appropri-ated, their skills patronized to produce useful goods, but they too have been muted, confined to images.
>
> (*ibid.*)

Such questions point to central problems in display strategies within museum spaces. From the various critical anthropological perspectives presented here it appears that when any form of representation predominates (whether textual or visual) there is a corresponding marginalisation of 'other' perspectives. Tracing the parallel histories of anthropology and photography by opening the archive is an admirable, but not an unproblematic solution – the practice of historical interpretation carries its own problems rooted in the politics of the archive.

Displaying process: a case study

Some of the pressing concerns within critical approaches to the writing and dis-play of cultures tend to focus around several interrelated problems in the repre-sentation of cultural (understood as necessarily historical and political) processes. Following from the framework of anthropological and museum debates outlined above, the present case study provides an analysis of one particular exhibition which aimed to address aspects of 'otherness' as understood in current research and display practices.[4] The 'Cultural Encounters' exhibition, curated by Elizabeth Hallam and Nicki Levell, opened at Brighton Museum and Gallery in February 1996.[5] The exhibition was a collaborative project involving Sussex University, Brighton University and Brighton Museum. As noted in the Preface to this vol-ume, the exhibition was conceived and organised as part of a series of research lectures, seminars and events based in the Graduate Research Centre for Culture and Communication (CulCom). Central to these activities were debates about cultural representations, including visual materials and written texts, together with the ways in which these are produced and received in different social and historical contexts. The discussions extended across geographical areas, academic disciplines and institutional locations. Throughout the planning and in the view-

ing of the 'Cultural Encounters' exhibition, a particular set of concerns regarding relationships between the university and the museum as sites which supported the production and collection of cultural representations, came into focus. The exhibition was conceived partly as a response to the writing culture debate within anthropology and formed an attempt to bring these issues into some relation with the problems in the display of culture noted in the previous sections of this chapter.

The exhibition specifically centred around issues relating to the research process and the representations which are collected, manipulated and disseminated throughout. Five researchers from the School of Cultural and Community Studies at the University of Sussex were asked to contribute some of their research materials which had been generated and collected through encounters with cultural difference during fieldwork, in museums and in archives. The exhibition consisted of the research materials of two anthropologists, an art historian, a geographer and a media studies lecturer which were displayed in the Cultures Gallery at Brighton Museum. Mounted in five cabinets, the materials included a wide range of texts (manuscript and printed) and visual images (photographs, prints, diagrams, tables, graphs, maps) as well as material objects.

Susan Wright, an anthropologist, contributed research materials from her study of Iranian politics and social relations. The cabinet displaying her collection, entitled 'Patterns and representations', contained fieldwork notes, a diagram of a village, a genealogy of kin relations and photographs of the village and local weaving practices (Figure 11.1). Craig Clunas, an art historian, selected material objects from the collection of Sir Alan Barlow together with a photograph of the collector for the 'Collecting china' cabinet (Figure 11.1). Elizabeth Hallam provided the research materials displayed in 'The archive's others' cabinet (Figure 11.2). These were collected during anthropological research on gender and ritual in an archive based in South East England. Here materials included copies of seventeenth-century manuscripts, a woodcut from the same period, maps and copies of the archive's catalogue. The cabinet entitled 'Listening in as a form of cultural encounter' contained a selection of Christina Brink's research materials providing insights from a media studies perspective on political propaganda and communication (Figure 11.2). Photographs and transcripts of programmes broadcast worldwide and received by the BBC in the 1930s and 1940s were included in the display. Finally, Brian Short provided materials relating to his research in historical geography for the cabinet 'Encountering the land of Edwardian England' (Figure 11.2). Copies of historical documents from the Public Record Office, maps, political cartoons and speeches relating to land and property in the early twentieth century figured in Short's contributions. Displayed within each cabinet were materials generated in particular historical contexts through cultural encounters involving diverse local and national bodies and institutions as well as personal social interactions.

Such research materials are not usually open to public scrutiny. They accumulate in filing cabinets, offices, drawers and book shelves. They might pass through various stages such as indexing and cataloguing, as they are written, read and

Figure 11.1 ' Cultural Encounters' exhibition, Brighton Museum and Gallery, 1996.
The cabinet on the far right of the Cultures Gallery contained the
research materials of Susan Wright ('Patterns and representations'). The
cabinet on the left ('Collecting china') shows material collected by Sir
Alan Barlow and a photograph of the collector, selected by Craig Clunas.
The text panels describing each cabinet were mounted on the opposite
walls (see Figure 11.3).

Source: University of Sussex.

rewritten into research papers, lectures, teaching materials, reports and books.
They are an essential part of research practices and, although they are valued and
known intimately by their owners, they usually remain secluded within private
spaces. They remain hidden behind the apparently accomplished and seamless
final product – the book, the article, the research report. Opening these collec-
tions to the possibility of visual display in a public arena involved negotiations
between the university and museum. The resilience of notions about what consti-
tutes a visually interesting object, appropriate for display within a museum,

Figure 11.2 'Cultural Encounters' exhibition, Brighton Museum and Gallery, 1996. The photograph shows three cabinets. On the right ('The archive's others'), the research materials of Elizabeth Hallam, including copies of a seventeenth-century manuscript and a printed image, were mounted on transparent sheets and enlarged on embossed paper. Fragments of the archive's codes used to catalogue manuscripts were enlarged and printed onto the background sheeting. The central cabinet ('Listening as a form of cultural encounter') contained copies of Christina Brink's research materials, including visual and written documentation of radio broadcasting. The cabinet to the far left of the gallery ('Encountering the land of Edwardian England') displayed Brian Short's collection, including a copy of an historical document printed onto the glass cabinet. Museum visitors were invited to look at the objects through the document, for example, a map on the back of the case (represented here in fabric). Slides of Short's research material were also mounted and displayed in a light-box outside the cabinet. Again, the corresponding text panels, in the same format as the one shown in Figure 11.3, were displayed on the gallery wall opposite the cabinets.

Source: University of Sussex.

led into discussions about how to install research materials. There was a need to convey a sense of the ways in which these objects had acquired value and meanings from the point of view of the researchers as well as providing a visually engaging display from the point of view of the visiting public.

The researchers' written and printed texts (either collected from archives or produced by the researchers themselves) became particularly problematic. Although highly valued by university researchers, in the context of a museum exhibition, they seemed to fail to meet conventional display criteria. Not only were these objects free from pictorial content, they were flat and apparently resistant to museum installation. The conventions inherent within the organisation of museum space tends to ensure that text is confined to certain locations as noted above, on exhibition title signs, on text panels outside the display cabinets, on small explanatory object labels, and within exhibition catalogues. Museum discourse seemed to divide and separate text and the object to be displayed and this tended to reinforce their location, both conceptually and spatially, in different categories.[6] The exhibition aimed to move away from the use of text as providing 'objective' information towards an exploration of text as a process through which cultural ideas and representations are constituted and made meaningful within particular social contexts. This was reflected in the text panels which were written by the researchers to accompany and describe each cabinet – the researchers' names were also included on the text panels to signal their subjective involvement in both the collecting process and the making of the exhibition. These texts were divided into different sections and printed onto three layers of perspex (Figure 11.3). The text was legible from the front view but from the side angles the text fragmented rendering it difficult to read and thus visible primarily as a material object. The purpose of this was to highlight the material dimensions of the writing process and the written document.

All of the researchers presented their materials to the curators and described the ways in which they had been collected and interpreted. This was important in the incorporation of the researchers' intentions, and their readings of the materials, into the display. So the organisation of the objects within the display cabinets was dependent upon productive interaction between curators and researchers. The researchers understood their materials as part of a wider research process so the interrelationships between the various texts and images were particularly significant. For example photographs were related to notes and diagrams and maps to historical documents. Display styles, which were able to visually represent interconnected objects, were required. Trying to exhibit the research process within museum cabinets entailed consideration of the visual qualities of the research materials. The shape, texture, weight, size and colour of objects as well as the different manuscript, typescript and printed texts were important visual dimensions relating to conventions of cultural production. The relocation of the objects from the university to the museum tended to highlight the constructed meanings of the objects – they were transformed from university text to museum object. This foregrounded the importance of institutional location in the formation of their meanings.

Patterns and Representations

I have visited Doshman Ziari, Mamasani in Iran four times. In 1974 and 1975/6 I did 16 months anthropological fieldwork. I lost contact following the Iranian Revolution but returned briefly in 1992 and for 6 weeks in 1995.

This cabinet contains maps, genealogies and photographs - representations of aspects of these people's lives. In 1995 I returned the earlier photographs and genealogies to them. These became the focus for discussions about rapid cultural change.

The most obvious changes were that half the population had moved to town, and the main village had been hit by an earthquake. A official plan replaces the traditional village with urban style houses in a grid pattern.

Anthropologists seek out changing 'patterns' in everyday interaction. Here I am making this 'pattern' metaphor explicit by looking at interactions through carpets.

Carpets featured materially in interactions: men met sitting on a carpet whereas women talked as they wove. Carpets' clear linear designs, vying with a scattered multitude of shapes symbolised men's and women's perspectives. Men tried to draw clear boundary around their group and cluster of yards. Women tried to keep in play cross-cutting allegiances scattered throughout the village.

In 1995 carpets were rarely woven in the village. They no longer fitted the rooms of town-style houses - large machine-made carpets were bought instead. Such was the extent of changes, both materially and symbolically in patterns of interaction

Susan Wright
Lecturer in Social Anthropology

Figure 11.3 'Cultural Encounters' exhibition, Brighton Museum and Gallery, 1996. An example of the text panels, each written by the researchers/ collectors to comment on the research process involving the gathering and interpretation of their materials.

Source: University of Sussex.

In order to communicate the researchers' perceptions of their research in visual form special display styles were devised. A primary consideration was how to convey the relationships between text and image which are formed throughout the research process. This was facilitated through the intervention of a design group from the University of Brighton who devised the presentation and installation of the five sets of materials. The designers became familiar with the interests of the researchers to ensure that the designs for the displays were consistent with the researchers' main intentions. Text panels were written by the researchers and then used by the designers to help place the objects in appropriate ways within the cabinets. We hoped that the continued communication between researchers, curators and artists would help to produce a display which brought to the surface meanings attributed to objects by their collectors. Communicating the research process to the viewing public involved the manipulation of the materials to render visible the relationships between text and image. The research materials did not on their own possess the conventional 'authenticity' usually associated with museum objects. They consisted primarily of copies of documents held in archives or notes and images produced by the researchers themselves. The photographs, photocopies, slides, transcriptions and written accounts were not static objects to be preserved in their 'original' form. They had been produced, used and made meaningful through an interpretative process and as such they were open to manipulation in the practice of research. The visual content of the cabinets was required to convey something of this process. So the design group transformed texts by, for example, altering their size or exaggerating certain features, printing them onto the glass cabinets and displaying them on enlarged transparencies (Figure 11.2).

The exhibition aimed to visually highlight the complex layers of production, reception and interpretation that are always embedded within the institutional and social contexts in which representations are brought into play. Rather than an invitation to access 'another' society directly, museum visitors were encouraged to examine the processes of construction (via research, collecting and writing) that bring 'others' into view. Attempts were made to displace the fixed or essentialised category of 'the other' and to explore, instead, a range of cultural, social and historical differences. The exhibition aimed to raise questions about what constitutes 'otherness', the ways in which this category might shift over time, the problems and politics involved in representation of others. The project explored a diversity of cultural encounters: between the university and the museum, between the researchers and their objects of study, between the displays and the museum visitors, between text and image as culturally defined.

Conclusions

The 'Cultural Encounters' exhibition aimed to display cultural processes, foregrounding the practice of interpretation within academic research. The materials on display were drawn from the personal collections of researchers and related to different geographical regions and historical periods. The exhibition attempted to visually represent the interpretation of 'others' as a historically grounded practice

which involved the linkage of texts, visual images and material objects. This resituated texts as cultural objects, rather than carriers of 'objective' information. In the writing and display of the texts panels the researcher/collector was brought into the frame, indicating their subjective involvement in the formation of their collections and in the devising of the exhibition. To evaluate this project more fully would involve an anthropological study of the display to include museum visitor's interpretations. As Marcus points out, in this volume, the critical intentions of curators and the visual codes used in exhibitions which problematise their own foundations are often inaccessible to wider social groups. Furthermore, as Jordanova observes in her chapter, the interpretative work of historians is difficult to convey through visual displays. Developing a means to represent cultural and historical process in anthropological and museum discourses remains a difficult problem. The 'Cultural Encounters' exhibition attempted to address this through the display of text and image as interrelated processes involved in the constitution of social and cultural relations in different cultural/historical settings and within academic interpretation.

In order to develop critical perspectives on the question of 'otherness', reflexive strategies in both anthropological writing and display have attempted to reveal the ways in which cultural authority is consolidated through the politics of cultural representation. This has involved the interrogation of both textual and visual forms as problematic within discourses on cross-cultural encounters. While this anthropological critique has variously addressed the dominance of either the visual or the textual, both forms of representation are problematised in terms of the categories of 'otherness' that they construct. To analyse the shifting hierarchies of representational forms requires attention to historical context and process – attending to the particular social and political relations which configure the relationships between knowledge, text, visual image and material object. The writing and display of cultural processes, which acknowledges the complex power relations between 'self' and 'other' can be facilitated through anthropologies of cultural representations – including those 'held' in archives, museums, university and academic collections. Revealing the relationships between text and image and exposing the epistemological and political factors which shape these relations, involves critical and creative anthropologies of cultural representation which confront the question of 'otherness'.

Notes

1 Here Clifford is referring to anthropological work, approximately 1900–60, though, of course, during this period anthropological practices, methods and writing varied (Clifford 1988: 24).
2 Lidchi makes specific reference to the exhibition 'Paradise: change and continuity in the New Guinea highlands', Museum of Mankind, British Museum, London, July 1993–July 1995.
3 Here, Clifford's analysis is based upon the exhibition '"Primitivism" in 20th Century Art: Affinity of the Tribal and the Modern', Museum of Modern Art, New York, December 1984.
4 This case study is based on a revised version of the author's Introduction to the

'Cultural Encounters' exhibition catalogue: E. Hallam and N. Levell (eds) 1996, *Communicating Otherness: Cultural Encounters*, University of Sussex: Graduate Research Centre in Culture and Communication.

5 Further analysis of the 'Cultural Encounters' exhibition is also available in N. Levell and A. Shelton (1998) 'Text, illustration and reverie: some thoughts on museums, education and technologies', in *Journal of Museum Ethnography,* no. 10, 1998.

6 There were, however, points at which this museum classification dissolved. It seemed that certain texts were sometimes shuffled into the 'object for display' category. The museum would often exhibit diaries, newspaper items, books, magazines, historical documents, and so on. We began to explore the differences between the display of these apparently acceptable texts and those which we were proposing to exhibit. The main differences seemed to be marked through value judgements as to what counts as a significant historical document. This clearly depends on definitions of history and its making (see Jordanova, this volume).

References

Alpers, S. (1983) *The Art of Describing. Dutch Art in the Seventeenth Century*, London: Penguin Books.

Appadurai, A. (1986) 'Introduction: commodities and the politics of value', in *The Social Life of Things. Commodities in cultural perspective*, Cambridge: Cambridge University Press.

Bhimji, Z. *et al.* (1995) 'Zarina Bhimji, Faisal Abdu'Allah and Dave Lewis in discussion with Lola Young', in Charity, R. *et al.* (eds) *The Impossible Science of Being. Dialogues Between Anthropology and Photography*, London: The Photographers' Gallery.

Bond, G. C. (1990) 'Fieldnotes: research in past occurrences', in R. Sanjek (ed.) *Fieldnotes. The Makings of Anthropology*, Ithaca, NY: Cornell University Press.

Charity, R. *et al.* (eds) (1995) *The Impossible Science of Being. Dialogues Between Anthropology and Photography*, London: The Photographers' Gallery.

Clifford, J. (1986) 'Introduction: partial truths', in J. Clifford, and G. E. Marcus (eds) *Writing Culture. The Poetics and Politics of Ethnography*, Berkeley and Los Angeles: University of California Press.

Clifford, J. (1988) *The Predicament of Culture. Twentieth Century Ethnography, Literature and Art*, Cambridge, MA: Harvard University Press.

Cruikshank, J. (1992) 'Oral tradition and material culture. Multiplying meanings of "words" and "things" ', in *Anthropology Today*, 8 (3): 5–9.

Davis, C. 'Nothing to do with a corpus: only some bodies', in Charity, R. *et al.* (eds) *The Impossible Science of Being. Dialogues Between Anthropology and Photography*, London: The Photographers' Gallery.

Fabian, J. (1983) *Time and the Other: How Anthropology Makes its Object*, New York: Columbia University Press.

Fabian, J. (1991 [1985]) 'Culture, time and the object of anthropology [1985]', in *Time and the Work of Anthropology. Critical Essays 1971–1991*, Chur, Switzerland: Harwood Academic Publishers.

Hallam, E. and Levell, N. (eds) (1996) *Communicating Otherness: Cultural Encounters*, exhibition catalogue, University of Sussex: Graduate Research Centre in Culture and Communication.

Hughes-Freeland, F. (1996) 'Hooks and eyes: a review of the impossible science of being', in *Anthropology Today*, 12 (2): 17–20.

Jenks, C. (ed.) (1995) *Visual Culture*, London: Routledge.

Karp, I. and Levine, S. D. (eds) (1991) *Exhibiting Cultures. The Poetics and Politics of Museum Display*, Washington, DC: Smithsonian Institution Press.

Levell, N. and Shelton, A. (1998) 'Text, illustration and reverie: some thoughts on museums, education and new technologies', *Journal of Museum Ethnography*, 10 15–34.

Lidchi, H. (1997) 'The poetics and politics of exhibiting other Cultures', in S. Hall (ed.) *Representation: Cultural Representation and Signifying Practices*, London: Sage Publications.

Pellegram, A. (1998) 'The message in paper', in D. Miller (ed.) *Material Matters. Why Some Things Matter*, London: UCL Press.

Pinney, C. *et al.* (1995) 'The impossible science', in Charity, R. *et al.* (eds) *The Impossible Science of Being. Dialogues Between Anthropology and Photography*, London: The Photographers' Gallery.

Rabinow, P. (1986) 'Representations are social facts: modernity and post-modernity in anthropology', in J. Clifford and G. E. Marcus (eds) *Writing Culture. The Poetics and Politics of Ethnography*, Berkeley and Los Angeles: University of California Press.

Sanjek, R. (1990) 'A vocabulary for fieldnotes', in R. Sanjek (ed.) *Fieldnotes. The Makings of Anthropology*, Ithaca, NY: Cornell University Press.

Sanjek, R. (1990) 'On ethnographic validity', in R. Sanjek (ed.) *Fieldnotes. The Makings of Anthropology*, Ithaca, NY: Cornell University Press.

Sanjek, R. (1990) 'Fieldnotes and others', in R. Sanjek (ed.) *Fieldnotes. The Makings of Anthropology*, Ithaca, NY: Cornell University Press.

Stafford, B. M. (1994) *Artful Science. Enlightenment Entertainment and the Eclipse of Visual Education*, Cambridge, MA: MIT Press

Stagl, J. (1995) *A History of Curiosity. The Theory of Travel 1550–1800*, Chur, Switzerland: Harwood Academic Publishers.

Stocking, G. W. (ed.) (1985) 'Essays on museums and material culture', in *Objects and Others. Essays on Museums and Material Culture*, Madison: University of Wisconsin Press.

Street, B. (1993) 'Culture as a verb', in D. Graddol *et al.* (eds) *Language and Culture, Multicultural Matters*, Oxford: Clarendon Press.

Thomas, N. (1989) *Out of Time. History and Evolution in Anthropological Discourse*, Cambridge: Cambridge University Press.

Index

SOAS LIBRARY